THE
ROMAN
STAMP

THE
ROMAN STAMP

Frame and Facade in Some Forms

of Neo-Classicism

ROBERT M. ADAMS

UNIVERSITY OF CALIFORNIA PRESS

Berkeley · Los Angeles · London

1974

University of California Press
Berkeley and Los Angeles, California

University of California Press, Ltd.
London, England

Printed in the United States of America
Designed by Jim Mennick

CONTENTS

Time's golden thigh
Upholds the flowery body of the earth
In sacred harmony, and every birth
Of men and actions makes legitimate:
Being us'd aright, the use of time is fate.

GEORGE CHAPMAN, *Hero and Leander*, Sestiad 3

I

VARIATIONS ON SOME THEMES

Self and Selves

To think of self is, under one aspect, to strip away. Self is that which stands alone, without support or dependence. Self endures, it is constant. Imaginatively, we strip away a man's accidents and circumstances in order to see or suppose what he is "in himself." Conscious as we often must be of how much in our own lives is performance, we discount, we subtract, we set aside. We no more suppose a man is "himself" when he wears formal clothes, puts on the badge of an office, or speaks into a microphone, than when he dresses up for charades. Certain roles in life, we say casually, permit a man to express very little of himself (or, more pointedly, of his self); the locution implies that there is somewhere a full reservoir of essential being that gets drained into various roles in various circumstances. To see the man as "he really is," we must see him in all his roles and then construct what lies behind these different facades, the manipulator of these various puppets.

Subtraction is a powerful device toward clearing a view of the self; a wide field opens before anyone who wants to apply it. Apart from deliberate artifice and role-playing, there is no one of us who does not incorporate habits, mannerisms, inhibitions, and clusters of convention coming upon us from outside. Our social training is by

imitation to conformity; without ever intending to do so, we pick up the patterns and mores of our society, like electrostatic lint. This surely is not our selves; it is the mere superficial detritus of existence, to be brushed away if the essential self is to stand clear. Discarding this imitation, that compliance, the other outside influence, we can cut ourselves down pretty far—to a point, indeed, where not much is left. Imitative acculturation is not merely exterior dust; it is so thick an epidermis that, after stripping it away, we are apt to find little beneath except a few blind, anonymous instincts and a few indistinct potentialities to be written off as hereditary endowment. It is not very satisfying to set off in search of a definition of the self and wind up with two minuscule, uncertain quantities, one of which we hold in common with every other member of the species, and the other of which is defined precisely by its identification with our forefathers.

But there is another cant to the question, which simply inverts the pyramid and places selfhood at the base rather than the point. Starting with the very rudimentary set of givens which is ours at birth, we build our selves by accumulating experience: we are what we have been. Adding a book here to a horseback ride there, a fight and an affair, a job as an accountant and a hitch as justice of the peace, we accumulate over the years a miscellaneous, jerry-built, crudely homogeneous self, which is all most of us need or get in this life. Such an approach seems a little less portentous than the first, as it doesn't require us to find a deep individuating essence in everyone. On the other hand, without modification, it may prove as indiscriminate as the first view is constricting. It proposes man as simply the sum of his experience, yet it is perfectly clear that some men are ground into anonymity by their experience, while others focus and organize their lives around a concept of which they have had no direct experience at all. Simple accumulation gives us ground for supposing that a well-reinforced habit may overcome a weak one; but it does not account for any of the other energies involved in the forming of a self. Some people direct their lives more sharply and forcefully than others; they seem to command experience instead of being commanded by it. Most of us, no doubt, if we ever form a self at all, do so by a painful, tentative process of trial and error, jumbling many disparate experiences together and gradually assembling them toward

an architecture not far removed from that of a garbage midden. But Alexander is Alexander, as Mozart is Mozart, practically from the cradle. Experience is not passively added to experience to form the self: not always, not exclusively, perhaps only exceptionally. Experience is actively sought, ordered, valued, rejected; it is tied into a network of feelings, thoughts, values; it is contaminated and transfigured. An act which, experientially, looks trivial may become psychically enormous; and what performs this sort of self-making (and sometimes self-destroying) work, if not another and previous self?

Admit the concepts of will and choice into the process of self-discovery by subtraction, or of self-creation by addition, and all necessary gradualism disappears. A man may will himself to be the contrary of everything his experience "adds up to"; may discover himself to be the opposite of what he always seemed to have been—seemed, even to himself. We get identity leaps, transformations, reversals; disguise becomes reality, reality disguise; the frame enters and becomes part of the picture; the facade is seen as a component of the structure, while the ostentatiously functional structure turns out to be mere window dressing and painted flats. To study such gymnasts of the self in their first discovery of the art is, admittedly, to cut a rather narrow slice off the loaf of life; but it has the special interest of any extreme, any crisis performance.

As it is abrupt and not simply cumulative, the self-creating self is bound to manifest itself in the act of radical choice; just as clearly, the range of its choice is limited by iron circumstance in certain specifics. No man can choose to be born in another historical era, of other parents, of another sex, or of another color. He is nailed to time and place, and to a few other circumstances. But around this sparse cluster of immutable commitments flourishes a rich cornucopia of options. Men have opted themselves up and down the social scale, across national and linguistic frontiers, into and out of civilizations, from one sphere of existence to another. In the business, and for the purposes, of this social world, where we have to keep track of one another by some means less evanescent than private fantasies, people must be given some exterior mark and visible symbol of their diverse identities—a benchmark sealing them to something permanent. For most of us that seal is the name we are given at birth, a name derived

ordinarily from the fleshly father who begot us. It represents a fact beyond choice, beyond alteration; it is a permanency. But, by the same token, when a man does choose to change the sphere and conditions of his existence, abruptly and radically, one of the first signs that he is undertaking such a self-redefinition is very often a change of name. Symbolically and emblematically, he repudiates his natural father; the name with which he replaces his father's may well represent, directly or indirectly, the value because of which the leap away from mere existence, toward a new essence, is to be made.

Paternity and the Name

In the matter of names, we all start at the bottom of the well, and are defined by our parents, our associates, and our "native" language before we have any conceivable say in the matter. We are what we are called, and cannot help, at least for a long time, calling ourselves what others call us. To be John, son of Richard, of Salisbury, was once to define oneself very closely indeed, and may still be so. There are several Salisburys, to be sure, but they are far apart, and the specific one is likely to be defined by context. In any given Salisbury, there may be several John Richardsons; still, a triple calling-card of baptismal name, patronymic, and place of origin gives pretty complete and compact identification. During the middle ages and early Renaissance, when communities were smaller and people moved around less, geography had an importance in identifying people that it cannot have today. Ficino and Poliziano are known simply by adaptations of the names of the places where they were born (Figline and Montepulciano); Aquinas is Thomas from Aquina. In the closed, intimate society of modern gangsterism, it is still possible for a man to be known as Nathan Detroit or Benny Southside. But in the cosmopolis and the mass society, allegiance and identity are not defined by place. "Where are you from?" In various circumstances, I might answer that challenge in six or eight different ways, but none of them would represent the place where, chronologically, I have spent most time over the past twenty years—and which I am certainly not "from."

Geography, then, provides a less definite mark of origin—and so, presumably, of a self that can be vouched for by other people—than paternity. Who you are is who begot you, who gave you your name. We are all of course children of Adam, but to say who begot one is a convention of identity-assertion very frequent in western culture. That it is only traditional among us is a way of saying it is not natural anywhere. There are cultures, for example Miss Mead's Samoa, which make no particular point of assigning fatherhood or father's name to any individual—where a child is the child of the village or the family or the tribe or the general frog pond or of its mother. There are other cultures where fatherhood is loosely defined and casually attributed, on grounds which our culture would consider frivolous. "It is usual in the *Arabick Tongue*," says Humphrey Prideaux,[1] "when a man is remarkable for any one particular thing, thus to express it, by calling him the father of it"; and he instances an Arab called "Father of a Cat," Abu Hareira, because he occasionally carried a cat around with him. Such alternative definitions of fatherhood invite our amazement at the social weight we have placed, over the decades, on a relationship so close to undemonstrable.

"I am my father's son": it is an assertion at once appallingly obvious, of very doubtful significance, and completely incapable of public proof. At best it rests on a word, sometimes, alas, on a mere guess. The woman's word creates the father no less than her belly creates the babe. Literary men of nervous tendency have dwelt at length on the paradoxes implicit in this situation;[2] but the outer implications of the statement are odder, even, than its inner fragilities. "I am my father's son" implies that I inherit some of his qualities; whatever his credit in the world, I may lay claim to some of it, either by inheritance, or through the good influence of his example, or by sheer magical contiguity. The assertion also implies responsibility. "I am, if not necessarily the inheritor, at least the partaker of my father's goods; if he is a good credit risk, so, by extension and to a lesser degree, am I." "I am my father's son"—it carries a rich aroma of secondary implications, such as: "I take his position, and the position of our clan, in matters of controversy, the feud of one being the feud of all." Also: "I claim membership in a group of known principles,

[1] *The Life of Mahomet* (London, 1723), p. 169. [2] Strindberg, Joyce.

which I can therefore be trusted to observe." Girls, no doubt, sometimes say in the same way and with the same richness of implication, "I am my father's daughter," or even, though more rarely, "I am my mother's daughter." But one can scarcely imagine a boy saying, "I am my mother's son." Obviously he is; but in this culture, the term "mother's boy" carries it own overtones.

Through the father—so certain strains of western folklore seem to have it—one taps the established resources and secure values of the past. Sumner Maine tells us [3] that in primitive society (the examples he gives are ancient India, Greece, and Ireland), sacred teachings and writings were the work of a clan or family centered on a father, actual or metaphorical. The teacher often acquired *patria potestas* over his pupils, and the pupils were recognized as having claims to inherit the property of the teacher as if they were his true heirs, regardless of who begot them in the flesh. Father teaches the sacred code, from which political laws develop; he is law-maker, law-finder, law-giver, judges are only his surrogates, and the phrase "father of his country" is hardly a hyperbole.[4] Even when he is a begetter, father in western culture is not just a bestial begetter; in assigning his name to the son, he in some sort warrants the product. What audacity, then, for a son to appoint himself the appointer of his own father, to deny nature herself for a whim of his own taste!

It is a deep yet mysterious bond that he thus violates. On both sides, the relation rests on mere hearsay; the son has even less assurance of relatedness than does his father. Their dealings are further complicated by all sorts of frightful rivalries and jealousies, of which the old gentleman in Vienna has made us all too conscious. Professor Frazer offers an anthology of instances where the birth of a child, particularly a firstborn male, was thought to presage or even directly to cause the death of the father.[5] In India it was once the custom to hold a funeral for the father at the end of the wife's fifth month of pregnancy; infanticide and castration (ritually repeated in the cere-

[3] *Early Law and Custom* (London, 1883), chap. 1.

[4] Speaking of the first senators, Sallust says quite naturally, "ei vel aetate vel curae similitudine patres appellabantur" (they were called fathers, either because of their age or because of the similarity of their responsibilities) (*Bellum Catalinae* 6).

[5] *The Golden Bough* (London, 1911–1915), IV, 188–189.

mony of circumcision) were once widespread, direct responses to the father's jealous sense that the son had stolen his power. Yet for all these hostilities, it is no accident that so many men, asked suddenly who they are, will say before anything else, "My name is ———, I am the son of———." They give us their own name and the name of the man from whom they got it. Sometimes the only name they have tells us that they are John's son, the son of Matthew. To break so rich and tangled a skein by denying one's father and abandoning his name must be a violent metaphor, expressive of radical new spheres of elected existence.

The most obvious of these alternate spheres is that of religion. Abram and Sarai, entering into a new covenant with their heavenly Father, become Abraham and Sarah. Following the example of Saul-Paul, Christians of the early ages found it meaningful to change their names when they accepted Christ, in token of the new mode of existence which regeneration offered or required. Even today, as he passes out of the world into the cloister, a monk will alter the baroque elegance of Jeremiah Dinglehoffer to the Christian meekness of Brother Pacificus. The higher kingdom is here understood to require a new and purified character, and the change of name marks not simply a difference but a distance between two incommensurable spheres. The whole terminology of Christian rebirth seems admirably adapted to the circumstances of a man who passes from outside the Christian dispensation to inside it, or from life in the world to life beyond it. But when one's base line was Christian from the beginning, regeneration and rebirth had to assume a more extended and more metaphorical meaning in day-to-day existence. Instead of being single acts in time, they became recurrent, perhaps incremental. That left the gesture of declaring a new name and a newly created or newly discovered self where it had always been, in the hands of those with a crisis to celebrate.

Nowadays, of course, we accept the fact that without any sense of crisis at all people operate with and through all manner of fictitious names. We have *noms de plume* and *noms de guerre* (Anatole France was Jacques Thibault and Stalin was Djugashvili); we have stage names and a galaxy of corporate names, professional names, royal names and titles, trademark names, and names of religion (as

when a young man famous for years as Lew Alcindor decides he will be known henceforth as Kareem Jabbar). Among these names we recognize some that are clearly designed to affirm a loyalty and establish an identity; others, equally clearly, are intended to deny responsibility and shelter identity. In none of these alterations of name do we sense any desire to meddle with the facts of natural paternity; indeed, the spheres to which different names are assigned may be separated only for reasons of social convenience. We are far from the sacred horror that was felt for actors, for example, who seemed as late as the age of Voltaire, diabolically inspired impersonators, usurping the very names and beings of others. It is a contemporary cliché that all business is show business. But in earlier days it was not so, and the difference is our theme.

When the monk rededicates his life to the service of his heavenly Father and changes his name as a sign of the new life, it is an instance of what we could call vertical passage from self to self. His leap is authenticated by the powerful positive magnetism of God himself—and before this unquestioned tropism all distances and resistances are trifling. The move is safe, too, being societally approved: a going contemporary organization, set up by life, receives the refugee from life. But to uproot oneself from the field where nature planted one, and set oneself to growing in another ground, legitimized only by the fact that it appealed to one's imagination—to pass horizontally from "real" given self to imagined, self-begotten self— was in many ways a bolder, because a more individual, a less channeled, venture.[6] Perhaps our present liberties in the matter of identity discourage us from realizing how bold a step it once was. Over the past century or two, Romanticism and its persistent, inescapable successors have consistently emphasized that in the mere act of seeing the world and ourselves we re-create both. Thus liberated from mere pragmatic fact, the self discovers itself as a creator of new selves; it is, in the very process of perception, an ipso-parent. On a more social

[6] I am confirmed in my distinction between lateral and vertical mobility of self (though not in the value I assign the former) by Thomas Greene's "The Flexibility of the Self in Renaissance Literature," in *The Disciplines of Criticism*, ed. P. Demetz, T. Greene, and L. Nelson (New Haven, Conn., 1968), pp. 241–264.

level, meanwhile, sheer pressure of numbers and length of experience push the artist toward the bizarre and extreme. After so many postures, among so many posturers, what can one do to stand out as original? Because we ourselves haunt so persistently the too often violated frontiers of freedom, we may find it hard to envisage the stiffness and severity that men first sought when they began to experiment with the elastic, optional self. What they sought, as often as not, was exactly the opposite of imaginative freedom and fantasy; it was rigorous discipline, a strict standard of personal moral authority, the assurance of a severe accomplishment. The list of those who thus importuned Rome (the city, the empire, the civilization) to exercise paternal influence over them is in the first place a list of warriors of the imagination.

Rome

A book which set out to record the influence of Rome on the modern imagination from the Renaissance to the present day would not be written in one volume, nor yet in two. Fortunately the task at hand is more limited. The center of this study is an act performed by a man with relation to his own past, his own givens—it is the distance between a man's roots in nature and his redefinition of himself in Rome. Were the topic to be defined (which Heaven forbid!) as "the influence of Rome on the modern imagination," one would have to begin by defining with care the state of classical studies at each stage of the study. The degree to which classical texts were known and the way they were known, the processes of excavating, measuring, and reconstructing classical structures, would all be relevant. One might be called on to trace the history of institutions like the Holy Roman Empire, the Roman law, and the Holy Roman and Apostolic Church; no history, no chronology, no guidebook, opera, or grammar text would be negligible. But for self-creators in the name of Rome, the city is an occasion if not a downright pretext. There are energies within them that Rome releases. Perhaps indeed only Rome could have released them, or only in the particular direction they took. But the men are not passive, plastic wax on which Rome printed its masculine stamp. Quite the contrary, they demanded to be influenced,

required it. If Rome had not been handy, they would have found something else—or perished from exasperation at the lack of it. The Roman stamp may well be a seal, an impression, but it is also an imperious stamp of the foot, a military "no" to the life of nature as given. In saying this "no," in various tones of voice, various figures over the ages drew upon Rome as a repertoire of attitudes, a set of stylistic devices, embodied in myth, history, architecture, religion, ethics—whatever. Some of them, indeed, were impassioned students of Roman texts and remains; and what they knew or discovered on these lines may enter into the story. But what they did with it in forging themselves a style is the focus; and to tell this story we need inventory only sketchily the Roman wardrobe of props, gestures, attitudes, and vital energies on which imaginative, imperative men could draw. For men like these even the fullest account of what Rome actually was (in the scholarly sense) would fall short of the point or beside it. A man may study the orations of Cicero to satiety and beyond, yet be struck to the heart of his Roman imagination only by a single massive cube of travertine half-buried at a crazy angle in an abandoned field. The subject of "demanded" influence is full of intangibles, but even among the tangibles there are broad traits to discern.

To start with the perfectly obvious, Rome was, from the time of the Renaissance forward, a largely buried civilization. To be seen at all, it had to be dug up or scraped free of the incrustations left by intervening ages. From this single simple circumstance flowered a variety of attitudes and feelings. On the material level, burial for six centuries in an Italian climate effaced completely aspects of ancient civilization which survived without difficulty twenty centuries of entombment in Egypt. Physically, the Roman world is a world of stone; relatively little of metal and nothing of wood, cloth, or paper survived.[7] Roman wall-painting, with its dreamy atmosphere and fantastic landscapes, had to wait for discovery till almost the twentieth century. The fringe things of life—the luxuries and elegancies of the toilette or the dinner table, the tapestries and furnishings and decorations of daily existence—survive only in a few relics or in the words

[7] All manuscripts of classical texts represent copies of copies; the oldest known manuscripts of the *Aeneid*, for instance, are from the fourth or fifth century.

of the satirist or amorist poet. In losing the software, we have lost to laborious reconstruction many of the nuances and ephemera of Roman life.

In a more personal way, what attitudes could one take toward a culture that had to be exhumed? On the one hand, it was easy and natural for the church to follow Saint Augustine in denouncing the pagan gods as daemons and in identifying pagan civilization as the work of the devil. Such a view implied sharp awareness of the difference between the pagan and the Christian worlds. When the middle ages exercised themselves in moralizing Ovid, they did so less to censor out his wickedness than to do for him what, as they conceived, he would have wanted to do for himself. But Savonarola was actively hostile to the classical world, and as late as the seventeenth century men like Milton and Desmarets were still uneasy about the classic gods and classic legends. Yet there were accepted ways of reading Roman history as a necessary preparation for the coming of the King of Peace; did not Virgil's Fourth Eclogue prophesy His advent as clearly as the Book of Isaiah? So one could regard the Romans with attitudes ranging from sacred horror to pious reverence; only the sense that there was something questionable and alternative in their relation to the everyday world remained constant.

Historical and racial as well as religious distance prevented the Romans from ever being considered direct ancestors in the personal sense. As late as the mid-nineteenth century, Gérard de la Brunie could decide that he was descended from the emperor Nerva, and rechristen himself de Nerval; but this had been eccentricity for centuries. Still, it is apparent that as a great and powerful people living in the remote past, the Romans had long held a kind of totemic fascination for many seekers after an authoritative ancestor. From the middle ages on, men selected from the classic past, as it came down to them, some hero from whom they wanted to be derived, and then projected across the dark ages a long bridge of imaginary intermediaries who would convert the hero to an ancestor. Genealogy thus became a form of prayer, of invocation. Hector, we hear, was a parent widely in demand, in direct contrast with his conqueror Achilles, whom nobody wanted in the family tree. While the Bretons and Britons claimed descent from Brutus, the Spaniards from Hesperus,

the Italians from Italus, and the Tuscans from Tuscus, the Irish invented gossamer genealogies for themselves that passed through Miletus of Spain to Fenius Farsaigh of Scythia, and so on back to Noah and Adam. Jean Seznec has a splendid listing of these imaginary ancestors in *La survivance des dieux antiques*;[8] however ridiculous as statements of historical fact, they clearly served to express popular ideals and aspirations. The process is perfectly plain. Men did not investigate Hector or Hesperus, learn as much as possible about their characters, and then undergo "influence." They started with an image of conduct they admired, attributed it to the most congenial or convenient hero lying to hand, and modified his image to accord with the values they wanted him to exemplify. Much the same thing happened to the culture as a whole. The qualities which drew the Romans preeminently toward the exemplary role of father were antiquity and magnitude.

For a thousand years they were a pattern to the world of living, thinking, acting, and building on the grand scale. Dante makes use of Rome as a metaphor for Heaven itself; he speaks (Purgatorio XXXII, 102) of "quella Roma onde Cristo è Romano"—a phrase as stunning and lapidary in its concision as any Roman inscription. Harassed as we are today by problems of bigness, we do not easily lend our imaginations to the misery of the petty. The solidity of Roman masonry was (and setting aside the pyramids, still is) a fact unique in western history. The peasant whose life is given up to scraping a dusty field behind a donkey, the shopkeeper whose vision is bounded by the walls of his town, might well stand awestruck before the relics of these people, who not only conquered the world from Scotland to Parthia but covered it with their roads, their arches, their pillars, their laws, and the familiar pattern of their forum-centered, temple-crowned cities. Du Bellay likens them to heaven-storming giants:

Telz que l'on vid jadis les enfans de la Terre
　　Plantez dessus les monts pour escheller les cieux,
　　Combattre main à main la puissance des dieux,
　　Et Juppiter contre eux, qui ses fouldres desserre,
Puis tout soudainement renversez du tonnerre
　　Tumber deça dela ces squadrons furieux,

[8] (London, 1940), I, 1.

La Terre gemissante, & le Ciel glorieux
D'avoir à son honneur achevé ceste guerre,
Tel encor' on a veu par dessus les humains
 Le front audacieux des sept costaux romains
 Lever contre le ciel son orgeuilleuse face,
Et telz ores on void ces champs deshonnorez
 Regretter leur ruine, & les dieux asseurez
 Ne craindre plus là hault si effroyable audace.
(*Antiquitez*, XII)

XII

Like as whilom the children of the earth
Heaped hills on hills to scale the starry sky,
And fight against the gods of heavenly birth,
Whiles Jove at them his thunderbolts let fly,
All suddenly with lightning overthrown,
The furious squadrons down to ground did fall,
That th' earth under her children's weight did groan,
And th' heavens in glory triumphed over all:
So did that haughty front, which heapéd was
On these seven Roman hills, itself uprear
Over the world, and lift her lofty face
Against the heaven, that gan her force to fear.
 But now these scornéd fields bemoan her fall,
 And gods secure fear not her force at all.
(trans. Spenser)

But their magisterial influence is felt in matters as intimate and important as syntax. Dante, for instance, is able to build with big blocks of thought, which he poises with incomparable ease in sharply defined relation to one another (cf. the passage on Rome and Christ cited above), because he has an imperial perspective of things—a perspective which had been possible under Rome and had been lost during the barbarian invasions to an extent made amply clear by Auerbach in his classic analyses of Ammianus Marcellinus and Gregory of Tours.[9] Far from putting the events they describe in perspective and composing them into a controlled picture, these authors have trouble narrating coherently the events of a blood feud or a scene of mob

[9] Trans. W. Trask, *Mimesis* (Princeton, N.J., 1953), units 3, 4.

violence. The small, telling detail, the dramatic or melodramatic incident they can manage brilliantly; but the panorama is beyond them. Rome was something more than a wide, serene vision of things, but for many it was a pathway of access to that sort of vision.

A squalid village at the end of a wretched track serves to publish the misery and weakness of men. To inhabit the spacious mansions of the past, to feel one's feet guided in the daily round of affairs by architects of disciplined dignity is to assume almost automatically the attitude of a son toward the line of his fathers. The buildings buried under time and even more those which still struggled after millennia against nature and natural (contemporary) man taught a wordless lesson of Roman magnificence. The scale and solidity of their building, the prodigality of their capital expenditures are common themes, as they are obvious to any man with eyes to look. What is more striking, their buildings did not rise slowly, by painful secular accretions, like the great cathedrals, but were often flung up for a minor occasion, or even at some individual's fantastic whim (like Hadrian's villa at Tivoli) into forms which still retain their shape as they approach the end of their second millennium. Monuments of the middle ages generally represent the deepest spiritual strivings of the time; castle and cathedral are emblems of the secular suzerain and the spiritual hierarchy. But the Roman roads, sewers, bath-houses are older by a thousand years than the cathedral at Chartres, and not infrequently show fewer signs of wear. The materials in which the Romans preferred to work were unyielding: oak, bronze, marble, Carthaginians. Everyone must recall the surprise with which he looked upon some marble inscription or curled capital and saw that after two thousand years it was as crisp and sharp edged as ever. Where they have not been replaced altogether, the sandstones of Oxford are slubbering into gritty disarray after no more than three or four lifetimes; the column that Trajan erected to commemorate a minor victory over some Danubian tribesmen is as clear and bright as the pyramid of Cestius —which Poggio tells us was erected in just 330 days.[10]

Now that the battered relics of Greece are no longer kept from western eyes by the suspicious Turk, now that the striking achievement of the Etruscans has been unearthed from the mold of centuries, we are less than ever inclined to credit the Romans with any partic-

[10] Poggio, *Historiae de varietate fortunae libri quatuor* (Paris, 1723), p. 9.

ular originality. The case against them became overwhelming less than two hundred years ago; yet the fact is, they were not renowned for innovation, even in their own day, any more than for nuances of thought or delicacies of artistic style. Their philosophers were never subtle subdividers of the Logos, they were practical moral rhetoricians; their building included no structure as subtly proportioned as the Parthenon; and though their sculptors diligently copied Phidias and Praxiteles over and over again, some element of nervous Greek elegance always eluded them. They were popularizers, adapters, organizers, civilizers; if this sometimes implied ignorance or insensitivity, some of them at least accepted the charge, and retaliated with sneers at the "Graeculus esuriens" or hungry Greeklet who professed to be an expert in everything.[11] A Roman had more dignity, less cleverness (with the added implication of unscrupulous ingenuity). Father Anchises spelled it all out for son Aeneas in the underworld:

Excudent alii spirantia mollius aera,
Credo equidem, vivos ducent de marmore vultus:
Orabunt causas melius; coeloque meatus
Describent radio, & surgenti sidera dicent.
Tu regere imperio populos, romane, memento,
(Hae tibi erunt artes) pacisque imponere morem;
Parcere subjectis, & debellare superbos.[12]

Let others better mold the running mass
Of metals, and inform the breathing brass;
And soften into flesh a marble face:
Plead better at the bar; describe the skies,
And when the stars descend, and when they rise.
But *Rome*, 'tis thine alone, with awful sway,
To rule mankind, and make the world obey;
Disposing peace and war thy own majestic way.
To tame the proud, the fettered slave to free;
These are imperial arts, and worthy thee.
(trans. Dryden)

Government was their chosen art, and the theater of their most spectacular triumphs in the art of survival. The incorporation of the later Empire with the Church, its division into East and West, the

11 Juvenal *Sat.* 3. 12 *Aeneid* 6. 847–853.

recurrent revivals of its different parts, and their complex relation and cross relation to the different divisions of the Church, constitute a story of metamorphosis and readaptation peculiar in western civilization. Even when the fact of Empire was almost submerged under waves of fragmentation and disorder, the ideal of Empire survived; and long after the practical central authority of Rome had lapsed or diffused, both the major agents of order in the western world, the Church and the Empire, included the word "Roman" in their titles, as emblems of supreme authority. More amazing yet is the history of Roman civil law, where we find the Roman genius for borrowing active indeed, but boldly transforming its borrowings, and maintaining a coherent body of jurisprudence *ab urbe condita* (753 B.C.) at least through the death of Justinian (A.D. 565) and perhaps even beyond. Law was their mania; their perversions and excesses often parodied legal procedure by imposing one element of uniformity arbitrarily and without regard for consequences; they enjoyed erecting a whim into a law of nature. Antonius Geta gave dinners according to a single letter of the alphabet—one consisting, for example, of pullet, partridge, peacock, port, ptarmigan, pork, and so on; while Elagabalus not only gave his dinners (Des Esseintes–like) in different colors—green, iridescent, and blue—but sorted his guests like his dishes, inviting eight one-eyed men, eight deaf men, or eight men suffering from gout.[13] He bestowed upon his guests gifts in arbitrary units: to one ten camels, to another ten flies, to another ten bears, ten dormice, or ten pounds of gold, as if to deride order by imposing it absurdly. Their blasphemies betray their beliefs; law was their obsession.

Like all law, it was built upon the fact of violence; unlike most enthusiasts for law the Romans were frank about it. Varro tells us that the workmen who first dug for the foundations of the temple of Jupiter on the Capitoline found a severed head there.[14] The fable may be taken as an omen not only that the Capitol would be the head of the empire but that violence, like Romulus's murder of Remus, would lie at the foundation of its order. Christian and other varieties of humanitarianism have properly taught us to be horrified at Roman cruelty, and almost automatically the stock images rise before us of

[13] Aelius Spartianus 6; Lampridius 19, 29, 40.
[14] Varro *De lingua Latina* 5. 41.

gladiators butchering one another before a howling mob and of Christians being thrown to ravening lions. These things happened, indeed; but the larger reminders of Roman callousness took place routinely and on an undramatic scale. The whole vast slave system, the procedures of judicial torture, the armies of mercenaries, the systematic resettlement of populations, the occasional deliberate wars of extermination—all these bespeak a world in which human life was very cheap. What was the daily routine of the galley slave whose sinews kept the empire in constant communication? What was the life of the quarry worker whose labor helped build those magnificent Roman roads? It is ghastly to conceive; and the mercenary who plodded down the road, on a service leading to only one end, was no better off than the road builder. The human race customarily produces a set proportion of bloodthirsty sadists, which idleness, envy, fear, and the habit of mass thinking may augment; but the real brutality of a culture is to be estimated from its habits of social engineering. The Roman pattern was set early, in yet another prophetic myth. The rape of the Sabine women was a characteristic bit of decisive action to remedy an urgent social problem. It involved all the usual ingredients of a Roman situation: deceit, brutality, a direct and practical decision, sexual violence. These were followed by widespread and apparently heartfelt acceptance of the consequences on the part of the injured parties. We are assured that the Roman ravishers made excellent husbands.[15]

Something hard and grasping in the Roman character made itself felt very plainly in this matter of bloodshed. The Romans killed for frank profit, in wars of expansion; they killed for pleasure, in the arena; they killed for revenge; they killed from the sort of political conviction that insists on final decisions and knows only one finality; they killed themselves when continued existence seemed unlikely to

[15] The myth of the Sabine rape may date back to those obscure early days of the city when marriage by capture was the rule; it is also related by followers of Bachofen to the overthrow of an original Etruscan matriarchy for which the cults of Fortuna and Bona Dea can be made to yield some evidence. On the cheery outcome of the Sabine rape, it's regrettable that we don't have direct testimony from any of the ladies. That the Romans of the republic were quintessential male chauvinists they have sufficiently witnessed themselves: see M. P. Cato's speech on the female sex in Livy 34.

agree with their standards of personal dignity. No doubt our styles are gentler these days, or at least better camouflaged with cant.[16] The Romans invoked murder and suicide to solve problems for which our more civilized mores would invoke an ambassadorship to Ceylon, or the Chiltern Hundreds. In this aspect, however, they were not much different from the rulers of the Greeks, or of the Italian city-states, or of revolutionary Russia; wherever the game of politics is played in depth, the winner lives and the loser dies. Yet their appalling brutality has to be held somehow in balance with their belief in a civilizing mission; they seem on occasion to have thought of their gift for violence as a large sum of capital in a bank, on which they could draw indeed, but which prudence would reserve for special occasions.

As a nation of lawyers and rhetoricians, they were well practiced in the language of rationalization and compromise. They could hardly have governed without a certain readiness to kill, perhaps even a casual attitude toward killing; by they could not have governed as they did, had they not felt some severely practical compunctions about killing, or seeming to kill, for business purposes only. Even the gladiators do not infringe this rule, for they were a set of men otherwise worthless (in Roman eyes), originally intended to propitiate the gods at funeral services, later set aside to kill and be killed in order to placate a bloodthirsty mob, terrify barbarians within and without, and harden the citizens for war. It was an accepted idea that gladiatorial shows provided excellent training in despising suffering and death, that is, the suffering and death of others. That callousness should be thought a virtue *per se* indicates the appalling shallowness of Roman social thought, is evidence also of its readiness to find practical rationalizations for instinctual behavior; yet the total achievement of Rome was peace, the Roman peace, two hundred years during which, within the confines of the civilized world, war was unknown. If government is the art of securing maximum peace and security with minimum force, the Romans no doubt deserve the

[16] Comparing the Romans with politicians of his own day (degenerate weaklings like Francesco Sforza, Cesare Borgia, and Pope Julius II), Machiavelli decided that the pagans were "more energetic and more ferocious" (*Discorsi*, II, ii).

fame they enjoy, of having governed well. Their genius was for delay, compromise, and the sudden, timely act of decision; like all good governors, they used the wheedle, the compromise, the menace, and the lie before resorting to the sword. Like good pragmatic indifferents, too, they used the divine powers whenever they seemed handy and disregarded them when they did not. It was not a Roman general but one of those intellectually astute Athenians who lost a great expedition by delaying on account of certain unlucky phases of the moon.

The political structure they created, like their style in building, was big, solid, and rectangular. Ennius speaks of the city he knew as *Roma quadrata,* "square Rome"; [17] he may be referring to a layout of streets and walls, the evidence for which long ago disappeared. But there is also a sense in which their whole style was based on the right angle. Their camps, their buildings, their military formations were all geometrical, as if in celebration of an artificial discipline. Consuls, lictors, praetors, and tribunes always came in pairs or multiples of two, as if bilateral symmetry in government were the deliberate expression of a logical, masculine, creative order. Masculinity here is no adventitious accident. Much Roman terminology for the state was based on the relation of children to fathers. The *patria potestas* was directly analogous to, if not through tribal discipline an immediate source of, the power of the state. Many Roman rites and observances recall that, for them, the first act of political conquest was father's subjection of his family. It was seen as a masculine authority grab, an imposition of intellectual form upon instinctive nature, perhaps a male counter-tyranny supplanting an original matriarchy—in any case as a bold, dangerous subtraction from the sphere of nature. Even the official cult of the gods was somehow a diminution, because a formalizing, of their real and dreadful power. Hence brutal, joyous burlesque of the official gods was a routine part of their worship; it was a way of testifying that the mystery and power of the natural universe were not fully expressed in the official cult of the Olympians through the established forms. By the same token, before the bride entered into

17 Ennius *Annales* 3, frag. 157. M. P. Cato in the *Origines* and Julius Solinus in the *Polyhistor* also speak of "Roma quadrata," but probably they are following Ennius.

marriage, she was given for deflowering to a statue of the ancient god Mutunus Tutunus—as if nature must be propitiated in advance for the husband's audacity in taking to himself a woman who "by nature" belonged to all.[18]

In none of this Roman underpinning of myth, ritual, dread, and superstition is there much occasion for surprise. Ancient civilizations, being new civilizations, all had a sense of their own insecurity—of barbarism looking over one's shoulder, of the audacity of the social mind in encroaching on the dark areas of the mysteries and blood cults. Trusting the mind is one of the hardest lessons of the human race. Enlightened as we are in this fine twentieth century of ours, we, even we, still feel called on to propitiate from time to time, though shamefacedly, the forces of mystery. For them, all civilization on the imperial scale was a shaky bridge over a raging torrent.

Rome stood then before the world as an enlightened and magnificent civilization; technical, practical, just, severe, wise in its accumulated experience. Yet its whole achievement was edged with violence, internal as well as external, and underlain by uneasy awareness of its own artifice, its precarious authority. In making explicit these several alternative ingredients and attitudes, we see already a wide spectrum of feelings on which imaginative disciples could draw. But to these slippery ambages of the culture itself, we must now add a glance at the special situation in which men since the Renaissance have customarily encountered Rome. I mean of course the classroom.

For study of the Latin language and literature, of Roman history and institutions, constituted until fairly recently the core of every academic curriculum worth considering. That excluded, naturally, the female 50 percent of the human race, but apart from that, the requirement was universal. Whether one should study a subject or the Latin author who had written the classic book about it was a question that simply didn't present itself under the guise of alternatives. Milton, a brisk conservative man in these matters, assures us that his students will study agriculture in Cato, Varro, and Columella, "for the matter is easy; and if the language be difficult, so much the

[18] P. Klossowski, *Origines cultuelles et mythiques d'un certain comportement des dames romaines* (Ste. Croix de Quintillargues, 1968).

better." [19] But as a general rule he does not even list the subject matter; it is to be understood from the name of the classic author who treated it. We will read Orpheus, Nicander, Oppian, and Manilius (writing, as it happens, on precious stones, poisons, fish, and astronomy), not because the subjects have anything to do with one another, but because the language is approximately of a difficulty. Practice in translating into and out of Latin prose and verse was the close-order drill of stylistics; it also had practical ends. Latin was the language of ceremony, of legal formula, of international correspondence and diplomacy. It was taught by men to boys in the full assurance that even if the particular subject was meaningless, the linguistic discipline involved was not. For nearly a thousand years the learning of Latin was an initiation rite for pubescent males; [20] for a good part of this time it conferred on the successful student not merely the general rights of manhood but the specific (sometimes invaluable) rights of "clergy." If Ben Jonson had not known his neck-verse in a certain tight situation, English literature would be the poorer.

Latin literature and Roman history were taught to boys as a way of civilizing them, just as Caesar civilized the Gauls; the context was authoritarian, and verses were whipped into children as mercilessly as discipline was enforced in the legions. A curious blend of attitudes appears here; the "classics" were recommended to schoolchildren as a standard of literary excellence, yet the reading or translation of them was consistently assigned as a punishment. The steady rhythm of Latin hexameters must have mingled, in many a wretched child's subconscious, with the cruel metrics of flogging.

And yet even here there were ambiguities in the response the Romans evoked. They were the tyrant schoolmaster's chosen implement of torture; yet they had themselves spoken and acted against tyranny. None of the great revolutions of the seventeenth and eighteenth centuries (English, American, French) failed to invoke a cluster of Roman names. Cato and Scipio the severe republicans, Brutus the dedicated tyrannicide—no man moved by local patriotic fervor could fail to cloak himself in the glory of names like these. In

[19] "Of Education."
[20] I am indebted for the formula to Reverend Walter Ong, *Rhetoric, Romance, and Technology* (Ithaca, N.Y., 1971), pp. 113 ff.

conservative countries, study of the classics was frequently viewed with a jaundiced eye, on the ground that all this Roman talk about republican virtue was stuff too yeasty for student minds. A reader of Tacitus or Juvenal who took his author seriously might come up with some very ill principles indeed, at least in the judgment of an authoritarian ruler. And finally, the use of the Latin classics in the classroom raised the difficult problem of sexual morality.

Here it is difficult to strike a balance. If we simply report the Roman truth and report enough of it, we shall be accused of getting our image of the classic world from Signor Fellini. Yet the fact is that the classics as read in classrooms for hundreds of years had to be, and were, radically expurgated. They were more outspoken than anything the Christian west could tolerate for nearly two thousand years. Inevitably, such taboos affected men's feelings about the Roman classics and about the Romans themselves. They did not have a specific corpus of pornographic literature, which could easily have been relegated to any library's inferno; the very texture of their work, at its strongest and most delicate, was imbued with a spirit that neither a Christian nor a schoolmaster (at least as those terms used to be understood) could easily tolerate. The Roman satirists and moralists were bound to document their charges of licentious living, to provide illustrations of the conduct they deplored. Like the church fathers, who perpetuated the memory of dying heresies by combating them, the moralists carried forward iniquities that might have been forgotten without them. The historians, in recording the unspeakable depravity for which some earlier emperor was rightly loaded with obloquy, titillated as many imaginations as they touched with horror. Even the best of the Latin elegists and pastoralists might unfold at any point an unexpectedly "impure" thought. For though the Romans doubtless had a respectable set, who lived and thought exactly like Victorian churchwardens and vestrymen, their literature does not, as a whole, reflect this precise point of view. The urbane and gentlemanly Horace can be found occasionally speaking between wistfulness and cheerfulness of the joys of casual rape:

Num, tibi cum fauces urit sitis, aurea quaeris
pocula? Num esuriens fastidis omnia praeter
pavonem rhombumque? Tument tibi cum inguina, num, si

ancilla aut verna est praesto puer, impetus in quem
continuo fiat, malis tentigine rumpi?
Non ego: namque parabilem amo venerem facilemque.[21]

When your jaws ache with thirst, is it just golden goblets you'll
drink from? When you're starving, is it only peacock and turbot you
crave? Well, then, when your loins itch, and there's a serving girl
handy or a slave boy whom you could tear off in a minute, are you
going to stand around bursting at the seams? Not me; I like love
when it's cheap and easy.

The impassioned and sensitive Catullus, in his number 56, tells his
friend Cato of a ridiculous and slightly disgusting erotic trick that he
played in passing on a young couple; it's a rawer sexual joke than
any fabliau could stomach. There's no use laboring the point with
regard to Ovid and Martial; but even the gentle Virgil, in his Second
Eclogue ("that horrid one / Beginning *Formosum pastor Corydon*"),
suggests a set of libidinal values very distressing indeed to an
archdeacon.

If we extend the discussion through sensual sculpture, Priapeia,
and obscene wall-paintings to Fescennine verses, gross gourmandise,
and the weird varieties of homosexuality, we shall before long find
ourselves in the company of Signor Fellini and his merry crew. Still,
the point is already made; in addition to conquests and cruelty, im-
mense civilizing energy, legal genius, and solidity of workmanship,
the Roman reputation included an element of erotic license. And in
thinking of this, we can't overlook one difference between the
Romans and, for example, the Carthaginians, or oriental monarchies
like those of Sardanapalus or Mithridates Eupator. They were not
prisoners of a limited culture or of a desperate situation. They were
not controlled by a fanatical priesthood. If they did not look with
absolutely cold, clear eyes on the range of social choices available to
them, they at least gave the impression of doing so. They had all the
options before them; even if we are not so sure, *they* knew perfectly
well that they were not barbarians. Because they had looked at
human nature across the length and breadth of an empire, from the
depths of a history that included the full cycle of monarchy, republic,
and several imperial dynasties, they were extraordinarily self-aware.

[21] *Satires* 1. 2.

Marcus Aurelius and Septimius Severus were diametrically different men, but one can think of few rulers who knew so precisely at every point what they were doing, and why. They gave themselves with clear eyes to murder or meditation, debauch or dominion—and, when things did not work out, to death.

It was one more way in which they assumed dominion beyond that allowed to Christians—a point, as it were, of paternal privilege, and not a slight one. Statistically, the Roman practice of suicide may not have amounted to very much; imaginatively, as it came to the modern world through the grave, considered sentences of Seneca and Marcus Aurelius, it can hardly have failed to wield a major influence on men's attitudes toward antiquity and themselves. It was a striking instance of self rising above and commanding self, of natural man's power, not merely to pick among the alternatives offered by nature, but to exercise an ultimate veto over all nature's options. As if they didn't have freedom enough in being absolute, they took to themselves the ultimate freedom to be, whenever they chose, nothing at all, by throwing up the game entirely. It implied a direct criticism of providence which, under the new dispensation, could be envied if not emulated.

Roman cosmopolitanism may have been an accident of history or the almost automatic consequence of their big empire. As they monopolized the last days of the pagan world, they took part in that fantastic mixing of cultures which began as Hellenism and ended as something for which we have no proper name other than "decadence." But not every people could have shown itself so casually receptive to foreign weapons and tactical innovations, to foreign divinities and philosophical schools, foreign literary modes, foreign social customs and foreign architectural styles, as did the Romans. "No nation has ever surpassed them," said Polybius, "in readiness to adopt new fashions from other people, and to imitate what they see is better in others than themselves." [22] There is something almost sublime in the casual ease with which they adopted the Greek pantheon, adding

22 Polybius *Historiae* 6. 25. The Romans were not unaware of their reputation as universal thieves, nor much depressed by it. Sallust has an imaginary letter supposed to be written by Mithridates to Arsaces: "Neque quicquam a principio nisi raptum habere, domum, coniuges, agros, imperium? Convenas olim sine patria, parentes, pestem conditos orbis terrarum, quibus non humana ulla neque divina obstant, quin socios, amicos, procul iuxta sitos, inopes potentesque

a purely Italian nature deity here and holding onto the well-known Lares there—for decoration, partly, or for old sentiment's sake—but without ever trying to imprint on the whole complex a character distinctively Roman. If Isis or Mithra wanted to join the party, so much the better.

They were, in fact, great adopters, and their most successful political creation, the dynasty of the Antonines, was adoptive throughout. Some students have seen in the adoptive practices of the lower Empire a clumsy device of social necessity, a confession of weakness. Fertility failing, through some mysterious mechanism manipulated by selfish hedonism, the Romans are said to have resorted to adoption in clumsy imitation of nature.[23] Some truth may actually underlie this unlovely image. Their agricultural principles, taxation policies, and conscriptive practices did indeed conduce to a depopulated countryside. (Without germicidal sanitary techniques, every culture is engaged in a tense, complex struggle for survival, of which the balance may be swung by very minor accidents indeed.) But even conceding a widespread failure of fertility, for reasons we can scarcely estimate (Lesbia and Celia, heroically active today, failed to contribute then), Roman adoptive practices were exercised beyond mere physical necessity. They were exercised by men who had begotten sons aplenty, and outside the area of family relations. Indeed, one might easily argue that Roman adoption arose, not from a deficiency, but from an overflowing of paternal power. It was with their children as with their gods—where they came from mattered less than whether they could

trahant excindant. . . .'' (Don't you realize that they owned nothing from the very start except what they stole?—home, women, lands, empire? They don't have a native land, they don't have parents, they were created to plague the world. Nothing human or divine gets in their way when they want to take over and destroy their own allies and friends, whether near or far, weak or powerful. . . .) "Mithridates to Arsaces," 17. Compare also Rabelais's phrase on the Romans, "vainqueurs larrons de tout le monde" (Gargantua, V, xlii).

23 Montesquieu, following the not very steady footsteps of Vossius, argues, indeed, that the city of Rome alone was more populous than many great modern kingdoms (Lettres persanes cxii–cxxii). But Montesquieu was grinding the axe of modern degeneracy as contrasted with ancient virtue and fertility. How he reconciles his picture of antiquity with the laws of Augustus (Julia and Pappia Poppaea were their elegant names) taxing celibacy and rewarding parturition, is not clear. It is inconceivable that such laws would be necessary in a nation overflowing (as he describes it) with population.

be given the Roman stamp. The work of Roman fatherhood was too vast to be performed merely with the instrument of physical genera- tion. As it grew steadily easier to enter the empire, the city itself, and the *gentes* upon which the city stood, what process more natural than that of adoption? They were generous in the forming of fathers. One could be appointed a father on entering the senate. A character in Terence distinguishes with regard to his pupil, "Natura tu illi pater es, consiliis ego"; and Polybius tells us that a Roman, preserved in battle by his friend, will "reverence his preserver throughout his life as a father, and is bound to act toward him as a father in every respect." [24] Given the domestic manners prevailing between generations, this was no slight commitment. Horace, consulting Trebatius on a perfectly unserious point, addresses him as "pater optime," simply be- cause he seems to be an older and perhaps stricter man. Finally Macrobius, commenting on Scipio's dream, explains casually that "It is oracular since the two men who appeared before him and re- vealed his future, Aemilius Paulus and Scipio the Elder, were both his father." [25] Further explanation devolves on the modern editor, who points out that one was his father by nature, the other his grand- father by adoption. But for Macrobius they are both fathers, *tout court*. Seneca summarizes one easy consequence of this facility:

> Solemus dicere non fuisse in nostra potestate, quos sortiremur parentes, forte hominibus datos; nobis vero ad nostrum arbitrium nasci licet. Nobilissimorum ingeniorum familiae sunt; elige in quam adscisci velis; non in nomen tantum adoptaberis sed in ipsa bona quae non emit sordide nec maligne custodienda.[26]

> We sometimes say it was not in our power to choose the parents we drew, that they were given to us by chance; but really we may be the sons of whomever we will. There are households of the noblest minds; pick the one you want to belong to; you will inherit not just a name, but property such as you will never have to guard in a mean or niggardly spirit.

24 Terence *Adelphi* 126; Polybius 6. 39.
25 Horace *Satires* 2. 1; Macrobius, *Commentary on the Dream of Scipio*, ed. W. H. Stahl (New York, 1952), p. 90.
26 Seneca *de brev. vit.* 15.

The advice thus offered to Romans, to assign themselves as sons to worthy families, was taken by others, who assigned Rome or some particular Romans to themselves as fathers. The city no less than its inhabitants has a penchant this way. For two millennia its most distinguished citizens have been celibate priests—men who founded no families and left no blood kin (at least officially) but followed a line of succession quite other than the natural. It is a city wise in the ways of adoption. Like any capital city, it attracts ambitious, mobile young people from the provinces; it also attracts, from time to time, *dilecti filii* fascinated by its history, its "character," however nebulously defined.

A city can be many things to many people, and no city more so than Rome. I'm not saying that all the qualities outlined in the crude sketch of Roman attributes over the last twenty pages were present to any particular individual at any particular time. But, taken all in all, they present a composite of quite familiar qualities in quite distinctive combinations—a field of force, capable of exerting powerful fascination on certain temperaments. A galaxy of global personalities could be created out of this chaos of materials. But the core of a separate tradition is not hard to discern amid the crowds of the feeble and faithful, for whom Rome is simply a source of authority, a relief from responsibility. We set aside mere antiquarians and partisans of the picturesque, as well as the actors who want Rome only as a background for display of themselves. The quality to be defined is a kind of emulative affinity. It implies a primary hostility to nature, as inadequate at best; against nature is posed a masculine-ascetic vein of feeling, moralistic, rational, and social in coloring, assured and authoritarian. It is a counter-arrogance: the ideal of Rome is used as a weapon against mere natural accident, to supplement or sometimes to replace it. Machiavelli, returning home at night from his dice games at the tavern and his wrangles with woodcutters, changes his dirty shoes and soiled clothing for fresh attire and enters his library in robes of state to commune with the choice spirits of Greece and Rome.[27] Had he been a younger man, or a little differently rooted, it is conceivable he would have doffed his dirty natural self as lightly as his dirty clothes.

Self-creation is an extreme, but only an extreme, form of a wide-

[27] Machiavelli, letter to Francesco Vettori, 10 December, 1513.

spread, long-standing quarrel of the ancients and moderns, in which many men have felt individually impelled, at the cost of certain sacrifices, to seek certain advantages from association with a Roman past. The range of experience to be considered reaches from a kind of self-baptism in Rome, with new names and identities, to gross parody and burlesque of classical themes. In the limited middle range of these traffickings lies the bundle of styles and attitudes traditionally known as "neo-classicism." One broaches the term with some trepidation, because it has had, of late years, a distinctly bad press. Hearing the word, we think automatically of county banks or municipal courthouses masquerading as Greek temples, or statues of Abraham Lincoln thrusting his scraggy neck out of a toga's folds. Perhaps, on further reflection, we will add an image of Madame Récamier posing in a pseudo-Greek frock on an Empire Agrippina, with a psyche-lamp beside her; or of Pope playing arch games with the epistles of Horace for the titillation of the cognoscenti. These are certainly instances of neo-classical style and neo-classical technique; they marry disparate elements, and the odium which attaches to the style generally rises from a sense that the classical element is being used to glaze over, to falsify or conventionalize, the "real thing," the honest bank vault, the frank ungainliness of big Lincoln. But this is only one sort of relation, defining one sort of effect, to which the conjunction of classical with modern themes may give rise. Seeing that men can feel themselves reborn in Rome helps us to see that they may also feel it is their contemporary, their "natural" life, that is a masquerade. Is David's famous portrait of "Marat Assassiné" a picture of a man in a bathtub stabbed with a penknife, or of republican virtue sacrificed on the altar of freedom? Which is the vital energy, which the formal facade? Obviously all sorts of intermediate gradations are possible in the marrying of a topical present to a classic past; and especially interesting effects can be found at either end of the scale, where men may identify with classical values altogether (to their own condemnation), or deny that classical values are classical at all (thereby provoking new forms of self-definition). The traffic between Rome and those who would use her has been heavy for a long time, carrying freight of many sorts in many directions at many levels for many purposes. But it began (formally speaking) in one of the most radical and imaginatively

violent forms it ever took, as regeneration, rebirth. For some men at least, Renaissance was an individual and personal experience. Yet, paradoxically, it was liberation to a new strictness, an act of pagan protestantism to which the ancient culture, through its strict code of law and military concept of manliness, stood sponsor. As if it were only in the act of subduing himself to an impersonal law ("freedom is the recognition of necessity") that the adventurer into a new human dimension could find the authority to nerve his rash act.

II

REBIRTH

The less one was born to the first time around, the less deeply one is committed to the modality of nature, the easier it might seem to take that anti-existentialist leap, from a "natural" to an "ideal" existence, which is implied in a passage through the classical looking-glass. Perhaps it is a good working rule. But for imperious wills involved in total decisions, it is useless trying to calculate precisely the preconditions of a leap out of the safe warm dark into dangerous and precarious light. Something surely must be allowed for positive awareness of a distance to be crossed: if the classical world is not altogether different, there is little point in leaping toward it. That implies a well-developed sense of the pastness of the past, such as the middle ages, with their typical and figural way of reading the book of ages, usually did not have. Again, one must allow something for the currency of a sense that leaping is possible, not forbidden by divine or natural law—an awareness of alternate value-systems not too strictly subordinated to one another. Here simple quantity counts for something; the more different systems men were aware of, the more conceivable it must have appeared that one could live under another dispensation than that into which one was born. The impingement of China and America on imaginations already accustomed to contemplate Greeks and Romans can scarcely have failed to ease acceptance of the notion of plural worlds. On a plane less cosmic than this, Renaissance orators like Pico and psychologists like Ficino

helped to make individual rebirths thinkable by accustoming men to think of human nature as various and mutable, while a semi-Platonic philosopher like Charles de Bouvelles (Bovillus) grew eloquent over the possibility of using one or several of one's lower selves to create a higher one.[1] (What a difference it makes to alter only a little the model in the mind, from a vertical stacking of selves to a horizontal patchwork, a landscape of different fields in any one of which we can drop our seed!) The court society of the Renaissance, with its emphasis on masques and tourneys (mirror images of the court itself which constituted the audience), with its vociferous sense of the full human potential and desire to give that potential a law, provided stimulus for men eager to baptise themselves into Rome or into other communities. Two men who took the idea of "renaissance" quite personally many years before the term itself was coined or applied to them have become known to us as Andrea Mantegna and Julius Caesar Scaliger. Who they really were may take a little longer to say.

Mantegna

The question who Andrea Mantegna really was has exercised the historians surprisingly, given the fact that we see in him, from the age of seventeen, a vigorous and uncompromising individual. It is only recently that we find scholarship saying unequivocally that he was born at Isola di Cartura, near Piazzola on the Brenta, halfway between Vicenza and Padua. He was the son of a man named Blasius, that is, Blaise, whom we now know to have been a carpenter; and the year of his birth was 1431.[2] Whether this serried information fully answers the question of who he was is questionable; but the information itself is of relatively recent date. Among the several elements confusing the record are a story of Vasari's to the effect that young Mantegna tended sheep in the country near Mantua, a document describing the painter as "M. Andreas Blasii Mantegna de Vicentia,"

[1] Texts of Pico and Ficino are readily available in *The Renaissance Philosophy of Man*, ed. E. Cassirer, P. O. Kristeller, and J. H. Randall (Chicago, 1948); the major text of Bovillus is ed. by R. Klibansky as an appendix to Cassirer's *Individuum und Kosmos* (Leipzig, 1927).

[2] Erika Tietze-Conrat, *Mantegna* (London, 1955), p. 1.

and another denominating him "Andrea Mantegna quondam honor-
andi ser Blasii." [3] The honorable ser Blasius may be no more than a
polite formula; Andrea, at the time of this document, was already a
person of some importance, and so liable to flattery. On the other
hand, the name "Mantegna" itself needs a little explanation, and it
may be surmised with the help of Vasari's story that Blasius had
moved to Piazzola near Vicenza after an earlier career (either his
own or his family's) in the neighborhood of Mantua. This is only a
presumption, but there is nothing extraordinary about it, since Piaz-
zola is less than a hundred miles from Mantua. On the other hand,
the mere possession of the name "Mantegna" implies no particular
loyalty to Mantua; Andrea, who often called himself a Paduan, and
was called by others a native of Vicenza, might also have called him-
self an original of Piazzola, or even of Venice, had he chosen (the
latter city being in effectual control of Padua); and, as we shall see,
he had an equally liberal choice of patronymics. He could have called
himself after any one of his natal cities, or after Blasius; and in 1441
he acquired a second bond to Padua, a second father, and still an-
other name, when he was adopted by the Paduan painter Francesco
Squarcione. We know that he took over his stepfather's name, at
least for business purposes, because as late as 1461 we find him buy-
ing a house under the name Andrea Squarzoni which he sold in 1492
under the rather more splendid title of "spect miles et comes magnif.
D. Andreas Mantegna." [4] On the other hand, we learn from Scar-
deone, the historian of Padua, that as early as 1448 he painted an
altarpiece for Santa Sofia in that city, which he signed with a flourish,
"Andrea Mantinea Pat. an. septem et decem natus sua manu pinxit
MCCCCXLVIII." [5] This does not sound unlike a declaration of artis-
tic independence (he is a Paduan, his name is Mantegna: Blasius,
Squarcione, Vicenza, and Piazzola are exactly nowhere); and in fact,
eight years later, in 1456, Mantegna successfully sued Squarcione to

[3] Giorgio Vasari, Lives of the Eminent Painters (Everyman), II, 102; Paul
Kristeller, Mantegna (London, 1901), pp. 19, 20.
[4] Tietze-Conrat, Mantegna, p. 1; Kristeller, Mantegna, p. 20. Ulisse Aleotti,
as late as 1447, dedicates a sonnet to Andrea "Pro Andrea Mantegna pictore
dicto Squarsono" (Giuseppe Fiocco, L'arte di Andrea Mantegna [Venice, 1959],
p. 94).
[5] Tietze-Conrat, Mantegna, p. 13.

be released from his adoption, arguing that when the contract was made he had been a minor and under control of his father. The real reason was evidently Squarcione's penchant for collecting contracts and fees on the basis of work done by his "pupils." It follows from this curious set of circumstances that ser Blasius faded out of his son's life well before his own life came to an end in 1450; and it is also evident that Andrea had some reason for discontent with both his natural and his adopted fathers. The former sold him into something like slavery, the latter had tried to maintain it. Voluntarily or helplessly, Blasius gave up his role of father; Andrea, with the help of the courts, kicked Squarcione out of it; and so, having passed in short order through two filiations, he took for his patronymic one of his cities, and called himself after the town of Virgil, Mantegna, Mantenga, Mantinea, or the like.

To name oneself after a geographical district is to confess oneself in some sense a son of the soil, which Mantegna evidently was; to name oneself after the town of Virgil is to lay claim to a special destiny. Surrounded by marshes, muddy lakes, and languid rivers, the watery soil of Mantua has never supported much distinguished building, but it is a fertile breeding ground of necromancers, soothsayers, and men of supernatural wisdom. Its very name comes, according to one story, from Manto, daughter of Tiresias the Theban prophet; by Tyberis she had a son Ocnus, who founded Mantua and named it in his mother's honor.[6] During the middle ages, the vast, vague reputation of Virgil the wizard lent mystery to the name of Mantua, and in Dante's time it was the home of that darkly prophetic figure, Sordello. Whether Andrea knew of these traditions, or cared about them,[7] he certainly preferred the name Mantegna over those not very graceful alternatives, Blasius and Squarcione, from motives of arrogance, not humility. Even if we could not read his character in that fiercely contemptuous bust which still stands in Mantegna's chapel of Sant'Andrea's (see pl. 3), the record of his career would suggest a man untroubled by misgivings or self-deprecation. As he had fought

[6] *Aeneid* 10. 198–202, with Servius's notes on the passage.

[7] Among the few surviving sculptures associated with Mantegna is a "Virgil" which is probably not his but probably a copy of one he did; earnest, intent, and a bit awkward, it is a memorable image of the poet.

with Squarcione, Andrea Mantegna fought also with his patrons and employers, with his fellow artists, and with his neighbors. When a coat was not made to Andrea's liking, the tailor heard of it, the town heard of it, and so did the marquis, Lodovico Gonzaga.[8] There was a quince tree belonging to Andrea, with which a certain Francesco de'Aliprandi and his bastard brother, the soldier, made somewhat too free, to the extent, indeed, of five hundred quinces; this problem too Andrea brought before the Marquis and the aldermen with a ferocious vehemence worthy of a better issue.[9] And when differences arose with Simone de'Ardizone over the ownership of certain designs, Andrea not only had his fellow artist beaten almost to death, as he complained, but also piled on the unfortunate fellow an accusation of sodomy which forced him to flee as far as Verona.[10]

The man who brought to his daily social relations such an edge for combat was not reluctant to take the good things of life as he could lay his hands on them. Mantegna was eager for titles and distinctions. Like Shakespeare, and with about as little justification, he bribed his way into the ranks of the petty nobility, squeezing into the social register as a knight and a count palatine.[11] Having married early in 1454 Nicolosia, daughter of Jacopo Bellini, he hastened to beget upon her a family to carry on the heritage of the Mantegnas. He bestowed munificent dowries upon his two daughters, and planned to leave his two sons a splendid house, filled with his collections of antique statues and inscriptions. Andrea himself never lived in this house, which he began building shortly after arriving in his "eponymous" city, but doubtless this was because he had exalted ideas of the magnificence proper to Mantegnas. What survives, though elegant in itself and suitably occupied at present as an art school and gallery is no more than a small wing of the structure that Mantegna originally intended. As the founder and builder of a great house, he did not hesitate to mingle on a footing of intimacy and equality with the rulers of church and state. Among the informal societies of the learned, on an outing in search of classical inscriptions, Andrea might playfully adopt the republican title of consul, and joke over the fan-

[8] Kristeller, *Mantegna*, p. 198.
[9] *Ibid.*, App. items 22–28.
[10] *Ibid.*, pp. 199, 382, App. item 21.
[11] *Ibid.*, pp. 202–203.

tasy of a revived Roman republic composed of three citizens.[12] It was evidently a significant joke, implying active awareness of an alternate sphere of existence; but it was, in practical terms at least, only a fantasy, three distinguished citizens momentarily playing the game of antiquarian equality. In Mantua, in everyday life, Andrea wasted no time on idle republicanism, preferring to cultivate the most exalted society possible; and was capable of inviting a cardinal to dinner and entertaining him on quails borrowed for the purpose from a marquis.[13]

In all these details, which the industrious researchers of the nineteenth century brought to light, Mantegna acted the role of what we call, more truthfully than we always realize, the self-made man. So far as can be told, his rise from squalor to splendor, spectacular in the eyes of his contemporaries, was attributable to nobody's efforts but his own. This is the moral that Vasari draws from his life, reinforcing it with solemn and circumstantial consideration.[14] If there was a debt to Squarcione, the pupil paid it many times over by doing things with the teacher's style that he could not possibly have done himself. For the rest, Mantegna made his own career, as he made his own name, in large, independent strokes with an overtone here and there of violence. This quality of the man's mind carries over into his art.

Though often described as nostalgic, Mantegna's art, it must be confessed, is not profuse of charm; by contrast with the Bellini, even admirers of Mantegna must admit that his colors are frequently thin and sharp, occasionally inharmonious in their combinations. Above all, his figures are marked more by sculptural strength and forceful modeling than by softness and natural motion. Vasari is somewhat confused on the point of Mantegna's debt to antique statuary, saying at one point that he acquired from Squarcione a predilection for

[12] *Ibid.,* App. item 15. When one considers the probable mortality rate among items of tomfoolery written for academic junkets in the fifteenth century, it seems reasonable to think that this habit of playful thought must have been more widespread, and exerted more influence on the nascent humanist movement, than a single surviving document suggests.

[13] *Ibid.,* p. 201.

[14] *Lives,* II, 102.

painting from antique figures and at another point that Squarcione himself made this taste a matter of reproach to Andrea.[15] But the confusion concerns Squarcione, not his pupil. There can be no question that Andrea was strongly influenced by the ideal of classical sculpture and that this influence contributed to that quality of his style which is best called simply "masculine," its hard strength.

A corollary of this stylistic trait is the fact that Mantegna was evidently more fond of the masculine than of the feminine figure. He painted, of course, a number of madonnas, as his business required, and supplied them, when called for, with bambini; but, with an exception here and there, most of Mantegna's females are moon faced, muffled pillars of arranged drapery, while his men are vigorous and various figures, with arms, legs, and veritable features. The three Saint Sebastians that he painted might be supposed to show a special concern for the masculine figure, and perhaps they do: but the secondary figures in his paintings are better evidence of where his interests lay. There just aren't many women. Though his backgrounds are often crowded with forceful and striking masculine figures, he does not often introduce a decorative handmaiden or a female onlooker, and does not ordinarily give her much expressive action. In selecting among feminine features, he is most addicted to portraying the fresh, almost chilly features of virgins, and the lined, almost craggy features of elderly women. His hags and harpies seem to have been drawn in a vein of special feeling. With interesting exceptions to be noted, he does not very often represent the nubile, attractive woman, outside frankly commissioned works. Aside from madonnas, the few exceptions are a series of sketches, done apparently in the latter years of his life, and representing heroic women, like Judith, Tucia, Sophonisba, and (oddly) Delilah. In all these drawings the woman is shown either exemplifying manly virtue or inflicting fatal damage on a man. The Judith happily combines both themes. On the tree of the trunk in the background of the Samson and Delilah drawing has been incised a Latin motto which may or may not have applica-

[15] *Ibid.*, pp. 103, 104; "made him study from plaster casts of antique statues" . . . "saying they were bad because he had imitated marble antiques." It might of course be just another instance, neither the first nor the last, of a teacher telling a student to do something and then blaming him for doing it.

tions wider than the particular drawing: "FOEMINA DIABOLO TRIBUS
ASSIBUS EST MALA PEIOR." (Roughly: "Woman is worse than the devil
by a long shot.") Cut in the bark of a tree, it provides an interesting
contrast with the usual lovers' inscriptions, particularly since the vine
crawling over the tree is a traditional emblem of marriage.[16]

It may not, perhaps, be too abrupt to draw from these qualities
of his art certain tentative conclusions about the attitudes of Andrea
himself. He was a scholarly painter, not in the sense that he knew a
great deal about the classical world which modern archaeologists
would consider authentic, but because what he did know was a con-
stant element in his painting. Andrea's experience of the antique
world was, as has often been said, a veil, a romantic, idealized dream;
but it was also a form of discipline, a principle somehow hostile to,
as well as fulfilling of, simple nature. His landscapes are sparse and
rocky; the clouds that float in his skies are high and cold; the lean
and avid figures he delights to portray are eaten by passions that will
forever prevent their being contented Renaissance animals.

The beauty of his figures was, we hear, proverbial; but it is rarely
a placid beauty. Rather it involves a tension, frequently a grimace.
The sort of suffering portrayed in a famous little Louvre crucifixion
(it was originally painted for the altar of San Zeno in Verona; Na-
poleon, the well-known art-lover, brought it to Paris) casts a bitter
clarity over the entire picture. Christ is dead against an arid and
stony landscape, under a cold sky. The ridge of Golgotha, paved in
vast, angular blocks, arches over the hill and away; Jerusalem rises
in the background, at the summit of a hill grotesquely broken with
calcareous masses of rock. No vegetation softens the bitter outlines
of the landscape; the surviving thief (probably the bad one) struggles
in awkward agony under the casual, interested gaze of a horseman,

[16] Cf. Cesare Ripa, *Iconologia* (Venice, 1669), "Libidine," where Lust is
represented with a grapevine in the background. "La vite è chiaro indizio di
Libidine, secondo il detto di Terenzio: 'Sine Cerere & Bacco friget Venus.'" For
the specific advantage of the literal minded, be it said that we know nothing
whatever about Mantegna's married life. Professor Kristeller estimates that his
economic condition deteriorated considerably after the death of his presumably
more prudent wife; but that's hardly a secure index to the success or failure of a
marriage. Nor are antifeminine slogans necessarily to be taken at face value in a
society where they are commonplace.

and the broken body of Christ rises against the sky like a standard. In her anguish, the Virgin stumbles into the arms of an elderly female supporter, while the centurion in charge turns away with balanced disinterest to watch the ruffianly card game going on at the foot of the cross. The painting portrays a transcendence of nature, a moment of quiet after Christ's death to nature; and nature, in return, displays a hard, self-absorbed assurance, a disinterest in being transcended. His low point of view enables Mantegna to emphasize the weighty masonry of Golgotha; the hole in the ground is a grave out of which we look to see outlined against the cold still morning sky imperial Jerusalem, Christ like a flag, and the centurion's self-possession—S.P.Q.R. Like Herod Agrippa passing judgment on Saint James (in the fresco that used to adorn the Ovetari chapel of the Eremitani at Padua), the centurion presides over a religious drama outside his comprehension, a chairman administering the rules of order and going by the book. And the nature of the picture, in its exact perspectives, meticulous details, and wide horizons (vertical as well as horizontal) somehow comprehends his attitude. This cool tone is very Mantegnesque, but it involves energies dominated, not absent. Fiocco speaks of Andrea's "gusto per le esperienze alte, serene, apatiche a modo loro." [17] It is a serenity, an apathy, based most often on dynamic balance.

Nature, in Mantegna's backgrounds, reinforces the thematic points of the human scene, but in disciplined and unobtrusive ways. In the Execution of Saint James (before it was bombed to powder) one used to see in the center foreground a tree, characteristically lean and scant of leaf, one branch of which had been broken, though not broken off, and which still hung awkwardly; to the right an owl, bird of ill omen, brooded from the top of a ruined building, and a tower in the remote background was rent by a grotesque split in the masonry. In the London "Agony in the Garden," the little rabbits playing in the middle of the road symbolize the wakefulness of which the apostles have so signally failed; and in the "Resurrection" section of the San Zeno altarpiece (presently at Tours), the startling growth

[17] "His taste for lofty, quiet experiences, passionless after their fashion." Fiocco, "La cappella Ovetari," cited by Renata Cipriani, *Tutta la pittura del Mantegna* (Milan, 1956), p. 92.

of trees from fissures in a flinty rock can scarcely be mistaken as a commentary on the miraculous event itself. The Saint Sebastians of Aigueperse (now in the Louvre) and of Vienna are not only roped to broken pillars but surrounded by fragments of broken statuary—feet, heads, hands—while for the "Madonna of the Grotto" in the Uffizi, nature has cast up a fantastic fan-shaped screen of rocks as a natural alcove or chapel.[18]

The ways in which nature gets coaxed into serving the central theme of Mantegna's paintings are better discriminated than fused. The craggy scenery of his backgrounds is often exaggerated beyond any pretense of verisimilitude, beyond even medieval complexity; the raw earth, thrown up in grotesque shapes, is ripped apart by stony excrescences, exfoliating in artificial luxuriance, and contrasting vividly with the sculptural austerity of the main figures. Almost in spite of itself, the eye is drawn into these minute decorative convolutions, and held by their extraordinary richness and complexity of form. The arching energy of rocks, the intricate arabesques of drapery, the Rorschach tests of clouds attract the attention irresistibly and reward it sometimes with the discovery of actual faces or figures, latent but decipherable. Let this sort of thing represent Mantegna's "soft" fantasy.

Now against these rampant dream images are often set images pictured in the most striking and realistic detail, actual genre figures. The stoneworkers in the "Madonna of the Grotto," who excited Vasari's admiration, or the townspeople in the fantastically vertical village behind the Aigueperse "Saint Sebastian," are painted with unnatural clarity; in the same way, veining of marble is recorded precisely, the frieze on an arch or a wall is as if incised, the quiet details of the flat Mantuan landscape behind the "Death of the Virgin" are seen through a window. In this capacity, Andrea seems to aspire to the condition of a camera. To emphasize the power of his naturalistic perspective he will draw a horse from the rear or a cadaver from the feet. He sometimes assumes a strikingly low angle of vision (as in the "Camera dei Sposi" at Mantua) because he wants to paint the picture at the angle from which it will be seen by the spectator. The lighting within the picture often aims at extending the source

18 F. Hartt argues in the *Gazette des Beaux Arts*, ser. 6, 40 (Dec., 1952), for the iconographic significance of apparently realistic details in this picture.

of the light by which the picture as a whole will be seen. Indeed, there are moments within the Eremitani frescoes and in the "Camera dei Sposi" where the figures step out of the framework or in front of a painted pillar, to claim physical existence in actual space—these are figures of *trompe l'oeil,* and they may stand for naturalist-neutral Mantegna.

Finally, there is the "hard" fantasy of noble sculpture and heroic images, not only avowed sculpture reproduced in painting, but sculpturesque figures—weighty, formal, dignified. They neither tease the eye into the painting nor appear to extend our own living space. They reflect our thought from their own monumental and weighty presences, as if deliberately accepting the task of bodying forth the artist's mind; they make us feel that mind imposing its own self-sufficient ideals, if not on the world exactly, at least on the values represented in the painting and on the space it dominates. These are the images that Berenson characterizes as "his vision of a noble humanity living nobly in noble surroundings." [19]

Although it need not overshadow and can never be fully separated from the other two, Mantegna's most distinctive and most described manner is the third, the one in which learning seems to take arms against life, the artist's feeling to inform his figures, so that the heroic dream imposes itself on nature. A recurrent motto of the painter's declares that "virtuti semper adversatur ignorantia"; virtue is thus identified, like many versions of *arete,* with knowledge, while ignorance is equated with sensuality and vice as a characteristic of man's lower nature. A number of Mantegna's paintings, drawings, and engravings portray explicitly such a *psychomachia.* One understands the self-made man's passion for individual enterprise, indeed nothing could be more natural; he is bound to glorify Techne (skill) over Tyche (chance), ambition over well-ordered docility, energy over status. But there are qualities in these allegories which remind us also that their creator, in his chosen imaginative ambience, was no rude upstart but a consul, a man of serene, imperial authority. The details of his allegorical schemes may never come perfectly clear, but their peculiar mixture of assertion, assurance, and reticence makes them as intriguing and elusive as a canto of Spenser.

[19] *Italian Painters of the Renaissance* (Oxford, 1932), p. 246.

The most famous and fascinating of Mantegna's moral allegories is his picture (see pl. 1) of "Wisdom Victorious over the Vices," which now hangs in the Louvre. This painting was done for the famous *studiolo* of Isabella d'Este [20] and represents one of the last works of Mantegna's life; he completed it at the age of seventy. The circumstance requires emphasis because it points toward an otherwise undemonstrable conclusion, that Mantegna was in good part responsible for the content of his painting. On other occasions, Isabella and her humanist advisers were known to dictate to the painters whom she engaged every last detail of the pictures they were to produce. But Andrea was not only the first painter to work on this program, he was the most famous and the most firmly established in the possession of an individual style, an individual attitude. He couldn't have been dictated to; he wouldn't have been. Giovanni Bellini, invited to contribute, said frankly that the program set up for him to follow would have to be changed, indeed, was unacceptable as a whole, and so declined to work at an allegorical-historical design at all, producing instead a common "Nativity" that Isabella had grudgingly to accept.[21] Andrea could have objected too if he had felt like it; he had rejected commissions before. As official court painter in Mantua, with a will of his own and the authority to enforce it, Andrea's position was even stronger than his brother-in-law's, had he chosen to take a stand. As a matter of fact, the first of his contributions to the *studiolo*, the so-called "Parnasso" (also now in the Louvre), was in place less than a year after the project is first heard of; it may well have been begun on a bare premonition of the large-scale program that afterward grew up around it. In any event, with regard to "Wisdom Victorious over the Vices," there is no reason to doubt that Isabella and her adviser, Paride da Ceresara, influenced the conception; there is, equally, no reason to suppose that they invented it all by themselves and then imposed it on recalcitrant Mantegna. And if we can proceed on the unproved but very probable assumption that Mantegna took an active part in the planning of his own work, it may be possible to say something of this strange and

20 See, for detailed effort to reconstruct the "program," Egon Verheyen, *The Paintings in the Studiolo of Isabella d'Este at Mantua* (New York, 1971).
21 Kristeller, *Mantegna*, p. 345.

wonderful painting as the expression of his strange and wonderful personality.[22]

The central figure of the painting is a swiftly striding, sharply angled figure who might be variously identified as Virtue, Wisdom, or Athena: a scroll on the far right, ET MIHI VIRTUTUM MATRI SUC-CURITE DIVI (approximately, "O ye gods, help me too [or, even me] the mother of the virtues"), seems to make possible either of the latter two identifications.

Wisdom, though not very maternal in this armor-clad image, might well be called mother of the virtues. At all events, she is portrayed as a chaste, abrupt warrior, light of foot, keen of purpose, and severely beautiful. She is clad in just enough armor (shield, breastplate, helmet) to allow her hair and draperies to flutter becomingly about her boldly advancing limbs. Her spear is broken, and the point lies at her feet, unstained and unbent: we are forced to ask why it broke so easily. She holds the broken shaft loosely in her right hand; and the force of her glance does duty for weapons, since the nearer they are to her, the more distrait her enemies appear. About those fleeing enemies who have already entered their natal swamp, there cannot be much doubt; they are Vices, beyond any question. Fat, armless Otium is dragged away by the harridan Inertia; Ingratitudo and the hag Avaricia, on the far right, carry the crowned, inert form of Ignorancia. The black hermaphrodite monkey in the center of the picture is loaded with allegorical tags identifying him as "Immortale odium, fraus et malitiae"; four little sacks, hung about his body, contain "Semina," "Mala," "Peiora," and "Pessima." The Centaur is in the nature of things a notable image of lust,[23] and this one has in

[22] All this canny circumlocution about attributing to Andrea Mantegna responsibility for one of his major paintings may appear excessive, especially when the painting carries out so patently a "motto" freely chosen by Mantegna and obviously close to his heart. But relating a work of art to someone's psyche is always tricky, doubly tricky at a distance of half a millennium, and tricky above all when we deal with a social, public act like a court painting. It is well to be aware of the chance that we may not be analyzing Mantegna's psyche at all, but that of Paride de Ceresara—if, indeed, Paride had a psyche of any sort, and wasn't simply a bundle of Renaissance platitudes done up in ruff and doublet.

[23] G. P. Valeriano, in *Hieroglyphica* (Basle, 1567), p. 35, says the centaur signifies "Humanae Vitae Lubricitas."

addition the pointed ears of a satyr, though the nobility of his face and form may make us wonder; and the satyr with the head of a lion and the horns of a goat would be a complete monster if he were not carrying a perfectly formed human child.

Especially as they approach the central figure of the Vices, the grotesqueness of the images is modified; for this central figure seems to be no other than Aphrodite herself, armed somewhat singularly for this encounter with a bow, which she holds under her cloak, and no arrows. (The slender cord that crosses her breast may support a quiver, but if so it is behind her and only to be surmised.) In fact, she is not taking part in the conflict, her expression is disdainful and withdrawn. She steps languidly abroad the centaur's back and accepts his helping hand; but not in the manner of one either fleeing a danger or taking part in a battle. Her bow is slung idly over one arm, half hidden by her cloak. But her real weapon is on the other shoulder; it is the soft, perfectly formed arm, banded with gold and jewels just below the shoulder and above the wrist, which she presents to the viewer. Her nakedness is her best shield; the column of her indolent body is the axis of the picture; her indifference is the picture's strength. Yet, among the otherwise clad figures, she stands as the apex of a triangle of nakedness, the other two points being Otium on the left and Ignorancia on the right. The Ovidian motto of the picture, placed with deliberate prominence at the feet of Wisdom, emphasizes this conjunction: OTIA SI TOLLAS, PERIERE CUPIDINIS ARCUS. "Eliminate Leisure, and Break Cupid's Bow"—in other words, work is the remedy for lust.

The structural composition of the picture plays boldly across its thematic contrast. The Vices, descending and passive before the active energy of Wisdom, yet form a rising arc, which intersects and blurs the less distinctive alignment (is it a parabola or a sequence of slanting upward diagonals?) of Virtue's forces. Aphrodite is at the point where these forces intersect. If her bow has perished (that may be the point of her lacking arrows), she seems remarkably unperturbed by the fact. If her fate is linked with that of Otium, and she really is one of the fugitive, grotesque Vices, she does indeed redeem their cause a bit, but they also degrade hers.

The bow of Cupid, or the bow of desire, is not very easy to

identify in this picture, which is crowded with bows. Back somewhat from the water's edge, close to the menacing figure of Wisdom herself, is a female satyr, carrying three of her offspring in her arms and leading a fourth. These are evidently allies of Aphrodite and enemies of Wisdom, their animal nature being clearly evidenced in their goat feet. Perhaps we are intended to make a connection between them and the satyr on the lower right, who is also carrying a child, though a fully human one. In any event, the four baby satyrs here serve as a center of attraction for two groups of tiny flying creatures: a set of six properly formed *putti* in the guise of cupids and a more distant band of four owl-faced creatures scouting through the dusky air. Of the cupids three are armed with bows and arrows, one with snares, one carries a swath of drapery (perhaps a bandage for the victim's eyes), and the most distant one seems to be unarmed entirely. These are perhaps auxiliary vices, antagonists of Wisdom, though not very worthy ones. Like Aphrodite herself, they seem largely unconcerned with the war, and the furious charge of Wisdom appears disproportionate to such tiny and playful opponents. Moreover, the bows of the cupids, if these are indeed cupids, are not broken by the banishing of the vices. The cupids remained armed, not only with their toy weapons, but with their filmy wings, their baby faces, their insouciance. Wisdom's impetuous charge is made, thereby, to look a little heavy-handed. Evidently among the vices are numbered not only the bestial creatures of the foreground and the unflawed nakedness of the goddess of Love herself but the charming fantasies of a gay imagination.

We should understand all too easily a picture of Wisdom, armed and radiant and perfectly human, attacking the deformed and monstrous vices; but this is not the picture actually before us. Some of the vices are so attractive as scarcely to suggest vice at all. And, as we shall see, some of Wisdom's allies have a distinctly vicious look. Two of them, without being particularly vicious, are difficult to assign places in the allegory. These are the two maidens who run before Wisdom, one carrying a bow and arrow, the other a truncheon or unlighted torch. Neither has any label attached to her, but the nearer might be Artemis the huntress, guardian of chastity—in which case the farther might be Philosophia (though she will not cast much

light from an unlit torch). She has in fact been bluntly identified, sometimes with Philosophia, sometimes with Castitas.[24] But both identifications seem a bit redundant, Philosophia being properly subsumed in Wisdom, Castitas in the figure of Artemis. And cautious Professor Kristeller was not even certain whether the two figures were fleeing vices or Wisdom's allies.[25] Indeed, they are not particularly grotesque, but neither is Aphrodite. Their faces—tense, pure, and almost hypnotically determined—ought to establish them as virtues; but if they are such, their allegorical meaning is oddly undefined.[26] And though this indefiniteness might not have perturbed Mantegna, it does place a strain on the viewer's powers of interpretation, such as allegory does not generally impose.

Finally, among the other allies of Wisdom in the painting one must number the four little flying, owl-faced creatures who seem to be driving the cupids away. If Wisdom is Athena, her servant and emblem is quite properly the owl, and so these little figures belong to her camp. They are further identified with her cause by their direction in the picture: they are going from left to right—but so, on the other hand, are the cupids, to whom they are apparently, but not very directly, hostile. But even if they are allies of Virtue, their effect on a viewer is clearly that of grotesques. That effect is stronger even than the effect of some overt vices, who are simply deformed or disagreeable human beings. The owlets of Wisdom (if Wisdom's they are) look like fierce little monsters; and in fact owls are as often used to represent solemn ignorance and love of the dark as wisdom and love of the light.

24 Maud Cruttwell, *Mantegna* (London, 1901), p. 96; Richard Foerster, in *Jahrbuch der königliche Preussischen Kunstsammlung*, XXII (1901), 160.

25 Kristeller, *Mantegna*, p. 356; he calls them simply "two women . . . accompanied by a love god with two torches."

26 The unlit torch may well represent the defeat of love, as an antithesis to the lit torch of marriage; cf. Ovid, describing Cupid deploring the death of Tibullus:

Ecce puer Veneris fert eversamque pharetram
Et fractos arcus, & sine luce faces.
Amores 3. 9. 7–8.

We note, however, that, not only are there no *fractos arcus* in the picture, but the only broken weapon of any sort is Wisdom's spear.

There are many other details to be considered in the economy of the allegory—a goddess in the shape of an olive tree shrieking encouragement to the central figure, Hercules with a club for active and a column for passive fortitude, a number of tiny and enigmatic actions in the background. But what is most curious about the picture is the oddity that lies on the face of it. Aphrodite (who surely is sexual love, but may be married love or for that matter spiritual love as well) figures among the loathsome and disproportioned Vices; while Virtue or Wisdom has in her train, if not in her person, strong elements of the inhuman or unhuman. An extreme analogy would be with the icy asceticism of Swift, who deliberately caricatures appetitive man as a Yahoo and less consciously (or perhaps only more subtly) caricatures reasonable man as a Houyhnhnm. But evidently this is pushing matters too far, too fast. Let us merely note for the moment that it is thoroughly unusual among Renaissance paintings to find Aphrodite among the vices, animated vegetables inciting Wisdom to a charge against Love, and cupids with owl faces who, for all we can tell, may be Wisdom's agents in her onslaught against the vices or, so to speak, vice versa. It is, in fact, both a private and a public picture; one broad "lesson" it teaches is obvious to the point of blatancy, but the details are crowded with private nuances and impenetrable instances. Mantegna is bold in giving traditional figures meanings of his own, assigning them new relations, and inventing new figures; he mingles allegory, mythology, overt moralizing, and a fine sense of indirection to create a complex pattern around his central theme. From the baldness of the Wisdom-versus-Vice contrast, the picture shades off into complexities on which Mantegna has perhaps commented mockingly by filling his clouds with mysterious faces, somewhere between eight and a dozen of them, which either mimic the warfare on earth or suggest that nature itself is divided into warring forces, or mock our inability to grasp fully the picture's theme. It is a strange picture indeed, in which not only the traditional associations of the figures but the very art of painting reflect the intense pressure of an imposed idea. In this respect most of all, it is characteristic of one side of Mantegna's nature.

A similar complexity has been sensed in the companion piece done by Mantegna for Isabella's *studiolo* and placed there before any

of the others. The so-called "Parnasso" (see pl. 2) depicts well-known Olympian deities in more or less familiar postures and surroundings. Nine muses (or nymphs or graces or hours) dance at the edge of a fountain which might well be Hippocrene; beside it stands Pegasus, who created it by a stamp of his hoof. Mercury—it is surely Mercury— stands by the winged horse, wearing talaria and winged cap and carrying caduceus and Pan-pipe. The tradition that associates him with Pegasus is not particularly strong, and his carrying a Pan-pipe, though not unprecedented, is also iconographically odd. But if he is other figures secondarily, he is certainly Mercury in his primary character; and so with his brother and counterpart in the picture, who plays so rhapsodically on his lyre. He is very probably Apollo musagetes, though he lacks some of the dignity customary in that personage.[27] Moreover, the two bundles of whips lying on the ground before him may remind us of the death of Orpheus, while the fact that his foot rests on a chopped-off tree stump still showing the marks of the axe is another reminder of Orpheus, hacked up and dismembered by the Thracian women. This may be fanciful interpretation, but an inventory of the *studiolo* taken in 1542 refers to the lyre player as "Orfeo" and the nine dancing maidens as "ninfe." We are not bound to take an anonymous sixteenth-century cataloger as a final authority on mythology, or anything else, yet it is noteworthy that the subject matter of the picture was early in doubt, that this allegory like the other seems to have had its indirections and complications.

If this point applies to the secondary foreground figures of the "Parnasso," Mercury and Orpheus-Apollo, it applies in almost the same measure to the picture's central figures, Venus, Mars, and

[27] The idea of Apollo as leader of the Muses may well derive from the notion of the sun as chief of the nine planets: see Gyraldi, "De Musis Syntagma." Popular mythographies show the Muses closely allied with the Hours, Graces, Fates; and in fact Apollo is sometimes portrayed as pretty close to Orpheus, Mercury, and Pan. See the 33d Orphean "Hymn to Apollo," which actually identifies Apollo with Pan, and Servius on *Aeneid* 6. 645, where it is stated that Orpheus first instituted the orgies and first grasped harmony, that is, the sound of the cosmic spheres, which are nine. Discounting the first and last of these (the primum mobile and the earth itself), which make no sound, one has an "explanation" of the seven-stringed lyre.

Vulcan. Not that there is much question of their identities, it's a matter of the relations between them. Mrs. Tietze-Conrat used to think Vulcan was working merrily at his forge to make wedding presents for the happy couple; but it seems unlikely that anyone else ever interpreted the picture this way, and she did not hold this view for very long.[28] Vulcan is an injured and jealous husband, frankly derided by Cupid, ignored by his cheerfully adulterous wife, and mocked even by the bunch of grapes hanging outside his cave. Either they are sour grapes, or they are a traditional mark of contempt and scorn ("dare un grappolo" is an Italian "segno di disprezzo"). One way or another, they signify his impotence. With his right hand, Vulcan is clutching a bundle of fine wires, out of which he will no doubt make the net of his revenge. But for the moment, he is the humiliated, resentful cuckold; and there is, consequently, no reason to doubt that the pair of dancers on the far right of the picture are mocking his plight with a singular, derisive gesture. The rabbits crawling out of their holes are creatures sacred to Venus; the myrtle bushes growing in the background are emblems of Venus; and Venus dominates this picture even more thoroughly than its counterpart. She does so not only by means of her triumphant nakedness, her elevated position, and the deferential simper of Mars but also through the quiet, sinister threat of an arrow, held in the soft right hand after which Mars is blindly groping.

These are the terms in which the central action of the painting presents itself; and on these terms the triumph of Mars and Venus is the primary cause of Parnassian celebration. Vulcan protests helplessly and absurdly in the background but is derided by the muses or nymphs, by Cupid, by the happy couple, by the painter. Everyone else in the painting is either indifferent to the triumph of Mars and Venus or vigorously applauds it. Thus the muses, Apollo (or Orpheus), Mercury, Pegasus, and the rabbits are all celebrating an act of adulterous wrong.

Quite possibly this is the true character of the painting. No

[28] Tietze-Conrat, *Mantagne*, p. 195. Mrs. Tietze-Conrat's conversion took place in successive issues of the *Art Bulletin*, her assault (XXXI, no. 2 [June 1949], pp. 126 ff.) being promptly followed by Professor Wind's classic rejoinder (XXXI no. 3, pp. 224 ff.).

painter is bound to express every part of his philosophy (if he has one) in every picture he paints, and Mantegna may well have counted on the severe energy of "Wisdom Victorious over the Vices" to counterbalance the amoral revelry of the "Parnasso." If taken on these terms, the painting is peculiar, indeed unique, in Mantegna's artistic career; but there is no reason to feel sacred horror at this hypothesis. Many painters have painted pictures that are thematically or stylistically unique within their canon; and there are known circumstances to account for Mantegna's having done just this thing at just this point in his career. So we are not in any particular trouble if we take the "Parnasso" at its own surface valuation as a heroic glorification of frank adultery. The Renaissance would have known how to view such a picture within a tacit Christian framework, such, for example, as surrounds Chaucer's *Troilus and Criseyde* and rises to direct statement only at the end of the poem.

On the other hand, Mantegna was a man with an intrusive, almost compulsive moral sense; the program of paintings on which he was embarked had or came to have an elaborate allegorical program, and there is reason to think this program was either shaped by or at least congenial to Mantegna's temper. Finally, his awareness of wrong was especially fierce and insistent in matters of female misbehavior—witness, for instance, the "Samson and Delilah" drawing. When we find him painting the sort of picture I have just declared the "Parnasso" to be, it is a little as if one found the later Milton turning out, between *Paradise Regained* and *Samson Agonistes,* a poem on the order of *Venus and Adonis.* Surely the actual work of artists cannot be racked on the Procrustes' bed of a Platonic idea of what their work should have been like; on the other hand . . . but the argument completes itself.

Can any evidence be found, within the frame's four walls, of Mantegna's reservations about the triumph of love? I think it can. The signs are subtle, because the main impact of Mantegna's morality was to be conveyed by the companion piece; but the two pictures work intimately together, and I think certain elements of moral reservation are found in the "Parnasso" which qualify the triumph of Venus and make the two pictures complementary rather than antithetical. First of these is the net grasped by Vulcan; as every reader

of Homer will recall, it threatens the adulterous figures with exposure, public humiliation, and punishment at the hand of the Father of all the Gods. Second is a background figure worked into the landscape but with a clear allegorical purpose. The intrigue of Mars and Venus was first discovered by Helios or Sol, the sun-god; and, unless I am much mistaken, he is represented in Mantegna's picture in that curiously shaped craggy rock just above Vulcan's head. He is driving his chariot aloft into the heavens, and the lead horse is boldly outlined against the sky. Then there are the little animals down in the front of the picture. Two of them are rabbits, animals sacred to Venus because of their preternatural fertility and because, according to ancient authorities like Aelian and Pliny, the males gave birth as well as the females. They are not there just to entertain the eye, because they are on the very margin of Hippocrene itself, and if Mantegna had been out to entertain the eye, he would have put marsh-dwelling creatures there. But there is a third creature in the foreground, even more out of key with his surroundings than the rabbits; he can only be a hedgehog, and the position he occupies (unlike real-life hedgehogs, which are shy, nocturnal creatures) is open and obvious. Emblematically speaking, he is famous for guile and spite; [29] and his characteristic action is to roll himself up in a spiky ball that cannot be touched without danger of a wound. The spines of the hedgehog are reinforced thematically by the unobtrusive arrow that Venus is carrying. And the two switches which lie in front of Apollo-Orpheus rest on a sort of carpet or pavement that leads

[29] Ripa describes the "Derisore" (*Iconologia*, II, 180) dressed in hedgehog's skin, in evidence that the mocker, though unarmed, can wound like the hedgehog any person who approaches him. The unpleasant abstraction "Maldicenza" is also described (IV, 65) as wearing a hedgehog skin in sign that Evil-saying destroys not the life of its victim but his honor and reputation. Valeriano tells the familiar story (*Hieroglyphica*, pp. 74–75) of how the hedgehog, knowing that it is sought chiefly for its skin (useful in combing wool), urinates all over itself, thus causing the skin to rot and the spines to drop out. He also describes the hedgehog as an emblem of the dangers of procrastination, of the man fortified against all perils, and of readiness to seize opportunity, because it builds a nest with two exits in order to use the one through which the wind is not blowing at the moment. But these moralizings do not fit Mantegna's picture as effectively as the emblem of spiteful mockery. Sidney, in the *Defense of Poesy*, refers to the hedgehog as an emblem of ingratitude because, after being received into the nest, he drives out his host.

into the rear of the picture and seems to pass directly under that curious mound of earth which obligingly forms a platform for Venus and Mars. Why is this mound of earth hollowed out, against all natural probability? At the top, it is no more than two feet thick; yet it supports not only an armed warrior and his buxom mistress but a flourishing growth of fruit trees as well. Did Mantegna hollow it out merely to present a snatch of peaceful landscape off into the distance? Maybe so. Or else the arch of earth may be a "natural" parody of a triumphal arch, as the bundled switches stand for fasces. Passing under the yoke is the essence of every triumph, and Mantegna may well have intended to suggest here the sort of gloomy procession of servitude that concludes Petrarch's "Trionfo d'Amore."

Finally, if Mercury is given his full weight as presiding deity of the painting, we may see in him an element of ironic hedging against the whole notion of "natural" sexual lawlessness that the "Parnasso" seems to be celebrating. Mercury is the antithesis of true wisdom; he is the god of theft, of duplicity, of hermetic indirection. One might say it is Mercury's world that Mantegna's picture sets before us, and Mercury stands at the side of it almost in the capacity of master of ceremonies. His very presence thus implies moral reservations. Mythology reminds us that he began his existence by stealing in succession from all three of the central figures in the "Parnasso";[30] and his relation with the Muses, especially at those Parnassian Bacchanalia which Gyraldi describes on the authority of Macrobius,[31] can hardly have been a brother-and-sister affair. The argument that the Muses are bound to be sacrosanct virgins, and hence that Mantegna's representation of the triumph of love must have been seriously intended, stands on sandy foundations.[32] On the contrary, Mercury's presence

[30] Lucian Dialogues of the Gods 11 ("Hephaestus and Apollo").

[31] L. G. Gyraldi, Opera omnia (Lugd. Bat.—Leyden, 1696), "De Musis syntagma." I, 561, 1b.

[32] The conjunction of Mars and Venus was obviously material for Renaissance compliment whenever brave men married beautiful women. But only an oaf would call attention, in such a compliment, to the lady's outraged husband, while placing in the foreground of his picture known emblems of derision, spite, and malice. Mantegna, who had spent his life in courts, could not possibly have painted in a vein of courtly compliment the picture that hangs today in the Louvre. As a matter of fact, the chief marriage associated with this picture as its "occasion" is that of Alfonso d'Este and Lucrezia Borgia in 1502; given the

at a function already dubious in the light of Mantegna's standing quarrel with women and the world of natural desire that they symbolize, reinforces an interpretation of the picture that can hardly be other than sardonic. Between Mercury as frame figure and Mercury as latent participant in the action, I think the picture contains enough critical reservations generously to justify Professor Wind's characterization of it as mock heroic in spirit.

The relative merits of these two pictures have been somewhat inconclusively debated. Professor Kristeller preferred the Hellenic calm of the "Parnasso" to the Gothic gloom of "Wisdom Victorious over the Vices." Mrs. Tietze-Conrat tends to find the latter painting more fluid if perhaps less gracious than the former.[33] Without trying to resolve the issue (which has, I think, a little the quality of a debate between apples and onions), perhaps one can say that the frank depiction of struggle in "Wisdom Victorious" is more Mantegnesque, though the picture proper is less satisfying, than the "Parnasso." In neither picture do natural forms provide a full and capacious embodiment of the moral theme. The "Parnasso" comes closer to permitting some sort of repose, but it too represents a sly, muffled *psychomachia*.

Perhaps the quarrel with nature was no more than a major incident of Mantegna's genius; but it was a persistent element in his life and thought, and surely not unconnected with a feeling that from the first he had elected to make himself by conscious acts of the will. The idea of re-naissance was frequently a mode of completing, perfecting, disciplining one's naissance. Nature might be redeemed, purged, improved, corrected, methodized, by ideas of nature which a single word could summarize as *virtù*. The virtù that Mantegna admired and exemplified wore the armor of the conscious mind and took as its persistent enemy the languors of the naked flesh. The language in which it expressed its aspirations was sometimes strained, sometimes private; but it is part of the enchantment of this strenu-

checkered background of the bride and the notorious reluctance of the groom to assume the dangerous eminence of her bed, a painter would have needed more temerity than even Mantegna possessed to paint *this* picture for *that* celebration.

[33] Kristeller, *Mantegna*, pp. 350, 356; Tietze-Conrat, *Mantegna*, p. 29.

ous, half-forbidding, half-appealing figure, that we feel him always to be reaching after the greater assertion.

Scaliger

There are certain paintings of Mantegna's in which the sky is so pale and high and cold that one seems to be present at the world's very first morning. The clouds are thin and sparse, the grass pushes hesitantly forth; one seems to hear in the sacred silence only a few ritual bird peepings. For the rest, if there is life, it is totally inadequate to fill the vast, cold spaces that surround it. Wrapped against the chill, the peasant plods his self-absorbed way behind his inward donkey. Beast and man alike are withdrawn from the terrifying clarity of the altitudes that submerge them. Even the ritual in the foreground (crucifixion, adoration, or whatever) is isolated and purified of all personal feeling by the indifference of the morning. Whether Christ is crucified or not, the weather is clearly going its own way, the day has the rest of its cycle to complete; at the moment, if it is concerned with anything, we must call it birth, not death. It was in the still chilly spring morning of humanism, when the reedy voices of secular scholars first began to rise over soaked meadows, that a burly, black-bearded Italian of forty years or so, climbed out of the swamps and piedmonts of northern Italy, crossed the Alps, and descended on France.

The story of the house of Scaliger cannot be told forward, from beginning to end, like a proper story, because it has no proper beginning. So one place to start is the city of Agen, in the Department of Lot-et-Garonne, about seventy-five miles southeast of Bordeaux. Agen is today a hard and brassy little burg, a vestpocket Marseilles, dedicated to selling hardware, repairing tires, and doing curious things to prunes, which are raised in the nearby countryside and constitute Agen's only "specialty." With time, the city has grown shabby and grubby without growing picturesque; three or four ancient buildings and some fragments are preserved for the occasional tourist, but the king of the town is the commercial traveler, for whom special terms are announced in the best, bright, mean, little hotel and in the one good restaurant. Agen might have a great future if somehow it

could only get a presentable present. But our interest in it lies far in the past. Four hundred and fifty years ago, Agen was (*mutatis mutandis*) very much what it is today, a bustling and grubby little center, regulating its digestion with prunes and passing hardware from hand to hand while countercirculating brass. Perhaps it was more isolated than the modern town, a bit more independent. By no means a mere hamlet, it was half as big as Bordeaux, the fourth city of the kingdom; but already the pattern of Agen was set. It had recognizably the same shape, the same patterns of traffic, the same middle-class go-getting ideas as today. The stone walls that used to ring Agen have mostly been torn down, but the unmoving walls within the minds of its citizens have been rising slowly higher through the centuries.

Upon this town there descended, about the year 1521, a man whose name bore a double omen. He called himself Julius Caesar Scaliger, and he claimed to be of the princely house of della Scala in Verona. Julius Caesar was the conqueror of Gaul, and La Scala, l'Escale, or "the Staircase" is a name which suggests determination to rise in the world. The coat of arms that J. C. Scaliger bore as his own included a handsome staircase, but in many of the old portraits and prints it looks remarkably like a ladder—such a ladder as, in fact, the historic house of La Scala bore on its scutcheon. When one thinks of it, a ladder really does resemble a sort of portable stairway (its association with second-story-men is incidental); and in literal fact, everything that Julius Caesar Scaliger possessed had to be portable when he arrived at Agen in 1521. He bore his titles in his face, and his arguments for asserting them in a lean, well-worn scabbard at his side. He was a bold-faced, black-bearded figure of a man (see pl. 4), with a bull's roar and a dextrous tongue. He was about forty years of age, and up to this point had made no impression whatever on the world. In the sixteenth century, in Italy, forty might well be thought the threshold of senility.

It is hard to go forward in this story without settling, or appearing to settle, many points that must be left wide open. For instance, the last paragraph overstated Julius Caesar Scaliger's claim to be connected with the noble family of La Scala. He did indeed make this claim, after a fashion; and the name "Scaliger," which he signed

to all his writings, does indeed translate from or into "La Scala." But he never did claim more than an indirect connection with the main, princely line of the La Scala family, with those Mastini and Can Grandes de la Scala who lie buried beside the cathedral at Verona. That branch of the family had, by general agreement, been extinct for some time. But a collateral line had given rise to Julius Caesar della Scala a Burden: the only thing that cast doubt on this argument of the Scaligers father and son was the difficulty of establishing connections at either end of the line:

> Pater meus [wrote Joseph, the son of Julius Caesar] Ripae in Italia est natus [this could be either Ripa near Lucca or Ripa near Perugia or some other Ripa altogether] et educatus in armis; educatus fuit Burdeni in comitatu, qui erat Patruelis ex Matre [through relatives on his mother's side], quae erat ex Imperatore Constantinopolitano: Burden est in Sclavonia [Yugoslavia? Czechoslovakia?]. Ut Bonifacius Patruus [uncle Boniface: but who and where was pater's pater?], terribilis vir, illum à Tito fratre distingueret, vocabat hunc à Burden, cum non posset unquam esse heres illius Burden. [Safe enough: but why not just call one Titus and the other Julius?] Vocatur Bononiae [at Bologna] Tonso a Burden [Baldy from Burden]. Erat strictè tonsus, cum Itali reliqui gestarent capillos oblongos [longish, not oblong] in utremque partem.[34]

> My father was born at Ripa in Italy and trained to arms, trained in the district of Burden, which belonged to the family through a maternal cousin—she descended from the Emperor of Constantinople. Burden is in Sclavonia. Uncle Boniface, who was a frightful man, wanted to distinguish him from his brother Titus, so he called him *from* Burden, since he couldn't ever inherit that property. At Bologna he was called Baldy from Burden. His hair was cut short and the rest of the Italians wore their hair long on both sides.

The emperor of Constantinople on his mother's side: that was a splendid, though slightly left-handed connection. But who was Julius Caesar's father, and how did he connect with the princely house of La Scala? Joseph is not bursting with eagerness to tell us. Evidently, if properly modified, the claim of Julius Caesar to be related to the princely house of Verona was less improbable, but also less over-

[34] *Scaligerana* (Col. Agripp.—Cologne, 1695), p. 361.

powering in its implications, than a direct assertion of blood-related-ness would have been. Relatives of dukes and barons are, in the nature of things, more numerous than dukes and barons themselves. Julius Caesar Scaliger was not an outright adventurer; or, if outright, he was at least not barefaced; or, if barefaced, he was not wholly outrageous in his claims. The extremes of veracity and impudence are ruled out by the circumstances of the case. Julius Caesar was not a prince or a lord of the distinguished family of La Scala; had he been so, his genealogy would have been much more detailed and perspicuous, his acquaintance in upper-crust Italian society more considerable—and, the chances are, he would not have come wandering over the Alps with his sword as his calling card. On the other hand, he was not (as his enemies, and particularly that villain Gaspard Scioppius, later declared) simply a wandering bravo, a tramp with a sword. According to *that* story, the father of Julius Caesar had been nothing but a Sclavonian sign painter; the son was a second-generation fraud, his real name was Benedetto Bordoni, and his only connection with the lords of Verona grew from the fact that his father once lived in Venice on the "via della Scala." [35] But this story, though it rings gratefully on our degenerate ears because it is sour and cynical, has as many weak points as its opposite number. A vulgar adventurer who invents a noble genealogy for himself does not behave like Julius Caesar Scaliger; he makes a quick profit on his story and a quick getaway before its falsity is discovered. He doesn't publish to the learned world claims that could easily be exposed if they were false and could much more easily be exploited if they were not published at all. Julius Caesar never pretended to have estates or influence, never begged favors or accepted privilege on the basis of his rank, never asked any other terms of life than hard work, a strict judgment, and the standard recompense. One didn't have to be related to the ancient families of Verona to make demands like that. Burden, Burdenius, or whatever, may not even have been a name at all, but an ironic and rueful term descriptive of his economic condition: "Burden linguâ Sclavonica, quam etiam Pater loquebatur, significat sterile & desertum, & mon Pere fut nourry à Burden" [36]

[35] Jacques de Thou, in *Perroniana et Thuana* (Col. Agripp., 1669), p. 360.
[36] *Scaligerana*, p. 72.

(Burden in Slavic, which is a language my father spoke, means bleak and abandoned, and my father was raised at Burden). The people of Verona, it's good to recall, had quite as much interest in denying that he was a Scaliger as he had in affirming it; one of them, Augustinus Niphus, boasted to De Thou in 1573 that he had supplied Scioppius with all sorts of denigratory stories about Julius Caesar and his illegitimate claim.[37] Nobody bragged about it, but the Scaligers called distinguished contemporaries to witness that Italian expeditionary parties had been sent into France to assassinate them—and nobody troubles to assassinate a pretender who can be laughed out of court.

So who Julius Caesar Scaliger really was and where he came from are still open questions, after four hundred years and more of discussion. He was born, we may be sure, and probably of parents; but beyond that, we are on the high seas, and likely to remain there —listing a little bit, it may be, to the starboard, or skeptical, side, since the onus of proof always lies on the man who proposes a distinguished genealogy for himself, and his story must be straight, coherent, copious, and well documented, if it is to convince. On most of these scores, the tale told by Julius Caesar Scaliger, and maintained fiercely by his son Joseph Justus, leaves something to be desired.[38]

One thing is sure: whoever Julius Caesar Scaliger a Burden was in Italy, and whatever his connections, in actuality or imagination, with the princely house of Verona, he was not by a long shot the personage in Italy that he quickly became in Agen. His genealogical line was confused, no doubt about it. This has happened before and will happen again; human nature being what it is, proximity to a title of honor is worse temptation than proximity to gold, jewels, or forbidden virginity. But even if the titled connection was genuine, it served only to stifle for forty years one of the most remarkable men

[37] de Thou, *Perroniana et Thuana*, p. 360.
[38] J. F. C. Richards discusses at some length and reprints (in *Studies in the Renaissance*, IX [1962], 195 ff.) the "Elysium Atestinum" of Julius Caesar Bordonius, a poem written around 1519 or 1520. From his arguments it seems very probable that this author was our Scaliger, but also very probable that our Scaliger fell short, by a good deal, of the rank that's implied when one says simply, "My name is La Scala and I come from Verona."

of his age. Perhaps he really had engaged in that remarkable intrigue of which his son retained a memory—to make himself learned in logic and scholastic theology, become a monk, become a cardinal, and finally become Pope, in order to have means of making war on the Venetians and winning back from them the ancestral domain of Verona.[39] Carrying out a plot formed on this scale would inevitably take a good deal of time. Probably the claim of Julius Caesar to a place in the many-chambered house of La Scala was just genuine enough to keep him expectant but unexercised till the years had slipped by as in a dream, and, already past the midpoint of his life, he heard the trumpet sounding, and rose, and went to Agen, and thrust in his sickle.

The fields were already white. In the spacious manner of the early Renaissance, Julius Caesar Scaliger declared himself a doctor, and he first made his entry into Agen as personal physician to the Bishop of Agen, another Italian with a distinguished name, Mark Antony della Rovere. But to be a physician was, in those days, also to be something of a philosopher,[40] and perforce a linguist as well. Into all these fields, Julius Caesar strode with the boldness of his namesake. He published vigorously in a variety of languages, but mostly in the peculiar, crabbed Latin of his day, and on a variety of topics. He defended Ciceronian style against the attacks of Erasmus, and himself against Erasmus's friends. He wrote of his family, he edited and commented on the treatise of dreams by Hippocrates, he wrote books on comedy and on the principles of the Latin language,

[39] "Ce qui a rendu Jules Scaliger si docte en la Logique & en la Theologie Scholastique a esté le dessein de devenir Pape pour avoir le moyen de faire la guerre aux Venitiens & retirer de leurs mains sa Principauté de Verone: car il deliberoit de se faire Cordelier, & esperoit de Cordelier devenir Cardinal, & de Cardinal Pape. Ce qui fit qu'étant à Bologne, il s'employa diligemment à la lecture des Oeuvres de Scot. Mais il renonça au dessein de se faire Moine, pour quelque chose qu'il remarqua en ceux de cet Ordre; ce qui a fait que du depuis il n'a jamais voulu avoir de communication avec eux" (*Scaligerana*, p. 353). Did anyone before or since ever read Duns Scotus with such an end in view? And what, one wonders, was that dark "quelque chose" that he remarked among the Franciscans which caused him to view them ever after with such suspicion?

[40] Paracelsus could ask, "What is a doctor who is ignorant of cosmography?" in full confidence that every informed reader would supply the instant, instinctive answer, "Nothing."

he quarreled with Hieronymus Cardano at length and in detail, he turned off poetry on noteworthy heroes including himself, and he exchanged poisonous epigrams with his literary contemporaries. He ministered to the sick and gave instruction in the arts of medicine to well-qualified applicants who agreed, in writing, not to enter into competition with him at Agen. His son remembered that he was always the center of lively professional gatherings:

> Vidi Aginni medicos quorum potior pars eo convenerat ut doctissimi patris Julii Scaligeri colloquio fruetur, seque ei in disciplinam traderet, non ut medicinam faceret; ex eaque urbe plurimi celebres medici tanquam jugi fonte scaturierunt per universam Galliam hac illac sparsi.[41]

> I saw at Agen doctors, most of whom had come there simply to enjoy the conversation of my deeply learned father Julius Scaliger and learn his skills—not to practise medicine at all; and many celebrated doctors left that town like waters from a fountainhead, to spread here and there all across France.

Meanwhile, in his personal affairs, things went passing well. A violent temper, a quick, sharp tongue, a heavy hand, and a long sword gave strange but sudden law to the good bourgeois of Agen. They trembled before the martial figure of Julius Caesar and melted like so many of their favorite prunes under the poisonous distillations of his Latin contempt. His physical powers were not to be despised. He vaulted into and out of hogsheads, he lifted beams, he trailed the puissant pike, and exercised at thrust and parry, while expressing himself with loud disdain on the topic of provincials. He never had much use for the Agennais; his first visit to the town was made, says his son, only on condition that he could leave after a week—what could he have in common "cum ea gente, cum quâ ne unum quidem diem vivere possit" [42] (these people that he couldn't endure a single day)? But, after all, circumstances changed his determination; he settled among them, no doubt more to his own ease than to that of

[41] *Scaligerana*, p. 10.

[42] J. J. Scaliger, "Epistola de vetustate et splendore gentis Scaligerae, et J. C. Scaligeri vita," ep. 1 in *Josephi Scaligeri . . . epistolae* (Lugd. Bat., 1627), p. 39.

his neighbors, and made himself a man of European reputation before the local burghers had recovered from their first impression of him as a broken Italian swordsman. In due course, he picked up their strange Midi dialect, i.e., Gascon, which he added to his other languages—French, Latin, demotic as well as classical Greek, Arabic, Sclavonic, Italian, and Spanish—to such good effect "ut non potueris cognoscere, num extraneus fuisset" [43] (you couldn't tell him from a local). He might live among clods and bumpkins, but Julius Caesar Scaliger would not be found stumbling and fumbling in the marketplace for the dialect current among the tribe.

He triumphed even more intimately over the self-esteem of his reluctant hosts by marrying the loveliest girl in the entire countryside of the Languedoc. A middle-aged Prince Charming, his courtly manners and soldierly bearing captured an exquisite child of rank and fortune, fatherless but well supplied with guardians, protectors, suppliant suitors, and supporters. The legend of her beauty lingered for many years in the land. In 1529 Julius Caesar overcame the objections of her guardians, scornfully rejected the proffer of a dowry, and carried the young lady off to be his bride—to the dismay and disgrace of Lord knows how many local squirelings, merchant princelets, and popinjay pretenders to her hand. Her name, charming in itself, was Andiette de Roques-Lobejac, she was a distant connection of the house of Rochepozay; her age was sixteen, her husband's age forty-five; and everything indicates that they were ecstatically happy during the twenty-nine–year term of their marriage. Monkish learning provided him with a rich store of invective adjectives for use against women: "insida, suspicax, inconstans, insidiosa, simulatrix, superstitiosa, cui si potentia adiuncta est, fit intolerabilis" [44] (treacherous, suspicious, fickle, sneaky, artful, superstitious, and if you give her any authority, she's unbearable). But though every so often he rumbled through them, it was as an academic exercise, not a personal complaint. (A more authentic, though muffled, echo of domestic discussion resounds through Julius Caesar's straight-faced tribute to his wife—that if she had been a man, she would have made a wonder-

[43] *Scaligerana*, p. 239.
[44] *Poetices . . . libri septem* (Heidelberg, 1607), 3. 13.

ful lawyer, and won many bad cases.) [45] In any event, his youthful wife can scarcely have had time or energy for all the female vices that her husband could enumerate, since she proceeded to bear him no fewer than fifteen children. Of this numerous breed the tenth was Joseph Justus, the greatest classical scholar of his (or, some may argue, of any) age.

Our authority for much of the life of Julius Caesar Scaliger is the *Vita* written by his most famous son, supplemented by the continual drumfire of allusions to his father that runs through Joseph's collected conversations.[46] These *Scaligerana* (sometimes numbered I and II but generally conflated in later editions) were collected respectively by François Vertunien, Sieur de Lavau (a doctor from Poitiers), and by Jean and Nicolas de Vassan, sons of Perette Pithou and nephews of Pierre and François Pithou. They are in essence the table talk of a scholar, soldier, and man of the world, who leaped as casually and adroitly from French to Latin to Greek or Hebrew as from political scandal to biblical criticism to the *curiosa* of ancient civilizations. But the recurrent thread is of admiration, of almost superstitious reverence, for the memory of his father.

It is altogether fitting that Julius Caesar should survive so largely through the records and recollections of his son. We aren't even sure of the real name of Julius Caesar's father; ancestry he took very seriously indeed, but the first step toward ancestors is a father, and there, immediately, we encounter a mystery. On any level except the literally genealogical, this hardly matters. Julius Caesar was such an overpowering father himself that he could perfectly well have been, and in some sense was, father to himself, as well as to all those children, and some others whom we shall see. He was always playing the Roman *paterfamilias*, setting forth the familiar virtues of temperance, fortitude, magnanimity. Even when he was quarreling with Cardano,

[45] *Scaligerana*, pp. 360–361.
[46] Jakob Bernays wrote a perfunctory formal biography of Joseph Scaliger (Berlin, 1855); in 1950, Vernon Hall, Jr., did a much ampler biography of Julius Scaliger, published in *American Philosophical Society Transactions*, ser. 2, vol. 40, part 2. At his death Mark Pattison left in the Bodleian a major collection of materials toward a life of Joseph Scaliger, but the biography (like that of Casaubon, with which Pattison coupled it) was never written.

whose vast book *De subtilitate* he undertook to correct in an even more
stupendous volume, *Exotericarum exercitationum liber xv,* his lectures
were tinged with worldly experience, lordly authority, the kind of
wide assurance that comes from knowing Life as well as Mere Books.
"Soli indocti Grammatici vinum bibunt lymphaticum" [47] (Only
illiterate grammarians drink their wine with water in it), he will say,
dismissing an uncongenial argument with a sharp slap at his oppo-
nent's naïveté. Sometimes he lectures querulous and hypochondriac
Cardano on topics about which he could hardly have learned by
reading Duns Scotus: "Amantes, amantes visu fiunt. . . . In tactu
voluptas non maxima, quandoque dolor maximus. Etenim qui puel-
lam tangit, eius non manus sed mens afficitur voluptate" [48] (Lovers
fall in love through the eye. . . . The sense of touch doesn't yield
the greatest pleasure, though it is the medium of the greatest pain.
For when a man touches a girl, it isn't his hand but his mind that
experiences pleasure). The same trenchant, soldierly spirit breathes
through all his work. Cardano, being merely book-learned, might
bend a credulous ear toward those who proposed that the glare of a
wolf can strike men dumb; Julius Caesar Scaliger had looked many
a wolf in the eye:

> Utinam tot ferulis castigarentur mendaciorum assertores isti: quot
> a lupis visi sumus nos, sine iactura vocis. . . . Tantum abest ut
> obmutuerimus, ut magnis clamoribus primo perterritum compuleri-
> mus ad fugam: mox insequuti praedam, licet sine vita, abstuleri-
> mus.[49]

> I wish all those liars could be beaten with as many rods as we've
> encountered wolves without any loss of voice. . . . far from turn-
> ing mute, we roared aloud to drive them away, then followed them
> and carried off the spoils, leaving them lifeless behind.

And what was good enough for wolves was good enough for other
scholars; polemic was a natural mode for a man of this temper:

[47] *Exotericarum exercitationum liber xv,* Exerc. 101, sect. 4. Though the
book was first published in Lutetiae—Paris, 1557, I have used the more common
edition of Francofurti—Frankfort, 1612.

[48] *Ibid.,* Exerc. 298, s. 3. [49] *Ibid.,* Exerc. 344.

Ait Vives: tacitis meditationibus magis proficere nos, quam alterca-
tionibus. Quod verum non est. Etenim sicuti lapidum collisione: ita
ex disceptionibus elicitur veritas. Quin egometmecum saepe, diu,
multum nisi pugnem: infeliciter caedet mihi. A magistro igitur plus
excitamur. At adversarius sua vel pertinacia, vel sapientia, mihi
duplex magister est.[50]

Vives says we profit more by silent meditations than by disputes.
But that's not true. For just as [sparks] come from the striking of
flints, so truth comes from controversies. Indeed, often when I'm
by myself, I can hardly do anything for lack of a fight—it comes
out badly. We're more roused by a master. But an adversary,
through either his stubbornness or his wisdom, serves me as a double
master.

Cardano might strike forth sparks from the Scaligeran flint, and that
was good; but in other moods, Scaliger often found that the subtlety
of his own unaided thought (marked, in the margins of his *Exercita-
tiones*, by frequent hortatory annotations of "Subtil.," "Subtilliss."
and "Divina subtil.") left him beyond the reach of ordinary mortals:

Non ignoro haec me mihi canere, & Musis. Namque ut à vulgo ab-
horrent: ita vulgus ab eis abhorrere par est. Sed gratissimus est calor,
qui me apud te doctissimum, sine controversia, virum exercet in
novis subtilitatibus.[51]

I'm not unaware that I create these [thoughts] only for myself and
the Muses. For as they despise the common herd, it's only natural
that the herd should despise them. But I welcome the warmth that's
found in opposing you [Cardano], most learned of men beyond all
controversy, in the search for new subtleties.

Perhaps as relaxation from these eagle contemplations, perhaps from
exuberant overplus of paternal feeling, he surrounded himself with
disciples; and though his wife's o'erteeming loins might almost have
kept his classroom stocked with pupils, he brought in numbers of
congenial outsiders, whom he quickly adopted, in metaphor if not in
fact, under the generic title of "sons." Marc Antony Muret (later the
most eminent of Latin stylists) was one of Scaliger's sons; being son

[50] *Ibid.*, Exerc. 308. [51] *Ibid.*, Exerc. 30.

to Julius Caesar, he was perforce brother to Joseph Justus, who specifically recorded the fact: "Muretus me vocabat fratrem, quia Pater illum vocabat filium"[52] (Muret called me brother because my father called him son). Gervase Marsteller, first a doctor, then a bishop, was another; Arnoul le Ferron, later judge in Agen, was a third, and Gerard-Marie Imbert, poet and humanist, a fourth. Scaliger's relations with his sons, though founded on strict scholarship, were never cold or austerely intellectual. How often did he tell Joseph Justus, as the latter was fond of recalling, "je voudrois que vous fussiez plus docte que moy"[53] (I wish you were more learned than I). It was affectionate emulation that he tried to promote; and all sorts of growls about the degeneracy of modern learning, the laziness of modern readers, and the carelessness of modern authors were apt to subside abruptly in the presence of a genuine talent. A letter to Gervase Marsteller is generously addressed, "I. C. Scaliger suavissimo, doctissimo, optimo Gervasio Marstallero Medico Brunsuicensi. Pater filio. S.P.D." and concludes "Te etiam atque etiam, tuasque divinas manus tam chare scribentes exosculor, mi fili. Vale."[54] (Julius Caesar Scaliger to the kindest, most learned, best-hearted Gervase Marsteller, doctor in Brunswick. A father to his son sends best greetings [S.P.D. abbreviates *salutem plurimam dicit*]. . . . Again and again I kiss you and your sacred hands [in gratitude] for your dear letter, my son. Farewell.) Crusty as he was, there was something besides crust in old Scaliger.

Not only those whom he could teach, but men from whom he could learn, were compounded into the household of Julius Caesar Scaliger. His son Joseph reports that

> Pater Jul. Scaliger secum duos excellentes Mathematicos, Lucam Guarisum & Petrum Pomponatium [Pomponazzi, namesake of the philosopher] domi aluit & fovit, ut Mathematicas artes addisceret. Hi, omnes illius tempestatis in suâ arte longe intervallo superabant. Praeter duos illos qui opera sua ediderunt in lucem, habuit etiam

[52] *Scaligerana*, p. 276.
[53] *Ibid.*, p. 355.
[54] *Epistolae aliquot nunc primum vulgatae* (Tolosae—Toulouse, 1620), ep. 18.

Joannem Jocundum Veronensem qui illum prima matheseos elementa domi docuit.[55]

My father Julius Scaliger kept in his household two excellent mathematicians, Lucas Guarisus and Pietro Pomponazzi, so that he could learn from them the arts of mathematics. These men knew a great deal more about their art than anyone else in those bad times. Besides these two men, who prepared his works for publication, he also had John Jocundus of Verona, who taught him the first elements of mathematics in his household.

Energy and authority were the first principles of his life. Forty years after his death, Julius Caesar was still the favorite conversational topic of his son Joseph Justus; and it is always vigor and decision that he emphasizes. He was never out for cheap triumphs or mere vulgar display of knowledge; having collected twenty volumes of material for a botanical discourse, and overcome the major handicap of gout in order to learn painting and so represent his plants truly, he found that some other man had published first, and destroyed the greater part of his own collections as redundant.[56] Consulted by Benedetto Manzuolo about a puzzling passage in Theophrastus, he offered an impromptu emendation so apt, so satisfying, so subtle, as to prompt the thought that he must have been assisted by a familiar spirit.[57]

As one would expect, he had no great opinion of his own time, thought modern authors likely to be pretentious and flashy, but spoke out also against superstitious reverence for the ancients. His son retained a sharp sense of the difference between easy popularity and permanent merit: "Guersens," he would say for example, in that patchwork of languages which characterized his casual conversation, "est un excellent homme pour vivre entre les hommes du present, mais non pour l'avenir. Nihil enim facit aeternâ dignum luce" [58] (Guersens is a good enough man to live among present-day people, but not for the future. He does nothing worthy of perpetual light). No mawkish modesty withheld him from applying the standard of eternity to others and laying claim to it himself. It was a long sharp

[55] *Scaligerana*, p. 259.
[56] *Ibid.*, p. 359.
[57] de Thou, *Perroniana et Thuana*, p. 361.
[58] *Scaligerana*, p. 180.

lance that he brandished in the grinning faces of ignorance, sloth, and vice; he had a soldier's confidence in its efficacy:

> Les diables ne s'addressent qu'aux foibles [Joseph Justus used to say], ils n'auraient garde de s'addresser à moi, je les tuerois tous: apparroissent aux sorciers en boucs. . . . Dicitur Diabolus hirci formam accipere, non ederem ex hirco propterea. Genevae qui dederit se se Diabolo, statim comburitur. Pater Diabolum non timebat, nec ego timeo. Ego sum pejor diabolo, nunquam vidi ullum spectrum. Dicebat Diabolum non audere ipsum accedere.[59]

> Devils don't bother anybody but weaklings; they wouldn't dare appear before me, I'd kill them all: they appear to sorcerers in the shape of goats. . . . The devil is said to appear in the shape of a goat, that's why I won't eat goat's meat. At Geneva anyone who gave himself to the devil was burned on the spot. My father wasn't afraid of the devil, neither am I. I'm worse than any devil; I never saw a ghost. He used to say the devil wouldn't dare to approach him.

In the theological warfare that racked the sixteenth century, Julius Caesar seems to have remained at least nominally within the Catholic fold; but in his last years he took little part in either the physical or verbal clashes. His son Joseph, on the other hand, was active in both, and on the Protestant side, explaining that his father too in his last years had been moving toward the Protestant position, above all in his loathing for the Jesuits. But in fact, both were more scholars than Christians; Joseph's interest in the afterlife was almost spectacularly limited to the simple circumstance of the Resurrection —as if God, faced with the naked spirit of a Scaliger, could only have hesitated over his verdict in order to question whether He had the right to make it at all:

> Ego non curo quidquam, nisi resurrectionem; sepulchrum non curo; ubi sepeliar non interest. Cum moriar, meum corpus erit ut asini corpus.[60]

> I don't care about anything except the resurrection; I don't care about my grave; where they bury me is of no concern. When I'm dead my corpse will be just like an ass's.

[59] *Ibid.*, p. 123. [60] *Ibid.*, p. 360.

Nisi resurrectionem! that's driving right at the heart of the matter. The speaker of that sentence might be Catholic or Protestant, but the style of his sentence showed that he was a terse, authentic Scaliger.

To fear God, to hate the devil, and to cultivate good letters: these three articles made up a creed as succinct as, and not much less noble than, that of the ancient Persians. Joseph Justus had a strong feeling for the inseparability of these articles:

> Numquam Poesis aut Poetarum amor in abjectum & humilem animum cadit, & omnium maximè divina sequitur ingenia eorumque perpetuus ferè comes. Jamais homme ne fut Poëte, ou aima la lecture des Poëtes, qui n'eust le coeur assis en bon lieu.[61]

His own talents he assessed with a humility verging on arrogance:

> Je me connois en trois choses, non in aliis, in vino, poësi, & juger les personnes. Si bis hominem alloquar, statim scio qualis sit.[62]

> Love of poets and poetry is never found in a humble or abject soul; the man who follows divine thoughts is generally their constant companion. There never was a man who loved poets or the reading of poetry who didn't have his heart in the right place. . . .

> I know my business in just three things, no others; in wine, poetry, and people. If I talk twice with a man, I know what sort he is.

In all areas of comportment, whether great or small, Julius Caesar stood as a model and a standard for his son Joseph Justus. Though the father lived to seventy-four and the son to sixty-nine, "Messieurs de l'Escale Pere & fils ne se sont point servis de lunettes" [63] (the Scaligers, father and son, never made use of glasses). Though afflicted with gout, Julius Caesar maintained throughout life a military posture: "feu mon Pere marchait si droit, & cependant estoit goutteux: nous avons cela de race, de marcher debout" [64] (my late father stood erect, despite his gout: that's our inheritance, to stand erect). In fact, the son found it unbearably constraining to bend or stoop—"je ne me sçaurois courber, je m'estranglerois. Encore que je me panche,

[61] *Ibid.*, p. 318.
[62] *Ibid.*, p. 360.
[63] *Ibid.*, p. 354.
[64] *Ibid.*, p. 359.

c'est tout le corps ensemble, non la teste seulement ou les espaules" [65] (I wouldn't know how to stoop over, I'd strangle myself. Even when I bow, it's with my whole body, not just head and shoulders). His rigidity on the point, and on others even more trifling, was altogether spectacular. "Mon Pere ne tailloit point ses plumes, on les lui tailloit, je ne sçaurois bien tailler les miennes" [66] (My father never trimmed his own pens, someone did it for him, I wouldn't know how to do mine). The physical resemblance was something that the son, in his old age, was apt to insist on with almost comic vehemence:

> Mon Pere estoit honoré et respecté de tous ces Messieurs de la Cour. Il estoit plus craint qu'aymé à Agen; il avait une autorité, majesté, et representation, il estoit terrible, & crioit tellement qu'ils le craignaient tous. Auratus dicebat Julium Caesarem Scaligerum Regi alicui facie similem. Ouy a un Empereur. Il n'y a Roy, ny Empereur, qui eust si belle façon que lui: Regardez moi, je lui ressemble en tout, & par tout, le nez aquilin.[67]

> My father was honored and respected by all those gentry at the Court. In Agen they feared him more than they liked him; he had an authority, a majesty and presence, he was terrible, and roared so loud they were all afraid. Auratus used to say Julius Caesar Scaliger had the features of a king. Yes, like an Emperor. There's no king or emperor who had a style like his: look at me, I resemble him in everything and everywhere, the aquiline nose.

The blood lines of the Scaligers, according to Joseph Justus, could be read in their faces as well as in genealogical charts; he loved to talk of both: "Descendimus ex Filia Leopoldi Comitis Hapsburgensis, quae nupsit cuidam Scaligero, Atavorum nostrorum uni. Patrem meum ita petunt regium virum, ex sola facie poterat nosci descendisse ex Principibus" [68] (We descend from a daughter of Leopold, Count of Hapsburg, who married a Scaliger, one of my ancestors. So my father was thought a kingly man; just by looking at him you could tell he was descended from princes). Not, to be sure, that one couldn't, after all these years of doubt and argumentation, disdain

[65] *Ibid.*
[66] *Ibid.*, p. 358.
[67] *Ibid.*, p. 357.
[68] *Ibid.*, p. 359.

even one's own much claimed, much disputed blue blood: "Mea
nobilitas est mihi dedecori. J'aymerois mieux estre fils de Vander-Vec
Marchand, j'aurais des escus. On ne croit pas qu'un Prince puisse
devenir à estre pauvre." [69] (My noble blood is irksome to me. I'd
rather be a son of Vander Vec the merchant, I'd have some money
then. Nobody believes that a prince can possibly be poor.)

Even in the dismal matter of his own death, Julius Caesar was
peremptory and soldierly; for he "disait tousjours devoir mourir au
mois d'octobre, *quod factum fuit*" [70] (always said he was bound to
die in the month of October, and brought it off). Years after the
melancholy event Joseph recalled that the death of his father so
afflicted him that he could not eat for eighteen successive days. And
it was with almost clinical impersonality that he reported the effect
of this fast on his organism: though his bowels had always previously
been free and open, they were henceforth constricted, and in his
dreams he was perpetually confronted with rivers and bodies of wa-
ter.[71] The capacity to stand apart from his own behavior and to ob-
serve it without false dignity or false humility was evidently a trait
that Joseph learned from his father Julius Caesar.

The public career of Julius Caesar Scaliger is a matter of public
record, which this essay has no occasion to describe in detail. In
medicine, in philology, in literary criticism, he staked out his posi-
tions and fortified them with logic, erudition, and invective. In a
series of brisk engagements with Erasmus and Dolet he laid down,
by precept and example, the principles of Latin style as he under-
stood them; and in disputations with Rabelais and Cardano he
ranged across the fields of his encyclopedic erudition, correcting, re-
fining, rebuking, reinterpreting, and adding new errors to the sum of
human opinion. "Mon Père," his son says simply, "vouloit escrire de
tout." [72] His energy was volcanic, his opinions perfectly decisive; he
stormed Parnassus like a rebel fortress, superbly confident that there
were no obstacles that a bold front, sturdy common sense, and un-
limited industry could not reduce. Among the modern poets, he was
particularly fond of those who seemed born to assert, to command;

[69] *Ibid.*, p. 358. [71] *Ibid.*, pp. 352–353.
[70] *Ibid.*, p. 354. [72] *Ibid.*, p. 356.

he liked Poliziano, for instance, and said of him "que c'est le premier de son temps qui a osé lever le nez au Ciel pour les lettres" [73] (the first man of his age who had the guts to stand up for literature). His Latin *Poemata*, the offspring of his idle hours, amount to nearly a thousand pages; to their quality it is not so easy to assign a figure, for his Latin dialect is frequently knotty, and his temperament largely precluded the exercise of imaginative delicacy. Still, a thousand pages of Latin verse represent a monument of sorts, irrespective of quality. Conscious of his own fantastic powers, Julius Caesar regularly exaggerated them, and said, for example, that he had produced his book against Cardano in a mere two months. To anyone who will look at the book itself (some 450,000 words on an extravagant range of learned topics), the impossibility of this statement is obvious. In fact, Scaliger's book appeared in 1557, six years after Cardano's; his loyal son says Scaliger answered Cardano's sixth edition,[74] but this is a dark point to determine, since his references to Cardano's book are consistently, perhaps willfully, imprecise. Yet such lofty disdain is thoroughly typical of the man and of his imperial condescension to the limits of mere humanity. Was the namesake of Julius Caesar to exercise his full energies for more than a short while on the conquest of a single simple Italian physician, and a bastard at that? Having condescended to exercise his superhuman powers, however briefly, against Cardano, could his triumph be anything but cataclysmic? Evidently not. Scaliger surveyed the circumstances of the conflict, deduced from them the appropriate effect, and announced it to the world with a flourish as a *fait accompli*. Struck to the heart by the thunders of Scaliger's genius, mortified by a consciousness of his own wretchedly inadequate powers, and despairing over his ruined reputation, the miserable Cardano had perished; and in a generous oration, Scaliger paid lofty tribute to the sterling qualities of his fallen adversary.

This "oration" of Scaliger's on the supposed death of Cardano (it has sometimes been called a preface to a new edition or extra volume of the *Exercitationes*) has generally been taken as a piece of grotesque absurdity growing out of its author's insufferable ego-

[73] *Ibid.*, p. 319. [74] *Ibid.*, p. 357.

tism. At best, it has been defended as a dumb but honest blunder, to be excused, if at all, only by the badness of communications in the sixteenth century. But it has as well some of the marks of a consciously humorous performance. Not only the literary world, says Scaliger, has been deprived of an incomparable man; but

> Ego etsi priuatus sum & teste & iudice, atque etiam (proh dij immortales) laudatore lucubrationum mearum: eas enim ita approbauit, ut spem omnem defensionis suae in declinatione sola posuerit, in desperatione potentiae suae, in suarum virium ignoratione.

> I particularly am deprived both of a witness and a judge and even (by the immortal gods) of a panegyrist of my lucubrations; for he so approved of them that he placed all his hope of defense in this avoidance, in despair of his power, in ignorance of his strength.[75]

No sleepy victory for Scaliger, no triumph by default or abandonment; he wants to lead his antagonist in triumph through the city, and laments the loss to his reputation that so impressive a captive has taken the easy way out. There is no merit attached to a shameful peace, a back-door desertion of the cause; who would not have preferred a frank and manly admission of defeat, such as one must have anticipated from the great Cardano? Indeed, Scaliger considers it probable that he might "with extremely modest approbation (*modestissimis assensionibus*) have acknowledged me as his preceptor, his father";[76] and he considers this beautiful friendship the more probable since (given the earlier agitation of Cardano's mind) an attempt to dispute an impossible cause might have brought Cardano still closer to insanity. So he must necessarily have been grateful to Scaliger, had he lived. One has to be pretty literal minded not to sense here the keen edge of personal satire. The mixture of praise and bluster is purely epic (the speech of Achilles over dead Hector), but the vein is burlesque.

Indeed, Scaliger's Latin is a rough enough instrument so that one cannot easily tell when he is striving for a satiric nuance. But

[75] *Epistolae aliquot,* pp. 63–66. Also reprinted (in the Morley translation) by Hall, "Life of Julius Caesar Scaliger," pp. 142–143.
[76] *Ibid.*

there are in the "Judgment of Cardano" certain obvious verbal in-
congruities. "The bitterness of my destiny favors me so ill" (*mei fati
saeuitia tam misere mihi fauit*) says the first sentence; where the ex-
pression "misere mihi fauit" carries a secondary overtone of "favors
me to excess." And elsewhere Scaliger attributes to Cardano "a kingly
mildness, a popular elevation of mind" (*lenitas regia, celsitudo animi
popularis*) where it seems clear the epithets are deliberately reversed,
with satiric intent.[77] One wouldn't, it's conceded, think Scaliger's
"Judgment" a hilarious piece of writing simply on the score of these
verbal twists; but they are not easy to explain if the "oration" is any-
thing other than a burlesque performance. Burlesque was by no
means beyond the range of Scaliger's feeling: he was, after all, the
acquaintance and contemporary of a certain Master François Rabe-
lais, and a burlesque fragment of his composition, an oration in praise
of the goose, survives in a little book of *Dissertationum Ludicrarum
& Amoenitatum* put together at Leyden (Lugd. Bat.) in 1638. Com-
pared with Pirckheimer's "Apology for the Gout," Passerati's "En-
comium of an Ass," and the "Peripatetic Wedding" of Gaspar Bar-
laeus, Scaliger's joke is at least short.

Certainly if his judgment of Cardano was a joke, this joke would
have been characteristic of Julius Caesar Scaliger's rough, soldierly
temper. Swift, one recalls, was later to apply much the same cruel
plaster to the pretensions of the almanac-maker Partridge. On an-
other level too, it is possible that the "oration" implied a character-
istically Scaligeran declaration of independence from history and
from the tyranny of vulgar fact. Having chosen to inhabit this world
as the Prince of Verona, he would conclude his career with a chivalric
triumph in the lists of scholarship; and if it had to be imaginary, at
least it would be smashing. This does not seem inconsistent with the
general style of his life: Scaliger's combination of romantic dreams
with a tone of solid, pedantic realism somehow reminds one of
Mantegna, with his faces mysteriously hidden in cloud formations far
above the action of figures almost sculpturally solid. In any event,
history, with her familiar insistence on having the last word, records
that Cardano died at Rome on the 21st of September, 1576—eight-
een years, lacking a single month, after Scaliger, and surely with no

77 *Ibid.*

sense that Scaliger's *Exercitationes* had hastened his demise. If anything, the joke went the other way—Scaliger himself died the year after his *Exercitationes* were published—of over-exercitation, Cardano might have said.

Julius Caesar was thus a man of a double nature. Few who have looked into his career and his works have failed to be struck by the realism and detailed particularity of his knowledge; few have failed to note the magnitude of his heroic delusions. His encyclopedic knowledge was a massive tool in the hands of his sublime arrogance. Yet just because he used ideas as weapons, and remained always so deeply involved with the issues of his times, Scaliger wrote nothing that retains the fragrance of life today. His work seems hard, dry, dusty. One cannot pick up that immense volume of poems without a certain sinking of the heart; his natural philosophy has passed beyond absurdity and become simply quaint; his poetics, never translated as a whole into any modern language,[78] are rarely consulted, even by historians of criticism. The broad outlines of Scaliger's critical position are known, of course; for he was an influential figure, and one cannot suppose that he did not exist. He is remembered therefore as the man who categorically preferred Virgil to Homer; as a critic who made moral utility the prime criterion of literary merit; as the exponent of a notably literal concept of verisimilitude on the stage. All these elements of literary opinion might perfectly well be the work of a blindly bigoted, pedantic theorist; and actually, it is under some such image as this that the name of the elder Scaliger has, in a small and dusty way, survived. Rare indeed is the later student who, like Professor Saintsbury, has had both the energy to discover, and the generosity to recognize in Scaliger an unusual erudition, an occasional gift for ungainly academic comedy, and a broad vein of vigorous good sense.[79]

For nothing is more impressive, in the critical deportment of Julius Caesar Scaliger, than the way in which, after an extended passage of polemical hacking and counterhacking in the underbrush, he

[78] A joint project for translating the *Poetices* into English has recently been launched in Los Angeles: good heart to its movers!

[79] George Saintsbury, *History of Criticism* (New York, 1902), Vol. II, chap. 3.

will suddenly break into the clear (like Coleridge), and give us a perspective on his topic. The greater part of that thoroughly forbidding first chapter of the *Poetices* is devoted to logical exercises concerning the categories, and to upholding against Quintilian the proposition that these categories all aim to persuade. The orator, the philosopher, the councillor, and the historian all aim to convince, and are thus dependent, for their fulfillment, on an action within the mind of the hearer. But, Scaliger suddenly concludes, bursting into the open for his final statement, poetry is altogether different:

> Sola poesis haec omnia complexa est, tanto quam artes illae excellentius, quod caeterae (ut dicebamus) res ipsas, uti sunt, repraesentant, veluti aurium pictura quadam. At poeta & naturam alteram, & fortunas plures etiam ac demum sese isthoc ipso perinde ac Deum alterum efficit. Nam quae omnium opifex condidit, eorum reliquae scientiae tanquam actores sunt. Poetica vero, quum & speciosius quae sunt, & quae non sunt, eorum speciem ponit: videtur sane res ipsas, non ut aliae, quasi Histrio, narrare, sed velut alter deus condere: unde cum eo commune nomen ipsi non a consensu hominum, sed a naturae providentia inditum videatur. Quod nomen Graeci sapientes ubi commodissime παρὰ τὸ ποιεῖν effinxissent: miror maiores nostros sibi tam iniquos fuisse: ut Factoris vocem, quae illam exprimeret, maluerint oleariorum cancellis circumscribere. Eum enim solun qui oleum facit, quum pro consuetudine caste, tum pro significatione stulte appellare licet.[80]

> Only poetry embraces all these arts, excelling them for just this reason, that they (as we were saying) represent things as they are, after the manner of an auditory picture. But the poet, just like another God, and by the very same process, creates another nature and varying circumstances and at last himself. For in handling the creations of the Almighty, the other sciences are like reciters; but poetry, since it renders existing things more beautiful and gives to things which do not actually exist the appearance of doing so, seems not to describe the things themselves, like an actor (as the other sciences do), but to create them like another god. Hence a name which they share with God himself seems to have been conferred on poets, not so much by the consensus of mankind, as by the providence of nature. Which name (of "maker"), since the wise

[80] *Poetices* 1. 1.

Greeks created it very handily to describe the act of creation, I marvel that our ancestors were so unjust to themselves that they chose to limit the name of *Factor*, which means the same thing, to the sort of man who makes candles. For though it is allowed by custom to call a mere manufacturer of candles a maker, as far as the meaning of the words goes, it is stupid.

There can be little doubt that Sidney, in the *Defense of Poesy*, had this passage in mind when, after describing the subjection to nature of the astronomer, geometrician, philosopher, lawyer, grammarian, rhetorician, logician, physician, and metaphysician, he proclaimed the superiority to all these of the poet:

> Only the poet, disdaining to be tied to any such subjection, lifted up with the vigor of his own invention, doth grow, in effect, into another nature, in making things either better than nature bringeth forth, or, quite anew, forms such as never were in nature, as the heroes, demi-gods, cyclops, chimeras, furies and such like; so as he goeth hand in hand with nature, not enclosed within the narrow warrant of her gifts, but freely ranging within the zodiac of his own wit.[81]

It is not quite distinct, from the phrase "grow, in effect, into another nature," whether Sidney envisages the poet merely imagining another cosmos, or perhaps adding elements to this one, or (least radical of all) simply recombining familiar elements in unfamiliar patterns; or whether he actually envisages the poet becoming a new and different person. The mention of heroes, demi-gods, and so on militates against the more radical notion; yet, overpage, we learn that the poet can actually bring into existence men of a certain sort: "Which delivering forth, also, is not wholly imaginative, as we are wont to say by [of?] them that build castles in the air; but so far substantially it worketh, not only to make a Cyrus, which had been but a particular excellency, as nature might have done, but to bestow a Cyrus upon the world to make many Cyruses, if they will learn aright why and how that maker made him." [82] God Himself, a few lines later, is but the heavenly maker of a maker; and "nature" is starting to have multiple meanings so bewildering that Sidney's later phrase "second na-

[81] Sidney, *Defense of Poesy, ad. init.* [82] *Ibid.*

ture" could have reference to any of a half-dozen serried layers of reality.

The idea that the poet within / behind his work is like God within / behind the cosmos is one of the permanent commonplaces of Renaissance philosophy. But few of the followers of Julius Caesar Scaliger found occasion to insist on the doctrine that the poet creates, in addition to the cosmos, his own self. Either it was too obvious (if one creates an entire cosmos, one no doubt creates all the personalities within it), or else it was unnecessary (freedom to create a universe was enough; only special men felt the need to imitate God in the last act of his omnipotence, and make the maker.) In any event, given its revolutionary potential, Scaliger's doctrine of the poet's self-creation stirred surprisingly few echoes among his followers. So far as they accepted Scaliger's notion that the poet creates a substitute world, they saw it, like Sidney, as an argument for the poet's didactic at the expense of his mimetic function. (The historian imitates, and is tied to, particulars; the poet, freed from dependence on inconvenient and unedifying details, creates an ideal and therefore instructive world.) But Julius Caesar himself, whatever he meant by it in theoretical terms, is most unlikely to have overlooked the direct application of his critical creed to his personal history. It lay immediately to hand. He had created for himself a new world, varying circumstances ("fortunas plures"), and finally a new and different self. Actually, this notion of self-creation is not necessary for, and does not even accord very well with, conceptions of poetic creativity that Scaliger puts forward later in his treatise. He tells us, for example (*Poetices* 1.2), that poets may be divided according to their "spirit," as well as chronologically and by their chosen subject. This distinction according to "spirit," which he finds in both Aristotle and Plato, Scaliger develops into a distinction between inspirational poets like Homer, and those, like Horace, who work consciously (he thinks primarily of wine as a source of mundane inspiration) to sharpen their poetic techniques. But there is no notion that the poet who gets his inspiration from above can profit by developing a more efficient receiver-self, and no suggestion that the craftsman-poet may invent an artificial self as one of his tools.

Thus it appears that the idea of poetic self-creation never natu-

ralized itself in the critical theory of Julius Caesar Scaliger or of his successors. It was, however, firmly rooted in his personal thoughts and feelings. In the middle of an exercitation against poor Cardano, his thoughts revert to the connection between poetry and fatherhood as superior forms of creation:

> Accuratius Philosophi nostri. Nempe aiunt: Patrem gignere sibi univocum. Conditorem, & Fabricatorem ex partibus inventis, non ab se factis, construere totum aliquid, cui formam indat: qualis Carpenti, Navis, Aedium ποιητὴν vero, novum efficere ex iis, quae non extabant. Quare nomen hoc peculiare attribuerunt iis, quos etiam latinè Poetas appellamus.[83]

> (Our philosophers are more accurate. For they say: *father* is the only word for one who begets for himself. *Founder* or *fabricator* applies to one who constructs, out of parts that he has found, not made, some object to which he gives a form—a coach, a ship, buildings. But a *maker* makes something new out of materials that did not exist before. Therefore this special name is attributed to those whom, even in Latin, we call Poets.)

Or, as he begins a strikingly titled account of Latin grammar (*De causis linguae Latinae*), his thoughts will turn to the parallel between syntactical and natural law: "As nature is like an artist in relation to certain things which it forms (*molitur*), so the artist is like a nature in relation to those things which he presents (*figurat*)." It is useful to put this dictum against his repeated assertion that nature is the ordinary power or energy of God.

To be sure, Scaliger distinguishes largely: "Art does not make a living creature from what is not alive; but Nature generates," [84] or he will urge that only God creates in the sense of immediate constitution of substance from Nothing; what man does is to generate, transmute, alter. God's creation is done only outside time, man's work (however denominated) only within time.[85] But this is a kind of modesty of expression, a deference perfectly sincere no doubt but also perfectly conventional. Scaliger saw in the acts of human begetting, both imaginative and carnal, something more than a parallel to divine creation; he saw them as actual, intimate supplements to

[83] Exerc. 61, s. 3. [84] Exerc. 194, s. 3. [85] Exerc. 6, s. 14.

it.[86] One of his favorite themes (out of Aristotle) is that art and discipline (specifically, the liberal arts and scientific disciplines) are not properly contrasted with nature but should be joined to it: that they were suggested by nature, are complementary to nature, and yet lead (by a dialectical reversal offering no difficulties to a post-Hegelian generation) to a new nature. Shakespeare speaks in Scaliger's exact sense when he says that art amends and reforms nature, but "The art itself is nature." [87]

The notion that man may be a maker of himself is frequent in the poems, though not, it must be confessed, developed with any particular ingenuity. "Tibi vir esto" (Be a man to yourself) is the moral imperative that concludes his epigram on "Cultus virilis" (*Poemata*, p. 98); "Tui dominus esto" (Be master of yourself) is another of his injunctions (p. 134); and "Quisque Sui Faber" (Every man his own maker) is the title of a third (p. 127). About the poems themselves there is nothing whatever remarkable. They are two- or three-line moral apothegms, about as passionate and imaginative as the entries on a grocer's bill. Scaliger was not by temperament the sort of man who could give to self-creation the sort of golden glamor that attaches to the romantic doctrine of poetic masks. As a matter of fact, the figure in which he had been created by nature (that of an ambitious Italian swordsman mysteriously connected with a great house) was more "romantic" in our vulgar modern sense than that of the pedant and paterfamilias in whose likeness he created himself. But what he sought in Rome and perhaps in the figure of Julius Caesar, was authority, law, discipline—scarcely at all the freedom of

[86] Among the consequences of his view that nature is the ordinary form taken by God's spiritual energy is a readiness to take spiritual terms in a physical sense which would have raised the tonsure on a schoolman's head. "Quid aliud est Aeternitas quam continuata generatio?" (What else is Eternity but a continual generation?) he cries (*Poetices* 3. 101): and in a ringing passage to which an existential atheist could subscribe, he declares: "Naturae munus nihil aliud est, praeterquam esse. Esse vero & esse aliquid & esse bonum & esse unum & esse totum, idem est reipsa" (The gift of Nature is nothing else but being. To be and to be something and to be good and to be one and to be complete are all the same thing). To be sure, the context of this last passage is safely botanical; the quote occurs in a glossing of Theophrastus *De causis plantarum*, cap. 16.

[87] *Winter's Tale*, IV, iv, 96–97.

the mobile and uncommitted personality. His word did in effect become law: for two hundred years he dominated the critical theories of the Renaissance, and became, in the end, so potent an image that theories were attributed to him for which he was not in fact responsible. Until quite recently, the so-called "Aristotelian" unities of dramatic construction, which might much more properly have been called the "Castelvetran" unities, were known to French criticism, most improperly of all, as the "unités Scaligerennes."

That Scaliger was, like Mantegna, a man discontented with the self given him by nature, who called on Rome for a second, an artificial character structure, I take to need no emphasis. In both men it was a peremptory and authoritarian element of character that demanded the Roman leading; between natural nature and redeemed or Christian nature, they had little or nothing to choose, and gave themselves imaginative being in Rome, down to the election of a name. If what they did to create themselves a genealogy was not altogether convincing, at least they tried to provide themselves with militant, manly offspring, and with a law to guide them. Their kingdom was of the imagination, but it was not a refuge from everyday life, it enabled them to embrace and control the quotidian, even to joke with it. Let nature be as a mother, supplying *materia*, Rome a father supplying *forma*; Mantegna and Scaliger enjoyed the Oedipal audacities on a vast historical scale. Both appealed to that aspect of the Renaissance that was concerned primarily with law. Neither the one in theory nor the other in practice had much use for a purely mimetic art; the imperium to which they obey is one they created for themselves, even as they created the selves to inhabit it. Only the depth and abruptness of their transformations are remarkable. It was and long remained common enough to pick up a Roman property or association, as Petrarch had wanted to be crowned with Roman laurel on the Roman capitol, as Montaigne would travel to the city itself "pour obtenir le titre de citoyen romain." (He knew, characteristically, that "c'est un titre vein," but he wanted it anyway.) For Scaliger and Mantegna, the tensions were higher, the options more radical; the Roman experience wasn't a local episode or momentary attribute; it was a decisive act of personal elevation and alteration. It provided them with patents of nobility in a wider at-

mosphere than any to which they could have attained otherwise, and that atmosphere breathes through their work.

The hoop of self-transformation is one through which men of the Renaissance and since, in surprising numbers, have felt impelled to jump. They have brought to the act various moods and motives, from sullen imagination to ecstasy and madness. Ben Jonson was a strict Scaligeran of the first type in his surly, pedagogic correctness and militant rationality, as well as in his passion for sons adoptive as well as actual. Hölderlin, with his syncretic, visionary, all-absorbing religion, in which Christ mingled indissolubly with Dionysus and both were visually present to the hierophant, could be taken to represent the second type. Between these two extremes, and often at lower levels of spiritual tension, are found other aspirants to a classic paternity, for whom we may find other metaphors more appropriate.

III

KIDNAP

Self-creation and self-baptism are dramatic instances of rebirth in the image of Rome, made vivid by a change of name and a renunciation of one filiation or paternity as a preliminary to asserting another. Such acts, by their high-handed assertion of essence (and artificial essence, at that) against mere existence (routine becoming), bear witness to an abrupt and unexpected power of the human spirit over itself and its givens. In this imperial gesture of the imagination, toward a people not themselves famous by any means for fantasy, the stamp of Rome is invoked to give severe masculine form to the feminine plasticity of living potential. It is a manly and even a military ideal that animates the newly created images of Mantegna and Scaliger. One can think of it as an act of the revolutionary imagination that subjects all future imaginings to a deliberate and rigid law of its own.

But men could be kidnapped into Rome as well as reborn into it; and so could find themselves made mediators between a Roman ideal and a "first nature" they were not enthusiastic about giving up altogether. If Scaliger had met his young wife *before* he crossed the Alps, it's likely enough the streets of Agen would never have resounded to his martial bellow. Rome could sometimes provide a way up and out for those who wanted to polish and elevate what nature had provided, but not turn it in altogether. An outside impulse, not an inner option, might lead to a somewhat shallower redefinition,

where the imagination became not a substitute substance but a superimposed layer, a facade. In an opposite direction entirely, men could be kidnapped posthumously, and represented, after a life governed by the Roman ideal, as mere natural predators. The two tendencies, logically opposed, complement each other nicely when seen in a historical perspective. When Roman style had been successfully accommodated to the measure of the country squire and the provincial merchant, it was only natural that the last authentic exponent of Roman terribilità should be interpreted out of the Roman tradition altogether, as a brutal irruption of raw natural appetite. That he happened to be a Pope only added to the zest of the interpretive enterprise—for a certain sort of undertaker, anyhow. Our first scene is northern Italy, particularly those gentle hills and marshy flatlands between the Alps and the Adriatic, to which the Venetian Republic turned, with all its faded dreams of becoming a water counterpart of imperial Rome, after the loss in around 1500 of its lucrative oriental monopoly. The combination of a defeat and a counteroffensive disposes one from the beginning toward the idea of a compromise, or at least a balance of opposing forces, of which our chosen man may thus become the register.

The Persuasive Architect

Pietro della Gondola was the father's name; in official documents, it sometimes appears, via Latin translation, as "baretarius." He was a miller. The mother was known, it would seem, as "Marta zota," that is, "zoppa," or limping Martha. If she had a more formal name, nobody thought fit to record it. The birth took place at Padua, as now appears, on the 30th of November, 1508; this being Saint Andrew's day, it sufficed to give the boy his Christian name, Andrea.[1] They were very humble folk indeed, sons of the sea if not of the soil. The Gondola connection was rather fitful than otherwise, and the boy seems often to have been known simply as Andrea di Pietro, which would translate variously as Pete's Andy or Andrew Peterson. Being

[1] Roberto Pane, *Andrea Palladio* (Turin 1961), p. 17, with elaborate documentation; the "Regesto" prefixed to this handsome volume lays out the life and the documents pertaining to it in summary form admirable to be seen.

unremarkable in every way, he was indentured for six years at the age of thirteen to Bartolomeo Cavazza of Padua, who undertook to teach him the art of cutting stone. "You hold the chisel in your left hand, and hit it with the hammer in your right"—there's more to stone-cutting than that, but six years more? At the age of fifteen, Andrea evidently did not think so, for he ran away to Vicenza with his father Pietro until forced to come back and sign a new contract binding him to his apprenticeship for three more years. But that didn't take either; and within a year, he was back in Vicenza working as a stone-cutter and mason for a certain Giovanni da Porlezzo detto da Pede-muro, who we may fairly suppose thought him a valuable acquisition, because he paid a certain tax on his behalf.[2] Giovanni and his brother Girolamo da Pedemuro were plying a flourishing trade in the reconstruction of their native Vicenza. After many years of alternating and sometimes simultaneous war and pestilence, the town had finally found a small, semi-secure place in the uneasy peace that about 1530 started to spread across northern Italy, and Vicenzans who could afford it were embarking on a building boom. With the help of Pedemuro and his brother, our Andrea succeeded in asserting for himself a modest but altogether respectable role within this boom; under date of 29 March, 1530, a sober gravel-and-mortar contract refers to him as "magister Andreas baretarius Patavinus," and another of 11 February, 1533, calls him a "magistro lapicida," a master mason, or stonecutter. On 14 April, 1534, there is a document dealing with the dowry of Allegradonna, daughter of Marcantonio the carpenter, who has become the wife of "Andreae Petri lapicidae habitatoris in contrata Pedemuri." [3]

He is therefore established as Andrew son of Peter, born in Padua, working in Vicenza, married to Allegradonna, and father of a family of four sons (classically named, after the fashion of the Vicenza gentry, Silla, Leonida, Orazio, and Zenobia), when, early in 1538, we find him witnessing a contract between Gian Giorgio Trissino and a certain builder who was to be employed in the renovation of Trissino's villa just outside Vicenza, at Cricoli. On this job Andrea was evidently to be employed as a stonecutter and builder. But the job was not an ordinary one, nor were Andrea's relations with his employer to be the ordinary relations of contractor and client. Tris-

[2] *Ibid.* [3] *Ibid.*, p. 18.

sino was intent on enlarging his villa because he wanted to have an academy there. He was a man of independent means, a humanist, a poet, an antiquarian, a man of wide and general culture; he wanted to make of his villa a center of study and cultivation, where scholars, artists, and students of ancient Rome could foregather in easy and attractive surroundings for gracious talk. Trissino himself was engaged at the time on his large, learned epic, in unrhymed Italian pentameters, celebrating the deeds of his ancestors and the triumph of learning; *L'Italia liberata dai Goti* was its title, and it glorified the exploits of Belisarius and his army in an ambitious structure based on classic models and aiming at new standards of correctness.[4] For reasons about which we can only speculate, Trissino saw something besides an ordinary artisan in Andrea the master stonecutter, and in effect carried him off, family and all, into a more spacious world of literary-historical humanism. As "magister" he was already well beyond the canvas-apron and paper-cap stage of his profession, but Trissino put him to work on clasical texts, provided means for him to study Roman ruins and Roman doctrines of building, and finally conferred on him a new name and a new career. In *Italy Liberated from the Goths* there is an angelic messenger named "Palladio"; the name itself glances back to that statue of Athena, goddess of enlightenment and wisdom, which was the particular talisman of Athens. Andrea di Pietro became, about the age of thirty-two, Andrea Palladio; he ceased to be a "lapicida," and became, first a "scultore," and then (in a document of 2 June, 1545), takes final form as "Andreae Paladio q. Petri architectori." The "q." of course stands for "quondam" = formerly: he used to be the son of Peter, now he is Palladio, and nobody's son, unless it be Gian Giorgio Trissino's.[5] There is no reason whatever to suppose that he could or would ever have made such a leap under his own power.

[4] Whatever Trissino's intentions (doubtless of the highest), *L'Italia liberata* is not really a model of epic correctness. By Book III, a powerful emetic has been administered to the passionate heroine Sofia to save her from suicide by poison (she thought her lover Giustino had drowned, but he hadn't). Meanwhile, the Empress Theodora, in spectacular imperial finery, has coupled abruptly and vigorously with her husband Justinian on the lawn of a private garden. Homer provides precedent of a sort for the latter episode (*Iliad* 14), but not for the former.

[5] Pane, *Andrea Palladio*, p. 20.

Palladio, of course, made good for his adventurous patron beyond all the wildest dreams of the most optimistic adopter. He became one of the most widely influential architects ever to practice the craft; his office was crowded, almost from the first, with commissions for villas, town houses, and churches. He rebuilt almost single-handedly the city of Vicenza as it now stands; and two of the most splendid churches of Venice, San Giorgio and the Redentore, are his work. Beyond the relatively limited area of northern Italy where he actually built in bricks and mortar, his influence spread throughout Europe, carried by disciples and imitators, and even more decisively by his books. For it was an important part of Palladio's new style that it could be and was conveyed by means of woodcuts, diagrams, mathematical formulas, and printed words, as the art of Michelangelo and Bernini never was and could not conceivably have been. Actually, Palladio was more successful as a creator of books than of buildings. A succession of Vicenza clients ran out of money after he had erected splendid facades for them; but all three of his books were completed, and all three were spectacular successes. A guidebook to the Roman antiquities, composed during his fifth journey to the Holy City in 1554, immediately replaced the centuries-old and fabulously inaccurate *Mirabilia urbis Romae*, to become the standard handbook for sixteenth-century sightseers. An edition of Caesar's *Commentaries*, with notes, preface, and cuts illustrating the Roman arts of war and fortification (1575) also became a standard. And then there were the *Quattro libri dell'Architectura*, founded on Vitruvius and published in Venice in 1570.[6]

In fact, it's not irrelevant to bear in mind, when we come to look at the actual work done by Palladio, that he was a fully formed craftsman if not a builder before he began his study of classical antiquity, that his archaeology found generous expression in literary (i.e., *paper*) forms, that the one thoroughly classical building of his

[6] The first sentence of the Proemio to the *Quattro libri* tells us that Palladio from the beginning "mi proposi per maestro e guida Vitruvio" (took as my master and guide Vitruvius): facsimile reproduction of 1570 edition by U. Hoepli (Milan, 1968). Professor Wittkower assures us that the book, in a different form, had been ready for press as early as 1555 (*Architectural Principles in the Age of Humanism* [London, 1952], p. 58 n. 1). Inigo Jones was busy translating it into English within fifty years after its publication, though his version did not appear in print till 1715.

making was a theater for an academy. In other words, he represents a marriage between learned fantasy and indigenous structural traditions. His actual building involves most often a skillful mixing and blending of elements, a binding together of diverse functions and qualities in a proportioned and dignified image of classical repose. Palladian taste represents humanism, not struggling with gritted teeth but harmonizing life easily and naturally, art walking hand in dignified hand with nature.

Persuasion was, and had to be, the mode of Palladio's existence. He worked in bricks and mortar, consequently in large sums of other people's money. (We don't often pause to realize how paperwork and authorship suddenly, during the Renaissance, made clever, articulate fellows almost the equal of men of property.) Palladio was not by native temperament, and could not by circumstance become, a gladiator like old Scaliger; nor could he shop around among competing princes of city-states for the patron who would give most while restricting least—as Mantegna had, to some extent, done. Palladio worked in the prudent, practical shade of a precursor, Alvise Cornaro, and he worked for provincial gentlemen. These gentlemen were by no means devoid either of culture or of dignity, but neither were they indifferent to considerations like economy and practicality. If he built primarily in bricks and stucco rather than stone, it wasn't because he did not know very well which were the more solid and permanent materials. It has indeed sometimes happened that there were architects who designed in lofty indifference to the client's interests and directions; if such there ever were, Palladio was not one of them. His own words reverberate with recollections of arguments, conferences, compromises:

> Io mi rendo sicuro, che appresso coloro, chi uideranno le sotto poste fabriche, e conoscono quanto sia difficil cosa lo introdurre una usanza nuova, massimamente di fabricare, della qual professione ciascuno si persuade saperne la parte sua, io sarò tenuto molto auenturato, hauendo ritrovato gentil-huomini di cosi nobile, e generoso animo, & excellente giudicio, c'habbiano creduto alle mie ragioni, e si siano partiti da quella inuecchiata usanza di fabricare senza gratia, e senza bellezza alcuna. . . .[7]

[7] *Quattro libri*, II, 3.

I'm confident that those who inspect the designs given below, and who know how hard it is to establish a new practice, especially in the art of building, where each man imagines he knows as much as the next fellow, I'll be thought very lucky in having found gentlemen of such noble and generous minds, and such excellent judgment, that they accepted my arguments, and left off that ancient, graceless way of building, without any elegance at all. . . .

His book persuades and ingratiates all the more effectively by virtue of the author's modest assurance that he knows his own business and can explain it in few words and clear diagrams; he rests on the solid foundations of Vitruvius and his own archaeological investigations, but he neither dogmatizes nor antiquarianizes in his proposals toward an art of building well. The best argument for a design is that the owner is pleased with it, and Palladio's sparse comments on his various inventions are devoted mostly to pointing up arrangements that have worked well—pragmatic adjustments and adaptations, not instances of archaeological authenticity. Reconciliation and diplomacy were evidently rooted in the character of a man who could gracefully allow himself, in his early thirties when he had been ten years married and established himself as a master in his craft, to be rebaptized by a generous patron and sent forth to carry the proud name of Palladio among the petty Vicenza gentry, without forgetting that he was also "Andreae q. Petri."

The splendid villa at Maser illustrates many of these Palladian principles of reconciliation. It stands on the first ridge of hills breaking the plain that stretches south toward Venice and the Adriatic, unbroken by any rise or undulation as far as the horizon. At its back rise the Alps. Palladio built the villa for Daniele and Marcantonio Barbaro, whose names are written large across the central facade. They were men of distinction in public affairs, and between them had been active in the callings of lawyer, diplomat, philosopher, editor and banker; Daniele rejoiced in the glorious title of "Patriarch of Aquila." As gentlemen farmers in Maser, their desire was evidently for rural space, air, dignity—a natural impulse for men whose business life had been spent perforce in the cramped alleys and footwalks of Venice. At Maser they were not building in any degree for defense; on the contrary, the villa lies wide open to the landscape,

withdrawn a bit behind its open lawns and terraces, but accessible from all directions. The days were long past when a lord could expect to assemble his loyal thanes, pull up his drawbridge, lower his portcullis, and fight off barbarian hordes by dropping stones from the parapets. If there were any question of invading hordes, the brothers Barbaro could always retire to Venice. But such questions never crossed their minds, or Palladio's, when he designed Maser. The very situation chosen for the villa implied easy access, elevation without isolation. At the same time, what the brothers Barbaro wanted at Maser was not just a summer house or a play house. Palladio's villa was to be the main residence of distinguished people and their family, both intimate and extended; it was to be both the center of a working farm community, with access on every side to the sights and sounds of the country, and a nobleman's residence. A miniature village, it would both embrace and distinguish, asserting free access to the community along with a principle of order and degree within the community. The living quarters of the masters, though separate from and physically superior to those of the servants and farmers, would be in the same unified structure; the yards, especially those on the sides of the villa, could be either courtyards or barnyards. In the days before lawnmowers, it's probable enough that even the front lawns were kept trimmed by sheep. Nobody forgot that the nymphaeum, with its handsome, statue-surrounded pool by the side of which ladies and gentlemen could picturesquely promenade of an evening, would also be expected to provide fresh fish for the master's table; having served that useful turn, its waters passed by subterranean pipes into the kitchen and were led thence to irrigate the garden.[8] The arcades, which both link the dovecotes on either side to the central structure and subordinate them to it, could be, and apparently were, used to store carts and scythes and pitchforks, out of the weather but ready for use. Yet this is the front of the house, the head of the formal garden, the very place from which, in a strictly aristocratic structure like the Trianon, all vulgar agricultural implements and utilitarian machines were most strictly banished.

The theme of interlacing worlds, figures intruding and space extending beyond the actual walls, is carried out with particular wit

[8] *Ibid.*, II, 14.

and delicacy by Veronese's *trompe-l'oeil* frescoes which fill the villa
with playful gestures and invite the mind to adventure into unex-
pected dimensions of space. Doors and windows open abruptly in the
midst of solid walls; through them one glimpses a life beyond the
solid surface, or finds some representative of that life (a busy maid,
a solemn little girl) moving out of her dimension and peeping de-
lightedly into ours. Open windows with curtains aflutter lead the eye
out and into the treetops, where painted birds carry out the mythical
masquerade of the natural. A Shakespearean princess disguised as
a shepherdess disguised as the Queen of the May could wander
through these rooms, reflecting brightly and casually on the inter-
weaving of art and nature. Yet she would be in no danger of dis-
appearing into any sinister underbrush; the pattern of the house is
majestically simple, and from the spot where they cross, the two
axes of the house can be traversed by the eye from front to back and
side to side. The main hall is magnificent, even princely; the splendor
graduates down and radiates out toward the outskirts and down-
stairs of the villa.

So far as we can tell, no domestic architecture that the Romans
actually produced was very similar to the superb villa at Maser. The
town houses that we see at Pompeii or Herculaneum, or the imperial
dwellings of Rome itself, don't manage or for that matter attempt
the same thing. A single central area they might have for ceremonial
occasions, where the house put on its public face. But the living quar-
ters were generally a jumble, often a cramped jumble; and from the
outside the houses looked like forts. Public buildings were quite an-
other matter; but private houses and (so far as we can tell) country
villas were mere collections of rooms. And yet the villa at Maser is
profoundly Roman in feeling and inspiration, if not in details. The
massive simplicity of its plan owes a great deal to Roman temples;
and its low, weighty profile aims (above all when seen from the front
and below) at imperial dignity. But though strong from the outside,
Maser has its own airy, elusive ways of making nature accessible to
those on the inside. If Palladio was displeased with Veronese's
frescoes (as the scholars have recently speculated), it may have been
because Veronese was having the same sort of perspective fun with
Palladio's architecture (alternating solid realism with lucid, infinite

fantasy) that Palladio was having in his design with nature herself.[9]

Palladio did grander buildings than the villa at Maser and many more influential ones: before the age of the automobile, the Barbaro villa was too remote to attract many visitors. But it exemplifies as strikingly as any of his works the principle of harmony and reconciliation which rendered his neo-classicism so readily accessible. He thought architecture was an art founded on nature and in some respects still imitative of it (columns taper upward because trees do); he also thought nature must be methodized by the rules of nature itself, proportion and symmetry; he thought, most interestingly of all, that buildings should resemble the human body:

> Percioche si come nel corpo humano sono alcune parti nobili, e belle, & alcune più tosto ignobili, e brutte, che altramente, e ueggiamo nondimeno che quelle hanno di queste grandissimo bisogno, ne senza loro potrebbono stare; cosi ancho nelle fabriche deono essere alcune parti riguardeuoli, & honorate, & alcune meno eleganti: senza le quali però le sudette non potrebbono restar libere, & cosi perderebbono in parte della lor dignità, & bellezza. Ma si come Iddio Benedetto ha ordinati questi membri nostri, che i piu belli siano in luoghi piu esposti ad esser ueduti, & i meno honesti in luoghi nascosti; cosi ancor noi nel fabricare; collocheremo le parti principali, e riguardeuoli in luoghi scoperti, e le men belle in luoghi piu ascosi a gli occhi nostri che sia possibile: perche in quelle si riporranno tutte le brutezze della casa, e tutte quelle cose, che potessero dare impaccio, & in parte render brutte le parti piu belle. Però lo do che nella più bassa parte della fabrica, laquale io faccio alquanto sotterra; siano disposte le cantine, i magazini da legne, le dispense, le cucine, i tinelli, i luoghi da liscia, o bucata, i forni, e gli altri simili, che all'uso quotidiano sono necessarij. . . .[10]

Just as in the human body, some parts are noble and beautiful while others are more ignoble and ugly than otherwise (and yet

[9] There is a speculation that Veronese may have been influenced in his designs for Maser by the newly excavated frescoes of Nero's Domus Aurea in Rome; certainly the perspective fantasies of Roman wall paintings (though most of them have become known only since the sixteenth century) radically modify our sense of the Romans as a literal-minded and unimaginative people. Cf. Terisio Pignatti, "Paolo Veronese a Maser," *L'Arte Racconta* (Fabbri-Skira, no. 2).

[10] *Quattro libri*, II, 2.

we see the latter are very useful and necessary), so also in buildings —some parts should be dignified and honorable, while others are less elegant, even though without the latter the noble parts could not stand free and so would lose a good part of their dignity and beauty. But just as the Good Lord arranged these limbs of ours so the most handsome should be most visible and the least beautiful should be hidden from sight—so also we in our building. We'll put the principal parts, and the most imposing, in open view, and the least beautiful we'll hide as much as we can. Because in those we want to confine all the ugly things of the house, all those things that could make a mess and thus disfigure the noble parts of the house. That's why I arrange for the lower part of the structure which is a bit underground to contain the storerooms, woodboxes, pantries, kitchens, servant quarters, laundries, bathrooms, ovens, and all such things that are needed in everyday living. . . .

Taken at their face value, these are the merest commonplaces of arrangement. We put the furnaces, laundries, toilets in the bottom or back of the house, and the "social" rooms, however styled, up in front—well, of course. But on another level they provide a rationale for what is sometimes felt as an artifice of Palladian planning—the contrast between decorative facade and the strictly practical body of the house. Part of this contrast is factitious; Palladio's book presents the facades of his numerous inventions in considerable detail, but gives merely a geometrical outline, a diagram of the floor plan, and only at one level. From the floor plan one can scarcely tell which rooms are to be two stories high and which only one; from the diagram of Maser one gets no sense whatever that the central hall is to be a lofty, richly decorated, and brilliantly lit room. On the other hand, the town houses particularly leave the impression that the facade is one thing, the building behind it another—and that within rather generous limits, almost any facade could be attached to almost any combination of rooms. This is in fact true. Palladio's rooms are generally proportioned to one another and sometimes loosely related, as sequences along a corridor or successive enclosures; they aren't very often linked in a tight, dynamic economy. One reason may be that his gentry wanted their buildings to have an extremely loose fit. Several of Palladio's designs are in effect two

separate houses sharing a central court; he explains that the owner
and his ladies (his sisters, cousins, and aunts, evidently, as well as his
wife) will occupy one unit, and leave the other for guests. Or again,
he envisages a family occupying the relatively small southern-exposure
rooms of a house during the winter months, and moving to the more
spacious rooms along the northern exposure during the dog days.
Such was life among the Venetian provincial aristocracy of the six-
teenth century.

Palladian style in domestic architecture was easily diffusible, and
adapted to a broad range of domestic, public, and semi-public cir-
cumstances. Contant d'Ivry took Palladio's version of the Maison
Carrée at Nîmes as the basic inspiration for the Madeleine at Paris
and Cass Gilbert adapted it (by adding a couple of office wings) for
the Supreme Court Building in Washington. The Villa Rotonda,
which Palladio describes as standing on a "monticello" near Vicenza,
carried that name with it when Thomas Jefferson built a modified
replica in Charlottesville, Virginia.[11] Basilicas and palaces carried the
style, perhaps, a little beyond its natural middle or upper-middle
range. Blenheim Castle (done by Vanbrugh under Palladian inspira-
tion) and San Petronio at Bologna (for which Palladio himself
designed a multileveled facade, happily never built) were both too
weighty and pompous to be effective. On the other hand, a squire-
archy (whether in the home counties, or the hills around Dublin, or
in the plantation country of the Old South) found the proper
measure of dignity and artifice in the clear classic poise of a Palladian
manner. The sort of structure that Palladio envisaged as a Vicenza
gentleman's town house adapted nicely to use as the quarters of
a Mayfair club or as the central office of a bank. His architecture,
which showed from the beginning a genius for compromise, found
its natural orbit in the middle range of structures built for and by the
middle sort of people, as if the oligarchy of Venice had somehow
drawn a line across Palladio's imagination at the level of the

[11] Colonel Isaac Coles to General John H. Cocke, 23 Feb., 1816: "With
Mr. Jefferson I conversed at length on the subject of architecture. Palladio, he
said, 'was the Bible.' You should get it and stick close to it," quoted in *Thomas
Jefferson Architect*, ed. F. D. Nichols (New York, 1968), p. vii; see also, for
the tangled story of Monticello, pp. 22, ff.

merchant prince. It just isn't in the Palladian vein to stun, stupefy, or overwhelm; Versailles and Saint Peter's are out of his range altogether.

Circumstances might have been responsible for this option: it is not, after all, the lot of every architect to fall in with an imperial client. (Piranesi's wild imaginings outran all the possibilities of brick and mortar, but Palladio was first of all a builder, and trained to come to terms with money, clients, foundations, and engineering principles.) Two structures in particular confirm, even as they qualify, this upper limit of Palladian style. One is the church of San Giorgio Maggiore, which stands on a little island of its own off the end of the Giudecca directly opposite San Marco. Palladio started it in 1566, toward the latter end of his career when villa commissions had started to dry up just as ecclesiastical commissions started to come in; and it represents the monumental limit of Palladian style. As facade and as interior, it is a church to be looked at under two separate aspects; and under both aspects it represents a high level of creative adjustment.

Ample, simple, and abrupt (see pl. 7), the front of San Giorgio stands back just far enough from the water's edge to frame the flat, windswept stone piazza in front of it, and to give the viewer arriving by boat (as he must) first the sense of a platform under his feet and then space for a point of view upon the church. But its components are also large enough, lofty enough, and boldly enough outlined in light and shade to be distinctly visible from San Marco across the water, the perspective from which it is generally seen. As a matter of fact, the facade of San Giorgio is really two facades, or rather a facade and a half. In front of the main nave, lofty, massive, and relatively narrow, stand four powerful columns raised on ponderous pedestals; they support a pediment and a roof which would look absurdly narrow and teetery (like the fragment of a palazzo, begun in Vicenza for the Breganze family, but never completed—three columns framing two windows, and nothing else) if they weren't sustained from behind by the outer edges of a second pediment fronting the two side aisles and suggesting, because the horizontal base of this pediment is strongly completed behind the four main columns, that a low-angled roof is there too. The columns sustaining

the outer corners of this second facade are carefully subordinated to the four central ones, first because they do not stand on those massive pedestals; [12] then because they are built into the walls they sustain, flattened against them, and so are not outlined in shadows by the sun; and finally because, rather against the doctrine of the orders, they are light Corinthian columns, whereas the higher columns are of the heavier Tuscan order. Neoclassic doctrine had it that the lighter columns should always be in the upper order; but precisely the reasoning behind the principle dictated here that the lower and secondary orders should be Corinthian, while the taller, primary ones were in the heavier Tuscan form.

Professor Wittkower has argued that Scamozzi, when he completed the San Giorgio facade in 1610, betrayed Palladio's intent by putting those pedestals under the main columns; [13] and indeed there is a drawing of the facade which shows all the columns starting from the same level. On the other hand, it's perfectly possible that Palladio found that this made the disproportion between primary and secondary columns too great; or that it gave his church too much the look from San Marco of standing, unconvincingly, in the water. And in any case, we note that the theme of columns standing on massive pedestals is carried throughout the structure, indoors as well as out. It hardly seems likely that Scamozzi could have been exclusively responsible for a major building feature that must have asserted itself almost as soon as the structure rose above its foundations. Whether the pedestals are or are not Palladio's idea, it is perfectly

[12] It is part of the graceful artifice of the style that, though the outer columns do not stand on pedestals, the main niches of the outer facades, without any engineering necessity for it, do. The two extra blocks help tie the two facades together, while making the outer wings slope toward the outside, just as the arrangement of five statues, rising from the lower ones placed on the wings of the facade toward the higher one placed at the center, serves to connect and compromise the two roof lines.

[13] Wittkower, *Architectural Principles*, pp. 84–85. H. Lund, in a brief note "Facade of San Giorgio Maggiore," *Architectural Review*, CXXXIII (1963), 283–284, argues that Palladio himself was responsible for this oddity, but confuses the matter by saying on the one hand that Palladio was forced into it because he lacked big enough columns, and on the other hand that the same feature is found inside the church—which suggests that it was a deliberate decision.

arguable that they are one of the really admirable things about the church—that they give those massive verticals a credible base to spring from, and raise them to the necessary height while keeping them from attaining Cyclopean proportions. In this matter of dimensions, San Giorgio is in fact a very tricky church. From San Marco, the portico looks relatively small, seen as it is with dome and tower, not to speak of the immense lagoon, behind it; but from the landing platform, the facade looks really gigantic and very strong, with its big blocks of light and shade. When we separate them mentally, disassembling the facade into its two main components, each of them looks ridiculous. The half-portico that frames the side aisles would be a groveling, abject structure if it stood alone; the central facade, if it stood alone, would be absurdly top-heavy and unstable. It is the sense that they really work together, that something taut and energetic enters into their connection, that makes the facade of San Giorgio Maggiore so satisfying. And on the technical side, it is nice to know (on the authority of Professor Wittkower) that it represents a definitive solution to that problem of adjusting a classical facade 𝌆 neatly to a Christian basilica 𝌆 which had been tantalizing Italian architects for better than a century and a half.[14]

Inside, San Giorgio has the light, spacious, airy quality of a Brunelleschi church like Santo Spirito at Florence; but it is far less bare, and one feels from the first that it gives the eye more to do. Once again, the plan represents a compromise (see pl. 5b). Like many Renaissance architects, Palladio felt the rotunda was the ideal form of a church, but found that the needs of the ritual and the demands of the celebrants tended to drive him in the direction of the Latin-cross plan.[15] In San Giorgio the aisles are rather wide, each just half the width of the central nave; this creates an ambiguous space on either side of the cupola, which could be either the side aisle pursuing its vertical course (as it does, toward the screen and low steps which divide tribune and choir from nave and transept) or else the horizontal transept itself. If we measure the transept straight

[14] Wittkower, *Architectural Principles*, Part III, sect. 4, "Palladio's church facades."
[15] *Ibid.*, Part I.

across, it is just as long as, or perhaps a little longer than, the basic
vertical axis of the main church, measured from the inside of the
facade to the screen that sets off the tribune. But if we measure only
the projection of the transept from the outside wall of the nave, it
appears that the transept projects less than twenty feet from the wall
of the church. It is a cross, in other words, but not a strong cross—
it isn't a rotunda, but it has almost as much open space as a rotunda,
and under certain circumstances it can be treated as four rotundas
set in a line.[16] Tribune and choir, as they extend only the line of the
main nave, are just half the width of the body of the church, and
are, put together, just about half of its length (68 as against 132
feet); the first set of massive pillars sustaining the cupola is just
about as far from the inside of the facade as it is from the beginning
of the tribune. The divisions between the various sections of the
church (nave, transept, tribune, choir) are characteristically tactful
and ambiguous; a low step or two, a pair of massive columns, a low
vault—the eye can either unite the space or divide it at will (what
is architecturally a colonnade may be optically a wall), depending on
whether one glances through spaces and across airy vistas or accepts
the hints as given and takes the space a piece at a time. As the arith-
metic above suggests, wherever the eye looks, it finds harmonic bal-
ance, proportion, poise—a lucid and ordered correspondence of part
with part, in which not only the formal architectural proportions but
the movement of light itself is controlled toward spacious quiet and
composed dignity.[17]

Palladio's last, largely posthumous project was the Teatro Olim-
pico in Vicenza, built for just such an academy as Gian Giorgio Tris-

[16] Palladio's gift for drawing in light and shade was recognized long ago as
the distinctive feature of his art. G. C. Argan made this chromatic quality the
main point of Palladio's difference from the Florentine-Roman tradition of
antique-imitation, with its emphasis on plasticity: "Andrea Palladio e la critica
neoclassica," *L'Arte*, I (1930), 327–346.

[17] In all of Palladio's designs, the importance of mathematical proportion
and harmony has been amply demonstrated by Professor Wittkower. The fact is
beyond question; but the buildings that result could be as cold and sterile as
Palladio's worst enemies say they are, if it weren't for the frequent duplicities
of what is being measured—the equivocal way in which distance A permits
itself to be seen either as a subdivision of B or as a unit in its own right, with
relationships to C, D, etc.

sino had once envisaged. Founded only five years after Trissino's death in 1550, the Accademia Olimpica had become, after a quarter century of growth, a stable and flourishing institution. Not a private citizen's whim, or a patron's plaything, the Academy had developed into a civic club within which Trissini and Valmaranas predominated, to be sure, but which was open to a very broad spectrum of the culturally minded citizenry, in Vicenza and elsewhere. As it grew in wealth and dignity through the late sixteenth century, the academicians began to feel the need of a place where, during the carnival season, they could properly perform their own dramas and stage those they had duly translated from the learned languages. Their fellow academician Palladio was the obvious, indeed the only conceivable, choice as architect. He had studied the ancient theaters in archaeological detail, providing for Daniele Barbaro's 1556 edition of Vitruvius many careful specifications for the construction of a theater on the Vitruvian model.[18] He had built a working theater in Venice for the Compagnia della Calza, though, owing to a momentary flush of virtue on the part of the Venetians, it didn't long survive. He had designed a temporary auditorium for the presentation of plays in the Vicenza "Basilica"—Piccolomini's Constant Love in 1561, and Trissino's tragic Sophonisba (a clamorous success) in 1562.[19] Nothing more natural, then, than that Palladio should be asked to design a theater for the site of the "old prisons," newly made available to the Academy by the commune for dramatic purposes. So designs were made, many of which are mentioned in the documents and some of which actually survive in collections which (for irrelevant historical reasons) are at London; but before construction had much more

[18] A major feature of Barbaro's notes to Vitruvius, which are generally a good deal more voluminous than the original text, is the emphasis he places on mathematical proportions, far more elaborate and subtle than those of Vitruvius himself: M. V. Pollionis, De architectura libri decem cum commentariis Danielis Barbari (Venice, 1567), Book III, cap. 1. But though he cheerfully mathematized Vitruvius, and even his own designs, Palladio was a good deal more pragmatic in brick and plaster than he was on paper. His work doesn't always conform to the formulas in which he defines it.

[19] J. S. Ackerman, Palladio (London, 1966), p. 179. Though published in 1524, Trissino's Sophonisba got involved in some of its author's proposals for spelling reform and was not represented till 1556; the successful production of 1562 was, alas, twelve years too late to interest Trissino himself.

than begun, while the outer walls of the structure were still being re-worked, on 19 August, 1580, Palladio unexpectedly died. Four more years were to pass before the theater was brought into usable form; the inaugural performance, a translation of *Oedipus Rex* by the Venetian litterateur Orsatto Giustiniani, actually took place on 3 March, 1585. Doubtless Palladio's designs were followed in the main by those who pushed the work to its conclusion; but it is by no means clear how detailed those plans were, or what liberties Palladio's chief successor, Vincenzo Scamozzi, felt entitled to assume for his own ideas and intuitions. The Academicians were divided as to Scamozzi's success or failure, even in the sixteenth century, and scholars are still arguing the matter as its four hundredth birthday approaches.

But before entering this highly civilized wilderness, it may be worth saying a few words about the Accademia Olimpica as it existed at the end of the sixteenth century and the beginning of the seventeenth. For one thing, "Olympic" may be a stumbling block. The academicians did not consider themselves Olympian deities, or see Vicenza, with its very modest elevations, as Mount Olympus. Their name came from the Olympic games, their impresa represented the chariot race (an Olympic contest but also an emblem of the race of life), and their motto was the Virgilian "Hoc Opus, Hic Labor Est." It can be read as implying a need to "evadere ad auras," perhaps even as insinuating that life without a lot of hard work and some luck is hell. "Up and out" is writ large in it. The bas-relief decorations of the Teatro Olimpico lean heavily on the figure of Hercules, that favorite totem of the self-made man, whose twelve labors raised him among the immortals. Finally, on the great screen of the stage, the academicians inscribed their dedication, *Virtuti ac Genio*. No doubt it was the virtue and genius of their colleague Palladio that they had chiefly in mind, for they specified him four years after his death (rather than the still present Scamozzi) as the shaping spirit of the structure. But evidently they wanted to dedicate their theater to virtue and genius wherever found. They may even have intended the implication that, as the Olympic games were the showplace for Greek virtue and genius, so the Olympic Academy might serve to blazon forth Italian virtue and genius. And they certainly would not have

minded the implicit boast that no men could be better judges of these qualities than Olympians who had already displayed them in their own persons. Self-congratulation is perhaps inseparable from the existence of academies and institutes. Grosser aristocracies have been known to glory in certain orders and distinctions precisely because "there's no damned merit about them"; academies have to pretend that within their hallowed walls, "virtue and genius" make their own distinction.

Aristocracies of merit were doubtless in vogue around Vicenza because not much authentically blue blood flowed in the neighborhood. Trissini and Valmaranas represented the great houses of the district; the Academy, listing in 1608 those thirty-two members responsible for the new theater, included three of the former and four of the latter. But there are no other well-known families on the list, and even Trissino and Valmarana, amply respectable as they are (and more than amply endowed with tangible assets), don't take rank among the grand nobility.[20] Perhaps by way of atoning for the

[20] Even Paolo Beni, author of an enthusiastic *Trattato dell'origine della famiglia Trissina* (Padua, 1624), feels obliged to defend himself from the charge that the Trissini aren't worth a *trattato*; he concedes that Italian genealogies have been so often faked that they are not much respected elsewhere, but points to his own elaborate documentation as evidence that authentic genealogies can be established. His work, however, is distinctly scrappy from an antiquarian point of view; and after a first book of bits and scraps, he falls back upon the easier course of reprinting Franciscus Rugierus's lovely long counterattack upon Boccalini (who had ventured to crack a joke or two at the expense of Trissino in the *Raguaglio di Parnaso*). Just to give the flavor of Renaissance scholarly polemic, we translate here the last sentence of Rugierus's *Trutina Delpholudicri Tabellariatus Traiani Boccalini*, quâ lustrationis carcerum Pegaseorum ineptum commentum expenditur, & perstringitur, sillus probrosus in Io. Georgium Trissinum ab eodem auctore scriptus expungitur, et illustriss^ma Trissinorum familia commenditur: "And so it is my duty now to invoke, not your clemency or your pity, but your sense of truth, your spirit of justice; since, if by this my defense I have cleared Io. George Trissino from the iniquitous charges of an artful, crafty, wily, satyric reviler actuated only by mindless rage, if I have brought him off safe from the attacks of this new Laberius and Sophone, this mime-composer Boccalini, who would beat down with his pestilent jests and vicious jokes not only Trissino but practically everyone who ever deserved well of humane letters—[if I have done this] you may well render that judgment recommended by the famous Lex Talionis which the Romans received from those who inscribed the twelve brazen tablets and which C. S. Volusianus reports to us, and decree that Boccalini's writings, those hundred

plebeian surnames, Vicentine nobility were particularly fond of be-
stowing on their children the names of classical heroes—Scipio, Pom-
peius, Camillus, Horatius, Mutius, and Fabius, for example. So that
Andrea, once the son of Pietro Gondola, but now transformed to a
heavenly messenger, Palladio, represented simply an extreme version
of a process to which, in everyday life, the people of his society were
accustomed.

A modern viewer of Palladio's Teatro Olimpico in Vicenza gen-
erally comes away, it seems likely, with two strong impressions (see
pl. 6). One is the elaborately wrought permanent facade which
stands about halfway back on the stage, and acts, not as a frame for
the action, like a modern proscenium arch with a curtain, but as a
screen for the action to move in front of and through. The other im-
pression is made by the elaborate perspectives that perforate the
screen; they number no fewer than seven streets which, at angles
increasingly oblique to the central axis of the theater, debouch
through the great screen onto the forestage. The largest of these
streets is the central perspective, and almost everyone in the audience
can see some distance down it, though the farther one sits toward
the side of the auditorium, the less one sees. And this naturally ap-
plies even more to the perspectives on one's own side of the theater—
the sharper their angle to our line of vision, the less we see down
them. Sometimes they are deliberate traps in which to conceal from
most of the audience whatever is going on within them. The design
of the present screen in its broad outlines was probably Palladio's
work; a sketch of it exists in the collection at London, not in Pal-
ladio's hand, to be sure, but by one of his staff, and with evident
marks (so the experts say) of his style upon it. But there is not much

Delphic inscriptions worthy only of the brothel, those mud-bedaubed elucubra-
tions blacker than a dung-beetle, more pestilential than the swamps of Cama-
rina and Mephites—shall not only be stricken from the record, erased from the
very paper, and forbidden ever to be read again, but Blockhead Boccalini him-
self, as a criminal many times convicted, a conveyer of fraudulent merchan-
dise, having first been injected with PASTOMIDE under that shameless, lying
tongue of his which he acquired as a mark of his gentility, or stole from some
passerby, or inherited from his ancestors through the skill of the veterinarian's
art, shall be banished forever from the company of even the lowest stableboys
on Parnassus. DIXI."

evidence that the various "perspectives" in their present dimensions and character were what he envisaged. For one thing, they are very large; the Accademia did not even get title to the land required to build them until January 1582, a year and a half after Palladio's death. He had, indeed, perspectives in his design, considering them (erroneously) Vitruvian, but they would probably not have been as elaborately illusionistic as the present perspectives. They might very probably have consisted of, or allowed the use of, painted scenery behind the openings in the screen, so that the theater could be varied according to the play being presented. As for the screen itself, Palladio had more than Vitruvian reasons for perforating it, and wanting the perforations to be strongly felt. For one element behind its shape and character seems to have been the Roman tradition of the triumphal arch, an arch whose essential function consisted precisely of being passed through. The central opening in it, reminding us of that ancient tradition, is known as the *porta regalis*, or royal gate; it lets the eye of the onlooker go back into space behind the screen or concentrate on action taking place before the screen, depending on the shifting focus of the moment.[21] And the whole idea of penetrations in the screen, through which the actors can be seen advancing onto the stage and departing from it, gives their presence depth and authority.

Two other elements involving this onstage facade have to do with its relation to the auditorium, that is, to the banks of elliptical seats on which the audience is to be accommodated. As the theater presently exists, a variety of quite vigorous architectural devices separate the auditorium from the stage. Two massive walls, on either side, cut off the semicircle of seats and frame the big screen, which is set back by the width of the forestage from a line drawn between these walls across the front of the orchestra. If one viewed the onstage screen as a backdrop, one could imagine these two side walls, and the architrave that connects them across the ceiling, as the equivalent of a modern proscenium arch, decisively separating audience from actors; and in fact we are assured that, at the first performance given in the Teatro Olimpico, a movable curtain was hung in this opening. Another potent element of separation is the ceiling itself, which is

21 Lionello Puppi, *Il teatro Olimpico* (Vicenza, 1963), *passim*.

built forward from the screen, in elaborately decorated and patterned form, to the entire width of the forestage. This is important (and, some think, deplorable) because the ceiling directly over the audience and the ceiling glimpsed through the perspectives are both the same, long stretches of cloud-dappled sky. If the screen weren't built all the way to the ceiling (Palladio apparently once envisaged cutting it short), or if the ceiling over the forestage weren't a band of strikingly different decoration, we should have a much greater sense of space behind the scene flowing into space before the scene; and so, likewise, with the massive walls on either side of the stage, which are by no means so prominent in Palladio's designs. It seems to be the opinion of the experts that if he had lived Palladio would have managed the transition from auditorium to stage with more delicacy and greater indirection.

Those who have sat for several hours on end in the Teatro Olimpico speak with some asperity of its discomforts as an accommodation for an audience; and by contrast with a modern movie palace (lounge seats, wide aisles, electronic ashtrays, and popcorn) it is undeniably primitive, above all in its provisions for arrival and departure. But, given the circumstances for which and under which it was built, one can see it as still another triumph of Palladio's in unifying space and manipulating vision. The great colonnade in back, with its alternating solids and opens, with its splendid array of animated statues against the sky, frames an audience, as the great screen onstage frames the actors. Many Renaissance theaters, indeed, gave the audience more prominence than the actors, as many masques, tourneys, and festivals were essentially audience-participation games.[22] But Palladio, here as always, was an even-handed man. As it partly survives, even more as it can be reconstructed, his plan holds audience and actors in intimate, equal balance. The scheme is mutual visual intrusion, framed and concentrated by architectural directives. The audience is defined by statues, colonnades, and elliptical tiers, as a group of people—perhaps Olympians—acting in a stadium. The ac-

[22] A climactic instance of this tendency was Bernini's *Comedy of Two Theaters* (produced in 1637), in which the actors seem to have performed "in the round" between two theaters, one filled with real spectators, the other with actors made up to resemble exactly the real spectators.

tors are defined by possession of a space into which they can invite, and within which they can direct, the eye of the spectator. There is, indeed, a line between the two spaces: it is that line from the two side walls (such as they are) across the front of the orchestra, but Palladio, with characteristic indirection, left it almost unmarked and undefined. He drew his strongest line with the big screen, *behind* the actors, so that they and the audience are really in the same space; only, even that strong line is not absolute, it invites the eye down the alleys and into the world behind it. So that a sequence of penetrable barriers, in the Palladian theater, gives the eye liberty to wander, and entices it to wander, where the actors can direct its focus to their own ends; while the other spectacle, that which the audience presents to itself, is framed and concentrated into an equivalent vision of order and dignity.

When the chords of the specially composed overture died away, when the great blind actor Luigi Groto began to recite Giustiniani's resonant lines,

> O figli mei Thebani, de l'antico
> Cadmo, stirpe novella, qual cagione
> Hor fa voi qui seder col capo cinto
> Di supplicanti frondi? & la Cittade
> Di vapori odoriferi ripiena
> Risuonar d'Inni, & gemiti dolenti? [23]

the academicians of Vicenza, seated in their dignified, uncomfortable rows within their authentically Vitruvian-Palladian theater, must have felt that they'd gone, in the direction of Roman pomp, dignity, and culture, just about as far as they could possibly go. The dream they were living was one into which Gian Giorgio Trissino had long ago co-opted Andrea di Pietro della Gondola. In the process of translating it into brick, mortar, stucco, and wood (marble was a cut above the practicalities), Palladio broadened it toward his own sort of persuasive, low-keyed compromise, one that at its best manages men (at a very moderate cost) into feeling themselves momentarily a little wider and loftier of mind than nature made them.

"Kidnap" may be too strong a word for what Trissino did to

[23] Orsatto Giustiniani, *Edipo Tiranno di Sofocle* (Venice, 1585).

(or should we say, *for?*) his protégé. After all, it's been the aim of universities for some time now to catch talented young barbarians, give them some training, and bend their powers to the service of the polite culture. That isn't kidnapping, surely—or is it? When we go to the lengths of subsidizing, programming, and then rebaptizing our young person, we may not be far short of incubism. Trissino claimed descent from one of those sixth-century warriors he celebrated, who came with Belisarius to liberate Italy from the Goths; through the young stonemason whom he named Palladio, he struck a crushing Goth John Ruskin could never forgive Palladio his success in this blow for the liberation of Italy from the Gothic. That latter-day regard—though, curiously, when not ideologically inflamed, Ruskin found much to admire in Palladio's actual work.[24] What Ruskin most hated in Palladio, as in Renaissance architecture as a whole, was its soulless, arithmetical proportion, that conception of a planned and coherent unity which denied, as he saw it, the full expressive energies of the craftsman. As a true offspring of Coleridge, Wordsworth, and those romantics who took seriously the metaphor of "organic unity" in art, he was appalled by buildings that looked more like deftly designed artifacts than gnarled trees. And in all this he was partly right. Naturally, Palladian building is not as abjectly immoral as the Ruskinian rhetoric represented it—as a matter of fact, it is not as severely mathematical. When he saw an effect of light and shade to be captured in bricks and mortar, Palladio was likely

[24] Ruskin's best fulminations against Palladio and the moral principle he represented occur in *Stones of Venice* (I, i, 37): "Instant degradation followed in every direction—a flood of folly and hypocrisy." The paragraph goes on to specify "feeble sensualities," "idiot groups," "scenic affectations," "abused intellect," and "prurient pedantry," before concluding: "And thus, Christianity and morality, courage, and intellect, and art all crumbling together in one wreck, we are hurried on to the fall of Italy, the revolution in France, and the condition of art in England . . . in the time of George II." The "Venetian Index" follows up with a judicious account of San Giorgio Maggiore: "It is impossible to conceive a design more gross, more barbarous, more childish in conception, more servile in plagiarism, more insipid in result, more contemptible under every point of rational regard." But an interesting entry in Ruskin's youthful diaries (17 May, 1841) shows him examining one of Palladio's lesser churches in Padua with real respect and at considerable length; he seems to have had no notion that the architect was a dribbling incompetent working on a vicious principle.

to go after it, and leave abstract proportion, or for that matter the proper order of the columns, on the drawing board or in the book. For that very reason, a strict neoclassicist like Milizia (1768) was prone to speak disparagingly of Palladio's "architettura a tastone," (blind-man's-buff architecture), and to describe his taste as evidencing "bizzarria." (See above, n. 16.) Yet Palladian building is, after all, planned with certain numerical proportions and principles in mind; and one consequence is that the style, whether of the sixteenth century or the eighteenth, of England, Ireland, France, Italy, or America, is more homogeneous than any equivalent range of Gothic. It really does not allow much room for individual self-expression, unless perhaps for Palladio himself. The merchant prince does not generally want to live in a house that expresses the builder's total personality. It's a subdued, a "correct" style with which one subdues the Goth in oneself. But the apparent uniformity of Palladianism, which was its success, obscures a change, indeed a reversal, of psychic values. To domesticate Rome and subdue the Goths was in the sixteenth century an act of imaginative conquest, an act requiring nothing less than redefinition of self and rededication to a new sphere of creative order. By the eighteenth century, Rome had been thoroughly domesticated, absorbed, some might say miniaturized to bourgeois proportions. The doctrine of "correctness" had established itself so successfully that its founder himself seemed incorrect. The Goth in us must be subdued again and again; when the real Goths have been subdued, we find that their subduers were themselves afflicted with Gothic elements. The logic of "correctness" points inexorably this way: he who first proclaims it is the first to be outdistanced by it. A misunderstanding of this sort furnishes our second instance of kidnap, but this time of kidnap in reverse.

Le Démon Romain

Once again we start with a legend, not a fact, a seventeenth-century legend about a sixteenth-century figure. It is certainly a false legend; it certainly contains some grains of truth. It was not only denounced but corrected, early and often; yet, as frequently happens, the legend contained more vitality than the truth, however fully documented.

(Between "creative imagination" and a simple lie the distinction is sometimes hairline.) If the reader can suspend for a while his natural desire either to believe or disbelieve a story, this fabulous and potent romance about Pope Sixtus the Fifth can be allowed to uncoil its energies.

The story sprang full-grown from a single vivid imagination, about whom (setting aside momentarily the Pope himself) a word of introduction may be fitting. Gregorio Leti (1630–1701) was a scapegrace, satirical, vindictive ne'er-do-well, who concocted the popular image of Pope Sixtus (1521–1590) some eighty years after the pontiff had gone to his reward. Leti was in effect a spoiled priest; he had been raised among Jesuits and destined by his uncle for the priesthood. But the discipline proved ungrateful to him, so he ran away—to Geneva of all places—and became a Protestant. Rejoicing in his new liberty, he published some scabrous poetry and prose, some anti-Catholic libels, and a great many careless histories, among them this two-volume biography of Pope Sixtus (1669). But his value as a turncoat was soon outweighed by the scandal of his coarse wit and coarse fabrications; Geneva processed him as an offender against good manners, and expelled him from the city. He moved on to France, where he wrote unctuous panegyrics on Louis XIV, then to England, and finally to Holland, famous for its tolerance, which he tested to the absolute limit, but which turned out to extend even to him. All his life he was restless for "fame" and ready to settle for notoriety; this bent, reinforcing a naturally suspicious, keyhole temperament, produced a series of disillusioned, sneering books on such topics as nepotism at Rome, the intrigues of the French and English courts, and that biography of Sixtus the Fifth which was the only work of Leti's to take root and flourish. It enjoyed this special distinction, not because Sixtus the Fifth was a topic of any special timeliness, or because Leti's book had any particular historical merit, but as a novel by Scarron or the Abbé Prévost might profit by the taste of the day. It was a burlesque biography, which attributed to the Pope all the deceitful devices and motives of an underbred, unprincipled, aggressive scoundrel; it reduced the papacy of the previous age (Sixtus reigned only briefly, from 1585 to 1590) to a series of dodges and masquerades worthy of Figaro the

barber or a Spanish *picaro*. It viewed the mechanics of papal politics with a thoroughly disabused eye, and attributed to the papal curia a moral atmosphere rather like that of an army barracks next door to a Neapolitan whorehouse. Being vulgar, cynical, and frequently funny, it was naturally popular with libertine readers and so useful to the other party that it was translated in 1779 by an Anglican clergyman named Farneworth. The task must have livened many a dull evening at the old vicarage.

Felice Peretti is introduced to us, according to this legend, as a barefoot swineherd's helper, of Dalmatian descent, in the wild Apennine country back of Grottamare, on the Adriatic between Pescara and Ancona. Though ambitious and likely, he could not be sent to school because his labor was needed in the fields; so he was put to watching the cattle, and then, as a demotion, the pigs of a neighbor. But his mind was elsewhere; and one day when father Michael Angelo Selleri came through, looking for the right road to Ascoli, where he was due to preach to a monastery of *minori conventuali*, he found himself in the company of an eager ten-year-old swineherd, who could not be dissuaded from showing him the road, all the way to Ascoli.[25] Once there, the boy set himself to earn the brothers' good opinion; the consent of his parents in Grottamare was soon obtained (one less mouth to feed); the young man served an apprenticeship, and at the age of thirteen, on 25 September, 1534, he received the *cappuccio* and was enrolled in the Franciscan monastery at Ascoli. A momentary difficulty arose with regard to his religious name. The guardian of the monastery wanted to contribute his own name, Agostino; others advised the child to call himself Michael Angelo, after the man who introduced him to the order; still others proposed Francesco, after Saint Francis. But he clung to his own and became Fra Felice.[26] On the other hand, "Peretti" meant little to him, and some time in his young manhood, he took to calling himself Montalto, after a monastery of that name near Grottamare. It sounds like a brag: what is a high mountain for, if not to climb? and who a more

25 *Vita di Sisto V Pontefice Romano* scritta del signor Geltio Rogeri all'instanza di Gregorio Leti (Losanna—Lausanne, 1669), I, 22–23. The anagram represents Leti at his most subtle.

26 *Ibid.*, pp. 41–42.

enthusiastic mountaineer than this ex-swineherd? But he never tried to hide or forget his humble origins, and when raised to the purple would often brag that he came from the most illustrious house in all Italy, one illuminated by holes in the ceiling and all four walls.

Still according to the legend, the monks were not slow in learning that they had caught a bird of considerable promise; also, to change the metaphor, that they had a wild bull by the tail. Brother Felice saw at once that books were the way up and out, learned his ABCs, learned to read first Italian, then Latin, learned to preach from listening to others do it, and learned how to argue from the promptings of his mother wit. His popularity with the brothers was not long-lived; they envied his accomplishments, feared his ambition, and despised his origins. Whenever he appeared, they would call after him in the hall or whisper to him in the refectory, "Gru, gru, gru"—it was the swineherd's call to his charges. Brother Felice put an end to that pastime by bundling three heavy keys together into an improvised club and braining one of his fellow devotees with it, to such good effect that he knocked him cold and ripped up his ear.[27] But there were constant charges; he was watched, provoked, slandered; and he gave as good as he got. Once when the head of the monastery was called away, he was left in charge: his fellow monks anticipated a free hand and a relaxation of discipline. On the contrary; Brother Felice was twice as strict as the regular head, and on his return presented ten glorious sequins saved from the normal costs of the monastery.[28] He was an administration man from the start, and though Leti describes him as tempted on one occasion by Lutherans, on another by a girl, and is always slyly insinuating pederasty as a failing of monks, there really was not much to be done with Felice Peretti along these lines.[29] His story took place within the walls of various monasteries, it consisted largely of ecclesiastical ambitions and ecclesiastical jealousies (office politics, in a word), and if it reminds us overwhelmingly of Julien Sorel's career in the church, one reason may be that Stendhal was thoroughly familiar with Leti's biography, and made large use of it toward the end of Volume I of *The Red and Black*.

[27] *Ibid.*, pp. 63–65.
[28] *Ibid.*, pp. 56–57.

[29] *Ibid.*, pp. 81–86, 97.

Fra Felice Peretti made his way in the church, as ways are made in this sad, bad world, by a deft mixture of arrogance and servility, diplomacy and crudeness. Leti does not try to explain how the coarse-fibered, quarrelsome bully he describes came to be a famous preacher, a famous administrator, and an admired intimate of saintly men, eminent alike for piety and learning, such as Rodolfo Pio Cardinal Carpi, San Carlo Borromeo, and Popes Paul IV and Pius V. This is characteristic of our unholy legend-maker; when he invents, it is a small "revealing" story, incapable of verification; when he overlooks, he does so silently and wholesale. Big traits of character drop out of the picture without a word being said, when they would conflict with the impression he wants to make. And yet after all, there is no mistaking the prevailing temper of Sixtus; though reared in a convent, he was active, not contemplative; a soldier of the church, not a recluse (see pl. 8). That was how the church itself used him. In 1555, at the age of thirty-four, he was appointed Papal Inquisitor by Paul IV, with an assignment to Venice. This battle was as decisive for him as Marengo for Napoleon. The Venetians traditionally took a suspicious view of the papacy, from which it was their pride to have remained so long and so largely independent. They had no special love for Inquisitors, and they had heard frightening stories about Montalto and his rough ways. Worse, he was given some particularly disagreeable counter-reformation decrees to enforce during his five years in Venice. A censorship was to be imposed on the free Venetian press, a considerable group of uncloistered monks was to be ordered (and, if necessary, disciplined) back to quarters. Most dangerous of all, Pope Paul, the first of the medievalizing popes, thought it his duty to provide authoritative ecclesiastical leadership for the secular governments of Europe. In other words, he was out to assert a claim which every secular government in Europe was determined to reject. In all these clashes Montalto served his master's needs and wishes so well and ruffled the feelings of the Serenissima so painfully that—according to Leti—they sent officers after him, whom the Grand Inquisitor of Venice could elude only by night flight in a gondola.[30]

Yet these broils and alarms with the laity apparently did Mon-

[30] *Ibid.*, pp. 194–195.

talto no particular harm in the eyes of his ecclesiastical superiors. Rough he might be, but he was able, and willing to absorb odium: a new broom, to sweep vigorously clean, wherever he was bid. His five years' work in Venice moved him suddenly into the ranks of those prelates who serve the Roman curia in its international relations, the diplomatic janizaries and mamelukes of the Vatican. In quick succession he became (and here we have public records and documents to confirm the legend) Consultant to the Holy Office, Vicar-General of his order, Bishop of Saint Agata, and, at the age of forty-nine, a cardinal.[31] To his credit be it said, he was still too poor to support the dignities of the office, but papal aid was forthcoming in the shape of a modest allotment. His rapid rise through the upper hierarchy of the church took place under the protection of two strong popes in great need of hardworking, responsible assistants (Paul IV and Pius V), and it contrasts with his slow progress through the lower ranks. A legitimate inference may be that his gifts of command and decision appeared greater than his gift of docile obedience. But though he was less than fifty when created cardinal, it must not be forgotten that he had served almost forty years in the church and was nobody's unknown quantity.

Leti, in the course of this story, makes continual reference to the coming papacy, emphasizing those little coincidences which seemed to point Felice Peretti toward his destiny,[32] and repeating on every possible occasion *in italic type* words of the future Pontiff which showed him to be conscious of the papacy and intent on getting it for himself. But even if he had nourished such an ambition through long years of monkish obscurity, his arrival at the cardinal's hat was followed almost at once by an event which seemed to slam the door on further ambitions. The death of Pius V, occurring in 1572, deprived Cardinal Montalto of a close friend and dedicated

[31] *Ibid.*, pp. 196, 202, 228, 253, 265, 270.

[32] He was born the day the cardinals entered into conclave after the death of Leo X, in search of a pope whom they elected as Adrian VI; he entered the Franciscan order formally on the day Clement VII died. After the Venetian quarrel, he is said to have remarked, "Non ho voluto farmi impiccare in Venetia, perche ho fatto voto d'esser Papa in Roma" (I didn't want to get myself hanged in Venice, because I've taken a vow to be Pope in Rome) (*ibid.*, p.196). And so forth and so on.

supporter. Gregory XIII, the new Pope, actively mistrusted Montalto, excluded him from the administration of affairs, and even took away the little competence assigned him to support his cardinal's dignity. And thus Montalto's career seemed not only at a standstill but ruined for good. So serious a blockade he had never encountered before, and he seemed to take the check very poorly indeed. For he retired to the Vigna Peretti, a little farm near Santa Maria Maggiore, where a faithful sister could nurse his declining years.[33] He traveled little, studied much, and heard many confessions—to the general amazement, since cardinals rarely take "cure of souls" quite so literally. He undertook works of penitence, humility, and, so far as his resources allowed, charity. His health was afflicted: his posture declined, his foot stumbled, his voice, once loud in monkish brawls, was broken by a hacking cough, which obscured his every word. He walked only with the aid of a staff, spoke in a gasping whisper, exaggerated his age, and said he had been born in 1515. His health was daily despaired of. Questioned about their master's condition, his few servants raised their eyes to heaven, murmured something about resignation, and shrugged eloquent shoulders to indicate that it was only a matter of time.

Still, Montalto managed to live through the thirteen-year pontificate of Gregory XIII, as a broken man in semi-retirement. During a famine, he gave away the little he possessed, and went begging among his fellow cardinals for his own daily bread. His nephew was assassinated, and he took no revenge, contenting himself with patience and Christian resignation. Somebody met him and murmured that this must be the illegitimate brother of the other cardinals; someone else was heard to say that this was the pattern of piety in the primitive church.[34] Long forgotten now were the devices and habits of mind which had won him his scarlet hat; he was a mild, simple, innocent old man in an advanced state of disrepair.

Gregory XIII perished in 1585, and the conclave met to elect his successor. Montalto was not only out of the running, but apparently unaware of the race. Asked for his opinion, he smiled with sacred simplicity, and said, "That any cardinal was better qualified than himself, they would all make fine Popes, and he wished he had

[33] *Ibid.*, pp. 281–282. [34] *Ibid.*, pp. 286–287, 291, 293.

forty-one votes so he could give one vote apiece to every other car-
dinal." [35] Such remarkable Christian meekness verged on stupidity,
and colleagues who fancied themselves worldly often spoke of Mon-
talto (and sometimes in his very hearing) as "l'asino della Marca,"
the donkey of the Marches.[36] Meanwhile he moved blandly through
the conclave, smiling with vague good will and assuring each of the
leading contenders in turn that it would be a very great wrong to
the church if he were not chosen Pope.

But there were a number of contenders; in fact, the conclave
was split six different ways, and before long the cardinals were cast-
ing about for a compromise candidate. Montalto, being old and
feeble, satisfied the first prerequisite: he could be counted on to dis-
appear shortly. When the matter was put to him by the Medici fac-
tion, he said frankly that the papacy was such a fearful burden that
he could carry it only if he had all sorts of help from his good friends.
In fact, the only reason he would consider the task at all was so he
could do his friends some favors. They must be prepared to assume
the burdens of the office, he would just take the title for form's sake,
and not, alas, for long, since his health [37]—and here he coughed very
violently indeed.

Election of a pope, as is well known, may proceed by scrutiny
(i.e., by ballot), by accession, or by adoration. When the factions
consolidating behind Montalto judged themselves strong enough to
bandwagon him in, they held an accession—that is, they rose from
their seats and thronged around him. But the results were not al-
together decisive, and a confirming scrutiny was called for. The lead-
ers of Montalto's faction accepted, but Montalto himself instructed
them in the formula that the scrutiny "should be without prejudice
to the result of the accession." In other words, it could confirm the
accession, but not upset it—a curious legal position, since it took for
granted what the scrutiny was intended to verify. But pressures were
very high and few heads were clear. The count began; Montalto's po-
sition was certainly strong, perhaps sure, but before it could be made
mathematically certain, the candidate himself cast down his staff,
fell on his knees before the altar, and gave thanks to God for his

[35] *Ibid.*, p. 341. [37] *Ibid.*, pp. 336–367.
[36] *Ibid.*, p. 339.

victory. There were murmurs and mutters, someone said, "There's been a mistake," but he cried, "No, there's no mistake, no mistake," and began intoning the *Te Deum* in a voice so thunderous that no further discussion was possible.[38] And so he became Pope Sixtus the Fifth.

Little need now to fill out the rest of Leti's romantic story. Having conquered the papacy by cleverly dissimulated weakness, Sixtus the Fifth suddenly bore himself with the agility of a thirty-year-old, the boldness of a hussar. He seemed to have grown a foot taller, his voice rang with authority; when he was presented to the enthusiastic crowds of the city, they cried "Where's the Pope?"—unable to recognize in this erect, manly figure the creeping, meeching cardinal they were used to.[39] Those who put him in office also had some trouble recognizing him. Cardinal Rusticucci, who had been an early supporter in the conclave and had heard that speech of Montalto's about how necessary the help of his friends would be, tried to be of service in the matter of adjusting a robe, and was told brusquely not to get so familiar with the dignity of a Pope.[40] The cook came to ask what the new Pope would have for supper, and was answered in memorable words: "Great princes are never questioned as to what they want to eat. Go prepare a royal meal, and we'll pick out what we want of it." [41] He hanged all the bandits he could catch, hounded down the murderers of his nephew and hanged them all, promulgated strict sumptuary laws for everybody else, reformed the currency, established a highly successful foreign policy based upon an army that fought and a small navy that put to sea when told to do so, he steered a canny course between Philip II and the Venetians, encouraging the former to attack the English and the latter to attack the Turks, he built splendid aqueducts and enormous, if hideous, fountains, he opened up vast new streets (one of which, via Sistina, still preserves his name), he reared palazzi, colleges, libraries, and hospitals, put the cupola on Saint Peter's, put Saint Peter on Trajan's column and Saint Paul on Marcus Aurelius's, administered the law with spectacular strictness, raised the great obelisk in Piazza Vaticana, and, according to Leti's boast, "accomplished more in Rome in

[38] *Ibid.*, p. 414.
[39] *Ibid.*, p. 418.
[40] *Ibid.*, p. 422.
[41] *Ibid.*, pp. 423–424.

the space of five years than the Roman emperors could do in the space of five centuries." [42]

So far Gregorio Leti. It is impossible to defend his narration as serious history, and at this date superfluous to attack it. One doesn't need a very sensitive historical nose to recognize that his account of a Counter-Reformation Pope smells wrong, and since the day of its publication scholarship has not had any trouble in showing that, in detail after detail, it *is* wrong or unsupported. Felice Peretti was a very poor boy from Grottamare, but probably not a swineherd, or at least only for a very short time. He never had to flee from Venice in a gondola, and not one single contemporary authority reports anything like the scandalous scene in the conclave—which is, nonetheless, as a scene, Leti's masterpiece. Tempesti, for example, who thinks of Leti as the devil incarnate, is at pains to point out that of the forty-two cardinals in conclave, forty-one voted formally for Montalto, the one exception being Montalto himself, who voted for Cardinal Farnese.[43] Worse than any specific untruth—for if one views it broadly enough, Leti's narrative does describe the major phases of Sixtus's career—is a deep untruth in the tone and coloring of the story. Montalto was in retirement under Gregory XIII, nothing could be truer. De Thou saw him in those days, and verifies in his own person the broad fact:

> J'ai veu le Pape Sixte, estant encores Cardinal. Il avoit desja grande autorité, c'estoit un courageux homme. Il estoit fort petite-

[42] *Ibid.*, p. 10.

[43] Casimiro Tempesti, *Storia della vita e geste di Sisto Quinto* (Rome, 1754), I, v. In the prefatory "Idea dell'Opera," Tempesti delivers himself regarding his predecessor: "Riguardo a Gregorio Leti, non abbiamo voluto farli quest'onore di considerarlo. Egli sfoga il maltalento della sua perversa natura, che lo sprono a dir male. . . . forma di Sisto una si studiata, si artificiosa novella, piena d'inezie, d'irrisioni, di racconti vituperevoli, d'incoerenze, di anacronismi, che si vantasse la purità della lingua, il vezzo degli ornamenti, la nobiltà delle idee, del carattere nel suo genere di comporre, potrebbe servivre di Coronide al Decamerone del Boccaccio." (As for Gregorio Leti, we don't propose to honor him with any notice. He vents the malignity of his perverse nature, which incites him to evil-speaking. . . . he forms from the life of Sixtus such a contrived, artificial fable, full of crudities, absurdities, malicious tales, inconsistencies, and anachronisms, that if in addition it could boast purity of language, a knack of ornament, some nobility in the ideas, and a bit of art in the composition, it might serve as a crown to Boccaccio's Decameron.)

ment logé, sa chambre lui servant d'estude & de chambre, y ayant des tablettes de livres.[44]

(I saw Pope Sixtus when he was still Cardinal. He was already a man of great authority, a man of great bravery. He lived in very modest quarters, his room serving both as study and bedroom; there were bookcases all around it.)

But that is very different from the story Leti peddles, that those thirteen years were spent in hypocritical meekness, plotting a coup the very possibility of which could not be foreseen at all. Even when Leti tries to reinforce his version, he creates more doubts. For instance, he has a cock-and-bull story of having talked with some old retainer to get material for his biography.[45] But as nothing will alter the chronological fact that Montalto became Pope eighty-four years before Leti's biography appeared, the story requires us to suppose that the retainer was six years old when the events occurred (yet somehow in the confidence of a very forbidding man) and ninety when he retailed them to the historian.

The cynicism Leti attributes to Sixtus admits of no exceptions; and, more often than not, it is gratuitous. A man might do every last thing that the public record shows Sixtus doing, and yet have wholly different motives than those Leti attributes to him. When Sixtus is pictured sighing, after the execution of Mary Stuart, "Oh Lord, when will the day come that I get such an opportunity?" (i.e., to decapitate a sovereign), we are simply in the realm of the silly.[46] To create Leti's Sixtus, one has to invent a lot of stories, omit a lot of counter-evidence, and reinterpret radically most of what remains. A curious reminder of what was left out is provided by de Thou's mention of all those books that cluttered Montalto's modest apartment. Almost certainly they were for use in his big edition of Saint Ambrose, which, though spoiled, characteristically, by the editor's determination to follow his own ways regardless of previous scholarship, was nonethe-

[44] Jacques de Thou, *Perroniana et Thuana* ed. C. Dupuy (Col. Agripp., 1669), p. 362.
[45] Leti, II, 202–203. Leti says the old gentleman he talked with was a retainer of Montalto's *nephew*, but the stories he tells all have to do with Sixtus in the days of his pontificate.
[46] *Ibid.*, II, 274.

less a serious and disinterested labor. But Leti, who has a shrewd sense that his cunning conspirator would cease abruptly to be a cunning conspirator if he were shown peacefully editing Saint Ambrose, simply omits all mention of Montalto's theological labors. No doubt Cardinal Montalto was an ambitious man; one doesn't rise from country boy to Pope, either then or now, without a measure of aggressive instinct. The portrait bust that survives (pl. 8) shows a man with an almost frightening sense of authority. That quality too is written in the public record, in the severity of Sixtus's justice, the weight assigned throughout Europe to his political judgment, the extraordinary record of his building accomplishments during a reign of only five years. Yet Sixtus must have been more than a bully and a ruthless administrator. The spirit that moved Paul IV and Pius V, the sense of having to do something swift and desperate to save an ancient institution suddenly called into question, animated Sixtus as well. But neither this nor any other motivation apart from greed and cruelty and cunning is allowed to appear on Leti's smudged pages.

Partly this is because Sixtus the Fifth was from the very first a good man to hang a good story on. Perhaps the scene in the conclave did not take place as Leti described it, but that some of those who voted him into the papacy learned quickly that they had got more than their money's worth did not wait a hundred years for expression. Cardinal Perron tells a story how Cardinal d'Este had "made" Sixtus Pope on the strength of a promise that he would favor the French against the Spanish interest. Finding that things were not working out, he ventured to visit the Pope, and murmured the remonstration, "Padre santo, io v'ho fatto Papa"; to which Sixtus simply replied, "Lasciatemi dunque esser Papa" ("Holy Father, I made you Pope." "Well, then, let me *be* Pope").[47] Again, Sixtus may not have been a swineherd, but he was certainly poor, and all sorts of stories involving clever rejoinders by penniless priests got attached to his name. De Thou reports in all seriousness that when he came to Rome, Peretti

estoit si pauvre, qu'ayant amassé quelques aumosnes, il s'alla présenter à la boutique d'un rotisseur [*rosticceria*, nowadays] où il mit en deliberation en lui mesure, s'il employerait son argent à un bon repas, & à s'assouvir la faim qui l'affligeoit, ou bien à une paire de

[47] Jacques Perron, *Perroniana et Thuana*, p. 283.

souliers dont il avait besoin. Estant en cette méditation, un marchand remarquant en lui une action extraordinaire, lui demanda ce qu'il faisoit. Il lui dit franchement, qu'il estoit après à vuider une contestation entre son ventre & ses pieds, qui avoient également besoin d'assistance; ce qu'il dit d'une façon si agréable, que le marchand voiant de la vivacité en cet esprit, l'emmena chez lui, le fit bien disner, & decida par ce moyen le different qui l'embarrassait. Il s'en est souvenu étant Pape, & fit du bien à ce marchand.[48]

was so poor that, one day when he had put together a few pence given him in charity, he went into a grill, but stopped to deliberate whether he should use his money for a meal, because he was hungry, or to repair his shoes, which were in tatters. As he was thinking it over, a merchant took notice of him, and asked what he was doing. He told him frankly that a contest was in process between his belly and his feet, both of which were in need of assistance. He said this so cheerfully, and the merchant was so impressed with his wit, that he took him home, gave him a good dinner, and thus settled the problem that was bothering him. He remembered that incident when he was Pope, and rewarded the merchant many times over.

That is a legend with a thousand versions, a fable so elderly and attached to so many names, imaginary as well as real, as to be worthless on the face of it. Stories about Sistine ferocity also seem to have had a particular vogue. Leti tells with deep relish how the Pope dealt, early in his papacy, with a Spaniard who, having some notion that a Swiss guard had insulted him, clubbed the fellow over the head and killed him. Sixtus, we are told, would not sit down to breakfast till the murderer was stretching his rope on an improvised gallows in front of Saint Peter's, but then he ate with special relish, saying that it improved his appetite to see prompt justice worked on such a rascal. Rome knew the wretched Spaniard was hanged before they knew of the murder he had committed.[49] This sounds like a "good story" of

48 De Thou, *Perroniana et Thuana*, p. 361.

49 Leti, *Vita di Sisto* V, II, 196–201. Sixtus's stomach for his vittles thus became a theme for Pasquino's wit. A cartoon showed the sly fellow groaning under a tub full of chains, wheels, axes, and instruments of torture. Asked by Marforio what he was up to, Pasquino explained that he had a new tonic for the Pope's appetite (*ibid.*, p. 202).

the sort that Leti was perfectly capable of making if he couldn't find it. But there is a truth behind or around it. Gregory XIII had been a lax and therefore a popular Pope. Sixtus inherited from his administration not only a mass of civic corruption but a custom of open contempt for the law by "gentlemen" with powerful protectors and by outright bandits and brigands. These two groups, as often happens, shared each other's tastes and imitated each other's manners. The peremptory justice of the Pope was the foundation for his equally ruthless policies of taxation. And out of that grew not only safety and prosperity for the papal states, and international respect for the Pope himself, but that building program which was the marvel of Europe. In this last respect at least, Leti does Sixtus justice—in the final five years of his sixth decade, the Pope really did do more for Rome than the emperors did in five centuries.

So that Leti had a magnetic subject in Sixtus, a hero who was generating legends in his lifetime and getting traditional stories attached to his name. But what he made of this hero was something very much of his own. Without difficulty, one could tell the story of Sixtus as that of a man who used himself up in the service of his church, but for Leti he is the exact opposite—he is a man who despised the institution he professed to serve, using it for his own ends, and with absolute cynicism. Leti glorifies in Sixtus the spirit of a cuckoo bird within the church, a raucous, single-minded, muscular animal, intruded illegitimately into the nest, and strong enough, shrewd enough, to drive out by brute force the legitimate scions. The bastard is a child of nature; Sixtus's primary nature was for Leti an unbridled appetite, a lust for power which met and passed its supreme test during that thirteen-year masquerade when it had to pretend to be its exact opposite. Natural shrewdness, says Leti, makes use even of Christian asceticism and humility for its own aggrandizement; it is the secret red thread that runs unbroken through the twists, turns, and apparent contradictions of a man's public life. Though he looked far and wide, high and low, Leti never found another subject with dramatic interest equal to that of Sixtus the Fifth.

The subject was made to his order, or he had no trouble in making it fit. Leti, in the rich scenes of his story, is one rogue telling the story of another with a kind of vengeful glee that's almost contagious.

1. Mantegna, "Wisdom Victorious over the Vices."
Courtesy H. Roger Viollet.

2. Mantegna, "Parnassus." *Courtesy H. Roger Viollet.*

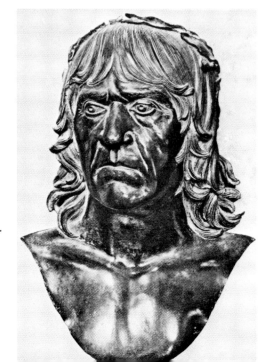

3. Portrait Bust of Mantegna.

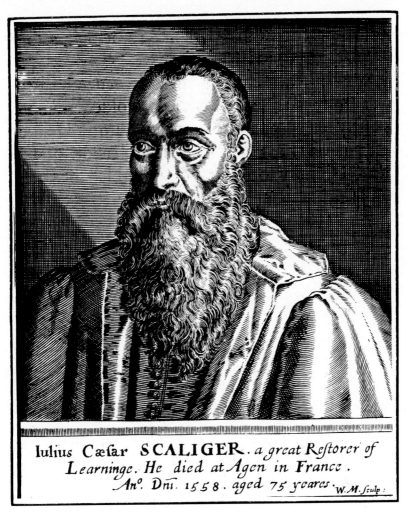

Iulius Cæfar **SCALIGER**. *a great Reftorer of Learninge. He died at Agen in France. Anº. Dñi. 1558. aged 75 yeares.* W.M.ſculp:

4. Portrait of Julius Caesar Scaliger. *Courtesy Huntington Library.*

5*a*. Palladio, San Giorgio Maggiore, Section.

5*b*. Palladio, San Giorgio Maggiore, Plan.

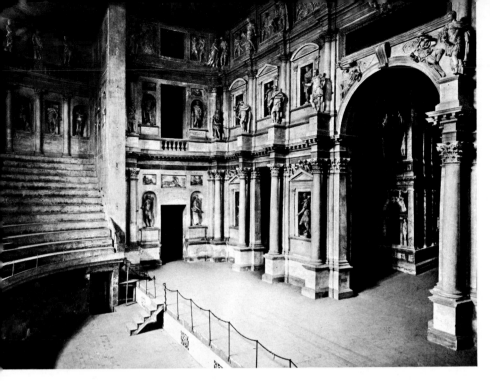

6. Palladio, The Teatro Olimpico, Vicenza. *Fratelli Alinari.*

7. Palladio, San Giorgio Maggiore, Facade. *Fratelli Alinari.*

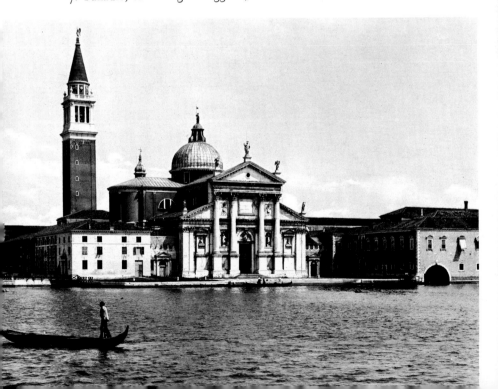

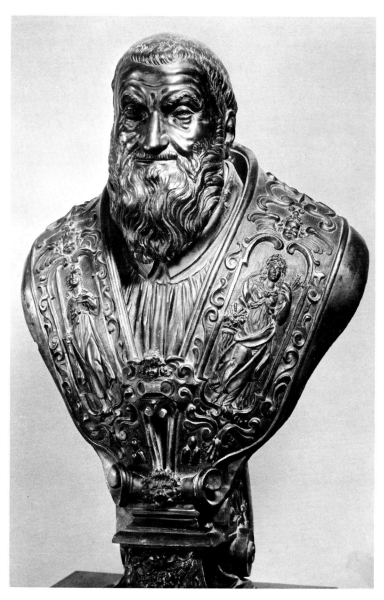

8. Portrait Bust of Pope Sixtus V. *Fratelli Alinari.*

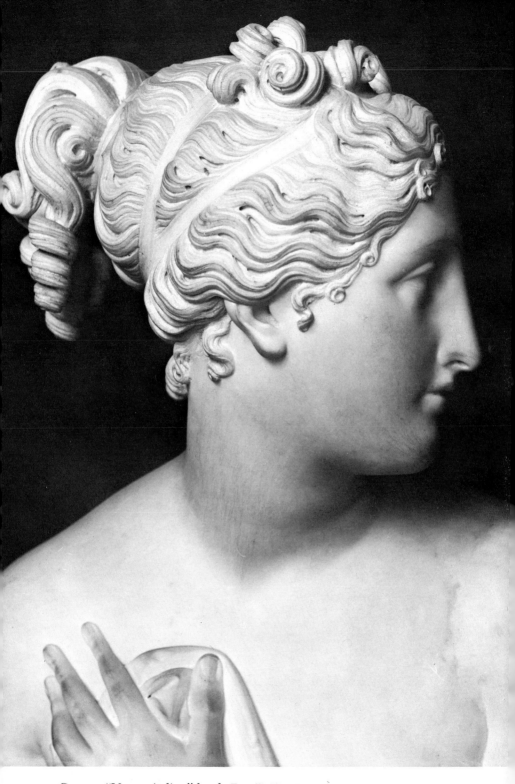

9. Canova, "Venere italica," head. *Fratelli Alinari*.

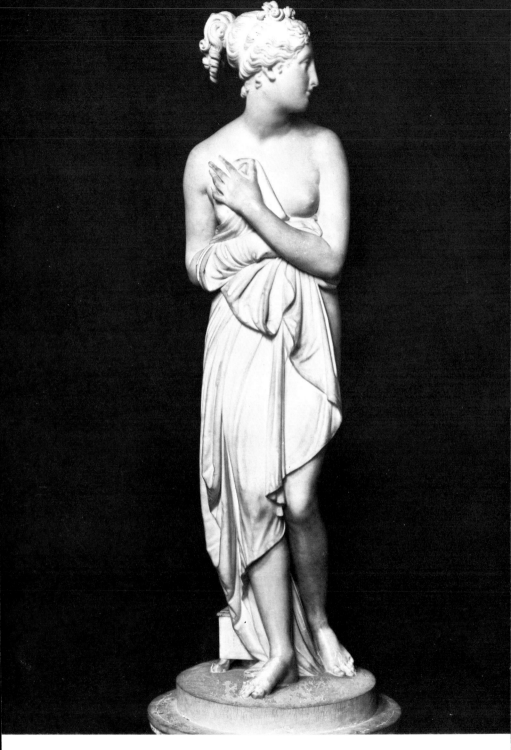

10. Canova, "Venere italica," full figure. *Fratelli Alinari.*

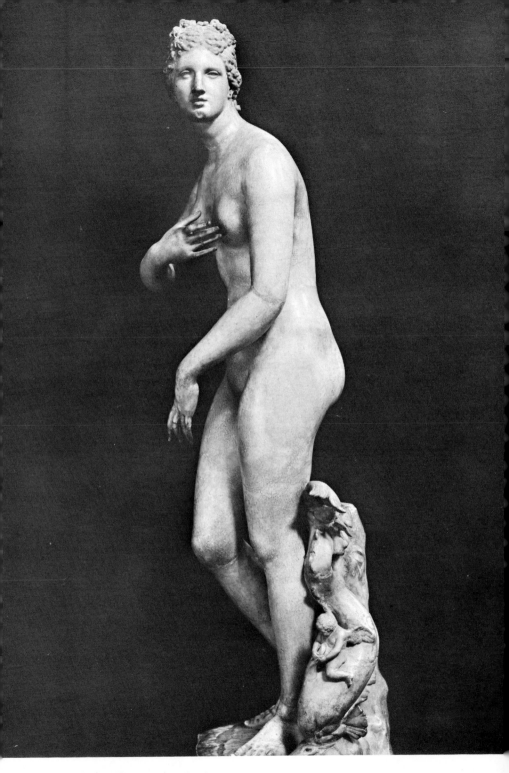

11. The Medici Venus. *Fratelli Alinari.*

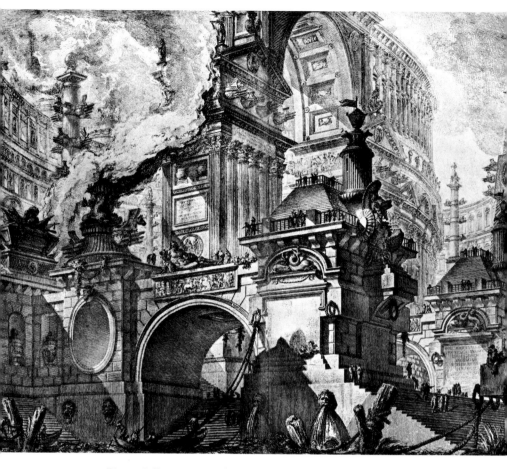

12. Piranesi, Perspective of a Monumental Port.

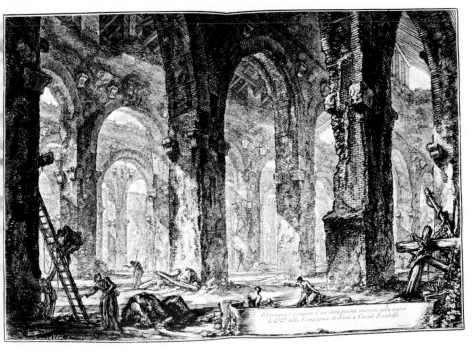

13. Piranesi, Cistern from the "Antichità d'Albano."
Courtesy Metropolitan Museum of Art, Rogers Fund, 1941

14. Piranesi, detail of figures.

15. David, "The Oath in the Tennis Court."
Courtesy Cliché des Musées Nationaux

16. David, sketch for "The Rape of the Sabine Women."
Courtesy Cliché des Musées Nationaux

17. Daumier, "Menelaus Coming Home with Helen."

18. Daumier, "Hercules in the Augean Stables."

19. Clodion, "The Kiss of the Satyr."

20. Albert Moore, "Quartet."

Naturally, he has handy all the threadbare platitudes of moral self-approval; he tells us, with an air of lavish complacency, that he is no mercenary of Rome, but a free man, free to respond to Reason—an Honest-John ploy that leaves the air thick with suspicion.[50] He can even advertise, with the brassy assurance of a patent-medicine barker, that his story contains useful hints for one and all. Princes can learn from it how to run a country, churchmen how to rule the church, statesmen how to manage their business with "politica," ambitious men how to rise in the world. . . .[51] We are forced to accept the goals as equivalent because he refuses to distinguish them.

He is a vulgarian's vulgarian, who will not even take the trouble to write well, but for what it's worth he does admire energy, which is a law to itself; and because of that genuine admiration, he can often sketch a good scene. He sees Sixtus V as another Leti—a clever and "natural" (i.e., genuine) outsider, caught in a world of artifice and forced to make its conventions serve his own "natural" ends. The theater is Rome, both the city and the pontificate; and Leti does not allow his hero much more respect for the one than for the other. In the matter of the city, at least, he is partly right. Sixtus did rip apart the famous Septizonium of Severus and demolish the outworks of Diocletian's baths, despite grumblings from the Roman populace, in order to mine cheap marble for his various constructions. The big obelisk he put up in Saint Peter's square had to bear two separate boasts that he had redeemed it from the wicked uses of paganism and given it a Christian function.[52] Unable to do anything else with the columns of Trajan and Marcus Aurelius, he capped them with Christian saints, as if his power, when it could not be exercised any other way, must find expression in a gross incongruity.

[50] *Ibid.*, p. 3.
[51] *Ibid.*
[52]

SIXTUS V PONT. MAX.	SIXTUS V PONT. MAX.
OBELISCUM VATICANUM	CRUCI INVICTAE
DIS GENTIUM	OBELISCUM VATICANUM
IMPIO CULTU DICATUM	AB IMPIORA SUPERSTITIONE
AD APOSTOLORUM LUMINA	EXPIATUM
OPEROSO LABORE TRANSTULIT	JUSTIUS ET FELICIUS CONSECRAVIT
A.D. MDLXXXVII Pont. II.	A.D. MDLXXXVI Pont. II.

If the brief period of his papacy imposed a distinctive tonality on Rome ("Sistine Rome" is a term the like of which exists for no other Pope), it came at a price.

Yet one has to have a very prim idea of Rome not to recognize that Sixtus V, far from being simply Leti's brutal child of nature, was an authentic fulfillment of the Roman spirit. His impulse was to get things done, and when issues like that were involved, it wasn't in the Roman nature to be archaeologically careful of anything, even Rome. They were constantly cannibalizing their own city, building new structures on old foundations, using bits and scraps of the past to make something useful for the present. Du Bellay saw this quality in them, and his lines might almost be thought prophetic of Sixtus' spirit:

> Regarde apres, comme de jour en jour
> Rome fouillant son antique sejour
> Se rebatist de tant d'oeuvres divines.
> Tu jugeras que le démon romain
> S'efforce encor d'une fatale main
> Ressusciter ces poudreuses ruines.
> *Antiquitez*, XXVII

> Then also mark how Rome, from day to day,
> Repairing her decayéd fashíon,
> Renews herself with buildings arch and gay;
> That one would judge, that the Romane daemon
> Doth yet himself with fatal hand enforce
> Again on foot to rear her pouldred corse.
> (Spenser trans.)

Like Sixtus, they were a people of no origins. Only a society of nobodies would have accepted without hysterical laughter the genealogy that Virgil contrived for them. Even imperial dignity was unequal to the task. Suetonius tells that some author or other tried to flatter Vespasian by deriving the house of Flavii from a companion of Hercules, whose monument he said was to be seen in Via Salaria; but the Emperor *irrisuit ultro*, laughed him, I suppose, out of court.[53] What was true of the Emperor was even truer of the citizens. They

[53] Suetonius, "Vespasian," 12.

were of plebeian, or immigrant, or even servile stock, to such an ex-
tent that it became a saying: Rome took them in as slaves and sent
them out again as Romans.[54] Their style in all things was aggres-
sively eclectic; they built with the same impatient, authoritative
haste as Sixtus, with the same ruthlessness toward what already en-
cumbered the ground, and with the same insistent economy of mag-
nificence. No work was too great, too difficult, or too expensive,
which would make the requisite splash; but it must be a long-term
splash. With regard to luxury and personal display, Sixtus was so
severe that at his death a crowd of riotous Romans attacked his
statue in the Campidoglio and hauled it down.[55] But for a work of
"magnificenza," a work which would last and carry his name down
through the ages, he never spared a scudo.

Leti sees this story of Sixtus as a masquerade, the humility of a
Christian serving as false face for "natural" greed, violence, and
ambition. But "nature" need not be defined so narrowly—or, if his
personal predatory instincts were Sixtus's first nature, the church in
which he spent his whole life was something like a second one. That
church, which followed the kingdom, the republic, and the empire in
settling on the seven hills, stood in relations of intricate rivalry with,
as well as succession to, its predecessors. The Pax Romana into which
Christ was born foreshadowed the coming of the Prince of Peace but
also stood as a reproach to the squabbling, chaotic state of Christen-
dom. The basilica of Saint Peter, upon which Sixtus triumphantly
placed the crowning cupola envisaged by Michelangelo (though
Sixtus or his architect managed to change the design completely),
stood on ancient foundations, subjugating yet fulfilling an ancient
temple of Apollo, and carrying in its very name "Vatican" a memory
of the "vaticinia" or prophecies accomplished by Apollo's priests.
Sixtus can scarcely have failed to see in ancient Rome a mighty civi-
lizing force which prepared the way for the church and found its
ultimate meaning in the church. From his point of view, Roman
columns were not really complete till capped with Christian saints;

[54] Montesquieu, *Considerations sur les causes de la grandeur des romains
et de leur decadence* (Paris, 1815) Cap. XIII, citing Tacitus 13 and Dion Halic.
4.

[55] Leti, *Vita di Sisto* V, II, 474.

and his furious authoritarian energy was not simply careerist, but a fulfillment of his double role as *imperator* and *flamen*. He was no cuckoo bird; he fulfilled a major part of the Roman spirit, and the spirit of his church, precisely by being imperial. He did not need to be a cuckoo bird, because all the things he wanted to do could be done in the character of a strict yet loving father; and a father was precisely what he proclaimed himself: father of the city, father of the papal state, father of the church. If they had let him, he would not have hesitated to become a stern paternal authority to all the princes of Europe. He was Roman in taking the civilized world as his family.[56]

Because he was a pope, and a brief pope at that, his political and social reforms were written on water; because he was the sort of pope he was, he left no spiritual or intellectual mark. But his work in stone was indelible; it endures to remind us that the best aspect of his Roman *terribilità* was a very Roman *magnificenza*, an amplitude of building that was purely his own, and Domenico Fontana's only as he became the instrument of Sixtus.

Of course money was one of Leti's main motives for writing a travesty of the life of Sixtus V. He was poor all his life, and the list of titles that streamed from his pen during the few years before he fastened his biographical claws on a sixteenth-century Pope provides a measure of his desperation. In 1666 he produced, under the neat pseudonym of Giulio Capocoda, *Gli amori di Carlo Gonzaga e di Margherita della Rovere*; in 1667 it was *L'istoria di donna Olympia Maldachini Pamphili, che governò la chiesa nel Ponteficato di Innocenzo X*; and in 1668, it was one piece of burlesque and one of open pornography, *Il sindicato di Alexandro VII con il suo viaggio nell'altro mondo* (did Byron make use of this for his *Vision of Judgment?*) and *Il puttanismo romano, o vero conclave generale delle puttane*

[56] Baron Julius Hübner's three-volume biography of *Sixte-Quint* (Paris, 1870) is rich in background materials regarding the state of Italy, the condition of Rome, and the entire intricate network of European politics at the end of the sixteenth century. Being concerned neither to demean Sixtus (as Leti was) nor to redeem him (as Tempesti was), it provides a useful corrective to both earlier volumes, and is made even more useful (for those to whom the politics of the age are of primary interest) by the presence of numerous original documents.

della corte, per l'elettione del nuovo Pontefice. Then, as we tick off his motives, malice is not to be neglected. Like many other apostates, Leti could never let the church alone, he had always to be worrying it and by implication justifying himself. This was an activity of which he never tired, and he is so barefaced about it that one cannot even accuse him of bad faith. What's to be said of a man who publishes his "private correspondence" (only in fact it is a plum pudding of scabrous advice to the lovelorn, formal essays arbitrarily chopped up into pretend-letters, and polemical exercises)—publishes them, and under a title like the following!

> Lettere di Gregorio Leti, sopra differenti materie, con le proposte, e riposte. Da lui ò vero à lui scritte nel corso di molti anni, dà ò à, Prencipi, Titolati, Ambasciatori, Ministri di Stato, Nobili, Consiglieri, Cardinali, Arcivescovi, Vescovi, Abbati, Religiosi d'ogni Grado, & Ordine, Accademie, Letterati, Mercanti, Cittadini, Principesse, Dame, Monache, & altre Persone, che la discrettione permette, che siano publicate [(Amsterdam, 1700), two volumes].

He bestowed his friendships as carefully as his enemities, knowing full well how much harm each was capable of doing; and was lavish in his admiration of Sixtus, being aware that each word was as a serpent's fang sunk in the Pontiff's memory. Kidnapping Sixtus V into the camp of nature—making of him a kind of papal Pietro Aretino—was deep polemical fun; in addition, it gratified Leti's itch to get at the inside story, his passion to get the valet's version of a hero in front of his public statue. But after discounting all these motives, another reason remains for the wholesale face-lifting which this clever, cosmopolitan, unscrupulous fellow imposed on Sixtus the Fifth, and that is simply a kind of historical distance with which his mind couldn't cope. In the years since Sixtus had come to maturity, the model of Rome had become more familiar, more domestic, more civilized.[57] Men like Palladio had made it so; the triumph of Renaissance educational ideas, like a good many other "triumphs," had

[57] What we are making toward is that scene in *The Vicar of Wakefield* (chap. 16), where the vicar's family demands to be represented in a collective domestic portrait under the aspect of various classical personages—the vicar's wife as Venus, the kids as cupids, Olivia as an Amazon, Sophia as a shepherdess, and the vicar himself in clerical garb, with his book in his hand.

amounted to an adjustment, a compromise, a running quarrel. Using the classics to "polish" contemporary mores produced mutual friction, and something rubbed off both parties to the transaction. When Leti wrote, the vogue of the eighteenth-century middle class for Horace was just around the corner. One has only to look at the chaffy, familiar dealings of Dryden with the classic authors to sense an immense change in the cultural weather. The classical world had been, in fact, desanctified, desacramentalized. Familiarity had bred something like contempt; in addition, the emasculation occurred that takes place, inevitably and unintentionally, when a culture is used as a model. Perhaps for Leti, who was something like a freethinker before the term became popular, the whole world had been desacramentalized; seeing things that way, he found it easy to think the Roman church had been nothing to Sixtus but a hypocritical mask for natural greed. But that wasn't it at all. We learn from Tempesti that Sixtus brought to his devotional duties, private as well as public, the same frantic energy that he brought to everything else in his papacy. People called him another Nero, but if anything he was an anti-Nero, who erected obelisks all over Rome only so he could top them with the emblem of Christian humility.[58] He was far and away the most arrogant exponent Christian humility ever had. He wasn't a hypocrite because he didn't need to be. What desires that he could have fulfilled in some other sphere did the papacy force him to repress? In trying to kidnap him out of Rome and the church, Leti simply showed what a narrow and shallow conception he had of both. His book is the biography of a lion as written by a weasel.

Straightforward cross-cultural kidnapping, such as Palladio underwent at the hands of Trissino, is the more frequent pattern; one last, well-known example may stand for many others. Nicolas Pous-

[58] Tempesti, *Storia della vita e geste di Sisto Quinto*, I, viii, 12; I, xiv, 20–21. "Fece ciò Sisto [says Pansa, referring to the raising of the first great obelisk] mosso da vero zelo di religione, acciocchè al suo tempo non si vedesse vestigio alcuno d' idolatria in Roma, e perchè la Croce santa, vera trionfatrice della terra e del cielo, fosse esaltata & riverita in più luoghi pubblici di essa" (Sixtus did this out of pure zeal for religion, so that no vestige of idolatry might be seen in Rome, and so that the holy cross, true victor on earth and in heaven, might be exalted and revered in public places, above the idols). The comparison with Nero is from the manuscript cited by Tempesti as "L'Anonimo Vallicellano."

sin was a miserably poor young man from Normandy who was wandering about the countryside of northern France during the early seventeenth century, painting tavern signs for his supper. He had a blind intuition that Rome was the place for a painter to go, and twice tried to get there; but sickness and poverty stopped him short, and he was struggling desperately in Paris when, in 1622, he became known to Giovanni Battista Marino, the famous *concettisto* who had followed Marie de Medici to the French court. Marino not only exposed Poussin to classical literature and the classic art of the Italian Renaissance, not only commissioned him to do a series of illustrative drawings on classic texts, but financed a trip to Rome and there arranged introductions to Cardinal Barberini, the Pope's nephew. It was a tremendous lift for a young man who needed it tremendously; for the rest of his life Poussin lived in Rome, returning only once, briefly, to Paris, in response to urgent solicitations from Louis XIII, but escaping to Rome again as soon as he decently could. His gratitude to Marino he expressed in an elegant, erudite painting (presently in the Prado), showing the poet in the act of being crowned by Apollo atop Parnassus hill.[59]

About the development of Poussin's artistic career there is no need to speak in detail. What he wanted from antiquity was neither a specifically "classical" style nor detailed images of antiquity. Instead of copying directly, he aimed to absorb the classic experience, to make it part of himself. The classic world, literary and mythological as well as artistic, was allowed to suggest moods and modes which he slowly assembled toward a "Maniera Magnifica" which was completely his own; to adapt Reynolds's phrase, he naturalized himself in the antique. For the atmospheric landscapes, so mysterious and quiet, in which he immersed his fables, he had no proper classic precedent at all; but the adjective "heroic," so often applied to the merely grandiose, seems here to take on its full dimension. The late Poussins are indeed "heroic landscapes." Their richness is the fruit of an imaginative indirection which he cultivated deliberately; it was from a treatise on ancient music that he derived concepts of tonal harmony within modal unity which ripened toward his own sym-

[59] Walter F. Friedlander, *Nicolas Poussin* (New York, 1966), p. 45, citing Panofsky.

phonic style.[60] In his mature work Poussin is continually suggesting a poignant mortality, a melancholy of the grave; as if he were holding in meditative momentary balance nothing less than life and death. But this ripe poise would never have been possible without that original act of visionary boldness on the part of the Cavaliere Marino. Young Poussin, like young Palladio, was more than ready to be kidnapped; but without the decisive early intervention, it seems unlikely that either would have attained to that serene kingdom of the noble imagination to which even Sixtus the Fifth had better access than Gregorio Leti will allow him.

[60] *Ibid.*, p. 35, citing Sir A. Blunt.

IV

WAR

When the Roman world is remote from that of everyday, and accepted as superior to it, abrupt acts of individual imaginative redefinition may be necessary to get into it or out of it. Men redefine their selves in Roman terms, or challenge the genuineness of someone else's Roman self, by a kind of psychic violence for which I've invoked words like "rebirth" and "kidnap." But war, in this context, is not violence; it is organization. When the battalions are lined up against one another, one can change allegiance by simply changing uniform or slogan; there is no need to tamper with one's sense of self. Warfare between the ancients and moderns became possible only when the gap between the two parties had lessened, so that they represented, not existential alternatives, but differing styles of thought and feeling in a contemporary framework.

Even at its most ferocious, it was only paper, that is, mimic warfare and for the most part it consisted of desultory, long-range sniping and signaling, with the participants more concerned to show off their own parts than to win a victory. Still, one's first innocent question about the whole affair—*Why did it happen?*—turns out to lead very close to the heart of things. From our special point of view, the advocates of the ancients seem like the most intriguing figures in the quarrel; surely among them we may look for those radical, imaginative tempers which boldly identified with the ancient world against their own times, their own experience. There is bound to be some-

thing paradoxical about a man who denounces his own time as degenerate; surely *he* must be at least a partial exception to the rule he so loudly proclaims? He must therefore be, temperamentally or spiritually, a noble ancient born out of his time, among degenerate moderns. But in fact the authority of the ancients, which their modern apologists uphold, is not really the authority of the ancients in antiquity; it is their authority as a contemporary cultural guide. In that matter, the position of their supporters is apt to be dictated, not by imagination or distant vision, but by recent tradition. The supporters of the ancients may thus be more modern, more deeply conditioned by modern conventions of understanding antiquity, than the avowed moderns themselves. What is "modern," after all? In terms of Roman antiquity, anything of the last five hundred years is modern; in terms of classical scholarship, only the work of the last fifteen or twenty years can be called "modern." The supporters of the ancients were sometimes committed to what they understood to be the most recent, modern scholarship in the field of classical studies. Either because they didn't have any classical scholarship at all, or because they were far ahead of the classical scholarship of their day, the unlearned were sometimes able to take a more creative view of classical antiquity, and of themselves in relation to it.

Boileau and Perrault

Generally, ample justice has been done to the foolishness of the quarrel between ancients and moderns which broke out in late seventeenth-century France after smoldering quietly across Europe for better than a century. The French flare-up was a six-alarm blaze while it lasted; but it lasted hardly seven years (1687–1694). And after the excursions and alarums and counter-forays had subsided, after the epigrams had ceased to whizz, and Monsieur Perrault had undergone ritual reconciliation with Monsieur Despréaux through the mediation of *le grand Arnauld*—after it was all over, even the combatants began to look around and wonder what all the fuss had been about. Writing a good many years later, the Abbé Conti described how the whole incident looked in retrospect:

Quand je suis venu à Paris pour la première fois, on disputait avec
la même ardeur sur l'Iliade d'Homère que sur la Constitution de
Clément XI. Les partisans des Anciens et des Modernes étaient
aux mains, et je comparais volontiers leurs disputes aux combats
des Troyens et des Grecs qui à la prise de Troie se battaient dans
les ténèbres, sans se connaître et sans savoir où ils allaient ni ce
qu'ils cherchaient. En effet, n'ont-ils pas disputé sans la connaissance
du grec, sans règle fixe de poèsie, et sans avoir aucun égard aux
moeurs des siècles et à l'histoire littéraire? [1]

When first I came to Paris, people were disputing over the *Iliad*
of Homer as violently as over the Constitution of Clement XI.
The partisans of the Ancients and the Moderns were hard at it,
and I enjoyed comparing their disputes to the battles of the Greeks
and Trojans who fought in the dark when Troy fell, without know-
ing friend from foe, or where they were going, or what they wanted.
Didn't they, in fact, argue without knowing any Greek, without any
standards for poetry, and without having the slightest regard for
the different customs of the ages or for literary history?

And D'Alembert was even more cutting, dismissing the whole quar-
rel as a "dispute aussi peu utile que presque toutes les autres, et
[qui] n'a rien appris au genre humain, sinon que Madame Dacier
avoit encore moins de Logique que Monsieur de la Motte ne
sçavoit de Grec" [2] (a dispute as useless as any other, and which
taught the human race nothing except that Mme. Dacier had even
less logic than Monsieur de la Motte knew Greek).

Neither nature nor scholarship loves a vacuum, however, and
it is clearly intolerable that a controversy should be judged alto-
gether meaningless and silly which dragged out over two hundred
years, and during its much briefer explosive phase absorbed the
energies of the foremost men of their age. How to explain so much
ado about an issue that came so close to amounting to nothing?
For the first methodical historians of the quarrel, the problem was
not hard of solution. M. Rigault in France and Professor Jones in

[1] Cited by Raymond Naves, *Le goût de Voltaire* (Paris, 1938), p. 7.
[2] Jean D'Alembert, "Eloge de Terrasson," *Oeuvres* (Paris, 1821), III, 374.

America [3] (the latter more explicitly than the former) saw in the revolt of the moderns against the ancients the liberating impulse of modern progress and modern science against the paralyzing influence of two closely linked and complementary concepts. These were the academic doctrine that the ancients provide in all things an ultimate model of perfection, which moderns may hope to imitate but not surpass; and the quasi-theological doctrine that the world is in a state of radical decline and decadence from which it cannot hope to escape. Released from the shackles of these two inhibiting creeds, the exponents of "modern" views paved the way for a concept of progress in the full implications of which they could not participate, but which nonetheless bore fruit in—and at this point one gestured largely at the surrounding cosmos.

But there were bound to be complications lying in wait for a view as simplistic as this one. At a first approximation, it made the "moderns" look perceptive and intelligent, while leaving the "ancients" no motivation but obtuseness and superstition. Perhaps so, but the scheme was hard to reduce to specifics. If the issues were that clear, why did the war last so long? Then Professor Baron in an important article [4] proved largely that the doctrine of *imitatio*, imitation of the ancients, had been modified many years before Perrault and Boileau began exchanging insults, in the direction of *aemulatio*, or striving toward equivalency. All sorts of political and cultural issues were involved in this changeover. It had to be recognized that the vernacular languages were not inherently inferior to the learned ones; it had to be accepted that perennial Rome was neither a practical nor a desirable ideal, that Florence, Venice, or France might be for their citizens what Rome had been for hers. And it had to be felt that artistic achievements, such as Brunelleschi's dome or the paintings of Giotto, no less than political and economic accomplishments, might entitle a city like Florence to challenge comparison with ancient Greece or Rome. And all these

[3] Hippolyte Rigault, *Histoire de la querelle des anciens et des modernes* (Paris, 1856); R. F. Jones, *Ancients and Moderns* (Berkeley and Los Angeles, Calif., 1965), *passim*.
[4] Hans Baron, "The *querelle* of the Ancients and the Moderns," *Journal of the History of Ideas*, XX (1959), 3–22.

positions had been worked out and established, if not triumphantly, at least defensibly, long before 1687.

As for the decay and decadence of the world, that doctrine didn't have to be confronted directly, as it was in the course of the seventeenth-century quarrel by those embattled moderns who asked jeeringly if the trees had grown taller in ancient Rome. (The argument was that if nature had not degenerated perceptibly in her power to produce tall trees, there was no reason to suppose her power to produce great men had diminished either.) Long before the encounter of Boileau and Perrault, men had learned to dispose of the modern world's alleged decadence by spreading and dismembering it. All nations and cultures (men were accustomed to say as early as Machiavelli) experience periods of growth, maturity, and decline. Loys Le Roy in a 1575 treatise *De la Vicissitude ou Variété des Choses* [5] set forth a fullfledged cyclical view of history, urging on the one hand that what goes up must come down, but adding a note of enthusiastic optimism in that emulation may lead men who know what other cultural cycles have achieved to outdo them. Vasari, confronting the history of painting after Michelangelo, and Sperone Speroni, theorizing on the history of languages, asserted cyclical views of cultural development and decline a full century before the *Querelle* broke out.[6] And these ideas were widely diffused and imitated. Montaigne speaks of cultural cycles as well known; Du Bellay, in his *Deffence et Illustration de la Langue Francoyse*, simply translated sections of Speroni; Hakewill in England, at the very moment when twentieth-century historians describe him as sounding the tocsin to assault the bastions of classical authority in the name of "modern" thinking, was simply translating a passage of Vives.[7]

Professor Baron thus showed that much that the first historians of the quarrel had thought startling fresh and original in the thinking of the "modern" partisans was already deeply rooted in Renaissance thought. And there's really no withstanding this position. (As a principle of prudence, one is always safe betting on a historian who says in effect, "What you think new and original is really much

[5] *Ibid.*, pp. 8–10, 12. [7] *Ibid.*, pp. 13–14, 21.
[6] *Ibid.*, pp. 12, 20.

less so than you suppose.") But the success of this gambit still leaves open, if it doesn't widen, the question of what all the stir in the quarrel was about. If both sides took traditional positions, either in basic agreement with each other or reconcilable in traditional ways, what was all the shooting for?

One concept that definitely emerged from the dispute, though it scarcely seems earthshaking, was a new categorizing of the arts. The point was made by Professor Kristeller in a separate and earlier article [8] describing the growth and gradual consolidation of a distinction between the sciences, which build on previous experiments and discoveries in a truly sequential manner—and the arts, which are far more a matter of independent personal achievement. It need not be maintained that the distinction is or ever was of the hard-and-fast nature; but it does answer to a certain rough difference in the activities. Any reasonably intelligent person who devotes a year or so to the task can learn more mathematics than Euclid or Pythagoras knew; there is no real way that the successors of Homer or of Michelangelo can pick up where those titans left off. In the sciences, progress of a sort (not automatic, not universal, not unconditional, not even necessarily unambiguous in its social import) can be demonstrated; in the arts, not so. And to this real, if not terribly useful distinction, the quarrel between ancients and moderns undoubtedly contributed. Still, it doesn't seem like much to have fought a literary war about, more like a by-product or a compromise than a *casus belli*. And this is true of a great many other differentiae between the combatants. We can discover and enumerate points of difference, but often they turn out to be matters that were fought out, or at least fought over, a century or more before Perrault engaged Boileau. The pastness of the past, the sense that Greek and Roman cultures were essentially foreign cultures, to be studied in their own right and in terms of their own natures, not moralized for the precepts and examples they could furnish for the guidance of the modern student: this was an important perception that grew out of the ancients-versus-moderns quarrel. Yet it was more than a century old; it was rooted in the perceptions of the

[8] P. O. Kristeller, "Modern System of the Arts," *Journal of the History of Ideas*, XII (1951), 496–527.

first Renaissance critics who began to look critically at classical texts and to study them as documents growing out of a time and place, using words which at different eras have different meanings.[9]

Maybe a better way to get at some of the issues involved is through a glance at the personal history of Charles Perrault, who did so much to stir up the sediment of ideas that had been settling since the early Renaissance, and so little to bring order and clarity out of them. He is an interesting fellow in his own right, son of a bourgeois translated to Paris from the Touraine, and involved all his life long with a pulsing, vigorous, versatile, and passionately cohesive family. There is no writing a biography of Charles Perrault; his chronicler does not even try, but takes as his theme "Les Perrault," which means Pierre Perrault *père*, Jean Perrault, Nicolas Perrault, Pierre Perrault *fils*, Claude, and the fifth son, Charles.[10] Boileau, who did not like any of the Perraults, once spoke slightingly of a "certaine bizarrerie d'ésprit" which they all shared, and drew down on himself a serious, not to say sententious lecture from Charles:

> Ma famille est irréprochable, et elle l'est à un point que je lui ferais tort, si je me donnais la peine de la justifier de votre calomnie. On n'y trouvera que des gens de bien, des gens de bon sens, officieux, bienfaisants, et amis de tout le monde.[11]

> My family is above reproach, and sufficiently so that I would wrong it in taking pains to defend it against your calumny. There is nobody in it but decent people, sensible people, kindly, generous people, and friends of humanity.

Fair enough; and absolutely right. But the answer didn't altogether meet the charge; a family consisting entirely of "hommes de bien"

[9] Throughout this discussion of Boileau and Perrault, I am indebted to the work of H. R. Jauss in the admirable introduction to his edition of Perrault's *Parallèle des anciens et des modernes* (Munich, 1964). The general direction in which critical thought moved after the ancients-versus-moderns controversy (if not because of it) was certainly very much as Herr Jauss describes it. For a sense of how close this position came to the premises of the first Italian humanists (Bruni, Valla, Poliziano), see the introductory chapter before Eugenio Garin's *Italian Humanism*, trans. Peter Munz (New York, 1965).

[10] André Hallays, *Les Perrault* (Paris, 1926).

[11] *Ibid.*, p. 4.

may nonetheless have a streak of kookiness, such as Boileau thought he detected, running through its solid texture of good sense, good intentions, and friendship to mankind. And the Perraults, when one looked at them across the board, did, sure enough, display a certain gift for ingenious, even inspired, kookery. They were versatile, they were restless, they were contentious. None of them possessed a single gift in overflowing measure; all of them exercised peculiar concatenations of callings; all seemed to feel especially restless in the presence of an accepted idea.[12] Pierre Perrault *fils* set the pattern. His career as a financial administrator in Paris had come to an abrupt, unhappy end when, with the best intentions in the world, he overdrew certain accounts and was asked to explain the deficits. Casting about for ways to fill the unexpected leisure that resulted, he found mankind complacently harboring a singular prepossession, of which, for their own good, he thought fit to relieve them. His little volume titled *L'Origine des Fontaines* (1674) argued that, far from fountains being the origins of rivers (as had too long and too easily been thought), rivers were the sources of fountains. Having undeceived mankind on this decisive point (on which, of course, he was partly right), he went on to display mediocre gifts as a literary critic and a translator of poetry from the Italian of Tassoni. Nicolas Perrault, though he died at the early age of thirty-eight, displayed equal versatility; he was a burlesque poet, a mathematician of some repute, and a theologian active in behalf of the Jansenist cause against the hated Jesuits; indeed he is credited with having inspired, at least indirectly, Pascal's *Provincial Letters*. Jean, the third Perrault brother, died too young to give evidence of the characteristic family versatility; but Claude had careers enough for two. He was a medical doctor (whether good or bad, there is some dispute), a biologist and physicist, whose publications in these fields were respectable as well as voluminous; an architect, responsible for the design of the colonnade and facade of the reconstructed Louvre; a translator and commentator of Vitruvius, an occasional poet, and

[12] Perrault's *Mémoires de ma vie*, extracts from which were published in 1759, 1826, 1842, and 1878, were finally given in their full form from the original manuscript by Paul Bonnefon (Paris, 1909).

an inventer of numerous machines and gadgets. And finally, there is Charles Perrault, youngest of the tribe, most turbulent, and in the end most famous.

Two stories are told about the youth of Charles Perrault, both indicative of something restless and undisciplined in his character.[13] He was sent to the Collége de Beauvais at the age of eight, where he proceeded to distinguish himself particularly as a composer of Latin verses. But one day, when he was still a very young fellow indeed, he quarreled with his tutor over a question of philosophy, was authoritatively silenced (after the manner of that distant day), and marched out of the class with a loyal supporter named Beaurain, never to return. For the next three or four years, Charles Perrault and his ally Beaurain studied together without a tutor, without guidance of any sort. There can be no question that they were intelligent and industrious boys; they read widely in the languages they already knew, but in a scattered and only half-organized way. And of course they didn't learn any new languages (such as Greek, for instance), or any disciplines apart from those in which they had already demonstrated an aptitude. Still, Charles Perrault was perfectly content (as autodidacts frequently are) with his own intellectual preparation. "Si je sais quelque chose," he wrote, "Je le dois particulièrement à ces trois ou quatre années d'études" [14] (If I know anything at all, it's owing specifically to these three or four years of study).

By way of exercising their burgeoning genius, the two renegade scholars undertook composition of a pseudo-Scarronic burlesque of the *Aeneid*, Book 6. Carried away by the exquisite wit and humor of the enterprise, a gaggle of other Perraults rallied to lend a hand; even Nicolas, the austere associate of Jansenists, was led to contribute. Having done all they could with the sixth *Aeneid*, they turned their attention to Homer, producing a burlesque entitled *Les Murs de Troie*; and this time they prefaced their joke with a statement of principles. It was the folly of imitating the ancients that they were out to attack; it was the "indecency," the "affectation," the "vulgarity" of the ancient authors that they proposed to make manifest, in order to deter their contemporaries from this folly.

[13] Perrault, *Mémoires*, pp. 20–21. [14] *Ibid.*, p. 21.

They were very cocksure young men indeed, and though what they wrote in the merry security of the Perrault enclave never circulated in the public press, it was not for that reason any less significant as a manifestation of an attitude.

Many years later Jonathan Swift, imagining a controversy between a spider and a bee as a means of imaging forth the dispute between moderns and ancients, had the latter accuse the former of being content with "a lazy Contemplation of four Inches round"— of being complacent, in other words, because content with the applause of a coterie all agreed in advance to admire one another.[15] The Perrault family circle merited this satiric lash as much as anyone, had they ever been made aware of it. Charles, the self-taught youngster of the family, arranged for his own self-taught graduate program; to spare himself effort and uncertainty, he had himself proclaimed advocate by some numb-brained incompetents at the Université d'Orléans, and then picked up the rudiments of law "on his own." Clearly, he had a ready wit and a way with words; he also had influential brothers, one of whom (Pierre) provided for him the shelter of a sinecure in that financial office which ultimately crumbled underfoot. In the meantime Charles Perrault had had ten years of happy leisure to cultivate (under his brother's aegis) important and influential persons, to write a good many bad verses, and to read, unhampered by program, instructor, or an overpowering sense of reverence, in his brother's excellent library. The ideas he found as a child, in the cheery family circle or as a runaway collegian with Beaurain, took root and grew in his mind without having encountered any criticism more rigid than what his brothers were disposed to give them. And that wasn't much.

That he was a clever man and an agile one, there was no denying. Given the smallest of toeholds, he made himself a niche in the entourage of the mighty Colbert, taking part in a whole galaxy of cultural, academic, and administrative enterprises for the greater glory of France. Colbert's enterprise consisted (if one may try to sum up a gigantic complex of revolution and counterrevolution with a metaphor) in trying to build a structure of economic walls and

[15] Swift, *Tale of a Tub*, ed. A. E. Guthkelch and D. N. Smith (Oxford, 1958), "Battle of the Books," p. 232.

columns under the already standing roof of a monarchy. The building had to be done, in short, not just to satisfy the builder's sense of convenience and seemliness but to satisfy the monarch's sense of his own dignity and importance, which was exorbitant. Architecture and academic enterprise thus walked hand in hand with, and remained carefully subordinate to, flattery. Puff and panegyric were the tools of Perrault's working life; his very existence as Colbert's assistant depended on making Louis XIV feel grand and civilized. Much of his work was done within what nowadays would be called a "ministry of culture"; it consisted of designing medals, inventing mottoes (*devises, imprese*), composing inscriptions, working out formulas of lapidary exaggeration. He was very good at this work—he tells us so himself.[16] He took part in architectural consultations, to decide which design of a building would best suit His Majesty's comfort and convenience while best expressing his particular glory. He was assiduous in attending meetings of the Academy, in articulating the ceremonial sentiments, in deciding which artist should be commissioned, which scientist pensioned, which antique statue purchased, or (failing that) reproduced in plaster cast for the benefit of art students in the royal institutes. He took an active part in the long, delicate intrigue by which Bernini was encouraged to disqualify himself as architect for the rebuilding of the Louvre, and one Claude Perrault was imperceptibly insinuated in his place.[17] For twenty active years, from the age of thirty-five to fifty-five (from 1663 to 1683), the life of Charles Perrault was dominated by a need for positive thinking about Louis XIV and his age. There is not the slightest reason to think him insincere in his professions; just as clearly, it was a kind of heuristic sincerity, which led him to praise Louis for being a certain sort of person as a way of encouraging him to be such a person. He practiced flattery, so to speak, in the imperative mood. And, what is pleasant to record,

[16] Perrault, *Mémoires*, p. 48: "la vérité est que j'ai eu du talent pour faire des devises." It was clearly true, but typical of Perrault to put it with such naïve complacency that the observation could either charm or infuriate.

[17] *Ibid.*, pp. 57.–86. It is a long story, but worth reading, especially for the climactic moment, in which Colbert deliberately selected the *wrong* design so that His Majesty could have the honor of choosing, by his unhesitating natural genius, the right one.

none of this high intrigue prevented Perrault from maintaining a simple and popular touch, as of a good bourgeois—witness the persistence, almost obstinacy, of his campaign to keep the gardens of the Tuileries open to the public. He was obviously one of that family he set forth in his riposte to Boileau, an *homme de bien, officieux, bienfaisant*, and all that sort of thing. And yet, wasn't there, in this lifetime of buying and selling culture, of middleman activities and pretensions to universal expertise combining with actual, personal achievement of the most mediocre character—wasn't there, in all this, something profoundly corrupting? There is one part of his life which is always treated as a thing apart, an almost extraneous afterthought, though it was responsible for much the best known of his productions. The Mother Goose tales, which he was the first to record from popular tradition and to put into artistically memorable form, seem radically out of key with the rest of his life. Of all the people in the world to write down fairy tales, one thinks. And yet behind them there can perhaps be felt a sense of relief, of self-discovery—if not a fulfillment of the public Perrault, then an escape from him. After a lifetime of playing Jack the Giant Killer, what a pleasure to relax, to agitate *la bagatelle*, to admit frankly that one is only Petit Poucet, Hop-o'-my-Thumb!

There is no occasion here to recapitulate the development of the ancients-versus-moderns argument, or to summarize the four volumes of Perrault's elaborate *Parallèle*. As everyone has seen, his case is weakest where it involves questions of taste and judgments of artistic value; strongest where it involves techniques and masses of observation that can be accumulated and refined.[18] His weaknesses are those that made themselves felt as long ago as *Les Murs de Troie*; and they are (in the old Irish bull) strong weaknesses indeed. Knowing no Greek himself, he yet undertakes to judge the merit of Greek poetry from translations, and not even good translations. He passes upon Homer and Virgil in terms of seventeenth-century standards of "correctness," and finds them, not surprisingly, deficient. He never

[18] Thus Perrault himself concedes that contemporary poets are far inferior to Virgil; but that just means that they don't have equal genius. By genius they are inferior; but the rules by which they work, the standards of their performance, are more distinguished. They may not be as good, but they're more correct: the man who takes that stance trembles on the verge of some very interesting discoveries (*Parallèle*, III, 153–155).

considers how Desmarets and Madame de Scudéry would compare on the score of energy, grandeur, poise (sublimity, in a word) with Sophocles or Homer. His mind remains tightly closed to the possibility that all that elegant correctness in which he glories may be destructive of the genius in which, he reluctantly concedes, modern poets fall short of ancient ones. He is insufferably complacent and provincial in affirming the taste and judgment of his own age as superior to those of any other. It is not simply that (generously conceding M. Chapelain's slight inferiority to Homer) he balances the scales by affirming that our modern "airs, chansons, et Vaudevilles" are unequaled; he goes on to find the *Astrée* more inventive than the *Iliad*, and a certain Jean Le Maistre comparable with Demosthenes.[19] Even the ages to come are not greatly to be envied, since they cannot hope to surpass appreciably the glories of the present era, the age of Louis XIV. Arguments like these are more an occasion for helpless laughter than for serious refutation; they remind one of Aesop's frog puffing himself up to be as big as an ox.

And yet, though one is always expecting poor Perrault to explode under pressure of his own flatulence, or the probing lance of Boileau's wit, he never does so. Where his case does not make itself for his advantage, he makes it in a blundering, graceless way; but he never ceases to make it. Partly this was just stubbornness, the immemorial gift of a Perrault for getting hold of an odd point of view and worrying it. But partly also it was because the idea he refused to surrender was not wholly absurd. In its simplicity, it yet has real power and authority. One can represent it worse than in the old proverb: A *live dog is better than a dead lion*. In effect, each present age, whether better or worse than the others (we can never decide this till it has had a chance to affirm and develop itself), has a right to take what it wants of the historic past and reject the rest. If classical antiquity holds us all in thrall, we cannot properly be answerable to that which, first and foremost, constitutes our selves. That is our immediate, personal response to things of the here and now.

Boileau's view of classical antiquity, like Sir William Temple's, was unitary and prescriptive. Classical authors were for him the

19 Perrault, *Parallèle*, II, 149–151, 204, 236.

supreme dignitaries of the human spirit, among whom a contemporary might presume to walk only at the full stretch of his most exalted vision. Like Machiavelli entering his library after a rowdy day among peasants and woodcutters,[20] Boileau and Temple assumed the ceremonial garments and inward reverence of a priest, before entering the august company. In the process, it was only natural to discount some inconvenient elements in classical antiquity itself, such as low humor, barbaric observances, odd sexual customs. Thus one disciplined contemporary taste by holding it up to the standard of antiquity, and disciplined antiquity in order to make it a better instrument of discipline. There is a curious sort of parallel-opposition here between Boileau and Perrault. Perrault located moral authority in Louis XIV, and tried with Procrustes' methods to extend it over the whole world of cultural affairs, so that Homer would be held to Madame de Maintenon's standards of *politesse*. Meanwhile, Boileau located the same sort of moral authority in the writers of classical antiquity and tried with Procrustes' methods to extend its control over modern sensibilities. The only real solution was a declaration of relative independence. It worked both ways. The modern sensibility was freed to recognize its own interests and feelings, to develop its own standards of dignity and harmonic poise. Further, when antiquity was not required to serve as a single, uniform standard and model by which the entire human cultural enterprise was to be measured, one was free to appreciate it as a product of a particular place and time, to recognize the specific differences between this classical poem and that, and to appreciate their different positionings in the cultural cycles of Greece and Rome.

A major ground of dispute involves the question of Homer's tone. Perrault, looking at the Homeric heroes with seventeenth-century eyes, finds them a pretty crude collection of fellows, swaggering, greedy, boastful, dishonest. Conceding that different ages have different standards of behavior, he nonetheless suggests that if Homer is to provide a model for contemporary authors to imitate, it had best be a model of burlesque style.[21] Far from exemplifying classic dignity and heroic worth, Odysseus and Achilles are so un-

[20] Cf. above, chap. I, n. 27. [21] *Parallèle*, III, 32 ff.

couth at times that, to a properly civilized eye, they are actually
funny. Boileau's response is a flat contradiction; if Perrault only
understood a little Greek, he would see how dignified and heroic the
Homeric heroes actually are. But this is to suggest that Homer's stan-
dards of heroism really were very much the same as Monsieur
Racine's, and that the closer we get to Homer's real text, the clearer
this truth will become. Stuff and nonsense! For all his ignorance
of Greek, Perrault saw an element in Homer that modern trans-
lators and commentators, who know plenty of Greek, have seen too,
and to which Boileau, with all his Greek (or rather, *because of* an
attitude buried in his Greek), was blind. The Homeric heroes are
not stately, portentous, statuesque; they *don't* stand on points of
honor; their ethical principles are *not* those of Port Royal or for
that matter of the Hôtel de Rambouillet. The Homeric translations
of Mr. W. H. Rouse are perfectly compatible with the view of
Homer propounded by Perrault: they fulfill it. To Boileau they
would be anathema. It is not to be argued here that Mr. Rouse has
settled at a stroke the ancients-versus-moderns controversy. Modern
taste, one could say, has indeed become Perrault-ized, but there is
nothing necessarily ultimate about it. In the twenty-first century,
the pendulum may perfectly well swing back to Boileau. What one
can say is that by now even a return to the ideals of Boileau would
constitute (in a sense that he would have seen as ultimately vicious)
a reaffirmation of the idea of cultural change, an admission that the
modern world (whatever at any given point it happens to be) can
pick up, lay down, or reinterpret the classic ideal as its own needs
or tastes require. And there is actually an aspect in which this
fluctuating of modern taste, which seems to be a derogation from
the authority of the classics, enables us to see and appreciate them
better. Perrault would not have been in the least distressed by the
work of modern anthropologists in uncovering the ritual and cultic
elements behind classical mythology.[22] The presence of these ele-

[22] Cf. particularly Jane Harrison, whose massive *Prolegomena to the Study
of Greek Religion* (Cambridge, 1908) is an act of war against the Olympian
gods, served under the ignoble formula, *do ut des,* and in recognition of the
darker vision behind them, only to be dealt with under the formula, *do ut
abeas.*

ments would explain qualities of the fables (cruelty, absurdity, improbability, for instance) that he had remarked and deplored as flaws when taken as prescriptive for modern practice, but that he could perfectly well have been content to understand as historical phenomena in their own right. But for Boileau's view of the classics, Apollonian and Olympian as it is, the presence of chthonic elements, only to be understood as immediate derivations from blood cults, would wholly undermine the moral authority and the strict aesthetic discipline of the documents as he understood them. The use he had for them wouldn't allow them to be their real historic selves.

There are two dimensions to the dispute. Boileau took a higher but a much less capacious view of classic art than did Perrault. Because it had to be supreme and exemplary, it could not be a number of other things that in fact it was—obscene, funny, cruel, undignified. As the ancient proverb has it, "le meilleur, c'est l'ennemi du bien." The point was verified in Boileau, whose little bit of "meilleur" served to repress a great many varieties of "bien." One of the overwhelming ironies of the whole controversy was the title under which his extended rejoinder to Perrault appeared, *Réflexions sur Longin*. It is a tedious string of picayune and pernickety pedantries, detailing the alleged "incorrectnesses" of Perrault's writing; and it could not conceivably have been more remote from the spirit of Longinus himself. Boileau, evidently, was too "classic" to reach Longinus with a ten-foot pole. And though the paradox appears almost too cute, one can argue seriously that Perrault, when he attacked the authority of the classics and sought to retrench it, did more to enlarge our conception of the classic age than if he had accepted it with superstitious reverence, and occupied himself with finding rationalizations for admiring it. The hero of the occasion was not, in fact, either Perrault or Boileau; there is no reason to argue that either one of them was "right" or nearer "right" than the other. As far as actual taste was concerned, indeed, they were very close together. What made their encounter important was its inconclusiveness. To take a single instance: neither Perrault nor Boileau seriously questioned the ideal of a heroic subject treated in the heroic style, they simply quarreled over where the proper model of heroism was to be found. Yet the work of Marivaux,

Prévost, and Diderot (to take three diverse examples more or less at random) was just around the chronological corner, and to all of them the heroic ideal is almost completely irrelevant, the heroic example (*either* heroic example) largely absurd. Obviously, there is no line of direct responsibility here; yet it is not unheard-of in a literary dispute that formalizing two positions in a controversy is the indispensable first step toward getting rid of both of them.

Beyond question, most of the issues raised in the seventeenth-century dispute had been many times aired before and were growing old and tired when they were reanimated for use in a controversy with social as well as personal overtones. But it is also true that solving this sort of problem in one age doesn't obviate the need to solve it in another. One of the constants in cultural history is the impulse to select a single area of the historic past and make of it a touchstone for present and future. It is part of the search for a privileged social position that we all find it so hard to disavow, even after we have convinced ourselves that logically there is no such thing. Boileau assumed a thoroughly traditional posture in using his Greek as a club to knock down the pretensions of an ignorant, upstart bourgeois; Perrault was nerved to push forward against prepared positions by his status as a Perrault and a former servant of the Sun King. For neither of them (at least in the moment of conflict) was culture much more than a handy shield, a defensive shell behind which to prepare a new slash. We could summarize the main strategies of attack and defense this way: neo-classicism generally claims to elevate and correct modern impulses by encasing them in a traditional form; it is countered by showing that it is itself a modern impulse, making use of traditional forms for repressive purposes that antiquity itself would have disowned as repressive. The war of moderns against ancients may thus serve to restore an ancient liberty to both.

The synthesis that lay buried in the dispute, only to emerge when the two sides had made each other look sufficiently foolish, was cultural relativism. Once the classic world (most prestigious and influential of all the optional worlds) had lost its directly exemplary status (not without acquiring other sorts of interest), it became clear in fairly short order that a lot of other conventional

value-judgments might have to be transvalued. Already in 1719 we find Abbé Dubos telling us in his *Réflexions critiques sur la poésie et sur la peinture* that to appreciate any work of art, one must put oneself in the position of the person for whom it was intended.[23] To look at a Venus intelligently, we must think ourselves into the frame of mind of a pagan; to appreciate an African mask, we must suppose ourselves cannibals. The tide did not rush at once to these extremes, but once it had set in this direction, we feel ourselves definitely outward bound. On another level of thought entirely, skeptical scholars like Pierre Bayle, in the simple process of setting forth the full range of speculative opinions that mankind had entertained, invited to a critical view of them all. The historical weather was making fast toward Voltaire's *Essai sur les moeurs*; and that little bit of fresh terminology is significant. When we start describing *moeurs* (mores), we are out of the realm of automatic good and bad. If the classic example is not necessarily and universally good, then the Topinambou example, with which Boileau reproached Perrault so bitterly, is not necessarily bad.[24] Candide, finding in South America some young ladies who have taken monkeys as lovers, is much scandalized; but wiser Cacambo finds it perfectly natural, and assures Candide that a man who has received a proper

[23] Abbé J. B. Dubos, *Réflexions critiques sur la poésie et sur la peinture* (Paris, 1740: first ed., 1719), II, xxxvii (cited in Jauss, ed. *Parallèle*, p. 62). It is interesting that Dubos, who is still fighting the war of the ancients versus the moderns, is strongly on the side of the ancients. In almost every contrast involving Boileau and Perrault, he takes the side of the former, although his general position actually derives most directly from the latter.

[24] Boileau, having listened to Perrault reading his poem on *Le siècle de Louis le Grand*, vented his indignation in these lines:

Où peut-on avoir dit une telle infamie?
Est-ce chez les Hurons, chez les Topinamboux?
C'est à Paris. C'est donc dans l'Hôpital des Fous?
Non, c'est au Louvre en pleine Académie.

(And where did such scandalous views find expression?
You'd think among wild men or Topinambos?
No, in Paris, it was. . . . Bedlam, you suppose?
Not at all. In the Louvre, an Academy session.)

Boileau's contributions to the *querelle* are scattered through the *Oeuvres* (Paris, 1934–1942), with the light raillery concentrated in Vol. 3 and the heavy criticism in Vol. 5.

education in the ways of the world won't raise an eyebrow.[25] Customs, like tastes and values and observances of every sort, can only be judged in terms of the social context within which they exist. A wise man observes, compares, and—whatever his own tastes, which he needn't abandon—refrains from identifying them with universal commandments.

Neither Boileau nor Perrault would have embraced that conclusion very gratefully; but historic hindsight sees it as the legitimate outcome of their vain endeavors—attributing, perhaps, a special legitimacy to the influence of Perrault. For he was a child of nature, and grew up (if he ever did so at all—even in his mature writings, there often lingers a touch of the ingenious, impudent gamin) without any correction from the classic world. He didn't mind using the classic world in his formulas and devices; but he had nothing to learn from it. That was the way he wanted things; and when he saw how well they had turned out for him, he could hardly fail to congratulate himself. But in successfully asserting his own independence of the classic example, he also asserted the independence of Greece and Rome from the ungrateful task of disciplining Perraults. What is fractured in this exchange is simply the ideal of a classic culture, the assumption of a single universal standard of taste. And that is a modern idea, foisted for pedagogic reasons on a rich and various literary heritage, and capable, if severely applied, of truncating the truth about classical literature as well as about modern experience. Perrault escaped from that Procrustes, if he didn't single-handedly defeat him, and deserves to be remembered as one of our lesser liberators.

Swift and Bentley

Across the Channel, where the ancients-versus-moderns controversy spread in time to spraddle the turn of the century, a very different balance of forces is involved.[26] For one important thing, the erudition

[25] *Candide*, chap. 16.

[26] On the backgrounds of the English ancients-versus-moderns controversy, see A. E. Burlingame, *The Battle of the Books in Its Historical Setting* (New York, 1920); Jones, *Ancients and Moderns*, and A. E. Guthkelch, ed., *Battle*

was largely on the other, the modern side. Perrault was a smatterer, Boileau in his own way a professional. In England, quite the other way: Wotton and Bentley, the moderns, had a command of classical scholarship far wider and deeper than anything at the disposal of their many dilettante antagonists on the side of the ancients—Swift, Temple, Atterbury, Boyle, and the rest. Not only did they know more Greek than their adversaries (that was the heavy armor of the controversy); perhaps profiting by Perrault's experience, they chose to encounter the enemy from the beginning on the broad plains of general knowledge, not simply in the narrow lists of literary taste. The four volumes of the *Parallèle* had made clear where the strength of the modern cause lay, and Wotton moved directly into that area with his *Reflections on Ancient and Modern Learning* (1694 and 1697). It was learning, not taste, that he was primarily concerned with; and he had close behind him, to lend moral authority if not active support, the potent reputation of Francis Bacon and the social prestige of the Royal Society. Not even the figure of Monsieur Descartes had carried such weight in France.[27]

The basic irony quickly makes itself felt here. Swift and Temple, as the outstanding "ancients" in the controversy, supported a concept of literary merit based on limited but authentic knowledge. Ancient wisdom was clear, precise, universal: it contemplated general human nature, and limited itself to saying what was true in all places and at all times for all men. The "modern" view, to its discredit, was more various and fantastic; devoted to pampering temporary contemporary fads and vogues, it never corrected them in the severe light of uni-

of the Books . . . with selections from the literature of the Phalaris controversy (London, 1908).

[27] In all attempts to describe or discuss an historical event, one is struck by the degree to which its character was determined by the institutions through which it took place. Why was the Académie in France primarily a literary body, while the Royal Society in England was essentially scientific in its interests? Was the "national epic" less of an issue in England than in France because the English felt they already had Spenser (and perhaps Milton)? The same controversy carried on under different circumstances may be given strikingly different turns because of influences like these—which we can explain only by saying weakly, "The circumstances were different."

versal wisdom.[28] But alas, in the controversy itself, these value-judgments had to be reversed completely. The books on the side of the ancients were desultory (like Sir William Temple's original essay), or trifling (Charles Boyle's "Examination" of Bentley's *Dissertation*), or frankly burlesque (Swift's "Battle of the Books"). Wotton's *Reflections on Ancient and Modern Learning* were substantial and judicious; Bentley's *Dissertations on the Epistles of Phalaris* (1697, 1699) were incomparably erudite. The solidly constructed books were written in support of what were represented as jerry-built opinions; the severities of ancient wisdom found their chief support in persiflage and witty derision.

History, never at a loss, can be invoked to explain many of these apparent discrepancies. The English monarchy (a recent import from Holland, more a business arrangement than an institution) had no such cultural stake in the quarrel as did Louis Quatorze in France. Another social dimension embittered the quarrel in England as it could hardly have done in France: the moneyed nonconformist classes were vigorously pushing their ways into positions of power and privilege traditionally occupied by landed gentlemen. This was not only a social, it was a cultural phenomenon as well. Daniel Defoe and Sir Richard Blackmore were the harbingers of a new polite bourgeois literature destined to supplant what the seventeenth century appreciated as "wit-writing." [29] Wotton and Bentley portended a new age of classical studies, a less superstitious attitude toward "classics" like Aesop and Phalaris. Sir William Temple pointed out (with some pardonable exaggeration) that in his youth the motive for learning was honor; in his later years, it had become money, and he thought as learning became mercenary, it also became contemptible.[30] Temple, Swift, and the Christ-Church wits would have been happy to despise Wotton and Bentley as thoroughly as Boileau despised Perrault; but

[28] "I have remarked that nothing is so very tender as a Modern Piece of Wit, and which is apt to suffer so much in the Carriage" (*Tale of a Tub*, "The Preface").

[29] Dryden coined the expression, with an apology for its scholastic flavor, in the Letter to Sir Robert Howard prefixed to "Annus Mirabilis" (1667).

[30] "Of Ancient and Modern Learning," in *Miscellanea II* (London, 1697), p. 68.

even as they tried to do so, their own position was being undermined and eroded, socially as well as intellectually. One could hardly deny that Bentley knew Greek, especially when one knew as little of it, oneself, as did Swift and Temple.[31] And one could hardly help feeling that the new attitudes were pushing back the old ones, that the values of a landed Tory-minded gentleman with a classical education and an uninquisitive Anglican credo were being shouldered aside by rough, ambitious people. It does not seem likely that Boileau in France ever had that sense of the ground collapsing beneath his feet to which Swift continually bore witness. Evil and folly pressed upon the English satirist from so many quarters that the only defenses against them were evidently other evils and equivalent follies. The sardonic argument against the abolition of Christianity is conducted, as Denis Donoghue remarks, "on the principle that only irrelevant arguments may be entertained." [32] The only way in which the positive recommendations of "A Modest Proposal" enter into that piece is via a sentence which purports to dismiss them: "And therefore let no man talk to me. . . ." Just about everything that Swift really means is out of the question; his arguments often proceed by letting the absurdities destroy one another, as if that were enough all by itself.

Swift was a partisan of the ancients on so many different scores that one is almost embarrased to enumerate them. He liked what men are given, what they find readymade, what they remember, he despised what they invent. He mistrusted insides (private inspiration, pride, excrement), and thought men ought to be content with outsides (the common forms), especially if clean; he loathed intimacy, and wanted to preserve the distance between subject and object.[33] He demanded a perspective on things. He saw the future oppressing and despising men like himself, whom (so he thought) the past had

[31] There has been very little direct, specific discussion of Swift's Greek or lack of it; but the list of his library published by T. P. Le Fanu, "Catalogue of Dean Swift's Library in 1715," *Royal Irish Academy Proceedings*, XXXVII (July, 1927), 263–273, and that in Harold Williams, *Dean Swift's Library* (Cambridge Eng., 1932), show that most of his Greek books came with a Latin translation.

[32] Denis Donoghue, *Jonathan Swift* (Cambridge Eng., 1969), p. 83.

[33] *Ibid.*, chap. 1.

honored. He understood the Christian religion as a precious testa-
ment, given by God in the distant past, and subject only to corrup-
tion, never to improvement, by human invention. He was devoted to
Sir William Temple and to his church, feeling for both much the
same passionate, tribal loyalty; his attitudes toward authority were
always violent and ambiguous. He could be both humble (Gulliver
in Brobdingnag) and arrogant (Gulliver in Lilliput); he loved to re-
verse the roles and turn things upside down. But generally, the more
remote the authority, the more he tended to respect it.

(One of the familiar disguises of arrogance is humility. There is
a high standard, not one's own making, no, an impersonal institu-
tional standard; measured by this exacting standard, one is utterly un-
worthy. But at least one gets a measure of secret credit for recognizing
the standard, along with a special bonus for authenticity because it
condemns one. And that entitles one to come down with ferocious
severity on those fatuous, self-pleased fellows who don't recognize it
or don't submit to its authority, who choose in their unspeakable
spiritual sloth to live by easier standards.)

He feared the Newtonian age of mathematics and philosophy be-
cause his abilities in those directions were moderate and his training
abominable; he despised literature (where his real talents lay) as
verbal falsification. In all English, no major writer is less literary than
Swift; his focus of response and intent was immediate and practical.
Whenever he could, he popped literary bubbles, and idealized an age
when truth, simple and austere, had sufficed. Never having known a
father or been one, he distanced and exaggerated paternal authority
into the image of a strict, disapproving (nay-saying) projection of his
own self-lacerating nature. Celibacy was of course at the root of that
stance, the celibate having as effectively as possible declared his inde-
pendence of the chain of generation, the tie that binds us most closely
to the present, and the only one that ties us to the future. Swift's nat-
ural gesture is a knight's gambit, down and across; he plays by in-
stinct out of the avuncular position. Hence his fondness for mimic,
analogous, or parodic action; he is always triangulating, transposing.
To take up the line of generation is to work on the square, directly;
it is to put aside the prudent comparative method, and to throw one's

dice upon an unknown and unpredictable quantity.[34] These are grounds enough for Swift's choosing the party of the ancients, if circumstances (including, surely, an intuitive fondness for last-ditch, forlorn-hope postures as such) had not helped make the choice for him.

Boileau and Swift are the great head-shrinkers of their respective literatures, and the classic precedent is an engine in the hands of their astringent impulses. Their art is to limit, to define, and to aim a whole long passage like a flung javelin toward a precise (generally destructive) point. "My little friend Grildrig," says the King of Brobdingnag, holding Gulliver's entire long panegyric on the human race as in a cupped hand—he holds it, examines it a moment, and in the simplest possible language, without effort, crushes it out of existence. To correct, to confine, to lop, to limit, to cut off and throw away, these were the characteristic actions of Boileau and Swift; in every sense of the word, they were chasteners. The broad directions of their impulses are clear and congruent; the sort of law that Boileau undertook to impose on the language of Ronsard, Rabelais, and Regnier, Swift undertook to impose on the language of Burton and Browne. Certain sorts of force and control were to be had only at the expense of certain sorts of depth and freedom; "cut it down to size" was their common motto. Yet for all their many similarities, it is apparent that the balance of spiritual forces was very different for Boileau and Swift. Boileau was at the center of his nation's cultural development. The First Satire might depict an indignant poet forsaking the tasteless town and storming off into the countryside there to cultivate his pride and purity; but this was an imitation of Horace, and a youthful imitation at that. The First Epistle, read before Louis XIV, offered dignified humanist advice on the arts of peace, and was promptly rewarded with a pension. Swift read no poems before the court of Hanoverian Georges. All his life he was a displaced parson, displaced from courts and episcopal power as well as from poetry, and

[34] Every pregnant woman presents her husband with Hobson's choice; Mr. McLuhan, who makes so much of the irrevocable quality of words on a printed page, might try a comparison here. There's no really feasible way to get a look at your children in galleys, to send them back for correction of misprints, or to bring out a second edition.

the more conscious of his "outness" because he had had, for a few years, privileged entrée to the society of such as Harley and St. John. As an Anglican dean in Dublin, he was on several outsides. And temperamentally, he was hostile to his own age on all sorts of levels where Boileau was in some measure at least reconciled to it. Swift, for example, stood far more directly than Boileau in hostility to science and to scholarship; [35] though he spoke for the "common forms," he was much further outside those common forms with which his own modern age confronted him. His response to this radical instability was to offset and diminish; he became his own mock monarch within Saint Patrick's close, he developed minuscule play-societies (George-Nim-Dan-Dean) and exercised playful tyranny over them.[36] Boileau has little of that spirit of play; "Le Lutrin" is an inter-office parody, all too successful in officializing a bureaucratic trifle. It works in precisely the opposite direction from Swift's miniaturizing of giant enterprises.

Although he is undoubtedly the most fascinating and unstable temperament involved in any part of the ancients-versus-moderns controversy, Swift probably did not undertake as interesting a controversial position as Richard Bentley. They make an effective contrast. Swift was the shallowest, by all odds, of all the major contributors, French or English, to the discussion, the least qualified to discuss Homer, architecture, entomology, or algebra; Bentley was the only man who developed out of the controversy a major contribution to human knowledge. Swift was a passionate "ancient," Bentley an equally earnest "modern." Yet Swift's is the only reputation in the controversy which has remained green and living today, while Bentley's has declined to the status of an antiquated academic autocrat, a period piece. The difference illustrates a major point established in the controversy itself; knowledge is cumulative (and so Bentley's expertise was, with the passage of time, outdated); art is individual (and so Swift's satiric achievement is still unequaled).

[35] Boileau, as a classical moralist, could express lofty disdain for minor technical details of science (*Epitre V à M. de Guilleragues*); but for Swift, science was a direct personal threat, a filthy mechanical view of things which degraded all moral and spiritual distinctions to the same horrible, mechanistic level (*Tale of a Tub*, Sect. IX, the Digression on Madness).

[36] Swift, *Poems*, ed. Harold Williams (Oxford, 1937), III, 1019–1027.

Here we might leave the matter, the presence or absence of literary gifts being notoriously inexplicable; but one cannot help pausing a moment to note how Swift's satire finds its best opportunities in reversing the established pattern of neo-classicism, by which modern impulses are cast in classic guises. Swift implies but cannot represent ancient values behind the grotesque extravagance of modern disguises. Indeed, his satiric point of view is often so elusive, so remote, so deeply buried, that has has sometimes seemed devoid of one—a merely destructive writer. But it is defined by reversal, by being the direct contrary of what the booby-spokesman takes for granted. Curious lore, self-flattering opinions, loose and bawdy wit; by rejecting these we may perhaps approach to the severe decency of the ancient way. (Yet we do so only with a difference, because the ancient way, whatever else it may have been, was not a way of rejection.) Swift never projects himself into the ancient mold, or idealizes it directly; he presents it as a negative, unreal quality. As it is no more than the opposite of what he despises, when it appears at all, the "ideal" is generally distorted—now as giants, now as animated volumes, now as horses. It is never a serene, unflawed human proportion. Bentley, by contrast, saw the classic world directly and practically, as a body of evidence, not by way of the reflecting and distorting mirror of modern abuses. He saw much more of it, of course; his vision was less polarized by hate and fear. But the whole nature of Swift's satiric games depended on the high tension at which they were played.

Perrault, we said, did something to liberate the classic experience from the exalting but restricting demands of Boileau's "correctness"; Swift, finding the classic world already largely in the hands of the enemy, withdrew his own version of it from direct display and direct criticism. To preserve the "ancient" ideal from vulgar usurpers like Bentley, he attenuated, inverted, and concealed it, finally building it into his strategy as a hiding place from which to ambush incautious moderns. Having lost the main engagement, or seen that it was lost before he even took the field, Swift resorted to the guerrilla tactics of hit and run. For Boileau that would have been abject surrender. But as Swift managed the tactic, it liberated his mobile imagination; the free psychic energy which earlier men had been ready and able to

restrain into classic shapes he converted to an engine of ingenious and various aggression. Instead of putting his psyche onstage, in classic decor and immobile posture, to be admired, Swift concealed the classic ideal behind the busy forays of his satiric wit, to be questioned, intuited, tacitly contrasted with degenerate modern ways. He set the classic values in a personal psychological frame, instead of vice versa; thus, in addition to being (on one level) the forlorn hope of a lost cause, he foreshadowed a whole reversal of values in handling the classic experience. If it was indeed a revolution that lay implicit in his work, he would surely have deplored most of its consequences. In future, we will not be able to see the classic ideal as simply an old bottle into which successive moderns pour new wine. They will assume new authority over it, inviting us to see through and around it, and to measure it by themselves as well as themselves by it. If we are in doubt as to whether the war of ancients and moderns accomplished anything, we need only note how radical a position was being taken, at the end of it, by the most conservative man ever engaged on either side.

The parallel holds beautifully: Perrault, who wanted to weaken the classic example, strengthened it by limiting its directly pedagogic (its exemplary) function; Swift, who wanted to defend the classic pattern, weakened it by making it a subordinate agent in a series of imaginative strategies of aggression. But such are the paradoxes of warfare, spiritual as well as physical.

Swift's experience in life was all with usurpers. Puritans were pushing into the church at the expense of loyal Anglicans, the houses of Orange and Hanover were pushing onto the throne at the expense of the legitimate Stuarts, the money-men were everywhere pushing land-men out of power and privilege—and a rough, uncouth fellow like Richard Bentley was leaning hard on a man like Sir William Temple. We can understand how Swift felt impelled to take refuge in fantasy and satiric persiflage when we see the utter assurance with which Bentley had planted himself in the practical world and the world of classical learning.

Like Swift himself, Bentley was a *novus homo* socially as well as intellectually, an upstart from nowhere in the framework of Sir

William Temple.[37] He came from a little town in Yorkshire, and of a
family in humble circumstances, whether tradesmen or yeomen it
hardly boots to enquire. His father died when he was young, and his
grandfather Willie became responsible for his education. That meant
the Wakefield grammar school (where he was thought a dunce be-
cause he didn't shout his lesson aloud but conned it inwardly), and a
chance to attend Cambridge as a subsizar, that is, a student who
earns part of his expenses by relatively menial chores around college.
His climb through the academic and ecclesiastical ranks was made on
hard merit, not ingratiation; from the start, people felt something
rough and rude in his character. He was, for example, tutor to Bishop
Stillingfleet's son James, a successful tutor and an admired associate
of the bishop himself: their relation was unfailingly harmonious. Yet
Stillingfleet, congratulated on the remarkable young instructor he had
acquired for his son, said simply, "Yes, had he but the gift of humility,
he would be the most extraordinary man in Europe." [38] The gift
of humility was one that Bentley never sought and never got. Like
both the Scaligers before him, he throve on controversy, and a great
number of his most important projects sprang from an immediate
polemical occasion. Even as a young man, he never hesitated to criti-
cize established figures or assert his own tough opinion. This is no
cause for scandal, and the fact that his opinions were generally better
than the ones he criticized made him seem, as a young man, simply
ardent for the truth. But in fact he had a strict and arbitrary disposi-
tion. It came out in a tenacious controversial manner, which found
no topic too trifling for dispute, combined with a gift for satire and
raillery which verged on the cruel. The Christ-Church crowd had no
reason at all to think themselves ill-used by Doctor Bentley's truculent
tongue; they had taken up the sword of banter and grimace and might
fairly expect to perish by it. But Bentley sometimes went at the work
of dismembering his enemies with a certain grim, unclerical relish that
does not necessarily earn him our lasting affection. His biographer
concedes that he might have shone as a lawyer or a general; as a clergy-
man and an academic, he sometimes seemed out of his element.

[37] The basic facts of Bentley's life are from J. H. Monk, *Life of Bentley*
(London, 1830).
[38] *Ibid.*, p. 37.

When he was given power, as over the wretched Fellows of Trinity College in Cambridge, he exercised it like an academic Judge Jeffreys. Having conquered authority the hard way, he forgot what it was like to be subject to it; he was status-conscious as only a man new to privilege would have had the nerve to be. For such behavior he had classical precedent, of a sort, and sometimes it was used against him; his comportment as Master of Trinity was compared with that of Verres as governor of Sicily, thus establishing the maker of the comparison in the flattering position of Cicero.[39] Yet in his absolute temper, Bentley outran even his classical precedents; he began, perhaps, as a dictator from the plough, but wound up establishing over the resentful Fellows of Trinity something that they could liken only to a Turkish sultanate.

And his appetite for dominion was not limited to a mere Cambridge college—where, indeed, he managed, by a combination of bribery, intimidation, legal hairsplitting, and sheer effrontery, to maintain himself in office for more than thirty years, breaking his enemies by sheer obstinacy and longevity, and inflicting unspeakable damage on the college he was ostensibly defending. He imposed his will more widely than that, taking part in wars on the Continent against men like Gronovius and Le Clerc whom he considered charlatans, and exercising his powers of emendation on the texts of Horace, Manilius, Terence, and finally of John Milton's *Paradise Lost*. His manner in all these various enterprises was much the same: ingenious, literal-minded, energetic, wrongheaded, acute, and imperious. If one had to take all his emendations or none of them, it is hard to imagine which alternative one would choose. The text of Horace that he proposed has been criticized with particular acerbity as serving better to display the ingenuity of the emender than the merits of the poet. It goes beyond the traditionally modest custom of classical editors by printing its emendations in the body of the text rather than as footnotes; it imposes upon Horace subtleties of thought that he probably never contemplated, and shows notable readiness to make him prosaic rather than in the slightest degree incorrect. Finally, it makes much of the critical originality of one Richard Bentley, and in the course of doing so liberally overlooks the work of earlier editors, who had often pro-

39 *Ibid.*, pp. 407, 284.

posed exactly the same emendations many years before. Occasionally, Bentley notes that a particular emendation has already been suggested but salvages his originality with the remark that the correction occurred to him before he saw it elsewhere.[40] It is a way of making a virtue of one's own ignorance that lesser scholars than Bentley have sometimes used to their own advantage. Certainly criticism as Bentley practised it required a special verve, energy, and boldness of conception, supported by massive erudition and the finesse of a Philadelphia lawyer. Bentley himself had no low estimate of the talents required for his line of work:

> Est et peracri insuper judicio opus; est et sagacitate et ἀγχινοία; est, ut de Aristarcho olim praedicabant, divinandi quadam peritia et μαντίκῃ: quae nulla laborandi pertinacia vitaeve longinquitate acquiri possunt, sed naturae solius munere nascendique felicitate contingunt.[41]

> What's needed in addition is a specially sharp genius, sagacity, and a high order of intelligence. What's needed, as they used to say of Aristarchus, is a kind of training in divination and serendipity: such as can't be acquired by any accumulation of mere experience or length of life, but only by the gift of nature and the accident of birth.

By the same token, he placed beneath the portrait of Milton standing before his edition of *Paradise Lost* the motto, "Nascuntur Poetae, Non Fiunt." Poets are born, not made: it was the importance of genius that he emphasized, but evidently it takes something like genius to recognize genius, and that peculiar gift he challenged for his own. As a matter of fact, he was a mediocre poet in his own right; but about his instinct for divining the true and proper vein of other

[40] In all this, be it noted, Bentley was re-enacting almost precisely particulars of the position he had assumed against Boyle in the Preface to the 1699 *Dissertation*, p. xciv: "there may truly be a First and Second and more Inventors of the very same thing. The *Chinese* invented the Use of Guns and Printing; and so did the Europeans, without knowing at that time, that they were us'd in the East." Bentley was a modern both in his assumption that the emendatory process was original, almost creative; and in considering invention a constant process, to which moderns could lay as good claim as ancients, even in inventing the same things.

[41] Monk, *Life*, p. 243.

poets, he never had the slightest doubt, nor of his authority to correct their taste in the light of his own. That privilege any critic has, that authority he must take, in dealing with a classic text which for centuries has been liable to scribal corruption. Bentley not only went beyond accepted norms in dealing with Horace but proceeded to impose his own notions of mechanical consistency and verbal correctness on Milton's *Paradise Lost*. He tried to make Milton explicit and literal where the poet clearly did not want to be; he cut out long passages which he judged to be "of a meanness of style contemptible"; he threw away passages which he thought might prove dangerous to the poet's "young and credulous Female Readers." [42] His perfect assurance in all these transactions is almost as striking as the fact that he is at variance, in passage after passage, not only with modern taste but with the taste of every major critic and reader of Milton since his day. When Dryden said (smiling, no doubt, regretfully), "Cousin Swift, you will never be a poet," what a gaping wound he inflicted! Swift never forgave him, never again said a favorable word about him, never passed his name without a sneer. The same judgment, or one even more negative, would hardly have penetrated Bentley's tough hide. One man is all quivering nerves and raw anxieties; the other all brass and self-confidence.

Bentley's career moved assuredly with the current of the times. His was the new critical scholarship, his were the new philological methods; his Boyle lectures show how closely he was in touch with the new science, and his Whiggish politics allowed him, when he needed it, good access to the corridors of power. If he had not taken to trench warfare as the Master of Trinity he could doubtless have risen in the hierarchy to a bishopric at least; if he hadn't tripped and stumbled over Milton, in the last years of his life, he would have gone to his grave with an unclouded reputation as a textual critic and linguistic polymath.

Professionally speaking, he was bound to be a modern in the

[42] Bentley dislikes "irrelevances" like Milton's long geographical lists, condemns allegory, objects to a low, technical word like "larboard" (II, 1019), demands more verbs than Milton feels the need of, deplores long-distance correspondences, and rejects hazy, nuanced suggestiveness in favor of literal and explicit correctness.

quarrel: this seems paradoxical, but only at first glance. The author- ity he exercised over corrupt texts, the energy with which he rational- ized absurdities and ran down anachronisms, were bound to grate on the gentle, superstitious reverence with which Sir William Tem- ple wandered amid the giant wonders of the ancient world. Bentley was a scholar militant, who studied the classics for what he could get out of them in the way of philological and historical understand- ing; Temple studied them for what they could make out of him, in the way of a cultivated gentleman.

But the glittering, formidable discipline in which Bentley en- cased himself hardened into a carapace. His scholarly successes, which were great and real, petrified his literary taste, which was never very delicate or adaptable. Swift, an original conservative, had to turn to new weapons when he found the traditional ones firmly in the hands of his enemies; Bentley, originally something of a radical, found himself limited to the traditional weapons because they were so successful in his hands. What really did him in during the great uproar over his Milton edition was that his tastes, formed during the late seventeenth century, were too severe for the new sentimental ap- proach which modern scholars sometimes call neo-romanticism. Wrathful Bentley hurled out of Milton's poem that long, loving, detailed comparison of Eden with the beauty spots of the ancient world (IV, 268 ff.)—seventeen solid lines that he judged too mean to be tolerated as Milton's work. They didn't properly describe, we may suppose, didn't recite colors and specify species, and so deserved to be flung back on the "editor." "Pray you, Sir, no more of your Patches in a Poem quite elevated above your Reach and Imita- tion." [43] It was of course this passage that made so deep an impres- sion on Coleridge that it rose from his memorious imagination to shimmer through the phrasings of "Kubla Khan."

Bentley was especially vulnerable to the restricting influence of his own immense scholarship because (like his antagonist Swift with regard to his satiric gift), he was nothing without it. As young men, they were both without father or family; they both discovered their genius in acts of verbal aggression, and remained acutely aware of

[43] *Milton's Paradise Lost,* ed. R. Bentley (London, 1732), note on IV, 268, p. 115.

what it had meant to be without genius. As a matter of fact, they may have realized, as the years flowed over the great controversy of 1694–1704, that they had more in common than they had ever supposed. Bentley was soon reconciled to Atterbury, who had been responsible for most of that sharp mockery produced under Boyle's name by the Christ-Church wits. Temperamentally, there was less reason perhaps to think that Bentley could ever be reconciled to Swift; both of them were too potent haters ever to consider such a gesture. Yet it is perfectly possible that Swift when he read *Paradise Lost* looked at it more in the way Bentley did than as those early Whiggish enthusiasts, the Jonathan Richardsons, father and son, did. Their adulatory *Explanatory Notes and Remarks on Milton's "Paradise Lost"* appeared in 1734, just two years after Bentley's edition, and in certain passages constituted an explicit response to it. They were indignant that anyone should try to improve on the immortal work, and flung Bentley's words back upon him with the choked fury of true believers:

> . . . when Conceited Daubers, though they have seen All that *Italy* is Adorn'd with, when such as have neither *Pittoresque* Eyes, nor Hands, Pretending to Excel Beauty, show us a Monster instead of an Angel, who can have Patience? if a Like Attempt is made upon an Admir'd Poetical Work, Who can forbear saying, *Pray you Sir, no more of your Patches in a Poem quite Elevated above your Reach and Imitation?* [44]

If Swift had any such exalted opinion as this of Milton's poem, he concealed it exceeding well. In a letter he once called himself an admirer of Milton, but this may have been half a joke; and we hear a story that he once annotated a copy of *Paradise Lost* to help Stella and Mrs. Dingley over the hard passages.[45] But there is very little citation of Milton in Swift's writing, and what there is either concerns points of theology or involves burlesque. A critical dictum in one of the letters expresses a preference for Milton's blank verse over James Thomson's on the score that it isn't all description.[46] Swift by

[44] Jonathan Richardson, *Explanatory Notes and Remarks* (London, 1734), p. cxxxvii.

[45] Swift, *Correspondence*, ed. Harold Williams (Oxford, 1963), II, 214n.

[46] *Ibid.*, IV, 53.

no means had the sort of pedantic mind that produces textual criticism, particularly of the sort in which Bentley indulged. But it seems very hard to imagine that he would have dissented radically from Bentley's general judgment that Milton's was a great, incorrect poem, potentially of moral value, but in need of tightening and clarification up and down the line.

"Milton's true Character as a Writer," say those happy critics, the Richardsons, "is that he is an Ancient, but born two Thousand Years after his Time." [47] What a peculiar and wonderful felicity was thus reserved for our age, to have created an Ancient of its own, an instant Ancient, as it were! Greece and Rome have nothing equivalent to show; antiquity as a whole took a number of years to become antique, and had to prove itself against general human nature in order to become classic. Perrault, who formed such generous estimates of Chapelain and Jean Le Maistre, would have thought the Richardsons modest to the point of understatement in their claims for Milton. But if Swift and Bentley ever saw this bit of criticism, one can imagine them responding to it with snorts of equivalent, if not identical, contempt.

If Swift and Boileau occupied traditional ground in the warfare of ancients and moderns, the jealous and resentful spirit in which they occupied it was hardly traditional at all. That spirit goes far toward explaining why the war was neither won nor lost in the seventeenth century, but had to be fought again and again, through one academic curriculum after another, well into the present age. The dead languages and their dead cultures (precisely in the measure that they were dead or could be made so) served superbly, not only as initiation rites for the pubescent, but as caste marks throughout adult life. Being hard to acquire and altogether without "practical" value in real life, the classics were ideally suited to distinguish gent from prole as long as such a distinction existed. When an occasional bounder came along who had, like Bentley, a real talent for the classics, he was easily absorbed into the system as a pedagogue. And because such intruders at least had to know something of what they were talking about, their authority tended to stiffen and rigidify a code that might otherwise have lapsed into early desuetude.

[47] Richardson, *Explanatory Notes*, p. cxlvii.

V

SEDUCTION

Although the war of ancients and moderns inverted only a few priorities and ultimates, it altered an old sense of balance. For two centuries and more a born Goth who loathed his natural Gothliness and yearned to identify with Rome had been able to count on a capacious classic form to contain and order his new self. But when Bentley showed that Phalaris was a clumsy forger and Sir William Temple a simple-minded amateur, the whole process of using the classic world as a personal model fell under suspicion. (An even earlier mortality among the ancients, when Casaubon in 1614 effectively obliterated Hermes Trismegistus, did not arouse much indignation; the victim was not a classic, a model figure.) Meanwhile the kind of easy cultural adaptation engineered by Palladio had rendered neo-classicism a formula, reproducible by simple imitation, without any occasion for the strenuosities of rebirth and individual option. To undergo rebirth only to emerge as a cliché smacks of delusion. Hence a new appetite for nuance in one's neo-classicism, an impulse to wear one's toga with a deliberate, personal difference. The cold, white neo-classic light suddenly starts to fracture through the prisms of multiple personalities, and classic form is invested with moods and themes of which it is merely a vehicle. In the Swiftian reversal, what used to be the container has become the contained; it is a change the more striking in Swift himself because it surely wasn't deliberate. But from another aspect, it can be seen as simply a deci-

sive stage in the process by which the infinitely expansible, infinitely dilutable modern self, nurtured in a neo-classic mold, first overflowed, then surrounded, then infused with its own subtle, pervasive questionings, the hard outlines of that classic shape to which it had first been eager to conform. Twin Januses at the portals of these new developments are those unlike children of an ambiguous age, Piranesi and Canova.

One reason why nobody has yet made an extensive comparison of Giovanni Battista Piranesi and Antonio Canova is doubtless that they don't have much in common. To be sure, they were near contemporaries (Canova was just twenty-one when Piranesi died in 1778); but they weren't involved with each other personally or artistically, and it was 1810 before Canova got around to doing a bust of his predecessor, to be placed in the Pantheon. They both came from the environs of Venice, but carried their arts to Rome, and were adopted into the city as "Marchese" Canova and "Cavaliere" Piranesi. (It's an elderly joke by now that in Rome even the café-waiters are addressed as "Cavaliere," "Dottore," or "Ingegnere.") Indeed, they both came in some measure to represent Rome abroad, particularly in northern Europe among Anglo-Saxons, being traded on the international art market and visited in their studios as part of the Grand Tour. They were both overpoweringly concerned with the classic past in its relation to the questionable present; they both practised traditional arts of representation, but with a subtle difference; in both there's something hard and something soft, a surface and a fantasy linked in a relationship which entangles, not only the eye, but the prying, many-fingered mind. The process of entanglement is very different in the two men: Piranesi gives us an intricate dark to get lost in, Canova a cool facade to look behind. But that's a less than fundamental difference if we define the process itself as entanglement.

In both artists, too, entanglement has something to do with an artificial, or at least a cultivated, self. Though Canova and Piranesi were both fascinated with the shapes and styles of classic art and architecture, what is hidden and enigmatic in their versions of neo-classicism often seems to find a focus in the act of self-contemplation. Canova's figures seem to stand staring with an inner eye into the black, motionless pools of their selves; Piranesi's "Prisons" invite

us all but explicitly to think of them as the dark, labyrinthine torture chambers of the mind itself. Where is this disturbing, questionable "self" of the artists to be found? Is it a screen between us, the viewers, and the subject represented, or do we find it lurking somewhere in back of the subject represented? The Canovan revery is intangible, undemonstrable, perhaps only a pose (yet hundreds of viewers have felt it, and testified independently to its power). Is the Piranesi nightmare achieved only by an obvious skewing of proportions, a lowered point of view, darkened shadows, and some ragged mimes or mutes? Somehow the effect, in both artists, seems out of proportion to any causes we can articulate. That, of course, is the art of seduction itself, the art of making the traditional and familiar mysteriously different.

Canova

Antonio Canova was born in 1757 at Possagno, just under Monte Grappa, only a few miles from Maser and not far in the other direction from Bassano.[1] Possagno is not now, and never was, much more than a crossroads, but Canova retained a filial fondness for it, built a white Palladian temple on the hillside, and established (precursor in this respect of Rodin, Gustave Moreau, Toulouse-Lautrec, and other odd artists of the nineteenth century) his own personal museum there.[2] As its name implies, the Gipsoteca contains more plaster than marble, but the idea of a one-man museum, erected to the glory of its own founder and enshrining his essential oeuvre, is a picturesque one, and very revealing of that terrible lonely nineteenth century. As for the idea of putting it at Possagno, rather than Rome or Venice, that is very Canova. He was a public figure all his life, an associate if not intimate of the eminent, a diplomat—but also an invalid, a neurasthenic, who was compelled recurrently to "get away," to withdraw, to cultivate solitude and the dream. Possagno is a place to get away from almost everything.

[1] A handy bibliography of Canova studies (more numerous than one might think) is furnished by Elena Bassi, *Canova* (Bergamo, 1943), p. 39.
[2] The nineteenth-century ipso-museum and its associated implications constitute a rich topic for future analysts of artistic attitudes.

His life was not, on the whole, dramatic or eventful; what "human interest" there is dates from early youth. His father died when the boy was three, his mother remarried and moved away, leaving him in the charge of Uncle Pasino. Uncle Pasino was master mason and gardener for Giovanni Falier of the famous Venetian family, possessor of a villa at Padrazzi di Asolo. The inevitable cute story has it that ten-year-old Canova sculpted out of butter a winged St. Mark's lion for the table of the *padrone*, who was so impressed by his prodigious talent, and so on and so forth. However all that may be, he turns up as an extremely youthful apprentice to a Venetian sculptor who worked for Falier, one Giuseppe Bernardi known as Torretti. But it cannot have been a long apprenticeship, since Torretti died in 1774, when Canova, by severe chronology, can have been little more than sixteen. Despite his youth, Falier promptly commissioned him to do a group, "Orpheus and Eurydice," which has a certain importance as the most baroque of Canova's compositions. That was the prevailing, the fashionable thing, and teen-agers don't go against the mode; so Eurydice stands in a cloud of curling marble smoke, out of which an imploring hand reaches after her. The whole effort of the style is after agitation, impression, and indefiniteness, as contrasted with the marble repose of Canova's mature manner.

Growing in years and reputation, he received several Venetian commissions, including an "Apollo," a "Dedalus and Icarus," an "Esculapius," and a portrait bust of the doge Renier. Then in September of 1779 he left, in the company of a couple of architects (Pietro Fontaine and Giannantonio Selva) for Rome, Naples, Herculaneum, Pompeii, Paestum, a plunge into the antique world. More important in some ways than his dip into the antique (which he had studied carefully at Venice, though chiefly at second hand, through the cast-collection of Filippo Farsetti) was his dip into the cosmopolitan society of antiquaries, painters, sculptors, critics, dilettanti, dealers, and tourists which made up the society of Rome.[3] Here

[3] The familiar letters of Président de Brosses give us a pretty drab picture of Rome in 1739, without a painter of note, a worthy architect, or an intellectual society of any width or depth; by contrast, Stendhal, writing fewer than a hundred years later, found Roman society lively, various, and thoroughly

the ideas of neo-classicism, of imitating the antique without copying it, of achieving what Winckelmann had defined as "noble simplicity and calm grandeur" [4] were the order of the day; Canova was promptly immersed in them, and came out as the Canova we know. He went back, hesitantly and briefly, to Venice, took stock of the situation by the lagoon, and in 1781 settled definitely in Rome. That same year he finished his first characteristic work, a "Theseus and the Minotaur," done first in clay, then translated into marble, and under that aspect presently in the Victoria and Albert Museum.

Somewhere in these early Roman years, we must find space for another "human-interest" story, the only one of its sort to linger in the vicinity of Canova's name. There was a young lady, Domenica, the daughter of an engraver named Volpato, to whom he was briefly engaged; but the myth has it that she was discovered two-timing him with Raphael Morghen,[5] and the discovery left him, if not with a broken heart, at least with a pronounced disinterest in the other sex. In Italy, where these matters are discussed as publicly as the foreign policy and often with more fervor, Canova's personal unconcern with the lovelies he sculpted so flatteringly could not fail to be remarked. Some attributed it to Volpato's perfidious daughter, others to the ruin of the sculptor's health during those long years devoted to the tomb of Clement XIII. Like Leopardi, who destroyed his constitution with too much premature study, Canova was said to have overstrained himself in wrestling with vast masses of marble—or, at the commentator's free option, he could be compared with Michelangelo, who twisted his neck and back awry painting the Sistine ceiling. Against all these picturesque suppositions stand two rather massive facts: apart from the busy biographers and rumor-mongers, Volpato's daughter left no trace whatever of her existence in Canova's life; and the sculptor, ruined health, broken heart, and all, survived to the age of sixty-five. If he was indifferent to the sex (*either* sex), it could perfectly well have been a matter of innate personal temperament.

agreeable, with a widespread interest in contemporary as well as ancient art: *Promenades dans Rome*, ed. H. Martineau (Paris, 1956), *passim*.

4 J. J. Winckelmann, *Reflections on the Painting and Sculpture of the Greeks*, trans. H. Fuseli (London, 1765), Section IV, "Expression."

5 Quatremère de Quincy, *Canova et ses ouvrages* (Paris, 1834), pp. 39–40.

And setting these sticky speculations aside, it's enough to say that Canova was always a lean, sinewy, and solitary figure, that his health was never strong, and that the retreat from nature in its rawer, more direct and engaged forms (war, love, disciples, social power of any sort) was perfectly compatible with, and indeed a natural consequence of, his lifelong passion for the veiled and private dream.

The first quality to strike one about a Canova sculpture is a cold and almost exaggeratedly classic formality of feature, gesture, and outline, combined with deep but veiled sensuality. The portrait of Pauline Borghese in Rome reposes on velvet cushions, worked with the greatest richness and voluptuousness of which marble is capable; it is plush petrified in the act. Yet the statue is not, for all that, pornographic. The lovely "Cupid and Psyche" at the Villa Carlotta in Cadenabbia [6] is at once voluptuous and chaste as the youthful and passionate love which is its theme. The hand of Cupid reaches down to cover the breast of Psyche, yet the two bodies are poised in space at a distance from one another; the total effect of the statue is less that of a squirm than a hover. Indeed, Cupid in his poised and placid curiosity has more the look of an explorer, or perhaps an imperious lawgiver, than a lover. There is something assured and impersonal in his gesture. Jumping miles, years, and métiers, we could compare Canova's classicism to that of Keats, in that both make use of the classical qualities (clarity, impersonality, balance) chiefly as a background for and contrast to a kind of sensuality which strains to extract the ultimate relish from every situation. The monumental "Theseus Killing the Centaur" in Vienna depicts the centaur being forced back on his haunches, his skin folding, his muscles snapping, while Theseus, his face set in an expression of stern disinterest, flourishes a giant club over his distorted head. Ferocious placidity mastering failed passion: it is a regular feature of Canova's work; and one senses in the balance of these qualities an expression of that peculiar dandy-intelligence which lies behind Don Juan's sensuality.[7]

[6] The piece at Cadenabbia is a copy by Tadolini of an original in the Louvre; there is another "original," a distinctly different version of the same piece, at Leningrad in the Palais Yousupoff. A plaster model for this statue is in the New York Metropolitan.

[7] Ellen Moers, in her laudably thorough, regrettably pedestrian account of dandy mores and the dandy mystique, *The Dandy* (New York, 1960), does in

His greatest pleasure is pride of mastery—mastery, at moments, over pleasure itself. Pauline Borghese looks out, with eighteenth-century poise, across the most utter nakedness of which sculpture is capable; it was with an expression like this that Madame de Merteuil received the Chevalier.[8] All experience is for the dandy a cast of the dice, a testing of his impassive features against the menace of luck. His pursuit of women is a still more dangerous gamble; but it is also an essentially Narcissist voyage of self-discovery. Canova is the dandy Don Juan of sculpture; his elegance treads a delicate, dangerous path between the frigid and the sensational; the purity of his technique is at desperate odds with the sensuality, and sometimes the sentimentality, that informs his conceptions. (In the other direction, there is always something in a Canova sculpture that is uneasy with the marble, that doesn't and can't get properly incarnated.) His eroticism is veiled, contemplative, self-conscious; at its finest, it produces an effect the reverse of sculptural, one which is found in no other sculptor of whom I know. It is an effect of simplicity conscious of being contemplated, a grave and aware libertinage (as in Baudelaire) tinged with just a fine edge of spiritual withdrawal. The patina which renders luminous his classical surfaces really is a sense of "l'heroisme de la vie moderne." [9]

fact make clear the dandy's intellectual pleasure in effortless, superficial domination, minimal wit, the wordless put-down—the effacement of self beneath style.

[8] Gautier, playing with the image of his mistress in a pink vestment which she finally discards, invokes the memory of Canova's figure:

> Jetant le voile qui te pèse,
> Réalité que l'art rêva,
> Comme la princesse Borghèse,
> Tu poserais pour Canova.
> "Pour une Robe Rose"

[9] To what extent Baudelaire's term "l'héroïsme de la vie moderne" is ironic can be guessed only from looking at it in context. The examples he cites probably identify modern "héroïsme" with traditional "bassesse." The minister who defends with superb contempt his impugned, and probably non-existent, honor is a beautiful modern scoundrel; the criminal who hurls himself under the guillotine is as "heroic" as a cornered rat, ferocious to the core. An analogy, just starting to be felt in the nineteenth century, is that which nowadays sees the ugly as a central part of the beautiful. Such deep and complex ironies I doubt if Canova ever felt; at least, they are not characteristic of him. But the process of his vision is the same as Baudelaire's, though the things he saw are simpler.

It is like a conventional topos in discussing Canova to praise the full vein of sensual awareness that crops out here and there in his work, but to suggest that the neo-classical style provided for this vein of feeling nothing more than a frigid and artificial tomb. On these grounds, the critics have been undertaking lately to dismiss Canova's finished statuary as merely incidental to the real achievement of his sketches, his little plaster models, his unfinished pieces.[10] There, we are told, the hand of the master is quick, responsive to his eye, and apt in rendering particularized reality. Even among the finished pieces, one can find an occasional achievement, where Canova forgot to be Canova and allowed his primitive genius to shine forth. The busts of Giuseppe Bossi and "Papa Rezzonico" (Clement XIII), or that of an old Roman porter (all to be seen in plaster at the Possagno Gipsoteca) really can be praised without irony in the terms traditional to Rodin. But the poised, polished, and generalized set-pieces —well, it is plain enough that nothing could be less congenial to the taste of our times, when the jagged nerves of the artist and the rough stuff of his basic material are supposed to be displayed without disguise or rationalization. Indeed, it is hard to oppose one extreme view of Canova's art without falling into the other. At their most frigid, his pieces do have that look of having been reduced to an impersonal gloss, like furniture. There is a regular wardrobe of terms for insulting this style of sculpture; it can be called hotel-lobby statuary, or Lot's wife, or distilled water, or erotic frigidaire style, or, bluntly, nonart.[11] But criticism would be pretty easy if it could be performed wholesale, by deciding abruptly that one style is good, another bad. Using such a yardstick, one need scarcely distinguish this artist from that, far less different works of a particular artist. It would be idle to deny that Canova or his studio (he was practically a national industry for

[10] See, e.g., Bassi, *Canova*, pp. 28 ff., for a sharp distinction between Canova's portraits and his ideal figures, his sketches and his finished works, always to the advantage of the former.

[11] The recent acquisition of the Canova "Perseus" by the New York Metropolitan produced a spate of such insults—a spate which, in the case of that particular statue, I'm afraid it's hard to describe as without justification. The prize was taken by Mario Praz, "Canova or the Erotic Frigidaire," *Art News*, LVI (Nov. 1957), 24–27.

many years, and most of his works exist in several copies) perpetrated a good deal of dead rock.[12] But the fact remains that for many years literary men, responding quite independently of the art critics, have persisted in finding a quality of poetry in certain of Canova's sculptures. The Paolina-Borghese "Venus," the recumbent "Cupid and Psyche," the "Three Graces" done for Josephine, and the idealized bust of "Helen" [13] have attracted particular interest, and interest of a particular sort, best exemplified by the response of Flaubert to the "Cupid and Psyche" in the Villa Carlotta at Cadenabbia:

> Je n'ai rien regardé du reste de la galerie; j'y suis revenu à plusieurs reprises, et à la dernière, j'ai embrassé sous l'aisselle la femme pâmée qui tend vers l'Amour ses deux longs bras de marbre. Et le pied! Et la tête! Le profil! Qu'on me le pardonne, ç'a été depuis longtemps mon seul baiser sensuel; il était quelque chose plus encore, j'embrassais la beauté elle-même. C'était au génie que je vouais mon ardent enthousiasme.[14]

> (I saw nothing of the rest of the gallery; I returned several times, and on the last visit I kissed under the armpit that swooning woman who holds out to Love her two long marble arms. And her foot! Her head! Her profile! God help me, it was my last sensual kiss for a long time; and it was something else, I was kissing beauty herself. My ardent devotion went straight to genius.)

[12] Stendhal, visiting *en bon touriste* the atelier of Canova, was gratified to find that the sculptor had been able to "oter" from "le procédé de son travail . . . tout ce qui est physiquement pénible;" but Stendhal was seeing pretty much what he wanted to see. Not only was Canova deeply interested in his craft, to the extent of making major innovations in its technical proceedings (see Vittorio Malamani, *Canova* [Milan, 1911], pp. 311–313); he did with his own hands much of the finishing work on his enormous volume of production.

[13] Byron wrote an epigram on it, not a specially good one, but worth the quotation of a quatrain for its sense of Canova's special interiority (*Selected Poetry*, ed. L. Marchand [Modern Library], p. 338):

Beyond Imagination's power,
　　Beyond the Bard's defeated art,
With Immortality her dower,
　　Behold the Helen of the heart.

[14] Flaubert, "Voyage en Italie et Suisse (avril-mai, 1845)," in *Oeuvres complètes* (Paris, edition du Seuil, 1964), p. 466.

It is like a confirmation of Flaubert's response that William Words-
worth, coming across what may have been a copy of this same statue,
threw up his hands in horror (as Haydon tells us), looked down his
long North-country nose, and exclaimed, "The Dev—ils!" [15]

Harry Heine did not feel very differently about the "Venere
italica" in the Pitti than Flaubert did about Psyche:

> Ja, es gibt eine Statue, die Dir, lieber Leser, einen marmornen
> Begriff von Franscheskas Herrlichkeit zu geben vermöchte, und
> das ist die Venus des grossen Canova, die Du in einem der letzten
> Säle des Palazzo Pitti zu Florenz finden kannst. Ich denke jetzt oft
> an diese Statue, zu weilen träumt mir, sie läge in meinen Armen,
> und belebe sich allmählig und flüstere endlich mit der Stimme
> Franscheskas.[16]

> (Yes, dear reader, there is a statue capable of giving you a marbled
> image of Franscheska's splendor; it is the Venus of the great
> Canova, which you can find in one of the last rooms of the Pitti
> Palace in Florence. I think often of this statue now, and sometimes
> dream that she lies within my arms, and rouses herself slowly, and at
> last whispers to me with the voice of Franscheska.)

And Antonio Baldini's little sketch, "Paolina, fatti in la" (reprinted
in Beato fra le donne) is still another sensual literary fantasy on the
theme of a Canova sculpture. A young man, weirdly intoxicated on
witch's brew, wanders into the Villa Borghese and, while sharing for
a night Paolina's cold, delicious couch of marble, learns to appreciate
her textures.[17] The essay of Mario Praz to which I am indebted for
most of these literary references, is still another instance of a literary
man's sympathy with Canova; and the figure to whom Signor Praz
ultimately appeals, as envisaging a Canova Society for the better ap-
preciation of the great man, is again a litterateur, Sir Osbert Sitwell.

How does it happen that literary men are so responsive to a vein
of sensuality in Canova to which the art critics are so markedly

[15] Diary of B. R. Haydon, ed. W. B. Pope (Cambridge, Mass., 1960), II,
entry of 29 March, 1824.

[16] Heinrich Heine, Samtliche Werke (Leipzig, 1912), IV, 347 ("Reise-
bilder," III).

[17] Antonio Baldini, Beato fra le donne (Milan, 1945); M. Praz, Gusto
neoclassico (Naples, 1958), pp. 139–162.

antipathetic—which, indeed, some of them deny entirely? Mérimée, in his memoir of "H.B." noted that Stendhal "cared more for Canova's sculpture than for any other, even Greek statuary; perhaps this was because Canova worked for literary people." [18] A further curiosity is the peculiarly intimate and sensual quality of the Canova-inspired fantasy in men like Heine and Flaubert who, though literary in their interests, have seen plenty of statuary, and don't ordinarily respond to works of art in this notably unaesthetic way. There is nothing pure about their response to Canova; yet a further curiosity lies in the fact that Canova himself not only proclaimed the purity of his art, its impersonal concern with abstract beauty, but was (as a result of that wretched Domenica Volpato or something) notoriously uninterested in the sexuality of women. But here, simply in setting forth the different parts of the problem, we have taken a long step toward solving it. There are two elements of a Canova sculpture. One is a glazed, polished, carefully finished surface, which controls, dominates, formalizes; which incarnates, or perhaps enacts, an attitude; which is ceremonial and (in its very assurance, emptiness, exteriority) hollow. Then there is the element not plastically represented at all, the meditation, withdrawal, dream. It is in the non-expression, primarily, the remoteness of the features from what the body actually is, or is actually doing. In classical sculpture (like the Parthenon friezes, i.e., the Elgin marbles, for which Canova was generous in his admiration),[19] the figures contain their souls easily, embody their actions fully in their actions and gestures. The gigantic torsos of Michelangelo *are* the twisted aspirations they (as we say) "express." But in Canova's figures, the soul is often lost somewhere in the interior—the body holds a posture that is indeed cold and formal, if that's all we see of it—but the soul is somewhere far away, where the mind strains to hearken after it. The very whiteness and (often) blankness of the facade emphasize the darkness and distance of the feeling that lies behind. That is not a sculptural, it's a literary appeal (not direct, but reflex; it doesn't embody directly, it evokes out

[18] Prosper Mérimée, "H.B." among "Portraits Historiques et Littéraires," in *Oeuvres complètes*, ed. P. Jourda (Paris, 1928), V, 165.

[19] *Letter from the Chevalier Antonio Canova on the sculptures in the British Museum* . . . (London, 1816); see also Haydon's *Diary*, I, 482–485.

of a vacancy or a conflict). And perhaps this is why Canova makes his appeal, above all, to literary people, who like surfaces, as of the dandies, which both repel and amaze and then, ultimately, entangle.

It is not easy to say on what grounds this appeal is illegitimate, if we concede at once that it is not properly sculptural. The work that makes it deals with a state of mind, an adulterate, sophisticate, perhaps degenerate, perhaps even sick state of mind. But it is hard to say that there isn't something artificial, not to say monotonous, in the regularity with which, these days, we are asked to confront and respond to ragged reality in the form of authentic welds and raw pigments. Honesty to one's basic materials is a decorum as distinct as any other (Geoffrey Scott argued this point going on fifty years ago),[20] with this further limitation, that it is precluded from dealing with the peculiarly double effects that one gets by doing veiled things behind surfaces. From the surrealists to the neo-realists, from Kafka and Joyce to Dali and Andrew Wyeth, one way to render the modern consciousness is through the suggestion of a recurrent queerness lying beneath a polished, enigmatic surface.[21] One of the well-known nineteenth-century novelists is said to have had a favorite literary exercise, which was to take a scrap of ordinary journalism and try to find the absolute minimum of variation by which it could be transformed to literature. What he sought was a reverberation, a *frisson*, the flare or shadow of an imaginative quickening, to be achieved with the least possible verbal gesture. Canova seems sometimes to have been playing this game, by taking an icy and regular blank, static and formalized like the bust of Helen, then seeking to insinuate the absolute minimum of vital, irridescent feeling which would give it the rich meditative appeal belonging to a work of art.

I have in effect made up this rationale for Canova to explain an intermittent but very intimate appeal that his sculpture occasionally exerts. The precise formulation will be sought in vain through the

[20] Geoffrey Scott, *The Architecture of Humanism* (London, 1947), esp. chap. 4, "The Mechanical Fallacy."

[21] Cf. Joyce's persistent emblems for his own art, the mirror and the razor or knife blade. But the problem is more complex than any conventional symbolism can represent, as it involves several different layers of transparency, in fluctuating orders of primacy.

tedium of his biography, his largely inarticulate correspondence, and such suffocating investitures as that of the insufferably long-winded Quatremère de Quincy. But the modern viewer is not just projecting a sentimental interest of his own when he feels in Canova the tug of an inward and personal interest. It is a comedy of historical errors which has made the name of Canova stand today for the coldest of neo-classicists; during his lifetime he was repeatedly assailed for his "betrayal" of a classicism which his junior, Thorwaldsen, was thought to exemplify more correctly. But Stendhal saw clearly enough that neo-classicism was merely a veil, a vestment, for the art of Canova, the essence of which is a dream, erotic, melancholy, and far withdrawn behind the glow of its own polished surfaces. There is in the little museum at Bassano a wonderfully idealized feminine head, whose introspective gaze is the most completely veiled, the most profoundly interiorized, that can be imagined. It is not necessarily a melancholy expression, though the head is bowed; merely one of tranquil, very deep revery, a perfect piece of pure and characteristic Canova. It was on the score of this inwardness that Stendhal hailed Canova as the creator of a new beauty: not a follower of the Greeks, not a continuer of the classic mode, but an original.

> Canova a eu le courage de ne pas copier les Grecs, et d'inventer une beauté comme avaient fait les Grecs. Quel chagrin pour les pédants! Aussi l'insulteront-ils encore cinquante ans après sa mort, et sa gloire n'en croîtra que plus vite.[22]
>
> (Canova had the courage not to copy the Greeks, but to invent a beauty of his own as the Greeks had done. What a humiliation for the pedants! And so they'll still be insulting him fifty years after his death, and for that reason his glory will increase all the faster.)

In the same way, Canova himself answered, in a letter to Quatremère de Quincy, the charge that he was not following properly the antique manner; the veiled allusion is to Thorwaldsen, for whom, when he wasn't being used as a club to beat other sculptors, Canova often had kind words enough:

22 *Rome, Naples, et Florence en 1817*, ed. H. Martineau (Paris, 1956) entry of Milan, 15 novembre, 1816.

Vi vuol altro che saper rubare *ragionevolmente* de' pezzi d'antico qua e là e poi raccozzarli insieme per darsi vanto d'alto artista! Convien sudare dì e notte sugli esemplari greci e romani; studiarli indefessamente; investirsi della loro massime; crearsi uno stilo sul loro e farselo proprio; e allora si potrà pretendere il titolo di vero imitatore ed emulatore.[23]

(You've got to know something besides how to pick up bits of the antique here and there in a *reasonable* way, and then slap them together, in order to set yourself up as a great artist. You've got to sweat, day and night, over the Greek and Roman models; you've got to study them constantly, enter into their heights and depths, create for yourself a style on the basis of theirs and make it your own; and then you can lay claim to the title of a proper imitator and emulator.)

"Crearsi uno stilo sul loro e farselo proprio;" that was the true Canovan enterprise, and that was why Canova could explain his lack of pupils and followers by saying that his art was based upon individual fantasy, a private dream, which there was no teaching to others. His neo-classicism is on these terms a version of romantic irony, a translucent disguise.

Surely the nineteenth-century was the supreme age of disguises and false fronts, not necessarily in the hypocritical sense made familiar by baiters of the Victorian era, but because, once the French Revolution had broken violently with the Renaissance tradition, and a machine-based economy had deepened that break to a chasm, all style became a deliberate affectation. From classic revival to gothic revival to Egyptian revival to oriental revival, the styles wandered restlessly back and forth. The very reaction to the Revolution became a royalist masquerade, in which Louis XVIII tried desperately to pretend that he was a Bourbon, and Louis Philippe concentrated his energies on not looking like a pear.[24] I. I. Grandville has a remark-

[23] Malamani, *Canova*, p. 310, citing Canova, *Lettere scelte*. See also Canova's defense of his own spontaneous impulses and indifference to the minutiae of formal correctness, in Melchior Missirini, *Della vita di Antonio Canova* (Milan, 1824), Book III, chap. 8.

[24] René Girard, *Mensonge romantique et vérité romanesque* (Paris, 1961) provides the classic analysis of romantic imitation. Louis Philippe's difficulties with the pear grew out of Charles Philipon's trial, when the authorities were

able set of caricatures (in *Les metamorphoses du jour*), showing the
art of transformation in its everyday operation—the costumes hang
on a line, flapping emptily while behind them lurk the more or less
"real" people destined for these disguises. Narcissus will dress up as a
belligerent hussar, a leering satyr will put on the public costume of a
judge, a gaudy whore will become a prude. Externalizing men's inner
attitudes is of course the essence of the caricaturist's art; and Grand-
ville was particularly adept at fitting human figures with animal fea-
tures to suggest their grotesque and bestial disposition under the
civilized surface of their garmentry.[25] And at the other end of the
century, Ibsen's last hero is a sculptor who manages to insinuate,
beneath the surface likenesses for which he is admired and paid, the
brutal likeness of various beasts—hog, horse, wolf, ape. The novels
of Stendhal, with their ambiguous temporality, are in effect contem-
porary period pieces, historical novels in modern dress, romances of
an age already seeing its own oddities and peculiarities in remote
historical perspective.[26]

We shall not look far for the most distinctive of these oddities.
They are the steam engine and its children, the railroad and the fac-
tory; the newspaper and its cousin the ballot box; liquid money and
the tyranny of the cheap; and population swamps, overhung by a
miasmic nostalgia for the infinite. And this whole image of nine-
teenth-century man is overlain and smothered by the grotesque nine-
teenth-century uniform. What age has ever paralleled the last cen-
tury in its conscious loathing of the chosen public costume? "O mon-
struosités pleurant leur vêtement!" was Baudelaire's outcry.[27] It is an
age that never tires of denouncing the tubular pantaloons, the black

trying to suppress *La Caricature*. Philipon, starting at one end of a blackboard
with a recognizable sketch of the king, modified it, detail by detail, to an
unexceptionable pear.

[25] I. I. Grandville, *Les metamorphoses du jour* (Paris, 1854); see also
Un autre monde (Paris, 1844), esp. pp. 41 ff., "Caractères Travestis," and
"Déguisements Physiologiques."

[26] Julien Sorel, though a figure of 1830, follows in his actions a pattern
laid down by Boniface de la Mole, who was executed in 1574; Fabrizio del
Dongo, though forced to exist in Peace-of-Vienna Italy, repeats the career, and
was modeled on the figure, of a sixteenth-century Farnese pope.

[27] *Les fleurs du mal*, V.

frock coat, and the voluminous, grotesque crinolines into which the human race is disappearing.

> Fools! make me whole again that weighty pearl
> The Queen of Egypt melted, and I'll say
> That ye may love in spite of beaver hats.[28]

What to do with this undignified, oppressive, anonymous uniform? As if seeing what its problem would be, the century gave rein, almost from its first years, to a wild proliferation of caricaturists, rising in Rowlandson, Goya, and Daumier to the status of classic art, developing through Gavarni and Grandville, Cruikshank, and Tenniel toward a gallery of splendid grotesques. The men who worked in pen and ink, if they had the requisite *panache*, thus profited by the horrors and absurdities of the age. But for sculptors the problem was larger and harder. As the public memorialists of their day, what could they do? Baudelaire had the splendid fantasy of thinking the somber modern dress a kind of mourning costume, in which the human race had undertaken to solemnize some universal funeral, perhaps the burial of that ruined poet that Flaubert thought was interred within every notary.[29] An immense cortège of undertaker's mutes: it's a splendid image of the modern population. But it's possible, least of all, for the sculptor who is forbidden color, or the public memorialist who is committed by his profession to finding images of dignity and individuality. (Not every sculptor is as lucky as Rodin when he found in Balzac that fondness for a monk's robe that resulted in such a striking statue.) Actually, Baudelaire's poetry, with its modernity heightened to spleen and morbidity, its surface classicism reduced to firmness of diction and precise metrical control, is a better model for Canova's sculpture than his direct ideas on costume. The principle is as old as Chenier: "Sur des pensées nouveaux, faisons des vers antiques." [30] In different forms and combinations, with different

[28] Keats, "Modern Love" in *Complete Poems*, ed. W. Thorpe (New York, 1935), p. 224.

[29] Baudelaire, "Salon of 1846," Sect. XVIII in *The Mirror of Art* (New York, 1955); cf. Flaubert, *Madame Bovary*, III, vi.

[30] André Chenier, Epigraph before "L'Invention," *Oeuvres complètes*, ed. P. Dimoff (Paris, 1938), II, 5.

coloring and intent, it found expression in Alfieri, in David and Ingres, in Talma, in every neo-classic artist who understood his craft as more than mere copying. The distinctive energy that makes neoclassicism work is a tension between form and spirit, an ability to make one element comment eloquently on the other. Whatever the precise combination or relation, this is the working principle; and, comparing him with his fellow practitioners, I think it would be a bold critic who should affirm that Canova's work is always in these terms a categorical failure. Its voltage is not always of the highest; the sculptor's invention was not unflagging, and there seems no doubt that the system, then in its infancy, of working on private commissions (with the further limitation of being very largely confined to portraiture) had its limiting and depressing effects. Canova simply cannot be thought of, in fact, as a great unshackled genius. Like Dante Gabriel Rossetti, he is a remarkable talent remarkably corrupted, remarkably enchained, technically at ease in his art, but with a set of feelings that somehow don't easily fit his medium.

The "Venere italica" in the Pitti, for example, whom Heine liked so much, is a subject at least three thousand years old, but treated in a thoroughly individual way (see pls. 9, 10). The lady who personates Venus is shown emerging from the tub, clutching a towel, peignoir, or other scanty drapery to preserve her modicum of decency from at least one direction. (Purists of the day objected to the possibility of a towel, considering its employment, or the very idea of its employment, undignified; but Canova quite properly wasted no breath on the debate.) If we look for specific evidence that she is Greek or Roman, or a goddess, not very much will appear. She has a Greek profile, unbroken from top of forehead to tip of nose, and her coiffure, though dainty to the point of suggesting curling irons and French maids, is succinct in the classical manner. But in other respects, she is less classical divinity and more lady of fashion. The garment she holds ineffectually before her is more likely a towel than a toga—its folds, breaks, and even its hem, are rendered with tender, loving care, and the sculptor has taken pains that, as it falls, it shall outline as clearly as possible the body before which it is draped. Indeed, at the inside of several deep folds,

Canova has worked the marble so finely that it's physically trans-
lucent—a kind of virtuoso effect in turning drapery into marble that
Bernini himself might have envied.

The posture of the lady is evidently that of one taken by sur-
prise though not alarm—as she clutches the cover just where it
won't conceal her breasts (some of the versions are all too distress-
ingly efficient in this respect) she looks aside over her left shoulder,
at more than a 90-degree angle to the direction in which her steps
are taking her. In the process she displays her elegant profile to the
viewer standing front and center, but also, by looking so sharply
out of her space and across the axis of her movement, she creates a
sense of cross purpose, of divided direction. It's not by any means
a moment of assured repose, but of momentary balance between
two different intentions. The response of the viewer is equally rest-
less; if he looks at the statue at all carefully, it's not from any point
of view, or even from several successive ones, but by wandering
around and around it. She is not, for this reason, easily represented in
photographs; and in fact, from several angles, she is neither a poised
nor a very shapely figure. From the south-to-southeast sector, she
looks distinctly round-shouldered; from the east-northeast she seems
far too well ballasted in the rear. Like Canova himself, she seems to
hesitate between two gestures, one expressing the *pudeur* of the
woman, and the other the serenity of the goddess. The ultimate
shape of her gesture, I think, is up, up, and away. She looks out over
the heads of her viewers, confronting nothing directly, not even the
duplicity of her own appearance. She's been made a goddess in spite
of herself, and as a woman she wants to get some decent clothes on,
and a bit of makeup; amid these alternatives, she pauses, hesitates,
looks away—and there Canova has caught her.

Canova's Venus was completed in 1812, when the Medici Venus
was momentarily absent from her traditional post in the Uffizi, hav-
ing been abducted by Napoleon some years earlier.[31] At the time of
her unveiling, there was even a move to have the new Venus occupy

[31] Canova would be responsible three years later for her return from the
Louvre, though not for the manner of it: he was apparently in tears when she
was "put into the cart" for her journey back. The whole story constitutes one of
the most gracious and endearing chapters in the history of France.

the old pedestal in the Uffizi Tribuna; though it was defeated by Canova's modesty, the assumption is inevitable that he expected a comparison to be made. And in fact, it yields some points of interest. Dating from about the third century B.C., the Medici Venus is a Greek copy of a (probably) Praxitelean original (see pl. 11). It is an unusually early work, unusually direct in its relation to a distinguished original, and unusually fine in its state of preservation. (Only the right and half of the left arm required restoration.) Even its provenance is simple and clear; the statue was found in Hadrian's Villa and brought to Florence in 1680. The subject is precisely that of Canova's statue, and the general posture and comportment of the ladies (except for the fact that the ancient goddess has no towel) are broadly similar. But differences make themselves felt at once. Though she too holds her hands in the classic gesture of *pudeur*, the Medici goddess does not clutch or shrink, like Canova's lady—her modesty is a good deal more relaxed. She is not looking straight ahead, nor yet avoiding our glance, but turns her head only slightly to one side, as if calm in the possession of her body. This isn't just a matter of the features—it's in the solid thrust of hip, haunch, and thigh which sustains her primary weight and moves her confidently forward, it's in her straight back and the easy balance of her whole posture. She's much nearer to a fine, healthy animal than Canova's delicate, nervous creature. Modern beauty, says the poet, has about it always something sick, if only in the consciousness of weakness:

> Des visages rongés par les chancres du coeur
> Et comme qui dirait des beautés de langueur.[32]

One can't very reasonably compare the finish of two statues so different in age; but Canova seems to have put much more of his lady's character in her surfaces, in the finish of her marble, in the careful inflections of her deeply folded drapery. (Is it fantastic to reflect that, as in Mallarmé, these deep *plis* or foldings of material back on itself do somehow suggest the self-questioning movement of the self-absorbed mind?) Withdrawn, cultivated, maybe even synthetic, she clearly reflects the fact that a woman of fashion may cut a fine figure when emerging from her bathtub, just as the Goddess of Love

[32] *Les fleurs du mal*, V.

did in the naked ages, but that for her it's quite a different experience, quite different indeed.

Perhaps one tacitly abandons any claim for Canova's status as a major artist when one starts comparing him with his English and Swiss neo-classical contemporaries, Flaxman and Fuseli. Still, the different ways they were spoiled as artists may offer points of contrast with the way he was spoiled, as well as a positive measure of his achievement. John Flaxman (1775–1826) fell as a youth into a print-and-paper culture, and never extricated himself from it. Perhaps it happened because he was a sickly, an almost deformed young man; but it was also because books were the polite, the genteel thing in his circles. Kind ladies read him the classic myths and he made sketches of the scenes that appealed to his imagination. The sketches caught on wonderfully, and he was designing for Wedgwood by the time he was twenty. Twelve years of this labor served to finance a visit to Rome that was projected as a two-year residence but turned to seven. Even in Rome, his successes were not in clay or marble, but on paper. He did illustrations for Homer's poems and Dante's *Comedy*, for Hesiod and Aeschylus; they were elegant and chaste drawings, not very different from those that had made such a hit on Mr. Wedgwood's teacups. For reproduction purposes, his drawings were engraved by other people, losing in the process a good deal of their never too abundant vitality. It was a discount that Flaxman allowed with characteristic good grace; he never made exorbitant demands on behalf of his genius.[33] By all accounts, he was a mild and agreeable person, a little quirky when touched in his private, Swedenborgian-flavored religion, otherwise gentle and good-humored. He did try sculpture, and it's the general consensus that, the bigger the effect he strove for, the worse he succeeded.[34] His talent was bigger than

[33] Crabb Robinson, in the *Diary, Reminiscences and Correspondence*, ed. Thomas Sadler (London, 1869), under date of May 7, 1822, contrasts the self-effacing naïveté of Flaxman with the dignity of his fellow diners at an Academy Banquet.

[34] "Übrigens gelingen ihm auch hier naïven und herzlichen Motive am besten . . . Im Heroischen ist er meistenteils schwach:" Goethe, *Schriften zur Kunst* (Zurich, 1954), p. 183. W. G. Constable, in *John Flaxman* (London, 1927), p. 54, explains that Flaxman designed his monumental works in miniature and left their actual construction to workmen, hence their tendency to scrappiness and disintegration.

teacup decoration, but not much bigger; and he didn't work very hard at making it grow. Unlike Canova's, his figures perfectly embody the emotions he pours into them; but since those aren't often more than lukewarm tea, the most they achieve is quiet charm. Probably he never dwarfed his talent, either consciously or unconsciously, to fit his style; the cool, limited style simply came natural to a cool, limited talent.

If Flaxman's was a meek, decorative talent that slipped unobtrusively into the most placid of neo-classic shapes, the raging Dionysian energy of Henry Fuseli (1741–1825) never found any proper shape at all, or rather it was continually overburdening and finally escaping from all the shapes in which he momentarily embodied it. What is peculiar about Fuseli's mind is that it seems to contain all the opinions of his age, all in their most extreme form.[35] He believes passionately in the absolute superiority of the Greeks; but he contrives to make Greek art mean for him what "Gothic" means for most of his contemporaries.[36] With Sir Joshua Reynolds, he believes the artist is bound to represent general nature; yet he exalts expression above beauty, or rather, affirms against Winckelmann, Goethe, and the official neo-classic theoreticians of his day, that beauty can be achieved only through fullness of expression.[37] So far as they have retained a contemporary interest, his paintings and drawings are to be

[35] Like a lot of men who are absolutely convinced of their own originality, Fuseli was a generous borrower, not only of ideas, but of designs and compositions, which he tended to take over and then freely rework. See Frederick Antal, *Fuseli Studies* (London, 1956), *passim*.

[36] One of his drawings, "Der Kunstler verzweifelnd vor der Grösse der antiken Trummer" (*Gemälde und Zeichnungen*, catalogue of the show at the Kunsthaus Zurich, 17 mai to 6 juli, 1969, abb. 4) expresses beautifully his ambiguity. The "kunstler" (figure within the frame) is indeed dwarfed by the gigantic fragments of the antique; but the "kunstler" who created the drawing triumphs over the disparity and draws his effects from it in all security. The drawing is reminiscent of several by Mantegna, whom, of course, Fuseli's critical principles didn't allow him to appreciate.

[37] "Expression alone can invest beauty with supreme and lasting command over the eye," says Fuseli's Aphorism 99; and the corollary supports it with a reference to the Greeks: "On beauty, unsupported by vigour and expression, Homer dwells less than on active deformity; he tells us in three lines that Nireus led three ships, his parentage, his form, his effeminacy; but opens in Thersites a source of comedy and entertainment." *Life and Writings of Henry Fuseli*, ed. J. Knowles (London, 1831), III, 96.

seen as forerunners of the expressionist movement; they are studies
in the nightmarish and the grotesque—had it not been for Mrs.
Fuseli's determined censorship, they would include a liberal element
of the obscene as well.[38] When Fuseli draws classic figures, they take
upon them a strident, vibrant energy, a tautness under the pressure
of expression that makes them quiver like bent bows. There is a man-
nerist element at work here, in the violent foreshortening of the fig-
ures, their anatomically exaggerated gestures; there is also a kind of
poet's contempt for reality, reminiscent of Blake. ("Damn nature,"
Fuseli is quoted as saying, "she always puts me out.") Sometimes
the Fuseli figures even explode in spirals of upsailing, gravitationless
free flight, as in a Tiepolo ceiling. Whatever the classic or neo-classic
ideas with which he began (and which, with characteristic stubborn-
ness, he maintained all his life), Fuseli clearly infused them with a
wholly different spirit, a visionary mood. The great drawing of
"Achilles at the Funeral Pyre of Patroclus" [39] is a marvelous and ter-
rible design; but its relation to the classic mood is of the most
peripheral.

 Between the restful decorations of Flaxman and the turgid vio-
lence of Fuseli, we place, in uneasy equilibrium, Canova. Given what
they were all trying to do—form a new and personal style on the
basis of the antique—his venture seems like the largest, if also the
most dangerous. Flaxman subdued his expressive impulses altogether,
Fuseli exploded them into mannered magniloquence; the extra di-
mension of Canova's work is that of an interior self lost between
subject and object, undefined, uncommitted in its relation to a pol-
ished surface. The classic surface serves Canova as a large, neutral,
and sometime troubling vacancy—a soul wanders somewhere within
or behind it, alone and self-hypnotized. His sketches have their own
immediate vitality, easy to see and appreciate; but he never aimed to
bury it beneath polished surfaces, and in his best work he didn't do
so. He had a saying that "la creta è la vita, il gesso è la morte, il
marmo è la resurrezione dell'opera d'arte" [40] (clay is the life, plaster

[38] Ruthven Todd, in *Tracks in the Snow* (New York, 1947), pp. 61–93,
argues for the "domestic" Fuselis and the obscene drawings as more terrifying
than the deliberately grotesque and gigantic pieces.
 [39] Antal, *Fuseli Studies*, fig. 38a.
 [40] Cited by Valentino Martinelli, "Canova e la forma neoclassica," in
Arte Neoclassica (Venice, 1957), p. 204.

the death, and marble the resurrection of the work of art), and there are times when he actually brings it off.

Piranesi

The classicism that Canova found in polished, impassive surfaces, and used to overlay a "modern" sensuality, dream, or doubt, is reversed by Piranesi, for whom classical antiquity is a mighty corpse overgrown with modern maggotry. For Piranesi, Rome is a vast dead mother, over whom (around whom, under whom) he clambers, as Baudelaire in his fantasy clambered over a young giantess, lithe yet vast, who was also his mother.[41] All sorts of details suggest the animism of the dead city. Vegetation sprouts from masonry like hair, ruined columns burst from the ground like enormous phallic mushrooms, and the gigantic paving stones of the streets are whorled with gigantic finger prints. Du Bellay had much the same vision two hundred years before when he described how Jupiter grew fearful that Rome might emulate the heaven-storming giants, and thus buried her under the seven hills:

Il luy mist sur le chef la croppe Saturnale,
 Puis dessus l'estomac assist la Quirinale,
 Sur le ventre il planta l'antique Palatin,
Mist sur la dextre main la hauteur Celienne,
 Sur la senestre assist l'eschine Exquilienne,
 Viminal sur un pied, sur l'autre l'Aventin.
 Antiquitez, IV

(Upon her head he heapt Mount Saturnal,
Upon her belly th'antique Palatine,
Upon her stomach laid Mount Quirinal,
On her left hand the noisome Esquiline,
 And Caelian on the right; but both her feet
 Mount Viminal and Aventine do meet.
 (trans. Spenser)

Piranesi's Rome is a series of monumental hairy arches within which ragged miniatures (animal, vegetable, or human) make elaborate, undecipherable, yet vaguely grandiose pantomimes. What the

41 *Les fleurs du mal,* XIX.

humans do is practically motivated on occasion, but mostly not; it forms on occasion a pattern of related gestures, as of invitation, recognition, encouragement, display—but mostly not. Ragged and mincing, Piranesi's figures are dwarfed by the enormous structures within which they darkly exist, yet are oddly indifferent to them too, as to the air they breathe. The vast moldering ruins seem to breed vagabond courtiers as a special variety of lichen; and one finds them in illustrations of subterranean watercourses and sewers, as surely as in the dark, hairy recesses of broken palaces. Dead Rome is a stage setting so splendid that it dwarfs all actors; it does not serve them, rather one feels they have accidentally strayed into it, and been enchanted there, languid characters in search of an occasional drama or at least a happening. Their deference and indifference are both Prufrockian; and in their bewildered, primitive elegance, they seem to wander through shaggier wildernesses and darker abysses than any built by Romans or ruined by Time. And yet Time falls through all the world of Piranesi, thick and palpable: even his prisons are like vast dark sundials through which isolated and interrupted shafts of day strike to mark off the leaden hours.

A weighty world, this of Piranesi, one of blocks more immense than man can think of lifting, buildings more staggeringly enormous than men could envisage occupying. Yet also a world in which the impalpable, subtle enemy of all solidities looms very large; and, depending on whether he happens at the moment to be more concerned with matter or with time, Piranesi shifts character like a chameleon. One Piranesi creates builder's blueprints, hard, precise, dimensional, within which the occasional isolated figure exists simply to provide a measuring scale. The other is an artist of towering dreams and impressions, of surfaces forever giving way to other surfaces, and immense, impossible disproportions, such as suggest an inner drama within the brain of a mad scene designer. The paths of these two Piranesis often cross, they try each other's idioms, to the dismay of logic and the proliferation of fantasy. Professor Poulet summarizes with *pointe assassine:* "C'est que les admirateurs de Piranèse pouvaient y percevoir simultanément deux obsessions—la hantise de l'espace at la hantise de la privation d'espace." [42] Some of the studies

[42] Georges Poulet, *Trois essais de mythologie romantique* (Paris, 1966), p. 186.

of Roman foundations, sewers, and watergates are both archaeologically precise and mysteriously atmospheric; while there is at least one immensely detailed floor-plan for a "collegio" beyond all conceivable collegii—a vast, fantastic proliferation of vaults, corridors, wings, atriums, libraries, chapels, apartments, stables, staircases, and galleries (*all on one floor,* too, so that the upper stories, which alone can keep the building from looking like a cellular pancake, must serve exclusively for display): a collegio, in short, such as only a megalomaniac emperor would set out to build.[43] These are among the mixtures of the two Piranesis, and there are many such blends. But at the extremes the two modes are quite distinct, and a major element of the distinction lies in an attitude toward surface.

A peculiar feature of Piranesi's strange and fascinating *Groteschi,* done about the same time as the first state of the *Carceri,* that is, about 1744 when Piranesi was just twenty-four years old, is the complete absence of any assured surface. Bodies, moldings, buildings, skeletons, scutcheons, emblems, and statues spring out of landscape and melt freely back into it. The dance of time, the rhythm of metamorphosis, is transformed here into the monument of a bewildering moment; the eye, unable to promenade serenely across the surface of the print, takes to puzzling over the details of its themes. The image invites a kind of interweaving of the eye and the mind's eye, the detail perceived and the pattern eluded; the sense is of something forever slipping away, and the characteristic action of the eye before the print, as of the shapes within it, is a writhing. Earlier works in the style known to Italy as "grotesque" (it's customary to mention G. B. Tiepolo as a predominant influence on Piranesi) tended to be flat, almost stencil-like: they are properly arabesques. But Piranesi's elaborate modeling suggests a perspective which the arrangement of his details is perpetually frustrating, and the ever-present element of horror makes the work "grotesque" in the modern as well as the technical sense.

43 This must be the plan that Piranesi produced in response to criticisms voiced by certain "pensioners of the French academy at Rome," to the effect that he couldn't design a buildable building. Sir William Chambers thought the design rather justified than refuted the charge. See A *Treatise of Civil Architecture* (London, 1791), p. 10. Sir William refers simply to "a celebrated Italian artist," but he means Piranesi, whose studio was right opposite the French Academy.

Merely to list the objects represented in one of the "Groteschi" would give an impression of inextricable confusion and disorder; but in fact the prints have a kind of perverse, anti-logical patterning. In one of the etchings (no. 4) a rope wreathed in flowers leads down from a swine's head with bull's horns to a jumble of decorated shields followed by plumes, fumes, and fruits, out of which protrude a chain and a trumpet which overlie a frieze decorated with a sash and medallions, behind which is another wall, above which we are evidently in a different order of reality altogether, for here a hand belonging to nobody is emptying a glass near a row of barrels half buried in the ground, near an inscription of which only the words "foglie" and "allegramente" are fully decipherable. The mixture of textures and modes of representation is violent and capricious; yet the print is dominated by its strongest images, to which, after a moment, all the others become subordinate. Four shaggy skulls are scattered across the bottom of the print, hidden in the recesses of the foliage or on urns, and even mimicked by a half-buried hourglass of bone in the foreground. These representations of death are perhaps less gruesome than the partially decomposed skeleton in the foreground of "Groteschi" no. 1, a languid, ragged figure, rotted halfway off the bone and into the earth, but still seductive under its garland of vegetation. Yet they dominate the print, and cast one back into it to seek out emblems of the mythological past, the pan-pipes, the club (of Hercules?), the abandoned caduceus, which testify to the power of time.[44] And only when one has explored these themes is one likely to notice that the surface of the print is itself a surface that one is invited to look behind—the very crumpled and ragged edges of the paper being represented as part of the image. One's sense is less of planes receding in an ordered or even a playful way, than of the whole picture as a series of unpeelings. The print itself moralizes in conventional fashion that the various disguises and entertainments

[44] In the "snake" print among the *Groteschi*, we see the quiver and arrows (of Cupid?), the monuments of war, and the brush and palette of the artist, all swallowed up under the writhings of sea-monsters, eels in the foreground, a dolphin in the background. (There's something Venetian or Dutch about these fantasies—the porous, cheesy, earth, the frequent uncertainty as to which way is up.) All the *Groteschi* might fittingly stand under a title like "The Triumphs of Time."

of life are but shapes of death; and then, by turning up its own edge, reveals that the morality itself is but another peeling on the corpse. There's a curious kind of entrapment here, as if the print got one involved in a general discussion of death, and suddenly turned under one's eye, just as one expressed agreement, saying in effect, "—and that statement you just agreed with is dead too, i.e., there's a dead thing right in your mind. Ugh!"

In manners less spectacular, perhaps less arch, the play with surfaces often turns, in Piranesi's ideal renderings, to a play with multiple levels designed to enlace, bewilder, and dizzy the wandering eye.[45] For instance, he sets out to draw a seaport worthy of classical traditions, and begins by locating one's eye in a low boat, as close to water level as he can get it, below even the splendid outlets through which the city's accumulated sewage pours grandly and directly into the harbor. Assuming that the visual dignity of these noble pipes atones for the stench they cannot fail to produce, one lands from small boats (there are no wharves for big ones), and goes up a flight of some twenty-five stairs. There one finds a broad plaza which has no apparent means of communicating with a further plaza, some 35 feet higher, which seems to lead to a truncated pyramid some 65 or 70 feet higher still, on the side of which is apparently a beacon, but beyond which a vast, rounded building rises at least 150 feet higher yet. The city is rich in columns, pillars, altars, sepulchral urns, giant statues, and picturesque trophies; but

[45] The famous passage of De Quincey (*Confessions of an English Opium-Eater*, "The Pains of Opium"), derived from a dream of Coleridge's and describing Piranesi climbing endlessly the staircases of an interminable structure, is probably based on one or several of the "Carceri," but it's not easy to say which. Coleridge and De Quincey (who, between them, set a whole generation of romantics to work on fantasies of dwarfed, doomed climbers in unending perspectives) saw pictures very imaginatively. Luzius Keller, in *Piranèse et les romantiques français; le mythe des escaliers en spirale* (Paris, 1966), offers a generous accounting of the theme in Gautier and a less incisive account of its existence in Hugo, Baudelaire, Poe, Mallarmé. In fact, Piranesi doesn't reproduce himself or imply successive stages of movement in any of the "Carceri." By itself, the technique is an old one, visible for example in Botticelli's drawings for the *Divine Comedy*. Some of the metaphysical overtones that modern criticism has extracted from the passage might be modified if it were looked at under this aspect. This, quite apart from the fact that De Quincey's picture is of his own (or Coleridge's) composition, not Piranesi's.

there is not a single street where a wheeled vehicle could pass (or a single wheeled vehicle to pass through it); one feels that the little clusters of leaning citizens, gathered picturesquely on promontories and behind balustrades to gaze on their insane city, are irredeemably cut off from one another. A pillar of romantic smoke rises from the altar; its cloud surrounds a column bristling with naval trophies and obliterates most of another one, leaving visible only the climactic figure of the victor in his glory. He rises out of the altar-smoke like a mountain out of cloud-banks, majestic and to all intents unsupported.[46]

As a working design, the whole thing is a farce; even if one sacrificed all wheeled traffic (as in Venice; and the reasons which forced the Venetians to do without streets would of course render Piranesi's structures completely impossible), the city imaged forth by Piranesi couldn't be realized in three dimensions under any circumstances whatever. But it is characteristic of him to ignore all practical considerations, to sink the observer's eye as low as possible, and to build his city as crowded and lofty as possible, so that it may bear down on the viewer with the weight of earth itself.[47] Very often the angle of his perspective is a dead man's: he is under ground looking up and out, he is shrunken out of all proportion to the living world. The parallel with Poe seems tantalizing. Geometry as the art of measuring earth, mother of us all, has a perhaps fantastic connection in Piranesi's mind with this corpse's eye view of things. A "Camera

[46] The print in question is number 23 of the *Opere varie* (1750), described by A. M. Hind, *G. B. Piranesi* (London, 1922), p. 80; also no. 122 in the catalogue of Henri Foçillon, *G. B. Piranesi* (Paris, 1918). See pl. 12.

[47] Visitors to Rome, arriving with Piranesi's prints in mind, often found the reality a great letdown. Cf. Farington's record of Flaxman's response (he was bitterly disappointed) and Goethe's *Italienische Reise*. Nodier was so impressed with Piranesi that he determined never to go to Rome at all. See Joseph Farington, *Diary*, ed. James Grieg (London, 1922–1928), date of 16 Dec., 1795; Goethe, *Italienische Reise*, Rom, 1787; and Nodier, *Oeuvres complètes* (Paris, 1837), XI, 187–188. In fact, Goethe was right in sensing the pyramid of Cestius to be much smaller than in Piranesi's prints. Piranesi shows it (Hind, no. 36) as comprising 57 courses of stone, each 4 or 5 feet high, and so scarcely less than 250 feet tall; in actuality, it's only about half that height. Piranesi's grandest effects are all achieved by this sort of distortion; when he has a really vast structure to reproduce, like the Coliseum or the baths of Caracalla, his prints tend to get scrappy and his details fussy.

Sepolcrale" (no. 12 in the appendix to *Descrizione e disegno dell'Emissario del Lago Albano:* Foçillon, no. 504; cf. also Foçillon, no. 531 and, "Antichità d'Albano," no. 22) is built like a cathedral yet, in defiance of all good sense, is underground. Its walls comprise tombs built like Dutch ovens in the masonry. They rise in strict geometrical lines around the sides of the structure, too high to be reached without special scaffolding, too high even for the inscriptions to be read. It is a building actually composed of death, the arches of which, dripping airy vegetation, merely amplify the arches over each individual tomb. Emptiness, loneliness, death. Those faraway figures on the shelf-like balcony around the room: how did they get there, what can they conceivably be doing there? Their gestures seem hollow, their expostulations idle in this rifled box drained down to its bare geometry by time. The one complicating counter-statement of the picture, which is otherwise an image of dusty vacuity, derives from the sun, whose rays enter the room through some high window we cannot see, and slope steeply through the atmosphere. It isn't just that the sun's rays provide, as so frequently in Piranesi, the only diagonals within a vertical-and-horizontal composition; by cutting across the pillars and getting lost among the shadows, they provide a kind of blotched, massively cross-hatched effect, very mixed and sinister (see pl. 13). There is a different variety of hard, even illumination in which Piranesi sometimes holds up for our inspection a vase or inscription—rather as if he were doing an illustration of ultimate lucidity for the great *Encyclopédie.* It was in this style that he catered, throughout his life, to the tourist trade, supplying huge etchings of funeral or decorative urns, done with marmoreal clarity and weight, and each dedicated to an English *signore,* a distinguished fellow and a lover of the fine arts. These were personalized magnified postcards, in effect, designed to serve as souvenirs of a Roman visit. But in the shadow of the grave, where the planes of geometry are interrupted by a truth so awful that it can only be gesticulated, Piranesi enters into the kingdom of his imagination, and its name is death.

Like his contemporary Magnasco, he had a fondness for ragged and misshapen figures, whom his first biographer tells us he used to seek out deliberately among the crippled and distorted Roman beg-

gars, in order to sketch their deformities; a corollary would be his indifference to the female figure, really nothing less than an active avoidance of it. An occasional ragged shepherdess clambers barefoot over the ruins of a Piranesi landscape, usually with a *bambino* huddled in her rags; a rare Roman matron is portrayed alongside her husband; when ladies occur in friezes, they occur in friezes, and Piranesi reproduces them. But the general absence of the female figure from his imaginative work accords with something hard and cold in his style, something frigid and self-absorbed in the quality of his fantasy.[48] He is less interested in nature than in the unnatural;[49] and the enwombing, entombing arches of masonry under which his mysterious cripples pursue their labyrinthine destinies provide the only mother principle his world requires.

Piranesi has the reputation of being the most painterly of etchers, as well as one of the few great etchers who never painted, a combination of destinies that carries with it a distinct sense of the precarious. The very techniques he made his own (engraver's needle, etching acids) have a sharp, bitten quality that contrasts with the thick, colorful luxuriance of oils; his attachment was always to the eating-away process, never to the greasy thumb and *impastatura* method of painting. Curious to think, then, what must have been the character of that autobiography which, we are told, Piranesi's sons were peddling about London in the early nineteenth century, but which has been lost ever since.[50] We have from the second-hand reports and fragments that remain a sense of rigidity and austerity, of avarice and perhaps of arrogance in dealing with patrons. When

[48] There is no doubt a satiric touch in a rendering of the Aqua Julia (Hind, no. 34), M. V. Agrippa's mighty aqueduct, the foreground of which is occupied largely by a ragged washerwoman hanging her ragged wash on lines fastened to knobs and protuberances of the vast ruin. This is a woman's response, a modern response, Piranesi seems to be saying, to an imperial structure.

[49] Nodier's essay on Piranesi, taking off from an unacknowledged transcription of De Quincey's report of Coleridge's fantasy as translated by Alfred de Musset, makes much of the anti-naturalist aspect of Piranesi's fantasy, setting up an opposition between instinct and culture that looks forward to Freud, and falsifying its relation to Piranesi only by giving it a religious, supernaturalist coloring.

[50] Piranesi's autobiography, brought to London by his sons and there circulated among publishers, somehow got lost about 140 years ago, and may even now be lurking in a Soho attic or the library of a stately home.

Lord Charlemont disappointed him, he gouged out the heraldic em-
blazonry on which the ignoble peer's name and arms had once ap-
peared, leaving the plates blind and mutilated.[51] We find, too, in
some of the etchings, indirections (slyer than might have been
expected) that in the quarrel between the ancients and moderns, he
took a stern, forlorn-hope position amid the ranks of the ancients.[52]
Some of the less imposing modern buildings reproduced in the
Roman Vedute, for example, San Lorenzo fuor le Mure (Hind,
no. 12), carry Piranesi's direct editorial comments in the form of
darkened figures visibly pissing on the architecture. There is a
very beautiful Atrio del Portico di Ottavia (Hind, no. 59) which
lists among the numbers at the foot of the print a number 4,
"Pitture moderne." The nearest thing to a number 4 in the print
proper is on some sausage hanging in an open-air shop in the lower
left-hand corner.[53] On the other hand, in the etching of Trajan's
Column (Hind, no. 51), a gentleman stands in the lower right
dressed in eighteenth-century frock coat, but striking the pose of a
Roman flamen in adoration.

Piranesi spoke out, then, often and with acerbity. He was re-
marked also for an exercise of *patria potestas* which slack, cheerful
eighteenth-century Italy found both sinister and vaguely comic: there
is a story of a doctor treating Piranesi's son who was told by the

[51] Piranesi was most unfortunate in his enemies; Lord Charlemont, an Irish
Chesterfield, was simply unworthy of him; and Winckelmann, with whom he
waged a barely undeclared war on the topic of Greek or Roman originality,
far outgunned him. No matter how much he knows about Rome, a man
who has never been to Greece can hardly speak with much authority to this
question.

[52] A paradox of this position was his impassioned denial, through one of
the great blind-man's buff controversies of the eighteenth century, that the
Romans were significantly indebted to the Greeks for their architecture and
design. He preferred to look for their antecedents among the Etruscans: a
thoroughly dubious place to look for roots. But a good deal of his feeling
about the controversy was moral, not artistic, since he thought the Romans
built essentially for the public welfare, unlike the Greeks, who built for luxury
and display. This would be in line with his standing interest in foundations,
sewers, baths, aqueducts, the undignified daily-life side of the city—though it's
odd in a man whose architectural imaginings have often been compared to the
work of a stage designer.

[53] Henri Foçillon, G. B. Piranesi (Paris, 1918), p. 92.

somber father to cure the boy or make his own will.[54] Authoritative, quarrelsome, ambitious, strict: these he must have been; and if his autobiography had anything in common with that of Cellini (as one who saw it declared), the resemblance must have lain in these austerities and ferocities, rather than in amorous escapades. His marriage, for what this biographical detail is worth, was a curious old-fashioned mixture of shrewd investment and straightforward attachment.[55] He found his wife, a shepherdess, while sketching in the Forum, reached his decision, and executed the marriage contract within five days. He bargained sharply over the dowry, and abruptly assumed power to invest it in the print-making business, but turned a splendid profit with it, and built the family fortunes on this simple foundation. One can understand the severities and Roman authenticities of such a marriage; but what sort of tawdry, elegant affair this exalted necrophiliac might have arranged (if any), it baffles the mind to conceive. Somehow the story is incomplete without a hectic, vagabond contessa, a creature of rags and imagination; but here we venture into realms of outright fantasy, for which the Cavaliere Piranesi was careful to leave us no warrant. Rather, it is to be noticed that the later etchings often include, amid the riot of enwreathed figures who fill the shadows of his buildings and the hollows of his turbulent landscapes, persons who no longer gesture or dance, invoke or invite, but who sit with vacant expressions and slack muscles, moping melancholy mad (see pl. 14). Lost in the labyrinths of their own tormented imaginations, they reflect the vacant desolation of Piranesi's; the death they ask us to confront is no longer theatrical, public, and past, it is inward, personal, present. The artist has perhaps had a premonition that the tomb he has been celebrating for so many years will soon be his own. The symbol is in a fair way to swallowing up its maker, as if the thousands upon thousands of little scratches that he had made on his copper plates now somehow ran together in his mind, to become the ultimate trench.

[54] *Ibid.*, p. 95. The story is based on an anonymous English paraphrase of the sons' life of their father, based on his autobiography (cf. above n. 50). It appeared in the *Library of the Fine Arts*, II (August, 1831), 8–12.

[55] He was a furiously jealous husband, apparently given to fits of rage in which he completely lost control of himself. See Foçillon, *Piranesi*, p. 92, n. 2, citing a MS life of Piranesi by J. C. Legrand, in the Bibliothéque Nationale.

Piranesi had loved the Romans because they were mighty strugglers against time, and the disordered masses of his great plates are as the ruins of a similar hopeless, superhuman enterprise. He appeals to us as a great sick imagination pacing restlessly the corridors of history, a delver after the wormy kernel of the grave, Art's number one resurrection man. Once more, Du Bellay speaks to the point:

Rome n'est plus, & si de l'architecture
Quelque ombre encor de Rome fait revoir,
C'est comme un corps par magique sçavoir
Tiré de nuict hors de sa sepulture.
 Antiquitez, V

(Rome is no more: but if the shade of Rome
May of the body yield a seeming sight,
It's like a corse drawn forth out of the tomb
By magic skill out of eternal night.)
 (trans. Spenser)

Like Canova, he seeks in antiquity the fulfillment of a private dream; but it finds its form in ragged decay, not delicate lust; it converts the accidents of antiquity into the essence. There is a story that on his deathbed he pushed aside the Bible and clasped instead a copy of Livy, with the words, "Non ho fede che in questo." [56] One is reluctant to question too closely a man's deathbed sigh, but it's not altogether clear what he meant by the phrase. As a rejection of Christianity, it's perfectly explicit, and scarcely surprising. There is almost always something belittling about the cross in Piranesi's art; either a satyr peeps around it or a pagan structure grandly overstrides it, as in the "Avanzi del Tablino della Casa Aurea" (Hind, no. 114), where a tiny cross is backed up against the light pouring through a gigantic pagan arch. But if he believed actively in Livy, Piranesi's faith was not and could not have been in rhetorical republicanism. It might have been in the ideal of Roman glory and Roman dignity, of which Livy was the spokesman; it might even have been in Livy the man, who had come, as Piranesi and Canova and for that matter

[56] *Ibid.,* p. 129. Apparently he raised his sons on stories of Cato, Scipio, and heroic Romanry, and thought it unbecoming a "civis Romanus" like himself to lie inactively on his bed waiting for death to take him.

Palladio had come, from the lands around Venice, and who had undertaken to restore Rome to herself, to make her degenerate modern children see her as she had been before. But for Piranesi, the effort to show Rome as she had been was always secondary to the investigation of what she had become. What he saw of Roman glory he saw always under the image of a colossal disaster, and everything suggests that the disaster was even dearer to him than the glory. Among the etchings dedicated to the Campus Martius, there is one, less pleasing than curious, which shows the district stripped of all modern encumbrances, all modern Rome reduced to a *tabula rasa*, from which emerge the smashed masonry and ancient rubble piles of the antique city. And it is curious to think of Piranesi, with his papal (i.e., pseudo-military) title of "Cavaliere," his mind full of copper plates and etching acids, sauntering through the streets (as he must have done), erasing with a hard, pensive eye the modern walls and buildings, the people, the traffic, the contemporary ephemera, in order to bring forth with more clarity the rotten, ragged body of the buried giant by whom alone he was fascinated, to whom he was, by some inward principle, linked.[57]

In their very different ways, Piranesi and Canova stand in a similar intimate relation to the surface and scene of Rome, to Rome as parent and sponsor. How to accommodate the infinitely expansible, infinitely compressible private dream to the cold image of the antique was their common concern. Canova tended to bury his dream under cool, classic surfaces, while Piranesi buried the surfaces, and his own geometric mind, beneath shaggy tangles of dream underbrush, mountains of crumbling masonry. Evidently Piranesi's inner life was a good deal more violent than Canova's; yet the arts of both men include an element of concealment and withdrawal. The vision is not all in what has been rendered; it includes, in both men, an echoing sense of absence and hollowness that's hard to define, but not hard at all to feel. Something is missing—so we feel

[57] That Piranesi was well acquainted with the thought of Vico, either directly or through intermediate influences, seems beyond question—and of an importance that surely merits further exploration. Cf. the "Saggio Introduttivo" by Maurizio Calvesi before the Italian translation of Foçillon, G. B. *Piranesi* (Bologna, n.d.).

in the presence of both: some sort of space isn't filled up. Obviously, this bothers people more in Canova the sculptor than in Piranesi the etcher; but it's substantially the same insubstantial phenomenon.

Both men have stepped down a stage from the hard, marble fantasy of Mantegna, who saw the battle for bright and ringing images of masculine law as his own. Canova's dream is that of a Mallarmé virgin so enfolded in her own icy thoughts that she abandons her polished, impenetrable body to the sculptor almost indifferently. Piranesi saw the city as a voluptuous, ragged female lying prone in an endless loving struggle with nature. It is one of the great visions of Rome, but its vantage point is that of a jailed criminal, a baby, a madman, or a corpse, i.e., someone bound, flat, and helpless. Though always *in loco parentis*, Rome was destined to be for Piranesi as a mother; for a Roman father would have told him to rouse up, set aside those dreams of crumbling magnificence, that nightmare of helplessness, that piddling, inadequate needle, and set to building on his own count. He did, in fact, set to building just once, around 1765, producing in the remodeled Santa Maria Aventina (which ultimately became his tomb) a curiously empty, heraldic building, a magniloquent hollow preamble to a structure. Marvell could have reminded him, had he needed reminding, that in the days of Rome's masculine greatness, they built in truer proportion to the inhabitants and their capabilities:

> . . . that more sober age and mind,
> When larger sizèd men did stoop
> To enter at a narrow loop.[58]

But the disproportion was Piranesi's destined talent.

Was it actually the sense that they were trying to inhabit, and could only haunt, a house built for larger and more substantial people, that spooked Piranesi and Canova? or was it, on the other hand, the feeling that they had more to say, had heard more of time's music, and represented a new fold in history's seamless web, that gave them both such strikingly bad artistic consciences? As we enter upon that most manic-depressive of centuries, the nineteenth, it's only fitting that we encounter this pair of Janus figures, who

[58] "Upon Appleton House," ll. 28–30.

look not only to the past and the future but also (by a process not
to be represented in three dimensions—as we have seen) down the
well of the self. That is why, when we picture them under the image
of seduction, we still can't tell whether their role in the drama is
active or passive—or, rather, why we are sure, as with Narcissus, that
it is both.

VI

DIFFUSION, DISINTEGRATION, MASQUERADE

In the wild flood of mummery and pageantry, disguise and mimicry and transformation that spilled out of the French Revolution—in the immense outpouring of romantic *Schwärmerei*, with its multiple layers of re-enactment (always under the guise of spontaneous originality), our subject disintegrates, as the Roman ideal inevitably fractured and fell apart. There were too many Romes; there were too many other things to be; too many people had already been what Rome could inspire them to be. Rome had been a social and civilized experience: though primitivist and apocalyptic versions of neoclassicism were possible, they represented rather a strain. The more people played the Roman game, the triter their common counters became, and the more shallow their commitment. From sheer multiplicity their tracks became untraceable, even as from sheer insipidity they ceased to be worth tracing. It is the usual thing with herds: all you can say (with a sweeping gesture) is, they went this way, or else that way. Because all academies taught drawing by means of plaster casts from the antique, Rome became a routine source of the picturesque for painters and interior decorators, a decor to be whipped up with a bedsheet and a dusty bust, or lifted in pieces from a book

of ornaments. A society novelist like Bulwer-Lytton, finding his senti-
mental German romances a drug on the literary market, cast enter-
prisingly about and came up with a Romans-and-Christians scenario,
The Last Days of Pompeii (1834). Sentimentalists seeking a stick
with which to beat the unlovely machine society of the nineteenth
century, found it easily enough in an idealization of those far-off
days when men, and specially girls, were naked, natural, and Greek:
rhetoric could copiously embroider the theme to anyone's taste, or
lack of it. Civic virtue and imperial pride continued to find expres-
sion in semi-quasi-classical structures like the Arc de Triomphe,
Nelson's Pillar, the Lincoln Memorial, and that amazing Treasury
Building in the heart of Wall Street. Being remote and marmoreal,
the neo-classic style took on cold adventitious dignities in public
structures, as of mausoleums or public toilets. Odes, epics, and clas-
sical fables with contemporary morals continued to preoccupy Vic-
torian poets to whom the faded embroidery of Hellenistic mythology
was, alas, second nature. A rapid scansion of names and groupings
will remind us, in as much detail as anyone wants, of some major
tonalities in nineteenth-century neo-classicism: we may think of
Augustus Saint-Gaudens and Puvis de Chavannes, Lord Leighton
and Walter Savage Landor, Lawrence Alma-Tadema and *Marius the
Epicurean*, J. L. Gérôme and A. W. Bouguereau, Empire furniture,
Ionian chitons, Theodore de Banville, Théophile Gautier and the
poets known as "Parnassiens," Pierre Louys and Algernon Charles
Swinburne, James Barry and John Martin, Gros and Moreau, Robert
Bridges and "L'Aprés-midi d'un faune," Vittorio Emmanuele's type-
writer and Wilhelm I's Denkmal, Thomas Cole, the New York
Public Library, and the British Museum. None of these various mani-
festations is completely contemptible; but behind them stand serried
ranks of anonymous academicians, mile after mile of dead canvas,
frigid sculpture, miserable narrations, grim buildings, and dutiful
moralities. Amid so much patent fraud, artifice, and inertia, it is
only here and there that we find the classic austerities surviving—
scarce and remote, difficult indeed to discern, and apt to turn stiff or
stuffy without even an occasion. Some of their vitality was evidently
residual; a style does not go dead all at once, and when it retains only
isolated spasms of strength, one may be interested to see where and

guess why. Besides, even a perishing style can be given fresh energy for a while by an artist who's not above getting larky with it. The classic precedent, which had such high specific gravity to begin with, suffered less than one might have anticipated from accesses of levity. And meanwhile, elsewhere, infrequently, still usually in moments of crisis and spiritual desolation, a few isolated spirits continued to find endurance or inspiration in the recollection of Roman examples.

The Last Stoic: Johnson's Dealings with Juvenal

The most authentic expression of Stoic philosophy in English is also the last. It is Doctor Johnson's imitation of Juvenal's Tenth Satire, "The Vanity of Human Wishes." The poem stands out, not only in English literature as more genuine than anything preceding it and unique among the poems following it, but as more subdued and philosophically scrupulous than Juvenal himself. There is, after all, a broad streak of vulgar wit and rhetorical declamation in the satirist; he had evidently picked up a vein of sardonic gutter eloquence from the street-corner philosophers of his day. This aspect of the poet was fastened on by Dryden, whose natural disposition included about as much of the stern stoic as of the embittered republican, that is, none at all.[1] Thus Dryden's translation of the Tenth Satire emphasizes vigorous rhetoric: it is a sweeping, swinging attack on abuses which are so obvious that one is not in the least exercised to take a stand against them. The moral issues being essentially black and white, no time need be wasted in analyzing them; it is the verbal fireworks that count. Dryden, in his version, sets them off with abandon, pointing his Roman candles at any English enemies in range. He is a natural aggressor, and somehow gets so much zest into his translation that one forgets completely that it is a sermon against the human will. Denouncing foolish monarchs and restless subjects, he invokes a violent, active vocabulary, full of extreme adjectives like "foppish," "gaudy," "huffing," or a linked unit like "depending, gaping, servile." The effect of this rhetoric is to put down

[1] Cf. H. A. Mason, "Is Juvenal a Classic?" *Arion*, I (1962), 8–44; in emphasizing Juvenal's wit and rhetoric while downgrading his moral seriousness, this rambling article aligns Juvenal (not very much to his credit) with Martial.

the misdeeds being denounced, and in the process to elevate the de-
nouncer into a thoroughly un-stoical dogmatist, one who knows all
the sweeping, categorical answers even before he has fairly formu-
lated the questions. This may indeed be an aspect of Juvenal, but
it is diametrically opposed to that aspect emphasized by Doctor
Johnson.

"The Vanity of Human Wishes" works through and against
Juvenal in a variety of ways that, despite a lot of discussion, may
still hide a few surprises. On a very simple level, Johnson, as dis-
cursive moralist, wanted to detach a reader from particular episodes
and cultures—not to surprise him by witty parallels between England
and Rome, but to raise him above them. That is the point of asking
him to "survey mankind from China to Peru" (neither of which
was within Juvenal's ken) and a reason for using two points of ob-
servation, an ancient and a modern. One important difference that
this most respectful poem wants to establish between Juvenal and
Johnson is that the latter knows more—he has a longer perspective
on history, has studied mankind more widely, contemplated different
religious dispensations—yet in the end he can only confirm Juvenal's
astringent conclusions. By following the order of Juvenal's topics but
finding for most Juvenalian instances a modern equivalent, the poet
does indeed exercise some personal ingenuity. But more importantly,
he builds in the reader's mind a conviction that things are as they
have always been and will always be, whatever the particulars of the
social scene. The unchanging laws that reveal themselves to the mind
hardened in philosophic brine are everywhere and always the same.
By its weighty, assured movement across the world's surface, its
confident motion from example to example, Johnson's poem super-
imposes on the grave stasis of stoic sameness at least the illusion of
movement and variety. The moral rules bridge from civilization to
civilization, laying out permanent avenues of feeling. Abstract public
moral laws are proved by the simple process of applying equally
well to imperial Rome and Georgian England. In the course of mak-
ing his moral diagnosis, the poet must necessarily override certain
differences; in saying that "under the surface" a Roman event is like
an English event, he can't help saying that certain differences are
"only" on the surface. That leads to special reductive parallels, such

as the one which aligns the Roman mob tearing down Sejanus's statue with the English bourgeois casting out his no longer acceptable family portraits:

> From every room descends the painted face
> That hung the bright Palladium of the place,
> And smoak'd in kitchens, or in auctions sold,
> To better features yields the frame of gold;
> For now no more we trace in every line
> Heroic worth, benevolence divine:
> The form distorted justifies the fall,
> And detestation rids th' indignant wall.[2]

The scale of events is smaller nowadays, our imperial palace revolts take place within the bourgeois parlor; but the moral scale is darker and deeper. The family turns with active detestation on its own origins, so that even the wall shudders with indignation. Instead of an alien tyrant, we assist at the overthrow and downfall of features on which—if the modern family only had eyes to see—heroic worth and benevolence divine could be read. Whose form, then, is "distorted"? The implication is allowed to stand. A particular elegancy is the way the "frame of gold" slips off one generation of portraits and onto another, as each new embodiment of the family frames itself in gilt and glitter.

Johnson's poem thus ventures into the practical, authentic world, and gives the reader's mind active, sometimes troubling, things to do with it. The English equivalent for Juvenal's account of Nero's political oppression might well be some black-hearted tyrant, perhaps Cromwell; Johnson steers the reader's mind toward those problems of disputed succession, as between the houses of Stuart and Hanover, which were actually tearing at English loyalties in 1749.[3] In a word, Johnson reduces Juvenal's imperial scale and turns the moral direction of the poem inward. It is a standing objection to many moral poems that they set up the example and then lecture about it, with

2 "The Vanity of Human Wishes," ll. 83–90.
3 Line 34 first read, "And leaves the bonny traitor in the Tower," in allusion to four Scottish leaders executed after the Jacobite uprising of 1745. The "dubious title" of line 30 has no warrant in Juvenal, but applies directly to the state of affairs in England after 1688.

one uneasy eye on the reader; Johnson burrows into the conscience and uses Juvenal to help his argument with the insinuation that those intimate follies which we indulge in small and in secret have already proven their folly when displayed in large. He makes the reader feel like a little Roman Empire in himself.

Bringing to bear on the individual psyche all the weight of all history's futility may yield the bleak assurance that we've seen everything and stood it. Pressure is one of the hallmarks of the poem; one feels the lessons of history being compacted by brute force into apothegms, then released to flower into examples. Sometimes this process of alternate compression, abstraction, and concretion produces a statement that is itself gnomic, absorbing most of its meaning from the nearby particulars. The active exercise in which this involves the reader combines with other duplicities (primarily awareness of Juvenal, and awareness of departures from Juvenal) to create a much more active poem than a simple statement of the stoic creed would suggest.

Because it is authentically stoic, what "The Vanity of Human Wishes" propounds is the human will disciplined and subdued to carry the weight of total history. Of course it is only an artificial, a learned self, that has to carry all that weight—a self which seeks out the weight in order to prove it can be carried, but also to prove to itself that there is neither further hope nor anything much worse to fear than what's already known. The stoic lives in a cellar room with very low ceilings: he can't fall far and doesn't have much room to look up. What he sees when he looks out the window is an infinite regression of other men's ruins. The more he sees, the more he's confirmed that the only place to live securely is a cellar. This readiness to see more and more widely at the cost, and perhaps with the end, of defining one's own existence more narrowly but more securely, is the root of the stoic mood. (There is a parallel in the closed and fruitless circles of Ecclesiastes, perfect images of Juvenalian desire encompassing its own inevitable defeat; the words of Koheleth were surely in Johnson's mind as he composed—witness, among other things, his title.) And it is exactly this imaginative act of closing off one's self, of limiting one's sense of potentiality by the

long, discouraging record of human history, that the French Revolution and its associated impulses abruptly rendered obsolete.

From the very beginning, as we've seen, identification with Rome had this quality of being subordination to a public or imperial law. Perhaps this is inherent in the nature of a classic as such. (Yet though Chinese literature is classic for Japanese literature, just as Greek and Latin are for the modern West, I don't think the same claim of universality is made for it.) More likely, specific cultural factors are involved—the lingering prestige of the empire, the use of Latin as an international language, the critical doctrines of imitation and emulation, and perhaps (for that matter) the ever present solidity of Roman building. In any event, Johnson's loosely tied Juvenalian mask serves to extend his view of history and to limit his self; the romantic comedians of the next generation will be using masks to limit their vision (to deepen it, to color it, but also to limit it) and to expand or multiply their selves. Johnson is the last poet for a long time to look square in the face of everything he knows and adjust his self to that knowledge, rather than vice versa. It's no accident that he also wrote a great reference book, a book surveying impersonally a vast mass of materials. The habit of survey was tied to a Roman perspective as artificial as any other; in giving it monumental expression, Johnson became one of the last of our poets to rejoice in the rough abrasive therapy of history against the inflammations and swellings of private, inward vision.[4]

For this triumphant expression of the stoic philosophy is in effect its swan song. When we look through the nineteenth century for another work informed with stoicism, defined by stoicism, we look in vain. What happened to stoicism? Without undergoing refutation or criticism, without being so much as remarked in its stealthy departure, stoicism faded away and became obsolete. We do not hear of it in the nineteenth century. It does not, by any means, cease to exist; it's

[4] If I take correctly Mr. Mason's argument in *Arion*, he would say it's precisely because of its novelistic quality, in adopting a frankly obscene point of view without making any overt moral comment on it, that Juvenal's Satire IX disqualifies the poet as a classic. I think this perpetuates a rather stuffy definition of the word "classic," but could not agree more that the habit of mind revealed by Satire IX is remote from that characteristic of Doctor Johnson.

simply attenuated, diminished, absorbed into cosmic pessimism or blurred into Christian resignation. It is as if a century which painted its spiritual existence in such gaudy colors lost all use for stoic gray. Walter Savage Landor knew the classics as well as any English poet, and worked frequently the vein of classic pastiche; but to the severe stoic note he was as good as deaf. Much later in the century, with Housman and Henley, we get an echo of it, but with ironic and sometimes Byronic overtones that make it a very different thing indeed. In a word, stoicism isn't compatible with the self-creating self; it's based on a direct relation to history which romanticism, by making us aware (ironically, by now) of our own projections, has rendered intricate beyond any untangling. Some contemporary poets are at present affecting a "public" voice; appalled by the demand that every new lyricist must have an authentic voice of his own, they propose a subdued and neutral tone, rather like Dryden's or Johnson's public speech. It is an interesting variation on counter-romanticism, but like most such efforts simply bears witness to the sticky and pervasive quality of the romantic habit of mind. It's hard to imagine how one could be a stoic these days, without major irony—it would be a composed work of personal archaeology. Nothing overt has happened in world history which couldn't be summarized under Dr. Johnson's formulas. The climax of modern technology in the bomb, the victory of democracy in the First and Second World Wars, the triumph of social justice in the Soviet Union are simple and obvious instances of the vanity of human wishes. Stoicism itself teaches us to expect nothing else of life beyond repetition of the familiar pattern. Obviously many men, perhaps most, live lives of essentially stoic endurance. And yet for literary purposes the attitude has become inert. The closest thing to a stoic vision in the nineteenth century is found in the work of that curiously stunted talent, George Gissing. This melancholy man had as many imaginary grievances against life as real ones; among them was a sense that his classical scholarship (which was not only devoted but impressive) entitled him to a sympathy from educated readers that he saw them bestowing freely on more facile and less cultivated minds. Here at least his grievance was imaginary. For the stoic outlook that Gissing developed from his combination of erudition and misery was a deadening influence on

his sense of fictional possibility. There were other difficulties as well, including the awful wooden lingua-franca of late Victorian fiction that he inherited from Lord Lytton *et al.* But stoicism at least contributed to that sense which Gissing's fiction conveys, in spite of himself and to its own infinite detriment, of a ground-down imagination, an unresilient vision quite without the gift of insinuation. Of all forms, the novel, which depends so largely on a mobile and maneuvered point of view, can least afford to be stiffened into the constricted room of Johnsonian authenticity.

The Ministry of Virtue—and Its Mockers

Jacques Louis David and the Napoleonic vein of neo-classicism in which he played a major part are customarily presented as a militant revolutionary reaction to the aristocratic, ancien-régime fripperies of the rococo age (Boucher, Fragonard, Watteau, and that ilk), upon which 1789 closed the door. Austere and dedicated simplicity was, according to this view, the keynote of the new age; sensuality, sentiment, and softness were subordinated to the stiff civic ideal. The seductions of color, the distractions of illusionism were minimized; all was to be clear and hard, linear and dignified, as a way of expressing the massive, heroic sentiments of republican rationality. David, by tradition, exemplified this new spirit; and in a painting like "The Oath of the Horatii" (1784), he displayed the fervid revolutionary spirit even before the revolution itself got around to happening. Perhaps the political inflammation of David's painting is a bit exaggerated in this account; according to the painter himself, his major inspirations for "The Oath of the Horatii" were Corneille, Livy, and Poussin.[5] But if not revolutionary in politics, David's first Roman painting was clearly neo-classical in a revolutionary way, which struck the late eighteenth century, and can still strike us, as unwontedly vigorous and strict. The force of the "Oath" is even a little sharper than it seems, if we recall that the traditional center of the story is not the three Horatii and their father, who, converging on

[5] There is also a reasonable chance that he drew some suggestions for the composition from Fuseli's "Oath on the Rütli," done several years earlier. See Antal, *Fuseli Studies* pp. 71–74.

the swords, make up the strong focus of the canvas—but, rather, the somewhat conventional and melancholy young ladies on the right. According to Livy and Corneille, a sister of the Horatii had been engaged to one of the Curiatii; when her last brother came back from exterminating his enemies, she ventured to shed a few womanly tears, whereupon the ardent young patriot (or beastly young Fascist: for the story has been given twists in both directions) [6] struck her dead. In David's painting she is shown in still-ambiguous Corneillian grief, divided between anguish for a brother or a lover; but the thrust of the painting is to override her human, feminine tears with the powerful appeal to public duty in which the four males of the family enthusiastically unite.

"The Oath of the Horatii" thus serves explicitly to dramatize the triumph of public logic and civic virtue over private sentiment; and there are a good many elements in David's later career to suggest that his neo-classicism often assumed this tone, served this theme. He was, in a sense, the master of ceremonies of the revolution; he arranged those strange public festivals in honor of the goddess Reason—half Venetian masquerade, half irreligious ritual—through which the revolutionary movement tried to inspire its Parisians with the sentiments of Cato and Scipio. He painted Marat lying murdered in his bathtub; he painted Madame Récamier reclining on a Greek couch, dressed in a Greek frock, in the presence of a Greek lamp; he drew, with cruel, meticulous realism, Marie Antoinette on her way to the guillotine. He was Napoleon's *premier peintre,* and after the Restoration he figured in exile at Brussels as the emblem of revolutionary firmness and conviction, playing for Napoleon the role that

[6] Corneille's play *Horace* has been a battleground for opposing interpretations of the story almost since it was first produced. Emil Faguet considers that it would be a modern, sentimental perversion of the play to give Camille so much sympathy that a full measure is denied to Horace, the surviving son (*En lisant Corneille* [Paris, 1913], pp. 114 ff.). But from a modern perspective it is Faguet himself who looks naïve and outdated. It is not only conceivable but probable that Corneille had more reservations about his protagonist than Faguet is willing to allow him. David's contrast between masculine stoicism and feminine humanitarianism is even more sharply emphasized in the picture of "Lictors Returning to Brutus the Bodies of His Sons": see the discussion in Robert Rosenblum, *Transformations in Late 18th-Century Art* (Princeton, 1967), p. 77.

Milton assumed in relation to Cromwell. David, then, if any artist can do so, must represent the chaste austerity of the classical temper, clear republican discipline controlling the turbulent sensuality of private fantasy.

The facts, of course, are quite otherwise. David was an enthusiast in his neo-classicism, as in his republicanism; he was an explosion, an outburst, an extravagance. If he didn't wholeheartedly endorse every whim of the wild-eyed "Primitifs" who hung around his studio and fed on his Orphically inarticulate words—men for whom Euripides was as bad as M. de Voltaire, and all columns had to be Doric to be worth erecting—he attracted them nonetheless irresistibly into his orbit.[7] He was a passionate activist in politics, and flung his art into the service of his social creed in a way that would have made Cato stare and gasp. If ever there was a Dionysian spirit, it was that of Jacques Louis David. Most of his feelings were violent, and he was practically incapable of expressing them coherently in words. Partly this was the result of misfortune, a massive growth on his upper jaw having rendered distinct speech difficult. Partly it was the result of an abominable prose style, out of which he could have been educated, perhaps. But partly too it resulted from a failure to control and order his thoughts. The famous, furious speech that he delivered in defense of Marat consisted entirely of grimaces, gesticulations, and the three passionate phrases: "Je demande que vous m'assassiniez . . . je suis un homme vertueux . . . la liberté triomphera!" (I demand that you murder me . . . I'm a man of virtue . . . liberty will triumph!) Even his parliamentary colleagues, accustomed to revolutionary enthymemes, found the sequence of thought indistinct.

One would expect to find the esthetic principles of such a man muddled if ardent, and so in fact they were: imperfectly rationalized, incoherently expressed, and frequently altered. Delécluze, his pupil and admirer, denies that he had any principles at all, or even a fixed style, representing him as a creature of successive impulses and passionate contradictions.[8] He did indeed work in a variety of styles,

[7] Maurice Quay in response to a citation of Euripides: "Euripides? Vanloo! Pompadour! Rococo! He is like M. de Voltaire!" Cited in Hugh Honour, *Neo-Classicism* (London, 1968), p. 187.

[8] Etienne Delécluze, *Louis David son école et son temps* (Paris, 1860), "Avertissement."

from the stripped to the upholstered, each of which has, by one school of criticism or another, been proclaimed the real David: a recent judgment, based upon David's one and only landscape, says "Here we see him as a painter pure and simple, stripped of all theories." [9] Pure and simple indeed; but for that reason, not much like Jacques Louis David. For his genius wasn't either clear or simple, and does not seem so, whether we look across the range of his work or at individual paintings. He isn't really much of an organizer, doesn't easily compose the different elements of his painting toward a coherent, natural order. In representing groups, he tends to create a number of individual figures with only rudimentary connections. Rarely, if ever, do the figures of David have access to the self-contained, self-fulfilled, natural poise of classic art. Sometimes they are stiffly posed, sometimes galvanized as with *furia francese*; they don't very often exist easily in and of themselves.

Brandishing the words about with deliberate, impressionistic looseness, we might set up a provisional formula that David used his neo-classicism with special edge and impetus in the service of Rousseauvian and ultimately romantic ends. (The English tradition tends to set "romantic" and "neo-classic" as dialectical terms of opposition; but the contrast on the Continent was not that sharp and did not take that form.) His neo-classicism at its most characteristic is not a plastic disguise imposed upon a real scene, it is a knife to cut reality down to its simplest, most heroic dimensions. In the famous painting of "Marat Assassiné," for example, the painter seems largely to have dispensed with pathetic exaggeration, as with formal dignity. His subject is a corpse in a bathtub, but it is also a patriot struck down in a moment of helplessness; and he has handled it with a very minimum of visual rhetoric, exaggerating neither the horror nor the dignity of the scene, and doing very little to spell out its political message. There is one important exception; with the aid of a classically lettered inscription, he has manipulated that box or crate standing by the tub into the likeness of an altar, which could be the altar of liberty as well as any other. But, that subdued and not very definite image apart, the painting can be said to make no overt, pro-

[9] H. W. Janson and D. J. Janson, *Picture History of Painting* (New York, 1957), p. 215.

grammatic statement. It is a simple, grave confrontation with the plain fact of death—limp hand, lopped head, the small deadly wound that stopped a man's process. The painting is a monument of classic arrest, and has often been praised as such. Yet the air around it is thick with protest, with energies dominated and concentrated, as of a man bending every impulse of his mind to give an exactly accurate, unexaggerated account of his own pain. You can say that David's real qualities as a painter lay in his gift for exact realism, and that here they are tactfully chastened into formality by neo-classic theory—with the quiet implication that the real success of the painting lies in the tact. Or on the other hand, you can say that it was precisely neo-classic theory that rendered Marat's corpse a sacred object, and that David's realism chastened and controlled it—controlled the martyr-of-liberty image, without which (it seems reasonable to say) David would have been no more inclined to exercise his painterly gifts on Marat's corpse than on any other victim of an assassination in Paris's teeming annals.

We are accustomed to see neo-classicism as imposing an antique facade on modern energies; at the very height of the neo-classic movement, in the greatest work of its most typical exponent, it's interesting to see that the energies may equally well be understood as antique and the facade as modern. How closely the two elements sometimes worked together and interpenetrated one another may be seen in the curious unfinished canvas of the "Serment du Jeu de Paume," now in the Louvre's lumber room (see pl. 15). The scene depicted is that stormy moment in the royal tennis court (21 June, 1789), when the assembled deputies of the three estates swore to continue sitting despite royal threats to adjourn their meeting. David first sketched the Assembly as a gathering of heroic antique nudes, of the color and consistency of fine Carrara marble. It was evidently the painter's intention that as the painting proceeded toward completion, they should be clothed in neckcloths, frock coats, knee breeches, powdered wigs, and other trappings of modernity. Fortunately, he abandoned work on the project before the dress-up process was completed, leaving the gentlemen in a fascinating state of semi-undress. Here again we see it is modern realism that is being asked to discipline an unrestrained classical fantasy. Only conceive a

room full of naked gents, hopping with political fervor, and without a stitch to their name! It is a fantasy of an absolutely surrealist order.

In fact, a sketch by David toward another painting survives to suggest a fascinating extension of the principle. A central figure in "The Rape of the Sabine Women" is an armed but unclothed Roman warrior who stands front and center, facing the viewer. David's sketch (pl. 16) shows him being constructed from the inside out. Evidently he first took form as an animated skeleton, and had been half-clothed in flesh (on his right side only), when the painter either was interrupted or interrupted himself, feeling perhaps that the sketch had served its purpose. Did the "Jeu de Paume" figures also begin their careers as bare bones? Probably not; yet David's concern for the genuine underpinnings of his paintings is apparent. For some of them, at least, it was a classical pattern, a classical model, which served as an armature over which one draped modern decor. Not only so; it was the classic authenticity of the model that provided the austere modern spirit of the finished painting, its focused revolutionary fervor.

In the ardent, visionary days of the First Consul, neo-classic style had a tendency toward the geometrically gigantic, the stridently austere. Had only 10 percent of the stupendous projects that boiled in the brain of E. L. Boullée been executed in brick and marble, earth would have sunk beneath the weight of them.[10] His sketches for pyramids have reminded viewers of the Tower of Babel; his monumental cubes and outsize memorial globes look forward to that special variety of architectural geometry reserved nowadays for world fairs; but Boullée's fantasy is many times more enormous than any conceivable realization of it. Apart from their nightmare dimensions, what is remarkable about Boullée's designs, and those of his more modest colleague C. N. Ledoux, is their ruthless simplicity. His ideal seems to have been a building without parts, a monolith. This simplicity isn't in any serious sense functional (the fashionable comparisons with modern design are completely off the point at this level). Both Boullée and Ledoux are prodigal of masonry and lavish of empty space simply to gain effects, solid or empty, of gigantism. In order

[10] See J. M. P. de Montclos, E. L. Boullée (Paris, 1969) for a stunning account of the architect's titanic visions.

to have a library look properly immense, Boullée proposed to build an enormous barrel vault, like a Piranesi *camera sepolcrale*; of the vast overhanging wall and ceiling space only a tiny fraction could conceivably be used for books, for readers, or for anything else. His pyramids might serve to train mountain climbers, but there is no space for ordinary people either on them or in them. Some of Boullée's monumental designs remind one of that famous plan for a fortress that put an end to Dostoevski's career as a military architect. By the simple device of eliminating all apertures of every sort—doors, windows, fire-slits, whatever—he rendered it absolutely impregnable to attack. And one sometimes feels about Citizen Boulleé's vast blind-wall designs that their heroic austerity and energy are inhuman, if not anti-human. One could hardly live long, I think, in the vicinity of these awesome cubes, balls, and pyramids, without a pretty strong impulse to blow them up. David escapes that response by avoiding too obvious monumentality; he is too much of an explosion himself to invite exploding. But the knotted conjunction of violence and constraint is much the same in both.

When David sent young Talma, the aspiring tragic actor, to the museum to study authentic Roman costumes, it was for motives the very reverse of antiquarian. Having duly performed his studies, Talma proceeded to play Brutus, sensationally, in toga and sandals instead of red-heeled *cothurnes* and *culottes jarretées* (17 November, 1790); and the revolutionary youth of France felt with wild enthusiasm that someone had spoken directly to the modern condition.[11] Sandals and toga—one was in the authentic presence of Brutus himself, who in the name of the republic had killed Caesar. (Vanhove, one of Talma's fellow actors, was less impressed by the whole idea: he asked, with some disdain, if that wasn't a bed-sheet that Talma had on. It probably was—where else does one pick up togas these days?) The last word in insurrectionary radicalism, among the farthest-out students of David's Bohemian atelier in the

11 *Memoires de J.-F. Talma* (actually by Alexandre Dumas) (Paris, 1849), I, 235 ff. Meeting Mademoiselle Contat backstage when wearing his new costume for the first time: "—Ah, venez donc voir, s'écria-t-elle: il a l'air d'une statue antique!" For Talma, "c'était le plus bel éloge qu'elle pouvait m'addresser." The leading lady, however, was deeply distressed that he wore no culottes under his toga.

Louvre, was pre-Phidian sculpture; having christened themselves "primitifs," the radical fringe bestowed the name like an accolade on anyone they wanted to honor. Delécluze tells us, not without affectionate irony, how Quay and Perrié, bravest of the brave, would sally forth dressed as King Agamemnon and Paris, Prince of Troy, to reform the dress, the customs, the very sentiments of the worldly Lutetians.[12] In an era when martial young Parisians were forming up phalanxes on the Champ de Mars and swimming the wintry Seine in emulation of Roman legionaries, the chances of such a reform were not quite as absurd as they now appear. And under such circumstances, the neo-classical mode conveys neither Winckelmann's dignified repose nor Doctor Johnson's disabused cosmopolitanism, it is a belligerent puritan statement of actuality, a revolutionary affirmation of essence against historical accident. There is nothing particularly surprising about this reversal of convention. Many a revolution has advanced at breakneck speed toward the future under the passionate battle cry of "Back, back to the good old days! All the way back!" The Greek and Roman classics have, perhaps, a particular gift for speaking to different generations the alternate languages of repression and revolution, of resignation and radical re-affirmation. In the great overthrow and counter-identification questionnaire that followed upon the Revolution and the betrayal of the Revolution (if you're not who you say you are, and I'm against what I think you used to be, then who am I?), neo-classicism revealed its own basic duplicity.[13] In becoming le style Empire, it converted as easily and imperceptibly as did the First Consul himself from an agent of liberation and insurrection to one of conformity and ultimately of repression. Like many another revolutionary force, it became the mirror image of that tyrant it had undertaken to supplant.

[12] Delécluze, Louis David son école et son temps, pp. 90–91. Whether dressing up as Paris involved making a kind of pun does not appear, but the Phrygian cap, still worn by Marianne and traditional to Paris (Alexandros), obviously caught on as a revolutionary symbol. Guglielmo Ferrero reports that in Turin in 1821 the police shot students for wearing Phrygian bonnets: Lois psychologiques du symbolisme (Paris, 1895), p. 118.

[13] For a provisional thematic listing of various categories of Neo-classic—"Horrific," "Erotic," "Archaeologic," "Stoic," and "Pathetic"—see Rosenblum, Transformations, chap. 1; the "Primitivist" and even "Cubist" categories are reserved for description later in the book.

And when that reversal had taken place, naturally any self-respecting republican had to deride the classic forms, to ridicule the heroic mythologies. No man had better credentials as a republican than Honoré Daumier who, barely seven years after the death of David himself, was serving a term in prison for caricaturing Louis Philippe as "Gargantua." Yet in the series known as "Histoire ancienne," which appeared in Le Charivari during the year 1842, he ruthlessly caricatured the ancient stories and classic ideals. His burlesque is not much different from that of Scarron in the seventeenth century; he reduces heroic to bourgeois dimensions, idealized to realistic conventions (see pls. 17, 18). Homeric nymphs become blowsy housewives; Odysseus, back home after twenty years of perilous adventure, snores in a nightcap. Hercules stands in hip boots, a mass of obscene brawn in a pile of obscene manure; Aeneas is a lean and peevish warrior in armor that flaps over his lank thighs; Dido is a dowdy. Daumier gets his best effects from the ordinary everyday that he substitutes cruelly for the routine ideal, the blank ideal that we accept only because it has never been challenged. The appeal is simply to our common sense: his caricatures nudge us with the ugly suggestion, "This is how the scene would appear now—can it have been so different then?" Baudelaire recalled finding a lyric poet of the "pagan" school in a rage before the work of Daumier; naturally, the spectacle pleased him immensely.[14] Sacrilege, as Baudelaire saw it, was the only proper response to an Ersatz-religion; and the sense that he was blaspheming semi-sacred idols clearly lent special zest to Daumier's crayon. He was desecrating a temple that Jacques Louis David had held sacred, desecrating it joyously and with immense inventive energy. But, as often in these polar situations, the energies work both ways: it counts against the modern world that all one has to do is reproduce it faithfully in order to render ludicrous the great classic images of the culture. David had used the ancient image of altar and victim to sanctify the corpse of Marat; Daumier threw a switch, reversing the current, and ran it

[14] "Some French Caricaturists" in The Mirror of Art, trans. J. Mayne (New York, 1955), p. 168. Similar parodic sketches are scattered throughout the body of Daumier's work; see, for instance, the drawings described and reproduced by K. E. Maison, Honoré Daumier (New York, 1968), items 452–469, plates 156–158.

through the same circuits. But the energy was altogether his own. One need simply look at a few of the burlesques and extravaganzas which were so popular in nineteenth-century English music halls to see that mere impudence with classical models wasn't enough. J. R. Planché, Henry James Byron, F. C. Burnand, and a long list of mummers illustrious in their own day produced one classical travesty after another without accomplishing anything memorable. It must be confessed that the rogues aren't always devoid of rowdy humor. When Ulysses is threatened by Medon with a horse-pistol, he explains to the audience in a leering aside that there's no occasion for fear, as gunpowder hasn't yet been invented (*Patient Penelope* by Burnand); and Eurydice, as she perishes of snakebite, implores Orpheus,

> O'er our child's education spend large sums:
> Knowledge is power.
> (*Orpheus and Eurydice* by Byron)

But the puns are invariably deplorable, the versification jog trot, and the foolery tedious as often as not. Daumier's caricatures, even as they degrade the classics, are themselves classics, by virtue of their taut and ruthless style; in their poise and clarity and energy, they put to shame the usual respectful imitation of the antique.

Amid these slippery transformations of terminology and style, it may be opportune to drop an elegiac word on the memory of Claude Michel, known as Clodion, crushed and destroyed at the end of his career by the very movement he must have thought he represented.[15] Clodion was not only a favored, he was a spoiled child of the ancien régime; and it was under the image of a graceful, naughty, happy child that most of his career developed. He was born like Callot in gray, military Nancy (1738), and emigrated like Callot as soon as he could to Italy. His father was a sculptor, his mother one of a

[15] The chief full-scale study of Clodion is that of H. Thirion, *Les Adam et Clodion* (Paris, 1885); but see also A. Jacquot, *Les Adam et les Michel et Clodion* (Paris, 1898). Clodion is the sort of man who is more appreciated in the auction rooms than in the schools or art journals; his minor pieces are continually coming up for sale at prices perhaps inflated by his reputation for decadent frivolity. A little Clodion statuette stands exquisitely in Lord Henry's drawing room, the center of naughtiness in *The Picture of Dorian Gray*.

large and flourishing family of artists (les Adam); but during his formative years (1762–1771) it was Rome that gave him a milieu and formed him toward a style. Leisured, cosmopolitan, and worldly, the international art fanciers of Rome saw in Clodion a rough diamond to be polished and set. He was not out of his twenties before he was hard at work on commissions for Catherine the Great: her idea of rewarding this lover of the sunburnt south was to offer him a permanent post in Muscovy—but she was generous with these gelid favors of hers. With that sort of cachet he created for himself a special and very comfortable niche of his own, somewhere halfway between the worlds of low fashion and high culture, as a sculptor in the Hellenistic mode. In the course of his artistic life, Clodion did little public, monumental statuary, sought no academic positions, applied for no government or ecclesiastical commissions. He worked for private collectors almost exclusively. Now and again he did a portrait bust, and did it very well indeed. But sleek terra-cotta fauns and pliable nymphs in postures of mutual absorption and in dimensions suitable for rococo drawing rooms or boudoir alcoves were his predominant stock in trade (see pl. 19). In this sort of specialization, he may well have been too successful for his own ultimate good. André Michel speaks with some disgust of his executing "innumerable statuettes or bas reliefs, generally in terra cotta, within which it's quite impossible—so numerous are the dances and entwinings, scenes of intoxication, kisses, sportive entanglements, smiles, and dimpled nudities—to determine the date of the work from any slight variation of type or style."[16] About Brutus, Scipio, the Horatii, or for that matter George Washington (ultimate emblem of civic virtue) Clodion evidently cared not at all. The difficulties of the art historian, perplexed at the problem of dating some individual Clodion frippery, never even crossed his mind. With every pinch of clay, every touch of the implement, he professed his indebtedness to the classic world, his consciousness of the classic model, his response to the classic challenge. He copied, again and again, from the antique, and sold under that title; it was, so to speak, the mask under which his carnival flowered, the card that admitted him to a world of license and revel. His art was designed to

16 André Michel, *Histoire de l'art* (Paris, 1924), VV, pt. 594.

gratify patrons of title and position, who had read the *philosophes* to be sure, admired the Roman Republic (the more easily because it was dead and could make no inconvenient demands), and built little classic temples at the heart of formal gardens around their summer houses. But they had also read the history of Manon Lescaut, *Les Liaisons Dangereuses*, and *Félicia: ou mes fredaines*— and it was Clodion's agreeable talent to bring these two strains of thought and feeling into intimate conjunction. He was not exclusively a boudoir sculptor, and even if he had been, that isn't necessarily the ultimate condemnation. There is a school of thought that esteems Clodion one of the cleverest men of his craft who ever lived.[17] There is also a way of saying this sort of thing that converts technical skill into a wholly contemptible and discreditable quality.

Whatever his ultimate merits, Clodion brought to the ancien régime artistic qualities which exactly *suited*. He worked like a whirlwind, he sold absolutely everything he made, he sold works before he had completed, and sometimes even before he had begun them. In his entire career, till the advent of David, he never knew what it was to suffer neglect or critical hostility. Success did not spoil him; it did not embolden him to try anything new or different; it did not relax the pace of his incredible energy. He worked for a society that loved pleasure; his work gave pleasure. That was what Roman society had wanted, that was what Roman artists gave it. Probably Clodion never formulated the matter as distinctly as that, if only because he never had to. We don't normally question or define the air we breathe. But assumptions like these, or intuitions very much like them, must have been at the root of Clodion's artistic existence. Then came the Revolution, the political revolution

[17] In all these judgments about the relative merits of artists working traditional, and now outmoded, veins, we come up against the schizoid character of modern taste, where certain frames of discourse can't possibly be manipulated to deal with anything between the most primitive forms of sculpture and the most recent. Men who were not basically impatient with the premises of Clodion's art have found some fine words for it. As recently as the turn of the century, Louis Gonse in *La sculpture française* (Paris, 1895, p. 232) was drawing on his recollection of the lyric poets to characterize Clodion: "un chapitre (dans l'histoire de l'art) où tout est lumière, mouvement, sourire, et volupté." More flatly, James Holderbaum, in *The Encyclopedia of World Art* (New York, 1960), III, 698, says, "his surfaces are more alive than any others in sculpture."

as well as the revolution in taste, a great burst of wind blowing mostly from the north, and sending the dimpled nymphs into shivering retreat. Clodion fled to Nancy, which was at least out of the eye of the storm. There he was able to survive by designing for a ceramics factory, while his former patrons sulked and skulked in exile, across the Rhine or the Channel. From 1795 till 1798 he lay low in the provinces; and then came back to a Paris that Napoleon, David, and republican virtue had rendered utterly alien to him. His style was out, his luck had changed; pleasure was suspect, and neo-classicism meant something entirely different from what sixty years of existence had taught him it meant. He had no commissions, he had no public, he had no purchasers; his prettiness was anathema to the geometricians of civic dedication. His wife had divorced him the minute the Revolution made divorce available; his only child, an adored illegitimate daughter, ran away and left him alone. Life, which knows so many bitter little tricks, never sprang the role of King Lear on a man less prepared, by temperament and experience, to sustain it. But he buckled down, with more courage and flexibility than most men would have shown under the circumstances, and tried to swim in the new tide. It may have been an ironic commentary on the world he had lived to see that his first work of the new century (exposed in the Salon of 1801) was a bas relief of the Deluge. (The end of the human race was a popular theme in the early nineteenth century; apart from the English Titan, John Martin, and his American disciple Thomas Cole, a poet like Byron, and a novelist like Bulwer-Lytton, we hear of a Swiss painter named Saint-Ours, who after the Revolution could paint nothing but earthquake and disaster pictures.) [18] But Clodion's day was done. He could not really learn the new tricks, and neither the new Napoleonic grandees nor the restored Bourbons seemed to want any more lascivious satyrs and dimpled nymphs. The ministry of virtue held magisterial office. Clodion lingered on, wretched and unsuccessful, till 1814; on March 28 he died, literally as well as symbolically, of cold which the doctors called "pneumonia." A few weeks later the contents of his studio were sold at public auction, for prices described as "dérisoires." [19]

[18] Honour, Neo-Classicism, p. 186.
[19] Thirion, Les Adam et Clodion, p. 373.

It is a story replete with Saturnian ironies, only this time it is the children who eat the father. Perhaps the gloomiest reflection we get from these violent revolutions of taste is that nothing counted for less than the actual artistic qualities of the hero-scapegoats. Clodion in disgrace, there's every reason to think, was a sculptor exactly as able, exactly as limited, as Clodion in public favor. Before he had been dead more than a few years, his work had started to regain the sort of favor with collectors that it had in his youth, that it has maintained to this day, and that has raised the price of his little terra cottas to the equivalent of their weight in liquid gold. And as Clodion went back up the scale of public favor (having, after all, only been rediscovered by the sort of person to whom he had appealed in the beginning), so David, during the last part of the nineteenth century, fell into obscurity and neglect. He clearly seemed cold, stiff, and ungracious to people who either wanted no revolutions at all or didn't feel the need to promote them under Doric disguises.

A curious, yet oddly heartening reflection makes itself felt amid these sterile, mechanical ironies: no literary or artistic style, it appears, is so closely tied to a particular content that it can't under different circumstances serve another and perhaps opposite content just about as well.[20] Within a few years, Géricault and Delacroix will be rejecting the principle of imitating classical antiquity (in their public paintings at least, if not always in their private drawings) for much the same reasons that David and his pupils had insisted on its rigid observance—truth to nature. Gérard and Ingres, in carrying on the tradition of neo-classical painting, will be moving it back toward the baroque decorativeness against which it began as a revolt. By a mere process of hardening arteries, stiffening joints, and mechanical repetition, le style Empire moves gradually toward ordinary Academic painting. Which is ordinary enough in all conscience; yet capable of engendering and nourishing in itself a talent subversive of the very forms it continued to observe. Like, for example, Albert Joseph Moore (1841–1893).

The only reason for being interested in Moore these days is that he challenges discrimination. He was a man of very considerable abilities, strong and healthy instincts, and great personal indepen-

[20] Cf. Rosenblum, Transformations, passim.

dence, whom ill fortune dropped into the very sink of Victorian bad taste. Perhaps the level of public taste is a more crucial thing for a painter than for a poet; at all events, Moore, starting from a position far outside the establishment, had to make his way—not precisely into it, but—into a defensible position on a field where the high ground was commanded by Frederick Lord Leighton, Sir Lawrence Alma-Tadema, and the Pre-Raphaelite Brotherhood. That he could do this without sacrificing the respect and admiration of a man as waspish and independent as Whistler suggests uncommon talents, of several different sorts.

Moore's origins were rather common than otherwise; he was the last of fourteen children born to a Yorkshire artist of local reputation. Through the help primarily of some of his older brothers, Moore came first to London, and then made his way, as a fellowship student, to Rome, where he found his individuality as a painter. Classic themes and a classic style were naturally as congenial to him as they were to the Academy. And yet, though he had to live among these people, he was not of them. The Academy pointedly declined to have anything to do with Albert Joseph Moore; he had said, apparently, unforgivable things about some of the fellowship. He did not seem to suffer from his exclusion, as he should have; rather, he went his way, and specialized in a variety of painting which that distant age could only describe as "decorative." Moore was a decorative painter.[21] This did not mean that he was fond of painting remarkably pretty girls in long, toga-like nighties and graceful postures—though in fact he did show a marked preference

[21] *The Encyclopaedia Britannica* (11th ed.) begins its brief unsigned account of Moore with the identifying tag, "English decorative painter"; and the only halfway serious account of him (*Masters in Art,* IX, 339–380) describes how he was directed toward "decorative" work by an architect named Nesfield and summarizes with the inevitable term: "what one feels most strongly in Moore's works is their decorative intention." But this word, so insistently repeated, seems fundamentally negative in its meaning; its strongest implication is that one can't look in Moore for a certain sort of sustaining and peripheral interest, without which the Victorian esthete felt very much at a loss. Harold Frederics, whose *Scribners* article on Moore (December, 1891) is cited by the *Masters in Art* mosaicist (p. 372), shows the rudiments of insight when he writes, "Albert Moore has made no revolt [against the Academy, against Victorian standards of taste] because he has never owed allegiance."

for these themes. Rather, "decorative" meant that he did not paint pictures to which it was easy to attach a moral or a story. "Azaleas," "Rose Leaves," "Follow My Leader," "Yellow Marguerites," "Midsummer"—whatever the title attached to the picture (and sometimes it seemed that the artist had simply slapped on some handy vocable after he had finished the picture), the picture itself usually consisted of one pretty girl, or several as the case might be, with nightie (technically, chiton) and graceful posture. The scenes were not archaeological; quite the contrary. Moore often indulged in deliberate, straightfaced anachronisms and incongruities. Beneath his smooth surfaces and cool designs, there's frequently a lurking sense of comedy at work. It isn't always as overt as it is in "Quartet," (see pl. 20) where four serious young Romans (one clad in a Dionysian leopard-skin!) are sawing away at the ornate Renaissance instruments (two fiddles, viola, and cello) traditional to string quartets. Three beautifully draped young ladies are watching and presumably listening, but without much expression, as their backs are turned to the viewer, and their eloquence is entirely in the sinuous twist of their trim torsos. It is a larky picture, the more so because everyone in it is so seriously intent on the unheard music— Mozart surely, and probably the "Dissonant" quartet (K. 465). Not all Moore's jokes are so broad. In "Yellow Marguerites" he poses a girl in a Greek tunic before what is unmistakably a Japanese or Chinese jar. Occasionally, to get a bit of intricate design to work against his marbled classic surfaces, he will introduce a scrap of anachronistic lace or a dress of richly patterned brocade. His taste includes a persistent strain of fondness for the "Japanese," as the late nineteenth century interpreted it from the prints of Hokusai and Hiroshige; thin, pure colors in broad panels are arranged in a relatively flat pattern. A prime example in Moore's work is titled simply "A Garden"; the leaves of the trees seem almost pasted to the surface of the canvas.

Though generally posed against classic marble backgrounds, most of Moore's young ladies were frankly and realistically represented as buxom young English girls. They don't have, they don't attempt to have, the pallor, the chill, or the repose of marble. Yet Moore was no portraitist. Clarity of outline, solidity of pattern,

and freshness of color were his main concerns. With its slightly fey touch, an Albert Moore painting has, sometimes, a way of looking like a particularly odd, carefully posed color photograph of a subdued happening. There's a kind of assurance about the serenity of the surface that's deliberately skewed by some impudent incongruity in the scene being displayed. Had he lived seventy-five years later, he might have become a kind of English Magritte. As it was, he acted the role of a quiet straight-faced subverter of the academic style of his day, while indulging to the full that sensuous, uncluttered satisfaction in plastic forms which led Swinburne to compare him, perhaps over-lyrically (but that was Swinburne's way), with Gautier among the poets.[22] It isn't, basically, a bad comparison; in both men there's something strict about the surface, with an edge of formalism, while under the surface some element of luxuriant fantasy flowers. Moore's girls, in particular, manage to be both cool and voluptuous, distant and fleshly. He used them to create those arrangements of colors and forms in which he was primarily interested, and in the meantime made just enough use of contemporary figures and features combined with a subdued classical accent to suggest that his surfaces were fantastic. No doubt he's not different enough from his fellow Victorians to justify his removal from their company—as we, for example, have no hesitation about removing Whistler. But Whistler distinguished Moore from his contemporaries, without the slightest hesitation, and when Albert Legros fell from the favor of the exclusive "Group of Three." Moore was elected to take his place, in the exclusive society of Fantin and Whistler himself.

If he is indeed to be lumped with Sir Frederick Leighton and Sir Lawrence Alma-Tadema, perhaps with Sir Edward Burne-Jones on his left wing, there's not much interest to be taken in Albert Moore, beyond that campy concern which anything quaint and corny can arouse. But there's no need to remove him altogether from the framework of the academic style; it is enough if we see that within that framework, and sometimes in the course of working against it, Moore was doing something rather specific of his own.

[22] Swinburne, *Complete Works* (Bonchurch ed. [London, 1925–27]), XV, 198.

It would be hard historical lines, if, after being suspect to his own solemn age as too venturesome and strange, he were now to be lumped with the stodgiest of his contemporaries as a mere conformist. Looking behind the facade and inside the frame, we can perhaps recognize, in these unlikely surroundings, the germ of a person and the outline of a strategy.

Pythagoras in Paris

As personal energy ceased to be poured into or press against the classic molds, the forms themselves stiffened and became inert. They could be animated only briefly, almost spasmodically, by heroic or sensual or satiric energy; then, time after time, as if drawn down by their own gravity, they sank into pastiche and frigid formality. But there was a moment, if only a brief one, in midnineteenth century, when Rome became itself the principle of variation and perpetual change, not a static form but an energy, extraordinarily fluid, vital, and personal, in the life of one visionary man.

Although striking, the change was not altogether outside the scope of the ancient culture's known character. We overstate the hard, square, public character of Rome if we don't recognize within it a buried stream of counter-thought. Ovid, for instance, is generally thought of as a brittle, cynical amorist with a talent for sophisticated wit; so indeed he was. Yet he also had a deep feeling for the old religion, the old observances, the roots of the fables. His great anthology of metamorphoses concludes with an account of the way in which that hazy, indefinite figure Numa Pompilius allegedly inherited the Roman system of religion from Pythagoras.[23] The story is fanciful to begin with, and Ovid tells it with deliberate vagueness, as if he were half-ashamed to put it off on us as a piece of history. It leads toward two clearly artificial rhetorical flowers, an exercise describing the apotheosis of Augustus and a brag about the poem just concluded, which is to be the poet's everlasting monument. Perhaps because of these inconvenient neighbors, readers have not

[23] *Metamorphoses*, XV, 75 ff.

always been confident about the seriousness with which the Pythagorean doctrines so liberally expounded in Book XV are to be taken. (The long doctrinal speech is a convention, some have said; but really the *Metamorphoses* are so much a poem of their own peculiar sort that there is no saying what conventions could possibly apply. One simpleminded soul read the passage as simply a defense of Ovid's own vegetarianism, as if that was the sort of thing a poet aiming at immortality would have at the front of his mind when he was concluding a major work.) But the Pythagorean creed is obviously related to the main theme of Ovid's anthology in all sorts of ways. His book had been a transformation of the Greek fables into new Latin forms, a recasting so successful that to this day most of us cannot tell which of the mythological stories reached us through Ovid and which did not. What could be more fitting than for Ovid to suggest at the end of his immense task (in the course of which, by making the tales more superficial and rhetorical, he had suited them exactly to the literary tastes of his times) that there was after all a deeper way of looking at them? The Pythagoreans, we recall, had been an outlawed and persecuted sect in Italy; they had been publicly assailed, burned out, lynched. For Ovid to suggest that their secret doctrine lay at the heart of the official Roman religion (a church within a church, as the Grail cult lay buried at the heart of the medieval church, at least in the minds of its participants) was a bold stroke both poetically and philosophically, a fitting climax to the poem on which he was staking his reputation. The specialists can tell us if this boldness may conceivably have contributed to the extraordinary (and unexplained) harshness of the sentence which fell on the poet even before his poem was completely finished. All the theories so far advanced are speculative— which is not to say that one speculation is as good as another, by any means.

At all events, the lesson taught Numa by Pythagoras in Book XV of the *Metamorphoses* is simple and direct: it is the universal lesson of mutability. Life is all one, the philosopher declares; all one, and all holy. Nothing remains unchanged, nothing perishes forever; one soul animates all things, slithering into and out of different forms unceasingly:

omnia mutantur, nihil interit: errat et illinc
huc venit, hinc illuc, et quoslibet occupat artus
spiritus eque feris humana in corpora transit
inque feras noster, nec tempore deperit ullo,
utque novis facilis signatur cera figuris
nec manet ut fuerat nec formas servat easdem,
sed tamen ipsa eadem est, animam sic semper eandem
esse, sed in varias doceo migrare figuras [24]

Or, as Arthur Golding translates it:

All things doo chaunge. But nothing sure dooth perrish. This
 same spright
Dooth fleete, and fisking here and there dooth swiftly take his
 flyght
From one place too another place, and entreth every wyight,
Removing out of man too beast, and out of beast too man.
But yit it never perrisheth nor ever perrish can.
And even as supple wax with ease receyveth fygures straunge,
And keepes not ay one shape, ne bydes assured ay from chaunge,
And yit continueth always wax in substaunce: So I say
The soule is ay the selfsame thing it was, and yit astray
It fleeteth intoo sundry shapes.

Under "varias figuras" it is always the same soul. Pythagoras recalls
that he used to be Euphorbus, whom Menelaus slew in the Trojan
war; and Virbius, an Italian nature-god, in the course of consoling
Egeria, quietly explains that he was formerly Hippolytus, Theseus's
son. Gods, heroes, and men thus repeat themselves in infinite reces-
sion; though Ovid avoids the point, Augustus himself and the whole
Roman empire can logically be seen only as fleeting manifestations
of an infinite process. All solidities, whether imperial or empirical,
disappear in an unending dance of subtle spirit; it is not a view of
things that would have appealed to the elder Cato, but among
cosmopolitans of the gold and silver ages, it found frequent enough
expression to qualify as an indigenous, intermittent strain of Roman
thought. One finds something of the same spirit, for example, in

[24] *Ibid.*, XV, 165–172; Golding's translation in *Shakespeare's Ovid.* ed.
W. Rouse (New York, 1966), p. 298.

the work of the second-century Greek or African or Latin Platonist or neo-Platonist or devotee of Isis, Lucius Apuleius.

Our uncertainties about the proper terminology for Apuleius are characteristic and revealing; he was born in Numidia, the son of a Greek-speaking Roman official; his education was at Carthage and Athens; he wrote in Latin, but tried consciously to introduce verbal ingenuities and ornaments derived from the Greek sophists. His real religious orientation seems to have been toward the mystical oriental cults, especially those of Isis and Osiris; and the story on which his fame rests was adapted, both as a genre and in the details of its plot, from Greek originals.[25] It is, as everyone knows, a story of the magical, the marvelous, the horrible, the funny, and the sacred, all mixed together. But the allegory is obvious enough: Lucius, trapped in the shape of an ass, is the soul trapped in the accidental, uncongenial body; he is liberated to his own true and divine image, only by the aid of the goddess-mother, Isis. Like Ovid, but with deeper religious feelings and a greater sense of awed reverence, Apuleius preaches the Pythagorean transmigration of souls, and the hope of redemption from the bondage of the flesh. He was, it would seem, a deeply religious man, a priest most of his adult life, but in a way that didn't prevent him from being (again like Ovid) a worldly, witty, and even a bawdy writer. And it was this combination of qualities which, in the nineteenth century, came to fascinate a restless young visionary who had been born to the name of Gérard de la Brunie.

Names are everything in the short, troubled life of Gérard de Nerval; names, analogies, and lineages fascinated him, and he twisted them into a network of affinities that served primarily to define his own constantly questioned identity. "Nerval," for example—he claimed descent from the Roman emperor Nerva; but was it not by a kind of devious, triangular logic, of which one apex was Nicolas Restif de la Bretonne, who had had the audacity to

25 By genre, "The Golden Ass" is a Milesian tale; its two prototypes were Lucius of Patra's *The Ass*, which no longer survives, and Lucian of Samosata's *Lucius, or the Ass*, which does survive, though not particularly to its author's credit.

derive his lineage from the emperor Pertinax? Or perhaps, alternatively, Gérard's name came from a property, part of which he inherited from his father, the "clos de Nerval," in his native Valois.[26] Or it may have been an anagram of that mother whom he lost so early in life; her first name was Laurent, which inverts to something like "(t)nerual." There was an early form of the pseudonym which came out "Louis Gerval"; there were other variants. His natural name, "de la Brunie," got contaminated with the imperial myth of Napoleon, with a certain Englishwoman the sight of whom caused him to be reborn at Torre del Greco near Naples, and with the image of a ruined tower, to become "G. Nap. della terre Bruniya." And there were even more radical leaps, as when the signature "Gaston Phoebus d'Aquitaine" combined the famous third Comte de Foix (nicknamed "Phoebus" for his personal beauty, but with all the Apollonian implications as well), and Gérard's own imaginary descent from an ancient family of Agen.[27] His dream life consisted of these multiple, allusive identifications; the poems that have made him famous are like those little glass-bottomed boats which allow us to glimpse, if only as wondering strangers, the mysterious green currents of an intricate submarine psyche.

In most of Gérard's list of precious pseudonyms, the combination of antique, Renaissance, and personal overtones is clear to be seen; his dream life consisted of aligning these transparencies so that the spiritual light of a constant Pythagorean identity might seem to shine through them all. Ronsard was one of his passions—Ronsard, whose love for Hélène was less love of a woman than love of an ancient, glamorous image made emblematic in a name. Seeing, for Gérard, was always seeing *through*, because he was entranced

[26] Gérard himself was born in Paris, but his family had property in the Valois to the northeast of Paris; his connection with Aquitania, and particularly with Agen, was largely the work of his own fantasy. His mother died in Germany, whither she had followed his father in the wake of Napoleon; Gérard's affinity for Germany was marked and explicit. He introduced many German authors (including Goethe and Heine) to French readers and often professed that his mind felt at liberty only on the other side of the Rhine, where the dividing line between fact and fantasy was less sharp.

[27] Letter to George Sand, 22 November, 1853. The poet's obsession with Aquitania and Gascony may have been conditioned by their proximity to the Pyrenees, linked by the Greek root *pyros* to the realm of fire.

by the double sense of distance and sameness. Always at the end of his spiritual wanderings and dream-transformations lay the classical world; generally, it was summarized in the name of a woman, embodying a particular myth but representative of all myths, or capable of being summarized in a single supreme myth. Aurélia, Myrthô, Delfica, Erythrea, Célénie (Selene), Cybèle, Proserpine, Artémis, and many other sibylline figures, daughters of the fire, empresses of the spirit, could all be seen under the aspect of Isis, goddess and mother. Meditating in the very temple of Isis at Pompeii,[28] Gérard entertained himself by conflating the classical and Christian myths of a torn god, ripped apart, buried, and resurrected by the devotion of a weeping mother—Christ and Dionysus, Osiris and Adonis—as if *The Golden Bough* were blossoming prematurely within his head. The image is not altogether frivolous; Gérard's dream world put forth sprouts that turned to tentacles, and clung to his mind with the unremitting tenacity of a parasitic plant. In a famous phrase, he spoke of the dream overflowing real life; if anything, the experience was more predatory and violent than that. We see the encroachment of madness (which the poet of course welcomed as transcendent insight) in the great esoteric sonnets. That which was ultimately entitled "Myrthô," for example, is addressed to a muse-goddess-mother-redemptress figure. Its simple title makes allusion to the myrtle, sacred to Venus, and probably also to Manto, prophetess who founded Mantua, the town of Virgil, who plays a central role in the poem as unifying the pagan and Christian visions. Another version of the title, "A J——y Colonna," carries a reference to the actress Jenny Colon, beloved of Gérard and later to be apotheosized as Isis herself in *Aurélia:* here she is half-identified with the Renaissance neo-Platonist Francesco Colonna, author of the famous *Hypnerotomachi Poliphili,* which is one of Gérard's sacred, visionary books.

Yet his mind grew, not toward darkness or incoherence (though he was repeatedly committed to asylums, and ultimately committed suicide), but always toward a more lucid and direct confrontation with his own madness. The myths and dreams and visions may have

28 "Isis," in "Les Filles du Feu," *Oeuvres* de Nerval, ed. H. Lemaitre (Paris: Garnier, n.d.), I, 648–660.

been a cancer on his mind, but they organized it magnificently for literature. They sustained and directed the final confessional vision of *Aurélia*, in which, like his prototype Apuleius, he was able to liberate himself imaginatively from the flesh and pass through ritual initiation to a new order of existence. The descent into hell, the redemptive vision, the rebirth to a purified humanity through the loving kindness of a gracious goddess, are described here with Blakean simplicity and Blakean force. The goddess who redeemed Gérard had many names and had appeared under many manifestations, but her true name was Isis—not indeed the Egyptian deity, in whom traces of brutish origin and barbarous superstition might have been found, but the purified and Romanized goddess, who could without pain be associated with Magna Mater or Virgin Mary.

There is one small but striking confirmation of this Nervalian ultimate in a little marginal note on a copy of the sonnet "Artémis." The text may seem passably obscure, but where would a truly hermetic mind like Gérard's reveal itself, if not in marginalia? And this note proposes itself as a key to the whole sonnet. It reads: "Vous ne comprenez pas? Lisez ceci: D. M. Lucius Agatho Priscus." And there is a further note, "Nec maritus." In explaining these orphic explanations, I simply follow in the footsteps of Nerval's recent editor, Henri Lemaitre, who himself draws on suggestions of Jérôme Carcopino and Jean Richer.[29] The sonnet proper deals, darkly enough, with a redeeming female divinity, identified with the number thirteen or the number one—identified further with death (la mort) or a dead woman (la morte). It invokes Gérard's favorite flower, "la rose trémière," the hollyhock rose or resurrection plant; and it expresses a passionate preference for red over white roses on the score that

La sainte de l'abîme est plus sainte à mes yeux.

With some of these concepts there is no special difficulty. The hollyhock rose is not only associated with resurrection, it contains

[29] *Ibid.*, pp. 702–704, with references to J. Carcopino, *La mystère d'un symbole chrétien* (Paris, 1955), and Jean Richer, in *Paru*, May, 1948 and October, 1949.

many flowers on a single stem, in evidence that a single life may flower into many personalities. The contrast between saints of the abysm and saints of the upper air reflects, no doubt, the occult sense of things below being the same as things above, the way down and the way up being equivalent. The red rose might thus be associated with Christian saints of Neapolitan provenance like Rosalie and Philomena, and perhaps with Lucy of Syracuse as well, all being volcanic daughters of fire, passion, and sensuality—sisters, as it were, of Teresa, and beyond that of the goddess of roses herself, Isis. The white rose evidently stands for a paler, more ascetic breed of divinity, an exclusive as opposed to a syncretic vision. In the tradition that Gérard elects, there is no knowing if one is the only lover or simply the last one, whether the redeeming saint is first or thirteenth in her line, that is, first of the first cycle or first of the second. On these terms the marginal comment deciphers as a traditional formula by which Roman worshipers of Isis signed themselves with a special name, the name of their initiation, at the moment of their death. *D.M.* stands for *Dis Manibus*, a Roman funerary formula roughly equivalent to a *hic jacet*. *Lucius Priscus*, that is, *Once Lucius* or *Formerly Lucius* identifies Gérard with Lucius Apuleius, through whom he came to Isis; and *Agatho* identifies him not only as a teacher of the true way (its literal meaning is simply "good"), but in hermetic terms as a divinity. This after all is the logical end toward which Gérard's anthology of self-identifications irresistibly points; he who becomes so many different divinities can scarcely avoid the conclusion that he is himself divine. And in this connection, the last marginal note picks up another of Gérard's standing obsessions—he is the groom of a heavenly bride, not simply virgin on this earth but a widower, as the first line of "El Desdichado" makes explicit:

Je suis le ténébreux—le veuf—l'inconsolé.

If the goddess is Isis, he is Osiris; if she is Cybele, he is Attis. There is no limit to the number of torn god-sons-husbands and grieving goddess-mothers-wives in whom he could see his condition.

He had always had a tendency toward identifying with the classic world; among the *illuminés* whom he memorialized as "pre-

cursors of socialism" (but the subtitle must have been partly ironic) was Quintus Aucler, who had written a book in the early years of the revolution ("l'an VII" or, in other words, 1798), proposing neo-paganism as a substitute for Christianity. Gérard saw the relation as "both-and," not "either-or," but he was still fascinated by the notion of a religion of humanity which should unite all men as children of nature. In the later writings, he tended to represent himself as a naturally Christian soul, led astray by his rational and pagan-minded uncle into fascinations with folklore and classical myth which for long years obscured his perception of the Christian church. Perhaps it was so. But the principle of syncretic vision was so deeply en-grained in the mind and art of Gérard that he must have been a wholly different organism without it. What is idiosyncratic, perhaps even mad, about him is his habit of feeling not just sympathy but identity with so many different beings and modes of being. That play of intricate, baffling lights, that labyrinth of veils and mirrors and ardent expectations, is Gérard himself. Neo-classicism tradi-tionally disciplines the energies of the personal self into clear and definite form. For Gérard, the classic world reinforced and explained his own mystical temperament; he found it to be haunted by whis-pers of the visionary spirit in which he sought it. Thus this nomad of the spirit achieved authentic identification with a strain of that culture which for two millennia had stood foursquare as an emblem of civilized stability and rational public order. It was a triumph, possibly a fatal triumph for the individual poet, and certainly not to be duplicated by anyone else. For Gérard stood neo-classicism on its head, imposing an intricate personal structure and a kind of private lucidity (if the paradox isn't too strong) on the shadowy romanti-cism of the classic prototype. It is an accomplishment the like of which we will not see again till Mr. Robert Graves begins to apply his severe sense of form and poised style to celebrating the cult of the White Goddess—a cult in which Gérard, surely, would joyfully have joined him.

VII

THE WAY WE
DO IT NOW

The point needn't be labored. That neo-classicism in any and all of its various forms is a stream that has ceased to flow is a premise, not a conclusion. This isn't to say that classical antiquity has ceased to figure in modern art (we see it vividly present in Picasso and Stravinsky, in Valéry and Gide and innumerable others, including Signor Fellini)—what we miss is a sense of tension and resistance, awareness of a classic culture which holds up standards of style (for imitation or mockery or any other purpose), instead of bending itself pliably to the demands of a masquerade. In the nineteenth century that vein of austere feeling opened into a stagnant lake; amid the dry sands and arid atmosphere of the twentieth century, it evaporated or seeped away without leaving a trace. Indeed, we might say it was four hundred years adwindling, since the Renaissance, and disappeared with the onset of the new Dark Ages.

In the sixteenth century, for some men at least, Rome was an alternate sphere of existence, a new world, a second option; by the nineteenth century, the Roman style tended to be simply another wig and scarf in the artist's wardrobe of costume-disguises; and in the twentieth century, Nerval's vision prevailed, when the past and the present became equally transparencies to be penetrated, peelings of an onion whose "center" could be anywhere. Originally, the

changes leading to this dead end were gradual and small. "Hostile" uses of the classics, like burlesque and parody, which look like stages in the decline of the classic mode, really testify to the weight of its continuing influence: the classic world is still something to push against, still oppressive enough to *need* pushing against. But when it is picked up lightly, and as lightly laid aside, Rome becomes just one more prop in the universal nineteenth-century game of charades (a sounding box for Macaulay, a gently sympathetic academy for Pater, an erotic occasion for Gautier). And then finally when the game has been played out, the breakthrough comes abruptly, the flats fall, the props crumble, the curtain disintegrates, and we are all on the same naked stage.

For the modern (twentieth-century) world, Rome's recession into the shadows has been particularly rapid, but hardly as a result of time's passage alone. We are only 10 percent farther from the classic age than the eighteenth century was. Our alienation is from the past in all its stages, from 1880 A.D. almost as much as from 880 B.C. So much has happened over the past century which is momentous and irreversible (primarily the explosion of the world's technology and populations), that all previous civilizations appear dubious models for modern man. If Greeks and Romans still have a prototypical function, they must share it with Kwakiutls, Trobriand Islanders, and Patagonian fire-worshipers, and take second billing, at that. Savages, we feel sure, have more to teach us of the 1970s than civilizations, any civilizations, especially those which lie in our past and can be held responsible for getting us where we now are. In token of this change, anthropologists have taken to studying the classical authors as if they too were Kwakiutls only thinly disguised —to reading Ovid, with Professor Frazer, for the recollections he contains of primitive rites and prehistoric practices, not for his urbane and "civilized" values. But this is in effect to bring the wheel full circle, to abolish most of those differences between the classic and modern worlds on which neo-classicism (as the term has been used in this book) depends. Ovid is a civilized author, and interesting for his civilized deportment, one notable element of which is his transparency to certain primitive elements of his culture. We too fancy ourselves cosmopolitan, yet seek to become aware of dark

strains beneath our enlightenment. We cannot mock Ovid, we need not imitate him; as we read him now, as we understand him, he is almost literally our selves. The middle ages read him in a curiously similar way, as simply another *passus* in a single immense text written by the hand of God, which means always the same single overwhelming thing, whether it happens at any given point to be dictating the *Ars Amatoria* or the *Summa Theologiae*. In lieu of Immanence, we now worship Structure: it's scarcely more than a verbal change. The consequence in either case is that we read literature anti-historically, in an effort to see through the historical specifics to the controlling pattern beneath. The "center" of a culture is thus displaced outside culture altogether, to the collective unconscious, to nirvana, or to some other timeless region where the difference between culture and culture fades into insignificance. Hastening this process of cross-cultural identification are superficial but potent forces like the decline of the classic tongues and the prevalence of "contemporary" translations—translations properly or improperly slanted to bring out the "modern" values of ancient texts. And since writing habits vary in tandem with reading habits, it is hardly surprising that much modern literature is written to be read stereoptically, with past and present held in a single focus. One doesn't use the ancient culture to comment on the modern one, or vice versa; they are conflated, they are identified, not across vast distances but casually, as by legerdemain. The point is not one that profits much from extended argument; either it commends itself to one's experience of reading works like the *Cantos* of Ezra Pound, the *Waste Land* of Eliot, and Joyce's fictions, or it doesn't. If it does, then one can make the applications oneself to Sartre or Giraudoux, Eugene O'Neill or W. H. Auden, and anything in between.

Still, it's interesting to see, in a single instance, how hard the habits of the Renaissance died, how deep lay the compulsion to make one culture comment on the other. During the first few decades after the publication of *Ulysses*, an inordinate amount of ink was spilled over the exact "point" of the classical parallel in that book. Did the classical fable bring meaning, structure, redemptive value to the sordid, grubby disorder of modern urban life? Or was its effect ironic and negative, as if to say, "This is the contemptible level at which

the modern world is doomed to re-enact the heroic (epic) past"? What wasn't seriously considered, till *Finnegans Wake* had given a better perspective on *Ulysses*, was the possibility that Joyce really saw the buried past surviving in the present without giving either priority over the other, because, for his vision, they were the same.

The most strongly marked parodic sections of Joyce's book show this evenhandedness most strikingly. In a section like "Cyclops," for example, the voice of modern realism, of indigenous, naturalistic Dublin, is that of the unnamed primary narrator. He provides for us a sour, cynical description of things "as they are," and we trust him naturally because we instinctively think the "low" more authentic than the "literary" and the "artificial." We trust him all the more because of the patent artifice of the many interruptions, legal, sentimental, archaic, heroic, and unctuous, that break in on his diatribe. The scene itself is utterly static, a frieze of motionless men standing about a bar; but speech ferments, bubbles, and swirls about them, a kaleidoscope of verbal disguises. By contrast with this mobility of language, its capacity to assume now this coloring, now that, the figures stand as if paralyzed. Only their tongues are ceaselessly active. The parodic speeches are never associated with identifiable speakers; they emerge from no dramatic context at all, and their simple variety advertises their unreliable and arbitrary character. Thus everything points to a contrast between the reliable narrator and the dubious parodies. Yet in fact the narrator manages to destroy his own position, and to cast doubt on his own narration, simply by being too consistently cynical about everything. Whatever topic comes up in the way of personal history (whether it is Bloom's, or Bob Doran's, Boylan's father's, Denis Breen's, J. J. O'Molloy's, or the Citizen's), the narrator has an "inside story" that's a good deal more picturesque and nastier than anything else we are told in the novel. He snarls at Bloom's Jewishness, and then at the Citizen for raising a ruckus about it—everything he says must terminate in a snarl. If the parodies destroy their own credibility by their variety, the narrator destroys *his* credibility by his uniformity and sameness.

In this context the word *neutrality* won't adequately describe Joyce's attitude, which is an acceptance of both extremes rather than an avoidance of either; and this comes out as he manipulates the

reader's feelings about Bloom warily negotiating this cave of danger-
ous troglodytes. On the one hand, he is a genuine apostle to the
Gentiles, an Elijah possessed of truth from on high, a helper of
widows and orphans, a semi-articulate but sincere preacher of love.
On the other hand, his "love" doesn't extend to the possibility of
easy conversation with anyone at all, or even to the modest gesture
of calling Joe Hynes or Alf Bergan by their first names. What's more,
his softness and gentleness are impugned, throughout the section, as
masks for self-seeking and commercial greed.[1] One little numerologi-
cal detail, such as Joyce loved to work into the margin of his design,
seems to support a "serious" view of Bloom as an exemplar of Christ,
but actually works the other way. All afternoon the number of
customers in Barney Kiernan's pub has been varying as different
individuals and groups arrive and depart. When Bloom steps out to
the courthouse, it drops to nine (counting Terry the curate), but
Martin Cunningham arrives with John Power and Crofton to make
it twelve, and Bloom's return brings it, for the first time all after-
noon, to the fateful number, thirteen. Thus the Citizen's turning on
Bloom, and the explosion of violence against him, are felt to be con-
trolled, not by his character or that of his associates, not by the
misunderstanding over a horse race, not by any social circumstances,
but by an abstract, ghostly paradigm of things, an occult number. It
has nothing to do with moral or personal values at all, but with some-
thing to be glimpsed far behind them.

The same point could be made with evidence supplied by the
image of Molly Bloom, who has been described by some critics as an
obscene slut and by others as an earth-goddess. Both views are cor-
rect, and neither can claim any particular advantage or priority over
the other. Fragments of thought-talk from previous existences drift
continually through the darkened consciousness of Mrs. Bloom;
their presence redeems her obvious sluttishness about as much as it
degrades them. She *is* Circe, Calypso, Penelope, as Penelope, Calypso,
and Circe *were* Maya the weaver, as every enlightened soul *is* the

[1] "Ga Ga Gara. Klook Klook Klook. Black Liz is our hen. She lays eggs
for us. When she lays her egg she is so glad. Gara. Klook Klook Klook. Then
comes good uncle Leo. He puts his hand under black Liz and takes her fresh
egg. Ga ga ga ga Gara. Klook Klook Klook" *Ulysses*, "Cyclops."

Buddha. He is not an inferior or second-rate Buddha, he is not an imitation Buddha, he is Buddha, and the hundredth incarnation is just as good as the first. So with Molly. The fact that there is something of the goddess in her suggests that there must have been something of the slut in her divine predecessors—since, in the religion of humanity, all gods and goddesses are more or less contaminated, all worshipers more or less enlightened. The reason it's impossible to speak of neo-classicism in connection with Joyce is that, even if his view of the cosmos and his art were "classical" in any useful sense, it wouldn't be "neo." If there is one thing sought by a man imbued with the classical temper, it is a precise definition of character and self, an exact, even if limited definition. Bloom and his wife clearly don't have such a definition; just as clearly their creator wasn't interested in providing one for them.[2] One of the main areas where he left them "open" was in the direction of mythic antiquity, as if they were free to flow limitlessly into and out of their figural prototypes. By the time of the *Wake*, the "characters" of contemporary life will have become little more than transparent containers for their multiple mythical analogues.

If human personality is transparent to the immense rubble and residue of the past, then human desire is a mere artifice, an illusion, compared with the limitless energies and inertias of preformed patterns. Perceptions like these erode the very idea of individuality that subsumes both romanticism and classicism. The I-other dichotomy on which both outlooks stand is a scarlet strand in the twisted cable of western thought; it is built into the syntax of the major European languages. Joyce had to create a language of his own to transcend it. Also deeply involved with the structure of western languages is the special western idea of time as linear and non-repetitive; Christianity, that most historically minded of religions, has added its own underlinings, interpolations, and marginal notes to the text of individual uniqueness. All these assumptions are called into question by the

[2] The two books at which I glance here and below are Mr. S. L. Goldberg's study of Joyce titled *The Classical Temper* (London, 1961) and Wyndham Lewis's diatribe called *Time and Western Man* (London, 1927). They are so pointedly and diametrically opposed to the outlook presented in this book that it would be idle to quarrel with them. They represent, ably in the one case, vociferously in the other, a different point of view.

movement of *Ulysses*, the achievement of *Finnegans Wake*, through
which the unfolding flower of Buddhist feeling, after its long, slow,
pervasive growth through the nineteenth century, makes its presence
overwhelmingly known. Whether we look at Pound's *Cantos* or
Eliot's *Waste Land*, we become aware of the same abolition of time,
personality, and cultural distinction; the momentary mask becomes
confounded with its mythical analogues.[3] History is an endless hall
of veils and mirrors. Looking through the veil of appearances to see
one or another brand of patent "reality" is an old trick; looking
through appearances to find only an infinite recess of appearances
and behind them the chill sense of nothing at all is rather different.
The logic of the situation points toward Buddhism, but for a western
mind with western notions of identity, real Buddhism is a major
piece of brain surgery, and pseudo-Buddhism just another exercise in
picturesque, self-regarding calisthenics. Short of these ultimates,
modern man remains trapped in his now familiar dichotomy of free-
dom without meaning. In giving one the right to throw up any flimsy
facade of pseudo-selfhood that seems momentarily pleasing or ad-
vantageous, the current brand of *self*-consciousness thins the mean-
ing of that act of choice, emphasizes the artifice of the contrivance.
If one were writing the appropriately endless book on this theme,
one could trace some roots of the development in the works of the
romantics, Parnassiens, and Symbolists, in the time-attitudes of
Schopenhauer and Spengler (not to mention Proust) in the work of
the Cubists and the Cambridge anthropologists, in the paintings of
Gustave Moreau, the drawings of Odilon Redon, the Hellenic illumi-
nism of Hölderlin, in the "perennial philosophy" of those occultists,
worshipers of Isis or thrice-great Hermes, who lie in the background
of so much symbolist theory. One could press on to qualify, restrict,
extend one's generalizations through the Strauss-Hofmannsthal
Ariadne, Rilke's *Sonnets to Orpheus*, Stravinsky's *Apollo* and Proko-
fiev's *Classical Symphony*, Kafka's quiet paradoxes, the myths and
masks of Yeats, some polished ironies of Jorge Luis Borges, and so
on to no fixed term. It's not the "disappearance of the object" that

3 The movement could be described in a rather special way as the triumph
of one side of Nietzsche's mind over the other: Eternal Return bends Superman
back on himself, linear aspiration turns into closed circle.

one would be tracing but its suffusion with a plenitude of shapes or contexts so rich and deep that no "self" can be conceived capable of absorbing, containing, or stopping them. The world then appears an animated, aggressive arabesque, an infinity of self-extending patterns and self-defeated meanings, before which the minds stands only as victim.

All that, however, is something else again.

AUTHORITIES CITED

In compiling this retrospective summary of authorities visibly coöpted into the service of my study—a bibliography of invisible influences would be just as long and perhaps more interesting—I have felt free to decline the reproduction of exact bibliographical details where they are patently useless and distracting. That occurs when the text referred to is well known, when it exists in many editions, and when the citation is given in such a form (*Aeneid* 8.431, for example, or Marvell, *Poems*, "Upon Appleton House") that it can readily be found in any text that lies to hand. Such blank entries are marked below with an asterisk *. In compiling the list I have also given preference to handy, modern, and preferably bilingual texts, whether or not they were the ones actually used in the course of my study's long gestation and multiple revision. Blessed are the accurate, but accursed are the finicky: between these two perilous injunctions, I have tried to steer my narrow course.

Ackerman, J. S. *Palladio*. London, 1966.
Anonymous. "Albert Moore" in *Masters in Art* series (Boston, 1908), IX, 339–380.
Antal, Frederick. *Fuseli Studies*. London, 1956.
Apuleius, Lucius. *The Golden Ass*. Trans. R. Graves. New York, 1955.
Argan, G. C. "Andrea Palladio e la critica neoclassica" in *L'Arte*, I (1930), 327–346.
Auerbach, Erich. *Mimesis*. Trans. W. Trask. Princeton, N.J., 1953.
Bachofen, J. J. *Myth, Religion, and Mother Right: Selected Writings*. Trans. Ralph Manheim. Princeton, N. J., 1967.

Baldini, Antonio. *Beato fra le donne.* Milan, 1945.

Baron, Hans. "The *Querelle* of the Ancients and the Moderns," in *Journal of the History of Ideas,* XX (1959), 3–22.

Bassi, Elena. *Canova.* Bergamo, 1943.

Baudelaire, Charles.* *Les fleurs du mal.*

―――. Selected writings on art, trans. J. Mayne as *The Mirror of Art.* New York, 1955.

―――. *Oeuvres complètes.* Ed. F. F. Gautier. Paris, 1918–1937.

Beni. Paolo. *Trattato dall'origine della famiglia Trissina.* Padua, 1624.

Bentley, Richard. *A Dissertation upon the Epistles of Phalaris.* London, 1697, 1699.

―――. Ed. Milton's *Paradise Lost.* London, 1732.

Berenson, Bernard. *Italian Painters of the Renaissance.* Oxford, 1932.

Bernays, Jakob. *Joseph Justus Scaliger.* Berlin, 1855.

Boileau-Despréaux, Nicolas. *Oeuvres.* Paris, 1934–1942.

Bovillus, Carolus. *De Sapiente.* Ed. R. Klibansky as an appendix to Cassirer's *Individuum und Kosmos,* q.v.

Boyle, Charles. *Dr. Bentley's Dissertations . . . Examin'd.* London, 1698.

Burlingame, A. E. *The Battle of the Books in Its Historical Setting.* New York, 1920.

Byron, Lord. *Selected Poetry.* Ed. L. Marchand. Modern Library.

Calvesi, Maurizio. Ed. and intro. to Italian trans. of Henri Foçillon, *G. B. Piranesi.* Bologna, n.d.

Canova, Antonio. *Letter on the Sculptures in the British Museum.* London, 1816.

Cardano, Girolamo. *De subtilitate libri xxi.* Nuremberg, 1550.

Cassirer, Ernst. *Individuum und Kosmos in der philosophie der renaissance.* Leipzig, 1927. Trans. (except for the appendix) by Mario Domandi as *The Individual and the Cosmos in Renaissance philosophy.* New York, 1963.

Cassirer, E., P. O. Kristeller, and J. H. Randall, eds. *The Renaissance Philosophy of Man.* Chicago, 1948.

* Catullus. *Carmina.*

Chambers, Sir William. *A Treatise of Civil Architecture.* London, 1791.

Chenier, André. *Oeuvres complètes.* Ed. P. Dimoff. Paris, 1938.

Cipriani, Renata. *Tutta la pittura del Mantegna.* Milan, 1956.

Constable, W. G. *John Flaxman.* London, 1927.

* Corneille, Pierre. *Oeuvres complètes.*

Cruttwell, Maud. *Mantegna.* London, 1901.

D'Alembert, Jean. *Oeuvres*. Paris, 1821.

De Brosses, Charles. *Lettres d'Italie*. Dijon, 1927.

Delécluze, Etienne. *Louis David son école et son temps*. Paris, 1860.

Demetz, P., T. Greene, and L. Nelson, eds. *The Disciplines of Criticism*. New Haven, Conn., 1968.

* De Quincey, Thomas. *Confessions of an English Opium Eater*.

De Thou, Jacques. *Perroniana et Thuana*. Ed. C. Dupuy. Col. Agripp.— Cologne, 1669. See also below, Perron.

Dionysus Halicarnassus. *Roman Antiquities*, with trans. by Earnest Cary. Loeb Library.

Donoghue, Denis. *Jonathan Swift*. Cambridge, Eng., 1969.

* Dryden, John. *Poetical Works*.

* Du Bellay, Joachim. "Les Antiquitez de Rome." Trans by Edmund Spenser as * "The Ruines of Rome."

Dubos, J. B. *Réflexions critiques sur la poësie et sur la peinture*. Paris, 1740.

Ennius. *Annales*, with trans. by E. H. Warmington. Loeb Library.

Faguet, Emile. *En lisant Corneille*. Paris, 1913.

Farington, Joseph. *Diary*. Ed. James Greig. London, 1922–1928.

Ferrero, Guglielmo. *Lois psychologiques du symbolisme*. Paris, 1895.

Fiocco, Giuseppe. *L'Arte di Andrea Mantegna*. Venice, 1959.

Flaubert, Gustave. *Oeuvres complètes*. Paris, 1964.

Foçillon, Henri. *G. B. Piranesi*. Paris, 1918. See also above, Calvesi.

Foerster, Richard. "Andrea Mantegna" in *Jahrbuch der königlich Preussischen Kunstsammlung* (1901), XXII, 160.

Frazer, Sir James. *The Golden Bough*. London, 1911–1915.

Frederics, Harold. "Painter of Beautiful Dreams" in *Scribners*, X (Dec., 1891), 712–722.

Friedlander, Walter F. *Nicolas Poussin*. New York, 1966.

Fuseli, Henry. *Life and Writings*. Ed. J. Knowles. London, 1831.

Garin, Eugenio. *Italian Humanism*. Trans. Peter Munz. New York, 1965.

Girard, René. *Mensonge romantique et vérité romanesque*. Paris, 1961. Trans. Yvonne Freccero as *Deceit, Desire, and the Novel*. Baltimore, Md., 1965.

Giustiniani, Orsatto. *Edipo Tiranno di Sofocle*. Venice, 1585.

Goethe. * *Italienische Reise*.

———. *Schriften zur Kunst*. Zurich, 1954.

Goldberg, S. L. *The Classical Temper*. London, 1961.

* Goldsmith, Oliver, *The Vicar of Wakefield*.

Gonse, Louis. *La sculpture française*. Paris, 1895.

Grandville, I. I. *Les metamorphoses du jour*. Paris, 1854.

————. *Un autre monde*. Paris, 1844.

Gyraldi, L. G. *Opera omnia*. Lugd. Bat.—Leyden, 1696.

Hall, Vernon, Jr. "The Life of Julius Caesar Scaliger." In *American Philosophical Society Transactions*, ser. 2, vol. 40, pt. 2.

Hallays, André. *Les Perrault*. Paris, 1926.

Harrison, Jane. *Prolegomena to the Study of Greek Religion*. Cambridge, Eng., 1908.

Hartt, Frederic. "Mantegna's Madonna of the Rocks." In *Gazette des beaux arts*, ser. 6, vol. 40 (Dec., 1952).

Haydon, Benjamin. *Diary*. Ed. W. B. Pope. Cambridge, Mass., 1960.

Heine, Heinrich. *Samtliche Werke*. Leipzig, 1912.

Hind, A. M. G. B. *Piranesi*. London, 1922.

Holderbaum, James. "*Clodion*." In *The Encyclopedia of World Art*. New York, 1960.

* Hölderlin, *Gedichte*.

Honour, Hugh. *Neo-Classicism*. London, 1968.

* Horace. *Poemata omnia*.

Hübner, Baron Julius. *Sixte-Quint*. Paris, 1870.

Jacquot, A. *Les Adam et les Michel et Clodion*. Paris, 1898.

Janson, H. W., and D. J. Janson. *Picture History of Painting*. New York, 1957.

Jauss, H. R. Ed. and intro. to Charles Perrault, *Parallèle des anciens et des modernes*. Munich, 1964. Facsimile of 1688–1697 ed.

* Johnson, Samuel. *Poems*.

Jones, Inigo. *The Architecture of A. Palladio . . .* (with) *Notes . . . by I. J.* London, 1715.

Jones, R. F. *Ancients and Moderns*. Berkeley, Calif., 1965.

* Joyce, James. *Finnegans Wake*.

————. * *Ulysses*.

* Juvenal. *Satirae*.

Keats, John. *Complete Poems*. Ed. W. Thorpe. New York, 1935.

Keller, Luzius. *Piranèse et les romantiques français: Le mythe des escaliers en spirale*. Paris, 1966.

Klossowski, Pierre. *Origines cultuelles et mythiques d'un certain comportement des dames romaines*. Ste.-Croix-de-Quintillargues, 1968.

Kristeller, Paul. *Andrea Mantegna*. London, 1901.

Kristeller, P. O. "Modern System of the Arts." In *Journal of the History of Ideas*, XII (1951), 496–527.

Lampridius, Aelius. Among the *Scriptores Historiae Augustae*, with trans. by D. Magie. Loeb Library.

Le Fanu, T. P. "Catalogue of Dean Swift's Library in 1715." In *Royal Irish Academy Proceedings*, XXXVII, C 13 (July, 1927), 263–273.

Leti, Gregorio. *Vita di Sisto V Pontefice Romano*. Losanna—Lausanne, 1669.

Lewis, Wyndham. *Time and Western Man*. London, 1927.

* Livy. *Ab urbe condita*.

* Lucian. *Dialogues of the Gods*.

Lund, Hakon. "Facade of San Giorgio Maggiore." In *Architectural Review*, CXXXIII (1963), 283–284.

* Machiavelli, *Discorsi sopra la prima deca di Tito Livio*.

———. * *Lettere*.

Macrobius. *Commentary on the Dream of Scipio*. Ed. W. H. Stahl. New York, 1952.

Maine, Sir H. S. *Early Law and Custom*. London, 1883.

Maison, K. E. *Honoré Daumier*. New York, 1968.

Malamani, Vittorio. *Canova*. Milan, 1911.

Martinelli, Valentino. "Canova e la forma neoclassica." In *Arte Neoclassica*. Venice, 1957.

* Marvell, Andrew. *Poems*.

Mason, H. A. "Is Juvenal a Classic?" In *Arion*, I (1962), 8–44.

Mérimée, Prosper. *Oeuvres complètes*. Ed. P. Jourda. Paris, 1928.

Michel, André. *Histoire de l'art*. Paris, 1924.

Missirini, Melchior. *Della vita di Antonio Canova*. Milan, 1824.

Moers, Ellen. *The Dandy*. New York, 1960.

Monk, J. H. *Life of Bentley*. London, 1830.

Montclos, J. M. P. E. L. *Boullée*. Paris, 1969.

Montesquieu, C. L. *Considerations sur les causes de la grandeur des romains et de leur décadence*. Paris, 1815.

———. * *Lettres persanes*.

Naves, Raymond. *Le goût de Voltaire*. Paris, 1938.

Nerval, Gérard. *Oeuvres*. Ed. H. Lemaitre. Paris, n.d.

Nichols, F. D. Ed. *Thomas Jefferson Architect*. New York, 1968.

Nodier, Charles. *Oeuvres complètes*. Paris, 1837.

Ong, Reverend Walter. *Rhetoric, Romance, and Technology*. Ithaca, N.Y., 1971.

"Orpheus." *Hymns*. Trans. P. B. Shelley as the Hymns of "Homer." *Poetical Works* of Shelley. London, 1925.

* Ovid. *Amores*.

———. * *Fasti*.

———. * *Metamorphoses*.

———. *Shakespeare's Ovid*, the *Metamorphoses* in A. Golding's trans. W. Rouse ed. New York, 1966.

Palladio, Andrea. *Quattro libri dell'architectura*. Milan, 1968. Facsimile of 1570 ed.

Pane, Roberto. *Andrea Palladio*. Turin, 1961.

Perrault, Charles. *Mémoires de ma vie*. Ed. P. Bonnefon. Paris, 1909.

———. *Parallèle des anciens et des modernes*. Ed. H. R. Jauss. Facsimile of 1688–1697 ed. Munich, 1964.

Perron, Jacques. *Perroniana et Thuana*. Ed. C. Dupuy. Col. Agripp.— Cologne, 1669. See also above, De Thou.

Pignatti, Terisio. "Paolo Veronese a Maser." In *L'Arte Racconta* No. 2. Fabbri-Skira.

Poggio Bracciolini. *Historiae de varietate fortunae libri quatuor*. Paris, 1723.

* Polybius. *Historiae*.

Poulet, Georges. *Trois essais de mythologie romantique*. Paris, 1966.

Praz, Mario. "Canova or the Erotic Frigidaire." In *Art News*, LVI (Nov., 1957), 24–27.

———. *Gusto neoclassico*. Naples, 1958. Trans. by Angus Davidson as *On Neoclassicism*. London, 1969.

Prideaux, Humphrey. *The Life of Mahomet*. London, 1723.

Puppi, Lionello. *Il teatro Olimpico*. Vicenza, 1963.

Quincy, Quatremère de. *Canova et ses ouvrages*. Paris, 1834.

Richards, J. F. C. "The Elysium of Julius Caesar Bordonius." In *Studies in the Renaissance*, IX (1962), 195 ff.

Richardson, Jonathan (father and son). *Explanatory Notes and Remarks*. London, 1734.

Rigault, Hippolyte. *Histoire de la querelle des anciens et des modernes*. Paris, 1856.

Ripa, Cesare. *Iconologia*. Venice, 1669.

Robinson, H. Crabb. *Diary, Reminiscences, and Correspondence*. Ed. T. Sadler. London, 1869.

Rosenblum, Robert. *Transformations in Late 18-Century Art*. Princeton, N.J., 1967.

Ruskin, John. *Diaries*. Sel. and ed. by Joan Evans and J. H. Whitehouse. Oxford, 1956–1959.

———. *Stones of Venice*. Vols. 9–11 in *Works*. London, 1903–1912.

Saintsbury, George. *History of Criticism*. New York, 1902.

Sallust. *Bellum Catalinae*, with trans. by J. C. Rolfe. Loeb Library.

Scaliger, Joseph Justus. *Josephi Scaligeri . . . epistolae*. Lugd. Bat.— Leyden, 1627.

——. *Scaligerana*. Col. Agripp.—Cologne, 1695.

Scaliger, Julius Caesar. *Epistolae aliquot nunc primum vulgatae*. Tolosae —Toulouse, 1620.

——. *Exotericarum exercitationum liber xv*. Francofurti—Frankfort, 1612.

——. *Poetices . . . libri septem*. Heidelberg, 1607.

Scott, Geoffrey. *The Architecture of Humanism*. London, 1947.

Seneca, L. A. *Epistolae Morales*, with trans. by J. W. Basore. Loeb Library.

* Servius the grammarian, notes to the *Aeneid*.

Seznec, Jean. *La survivance des dieux antiques*. London, 1940.

* Shakespeare. *Plays*.

* Sidney, Sir Philip. *Defense of Poesy*.

Solinus, Julius. *Polyhistor*. Trans. Arthur Golding. London, 1587.

Spartianus, Aelius. Among the *Scriptores Historiae Augustae*, with trans. by D. Magie. Loeb Library.

Stendhal. *Promenades dans Rome*. Ed. H. Martineau. Paris, 1931.

——. *Rome, Naples, et Florence en 1817*. Ed. H. Martineau. Paris, 1956.

* Suetonius. *Lives of the Twelve Caesars*.

Swift, Jonathan. *Battle of the Books*. Ed. A. E. Guthkelch. London, 1908.

——. *Poems*. Ed. Harold Williams. Oxford, 1963.

——. *Prose Works*. Ed. Herbert Davis. Oxford, 1939–1962.

——. *Tale of a Tub*. Ed. A. E. Guthkelch and D. N. Smith. Oxford, 1958.

Swinburne, A. C. *Complete Works*. Bonchurch ed., London, 1925–1927.

* Tacitus, *Annales*.

Talma, J. F. *Memoires*. Paris, 1849. Actually by A. Dumas.

Tempesti, Casimiro. *Storia della vita e geste di Sisto Quinto*. Rome, 1754.

Temple, Sir William. "Of Ancient and Modern Learning." In *Miscellanea II*. London, 1697.

* Terence. *Plays*.

Thirion, H. *Les Adam et Clodion*. Paris, 1885.

Tietze-Conrat, Erika. *Mantegna*. London, 1955.

Todd, Ruthven. *Tracks in the Snow*. New York, 1947.

Trissino, Gian Giorgio. *Tutte le opere*. Verona, 1729.

Valeriano, G. P. *Hieroglyphica*. Basle, 1567.

Varro. *De lingua Latina*, with trans. by R. G. Kent. Loeb Library.

Vasari, Giorgio. *Lives of the Eminent Painters*. . . . Everyman ed.

Verheyen, Egon. *The Paintings in the Studiolo of Isabella d'Este at Mantua*. New York, 1971.

* Virgil, *Aeneid*.

Vitruvius, Ed. D. Barbaro. M. V. *Pollionis De architectura libri decem*. Venice, 1567.

* Voltaire, *Candide*.

Williams, Harold. *Dean Swift's Library*. Cambridge, Eng., 1932.

Winckelmann, J. J. *Reflections on the Painting and Sculpture of the Greeks*. Trans. H. Fuseli. London, 1765.

Wittkower, Rudolf. *Architectural Principles in the Age of Humanism*. London, 1952.

Wotton, William. *Reflections on Ancient and Modern Learning*. London, 1694, 1697.

INDEX